Heart of the Heartless World

HEART OF THE HEARTLESS WORLD

Essays in Cultural Resistance in Memory of Margot Heinemann

Edited by
David Margolies and Maroula Joannou

Pluto Press
LONDON • BOULDER, COLORADO

First published 1995 by Pluto Press
345 Archway Road, London N6 5AA and
5500 Central Avenue, Boulder, Colorado 80301, USA

British Library Cataloguing in Publication Data
A catalogue record for this book is available from the British Library

ISBN 0 7453 0981 X hbk

Library of Congress Cataloging in Publication Data
Heart of the heartless world: essays in cultural resistance / edited
 by David Margolies and Maroula Joannou.
 p. cm.
 Includes bibliographical references and index.
 ISBN 0–7453–0981–X (hb).
 1. English literature — Social aspects — Great Britain. 2.
 English literature — Early modern, 1500–1700 — History
 and criticism. 3. Protest literature, English — History and
 criticism. 4. Literature and society — Great Britain. 5.
 Social classes in literature. 6. Great Britain — civilization.
 I. Margolies, David. II Joannou, Maroula.
 PR408.S64H43 1995
 820.9'355—dc20 95–2979
 CIP

99 98 97 96 95 5 4 3 2 1

Designed and produced for Pluto Press by
Chase Production Services, Chipping Norton, OX7 5QR
Printed in the EC by T J Press, Padstow, England

CONTENTS

PREFACE

When this volume was first proposed in early 1992 it was as a *festschrift* for Margot Heinemann. The suggestion had been made a number of times before but Margot firmly resisted it (as she always resisted anything she regarded as special treatment for herself). The hope was to present a suitable offering while she was still able to appreciate it. Events soon overtook the project, and Margot's death turned it into a memorial volume.

The book has been a long time in the making, and we gratefully acknowledge the patience and good will of the contributors. We thank Andy Croft, who was closely and enthusiastically involved from the beginning, for his help and advice, and we thank Jane Bernal, Dorothy Williams and Noreen Branson for their assistance with the chronology. Jane Bernal and Vera Gottlieb also have our special gratitude for their continuing encouragement and support. Vera would have written for the volume herself had she not been prevented by continuing illness (her contribution is invisibly present throughout the volume).

Maroula Joannou
David Margolies

POEM

FOR MARGOT HEINEMANN

Heart of the heartless world,
Dear heart, the thought of you
Is the pain at my side,
The shadow that chills my view.

The wind rises in the evening,
Reminds that autumn is near.
I am afraid to lose you,
I am afraid of my fear.

On the last mile to Huesca,
The last fence for our pride,
Think so kindly, dear, that I
Sense you at my side.

And if bad luck should lay my strength
Into the shallow grave,
Remember all the good you can;
Don't forget my love.

John Cornford

A Chronology of Margot Claire Heinemann

1913	Born 18 November, second child of Max and Selma Heinemann (sister Dorothy born 1911).
1917	Brother Henry born.
1919–31	Education at Miss Chattaway's School, South Hampstead High School, King Alfred School and Roedean School.
1931–34	Awarded Major Scholarship to read English, Newnham College, Cambridge; gains double First (Part I starred).
	Joins Communist Party after hunger-marchers pass through Cambridge.
	Friendship with James Klugmann; love relationship with John Cornford.
	Begins postgraduate research (which she does not complete at the time).
1935	Teaches at Day Continuation School at Cadbury's, Bourneville.
1936	Writes poems inspired by Spanish Civil War, including 'Grieve in a New Way for New Losses', 'To RJC' and 'On a Lost Battle in the Spanish Civil War'.
	John Cornford killed in Spanish Civil War.
	Begins full-time political work for the Communist Party in London.
1937	Joins staff of Labour Research Department (where friendship with Noreen Branson develops).
	Publication of Cornford's 'Poem' ('Heart of the Heartless World'), dedicated to Margot Heinemann, in *New Writing 4* (republished in *Poems for Spain*, 1939, and in *Penguin New Writing 2*, 1941).
	During 1930s teaches courses for Communist Party and trade union movement, for the miners in particular; begins friendship with miners' leaders Arthur Horner and Abe Moffat.
1938	Edits *Labour Research* (until 1942).
1941	'British Monopoly Capital and the War' in *Labour Monthly* (under name of Margaret Hudson).

1942 Assists Mineworkers' Federation prepare case for pay claim to Greene Inquiry into wages in the coal industry.

1944 *Britain's Coal: A Study of the Mining Crisis* (prepared for the Labour Research Department and published by Victor Gollancz for the Left Book Club); 'Wages and Exports', *Labour Monthly*.

1945 'Who Is to Plan our Post-War Industries?', *Labour Monthly*; 'Cotton Working Party', *Labour Monthly*.

1946 'Foreign Trade Problems', *Labour Monthly*; 'Britain's Economic Balance Sheet', *Labour Monthly*; 'Britain's Trade Problems' (as Margaret Hudson), *World News and Views*.

1947 *Wages Front* (prepared for the Labour Research Department and published by Lawrence and Wishart); 'British Trade Policy and the Crisis' (as Margaret Hudson), *World News and Views*; 'Harriman and Cripps', *Labour Monthly*; 'Britain's Economic Strategy' (with N. J. Klugmann), *The Modern Quarterly*.

1948 *Coal Must Come First* (prepared for the Labour Research Department and published by Frederick Muller); 'The Anglo-American Production Committee', *World News and Views*; 'Margate TUC 1948' (as Margaret Hudson), *World News and Views*; 'The "Marshall" Standard of Life' (as Margaret Hudson), *Labour Monthly*.

1949 Works full time for Communist Party; researcher for Harry Pollitt; begins love relationship with J. D. Bernal.

 Review of Andrew Rothstein's *Man and Plan in Soviet Economy* in *The Modern Quarterly*.

1950 Stands as Communist candidate in general election; develops chronic bronchial illness while campaigning; disagreements with party over electoral policy.

 'How Near Is the Slump', *Labour Monthly*; in *World News and Views*: 'Gathering Storm in the Coalfields', 'American Aggressors Speak Out', 'Arms Enough to Sink Us', 'Sheffield and the Fight for Democracy'.

1951 Writing for *World News and Views*: '"Bygones Are Bygones"', 'Europe against German Rearmament', 'Robbing the Poor for America's War', 'Coal and the War Drive', 'Gaitskell's Call for Wage-Freeze', 'Strachey's "Just Society"', 'Big Business Government' (2 parts), '"Mutual Security" and American Intervention', 'Transport House and the USA' (2 parts); contribution to 'The Caudwell Discussion' in *The Modern Quarterly*.

1952 Writing for *World News and Views*: 'Socialist Advances in East–West Trade', 'France Revolts against American Orders', 'East–West German Talks Have Begun', 'Unemployment – Or

East–West Trade', 'Fight Wage Freeze and Unemployment','The Tories and the Economic Crisis', 'USSR's Peace Budget', '"Class and the Classics"'.

1953 Daughter Jane Bernal is born; gives up full-time party work but continues to serve on London District Committee and on editorial boards of *The Modern Quarterly*, *Labour Monthly* and *Marxist Quarterly*.

1954 'André Stil and the Novel of Socialist Realism', *Marxist Quarterly*; review of André Stil's *A Gun Is Unloaded* in *World News and Views*.

1955 'Bankers versus Britain', *Labour Monthly*.

1956 Internal crisis in CPGB precipitated by Khrushchev's revelations and Soviet suppression of Hungarian rising; many of her close friends, including Christopher Hill, leave party; she remains in the party but is allied with dissident intellectuals and is censured for her part in a letter to *Daily Worker* critical of party policy; she is not again asked to serve on any leading party committee until the late 1970s.

Discussion contribution in *World News and Views*, 'Consult the Party on Controversial Issues'.

1957 'Shareholding or Socialism', *Labour Monthly*; discussion contribution in *World News and Views*, 'Some Problems of *The British Road*'.

Begins writing her novel, *The Adventurers*, while at home with her daughter.

1959–65 Teaches English at Camden School for Girls, London.

1960 *The Adventurers* published by Lawrence and Wishart.

1964 Start of J. D. Bernal's terminal illness.

1965 Appointed Lecturer in English at University of London Goldsmiths' College; works with Harold Rosen and others on working-class writing.

1967 First of several visits to German Democratic Republic, to attend writers' congress.

1968 Opposes Soviet invasion of Czechoslovakia; active in resistance to Vietnam War (which she characterises as 'the Spain of a younger generation').

1971 Death of J. D. Bernal; *Britain in the 1930s* (with Noreen Branson, published by Weidenfeld and Nicolson).

Serves on party's Cultural Committee and Theory and Ideology Committee; throughout 1970s involved in organising annual Communist University of London.

1975 'Middleton's *A Game at Chess*: Parliamentary Puritans and Opposition Drama', *English Literary Renaissance*, vol. 5, no. 2.

1976 Appointed Fellow of New Hall, Cambridge; '1956 and the Communist Party' in *Socialist Register*; edits *Experiments in English Teaching: New Work in Higher and Further Education* (with David Craig, published by Edward Arnold).

1978 'Popular Drama and Leveller Style – Richard Overton and John Harris' in *Rebels and Their Causes: Essays in Honour of A. L. Morton* (ed. Maurice Cornforth, Lawrence and Wishart).

1979 Edits *Culture and Crisis in Britain in the 1930s* (with J. Clark, D. Margolies and C. Snee, published by Lawrence and Wishart), contributing the article 'Louis MacNeice, John Cornford and Clive Branson: Three Left-Wing Poets'.

1980 *Puritanism and Theatre: Thomas Middleton and Opposition Drama under the Early Stuarts* (Cambridge University Press). Paperback edition in 1982.

1981 Fellowship ends at New Hall (but continues to lecture on tragedy, the Renaissance and other topics for English Faculty, to supervise and examine students, and participate in seminars until 1991).

 Works with Steven and Hilary Rose on 50th anniversary of 'Science at the Crossroads', international conference on history of science and technology.

1982 '*Burger's Daughter*: The Synthesis of Revelation' in *The Uses of Fiction: Essays on the Modern Novel in Honour of Arnold Kettle* (eds Douglas Jefferson and Graham Martin, Open University Press); 'Modern Brecht' in *London Review of Books* (August).

1983 Review of Warren Chernaik's *The Poet's Time: Politics and Religion in the Work of Andrew Marvell* in *History Today* (July); review of John G. Demary's *Milton's Theatrical Epic: The Invention and Design of 'Paradise Lost'* in *Modern Language Review* (July).

1984 'Brecht's New Age' (review article) in *London Review of Books* (March); 'Shakespeare als Dramatiker nachreformatorischer Zeit' (Shakespeare as Post-Reformation Dramatist) in *Shakespeare Jahrbuch*; 'Brecht in History' in *German History*.

 Involved in organising *History and Literature* conference at Ruskin College, Oxford; active support for miners' strike.

1985 'How Brecht Read Shakespeare' in *Political Shakespeare* (eds Alan Sinfield and Jonathan Dollimore, Manchester University Press); 'The People's Front and the Intellectuals' in *Britain, Fascism and the Popular Front* (ed. Jim Fyrth, Lawrence and Wishart); 'Shakespeare und die Zensur: *Sir Thomas More* und

Richard II' (Shakespeare and the Censor in *Sir Thomas More* and *Richard II*) in *Shakespeare Jahrbuch*.

Becomes grandmother (grandson Sam).

1987 'Utopie und Geschicte im Drama der Zeitgenossen Shakespeare' (Utopia and History in the Drama of Shakespeare's Contemporaries) in *Shakespeare Jahrbuch*.

1988 'How the Words Got on the Page' in *Reviving the English Revolution: Reflections and Elaborations on the Work of Christopher Hill* (eds Geoff Eley and William Hunt, Routledge Chapman and Hall, New York); *'Left Review, New Writing* and the Broad Alliance against Fascism' in *Visions and Blueprints: Avant-Garde Culture and Radical Politics in Early Twentieth Century Europe* (eds Edward Timms and Peter Collier, Manchester University Press); 'English Poetry and the War in Spain: Some Records of a Generation' in *'¡No Pasarán!' Art, Literature and the Spanish Civil War* (ed. Stephen M. Hart, Tamesis Books); review of Jerzy Limon's *Dangerous Matter* in *Renaissance Quarterly* (Spring).

1990 Edits *History and the Imagination: Selected Writings of A. L. Morton* (with Willie Thompson, published by Lawrence and Wishart); 'Political Drama' in *Cambridge Companion to English Renaissance Drama* (eds Albert R. Braunmuller and Michael Hattaway, Cambridge University Press); 'Drama and Politics in the Crisis of the 1620s' in *Theatre and Government under the Early Stuarts* (eds J. R. Mulryne and Margaret Shewring, Cambridge University Press); 'Drama for Cannibals? Notes on Brecht and Shakespearean Characterization' in *Shakespeare Jahrbuch*.

1991 'Rebel Lords, Popular Playwrights and Political Culture: Notes on the Jacobean Patronage of the Earl of Southampton' in *Yearbook of English Studies*, vol. 21; 'Demystifying the Mystery of State: *King Lear* and the World Upside Down' in *Shakespeare Survey*; '"Let Rome in Tiber Melt!": Order and Disorder in *Antony and Cleopatra*' in *Shakespeare Jahrbuch* (reprinted in Macmillan New Casebook on *Antony and Cleopatra*, ed. John Drakakis, 1994).

1992 '"God Help the Poor: The Rich Can Shift": The World Turned Upside Down and the Popular Tradition in the Theatre' in *The Politics of Tragicomedy, Shakespeare and After* (eds Gordon McMullan and Jonathan Hope, Routledge).

Dies 9 June at The Pines Nursing Home, Putney, London.

1 INTRODUCTION

David Margolies

The essays collected here have been written to honour the memory of Margot Heinemann. Their theme is 'cultural resistance', in keeping with someone whose life was devoted to fighting the injustice of society and for whom culture was one means of carrying on that struggle. Margot's intense political commitment and her deep concern for individuals made her an important influence in the lives of several generations. She shaped the outlook of countless students over her long career; her scholarship in several areas, the 1930s and Renaissance studies especially, transformed the understanding of many literary academics; and her landmark *Puritanism and Theatre* gave scholarly credibility to a radical perspective on the drama of the period. The diversity of the essays here suggests the range of Margot's interests, and all of them owe something to her influence.

Margot's involvement with people and with literature was passionate. She presented literature to her students, not as abstract patterns of human thought, but as a reflection of the lives of real people; the power of a work depended largely on its relevance to real lives. The combination of uniqueness and typicality she found in literature she also recognised in people; while she accepted that people were conditioned by social forces, she responded to them as individuals. She taught many different types of students, from shop-girls on day release and miners at trade union schools to girls at an academic secondary school and undergraduates reading for English degrees. They knew that she took them seriously, treating them as whole people with their own aspirations and desires, with personal histories and anxieties, with bodies as well as minds.

Margot was exceptionally devoted to students, attracted by their honesty and freshness, their eagerness and their outrage. Most were at a stage in their lives where the status quo held little attraction; they were free and willing to change the social structure. Margot helped them to understand that the injustice they saw around them and felt keenly was not just the casual failing of individuals or organisations but inherent in the capitalist system; and she led them to see literature – past as well as present – as relevant to making a better world. It tested assumptions, made motives clear and offered a model of being. Literature could make the transformation of reality seem possible and desirable; it could be part of resisting oppression and making a fairer world. That sense of a larger purpose in literature which she transmitted may be the reason why so many of Margot's students themselves became teachers.

Literature could change attitudes, but Margot was clear that the

political reality could be changed only by a movement. At the end of the twentieth century, the idea of building a just society through a mass movement may seem hopelessly utopian to many people, but for most of Margot's active life it could be taken seriously: there were socialist movements around the world that had led the fight against fascism and were in fact bringing about change. Tireless in her own efforts, Margot constantly encouraged other people to involve themselves actively in politics. This was never reduced to mere attendance at meetings. Political activity was not a temporary behaviour engaged in of necessity, nothing more than a means: for her it was natural to the character of humanity, a mode of life, a way of being. In the way that Thucydides, two millennia earlier, had described the Athenian character as restless with things as they were, always wanting to change them, always imagining improvements, always seeking to alter and advance, life for Margot meant changing the world. Even from her hospital bed in her final illness, Margot tried to persuade a friend to smuggle her out of Cambridge to a meeting in London so that she could make an intervention she thought necessary. She was constantly active in political meetings, with students, attending conferences, researching, writing – ceaselessly thinking, reflecting, processing ideas. Her mind was never at rest, and even in relaxation she would be judging, planning and organising.

But for Margot the mass movements that impelled major historical change were composed of individuals. History, as Marx said, does nothing by itself; it works through real people, with their own peculiar development and needs. It is individuals who make the history, and, as Marx and Engels said in *The Communist Manifesto*, individual development is the ultimate objective in abolishing class society: 'We shall have an association, in which the free development of each is the condition for the free development of all.' This recognition of the importance of the individual shaped Margot's politics and her teaching. The development of individuals was a primary concern of hers as a teacher; not simply getting students to assimilate information but encouraging their growth as responsible human beings. By presenting literature in terms of experience, by getting them to understand concepts not in abstraction but in terms of their own experience, she fostered students' self-confidence and encouraged them to judge things for themselves. She treated them as individuals and adults.

The emphasis on the world in terms of experience also meant an emphasis on reality – on individuals in actual circumstances, not just as statistics or embodied abstractions. This concern for concrete, individual existence, which made her an inspiring teacher and outstanding scholar, made her an excellent Marxist too, with a developed appreciation of the processes of change and also of the way individuals were implicated in them, in their imaginations as well as their material existence. Her purpose was perhaps best summed up in Marx's famous Thesis XI on Feuerbach: 'The philosophers have only *interpreted* the world in various ways; the point however is to *change* it.'

The essays that follow are all involved with changing the world. Despite

the apparent diversity of subjects, they all engage with the essential questions of cultural analysis: the role and value of cultural products. They are about culture as an area of struggle in society, and they look at aspects of resistance to the oppressions that are part of a society of class domination. Each one makes an individual scholarly contribution to knowledge of its subject, while together they offer a significant understanding of major problems of cultural theory. And they help make clear how cultural analysis, as well as the cultural products themselves, can be part of changing the world. Margot would have been very much at home with most of the essays; she would undoubtedly have found in them many points to dispute but, nevertheless, all of them share her perspective.

Cultural resistance in these essays has been found in diverse material. It is not the specific material but the way in which the phenomenon of resistance through culture is treated that provides the organising principle of the book. The essays are divided into three groups determined by the degree of generality of their focus. Thus the four essays of the first group raise theoretical questions that define the whole notion of cultural resistance and consider at a fairly general level how literary forms condition social attitudes. The six essays of the second group consider changing patterns of resistance or how specific cultural movements have embodied resistance in their material or the way it is organised. The five essays of the third group concentrate on how individual authors (including Margot Heinemann herself) have constructed their representations of a contradictory world so that they encourage resistance to the dominant ideology.

In 'The Politics of Modernism' David Forgacs rejects the ostensibly non-political, elitist posture that has dominated critical discussion of modernism. He shows how the various aesthetic positions of modernism are imbued with political attitudes, and he argues against the simplistic oppositions that usually characterise the modernism/postmodernism debate. Explaining that such reductionism obscures the issues, he shows that the complex determination of opposed positions must be taken into account and that the processes in which these determinants are themselves evolving must be recognised. Forgacs thus opens the fundamental question of cultural politics – how social and ideological dominance (and resistance to it) are actually expressed and activated through culture – and he provides a theoretical perspective that, to a greater or lesser extent, informs all the essays of this volume.

The next three articles elaborate theoretical understanding, through different specific subjects, of the way in which the forms of culture condition response, response which affects individuals' understanding of the material world and their behaviour in it. David Norbrook's ' "Safest in Storms": George Wither in the 1650s' extends the principles developed by Forgacs's discussion of modernism in explaining the contradictory attitudes and style of the Commonwealth poet George Wither. Norbrook examines Wither's readjustments of attitude and rescues him from the

position to which he has been relegated by the literary establishment's Royalist sympathies; he exposes the ideological construction of the 'literary' aesthetic and shows how Wither produced an appropriately radical aesthetic from his oppositional, republican politics. Norbrook considers Wither's attempts to make a kind of verse that avoids the elitism of, say, the classical tradition and which is accessible to general readers (he draws analogies with Whitman and MacDiarmid). He shows that Wither, like his contemporary Marvell, revised courtly poetic forms in a way that was radical both politically *and* aesthetically. But it was not merely a new versification of an ideological position; Wither, a consistent Parliamentarian, used poetry also to make sharp criticism of Cromwell. He produced poetry that went beyond a simply political content to be thoroughly democratic in its social and aesthetic outlook.

Robert Weimann's ' "Authority" in Calvinism: the Spirit Betwixt Scripture and Polity' deals with 'authority' – one of the most important concepts in current materialist discussions of culture – in sixteenth-century England. Like David Norbrook's treatment of Wither, it concerns explicit resistance and elements of culture that have a material effect. Weimann's study originates in a reference by Margot Heinemann to the sixteenth-century historian and martyrologist Foxe, who linked players with printers and preachers as focal points of resistance to authority. Weimann shows how the extension of discussion to areas previously dominated entirely by authoritative pronouncements had a radicalising effect, throwing open to question not only specific ideas but also the notion of authority itself. He follows Margot's understanding that drama was recognised by Puritans to be part of politics, not just entertainment. Using the explicit relation between state and ideology that prevailed in Calvin's Geneva, Weimann finds a model for how English Renaissance drama functioned as a political force. Theatre, by virtue of its mode of presentation, demands that the audience interpret the action on the stage, and thus it authorises *individual* interpretation and fosters a questioning attitude.

Edith Hall, using the material of the earliest novels (from Greece at the time of the Roman empire), extends consideration of how the style of presentation can serve as an element of resistance. In 'The Ass with Double Vision: Politicising an Ancient Greek Novel' she looks at an instance of literary resistance and its suppression in classical studies. The sexually explicit narrative *Ass*, the original source for more polished renderings of the story of a man transformed into an ass (including Apuleius's *The Golden Ass*), subverts the conventions and perspective of Hellenistic romance literature. Through the conflicting cultural perspectives of a man who has been educated into the elite and is possessed of an aristocratic consciousness yet who, when transformed into an ass, must serve as a beast of burden and experiences life among the lower classes, the novel cleverly provides an incisive, seemingly innocent, critique of the author's world. Just as David Norbrook demonstrates the radical significance of Wither's violation of the poetic conventions, Hall

shows how the issue of literary form can be an important arena of real conflict and how the form itself can be used as a device of subversion.

The next group, of six articles, deals with particular movements of cultural resistance. In 'Unity Theatre' Colin Chambers looks at one of the most successful attempts in radical history – probably the most successful in Britain – to combine art and politics, not just to interpret cultural resistance but to use it to change the world. Chambers explains the phenomenon of Unity Theatre and the distinctive qualities that made it a great popular success for many years. It was popular in membership as well as in subject matter. Ordinary people could join Unity and make theatre without any special training; not as rank amateurs tolerated according to a speciously democratic principle of abandoning professional criteria, but as participants in a collective venture, using whatever skills they already possessed while they learned others. It was a model of 'self-activity', of an oppositional theatre that belonged to, and was directed by, its members. It was not a case of art co-opted into politics but art that was genuinely oppositional as *art*.

Peter Holland's 'Communities: British Theatre in the 1980s' considers later manifestations of the social character of theatre discussed by Colin Chambers. After establishing that the theatrical experience (as opposed to, say, television drama) involves community by its very nature, Holland deals with how the sense of community changed during the Thatcher years from something of which the individual was an integral part to something that (like a protest group) served as a shield to protect the individual from the more abstract and formal structures of state or society. He traces the change from large-scale plays mounted by local communities (for example, Lyme Regis), where the community provides the subject, the means of realising it, and also the point of the whole exercise, to dramatic representation of the collapse of community (as in Jim Cartwright's *Road*).

Alan Sinfield also deals with political theatre, but less from the standpoint of its political effect than from what it has been expected to deliver as a part of the welfare state. Beginning with the left's response to the collapse of socialism, Sinfield offers a critique of the left's conflicting attitudes towards subsidised theatre and explores the implications of the confused notions of quality and equality. Analysing the contradictions highlighted by critical disappointment with the theatre of the present, he concludes that theatre can escape the restrictions of welfare-capitalist thinking only when it does not have to rely on state provision.

In 'Dramatising Strife: Working Classes on the English Stage', Jean Chothia looks at the changing portrayal of the working class. Class conflict in the English theatre is explained, not just in the general terms of economic conflict in the society, but in terms of the theatre's presentation of working-class experience. Chothia shows how the viewpoint of plays changes from one where the audience is encouraged to view the workers sympathetically, but from a superior position, as the 'other', to plays that actually present working-class culture and working-class individuals from

inside, where the audience is addressed as part of the 'we' of the working-class characters on the stage.

Christopher Hill's 'Liberty Outside the Law' shares Chothia's concern for the construction of a class identity. Hill takes as his starting point the question of how to explain the continuity of the conflict between liberty and property as a theme of English literature. Beginning with the different pictures presented by Brome's *A Jovial Crew* of 1641 and Gay's *The Beggars' Opera* of 1728, he looks at the different images of this conflict and shows how they articulate differing notions of social justice.

John Lucas's 'Love of England: Patriotism and the Making of Victorianism' shows how growing republican sympathies, radicalism and regionalism were countered by the construction of a myth of national unity focused in the symbol of Victoria. Official culture was used to overcome popular resistance to the consolidation of the state. Patriotism was distorted into anti-French feeling, which was then evoked to instil a sense of Nation, and it became difficult to construct any expression of patriotism that did not involve support for the establishment. Even liberty was co-opted as an attribute of the Queen. Lucas is able to show that popular support for Victoria nevertheless included contradictory elements. For example, the praise of the Queen, when she first mounted the throne, as the champion of the poor also conveyed the implicit threat that champion of the poor was what she had *better* be. Lucas argues that the apparent conservatism of music halls owes less to popular feeling than to censorship and self-censorship by licensing authorities and managers, and that republican spirit among the working class did not die; there remained in their culture a residual resistance.

The final group of articles focuses on the work of particular authors and presents detailed examinations of the complex way in which various determinants shape their work. Maroula Joannou writes on Ellen Wilkinson's *Clash*, the semi-autobiographical novel of an ardent feminist who was at various times in her life a woman's suffrage organiser, trade union organiser, and MP. She shows how Wilkinson uses the issues surrounding the General Strike to make clear the contradiction between the struggle for social justice (as then conceived) and the demands of sexual equality in the organised labour movement. Focusing the issues in one woman's attempt to resolve the conflict between personal and political demands, between her need for fulfilment in a love relationship and her passionate commitment to political struggle, Ellen Wilkinson was able to reach a wide audience through making use of the popular literary form of romance. *Clash* was in fact serialised in the *Daily Express*. The novel articulated women's problems in a way that was challenging, and provided a view of the interrelation between the personal and the political that could enable progress towards achieving both gender and class equality.

In 'Massinger, Mourner of an Unborn Past', Victor Kiernan looks at how Massinger constructs dramas about the past that offer parallels to the playwright's own day, enabling him to make an indirect but unmistakable

commentary on the corruption of the Court. Kiernan shows Massinger to be an eloquent advocate for the oppressed, portraying the Court and aristocracy as parasites. He sees Massinger, as he sees Shakespeare, as a conservative looking back at a past that he constructs in imagination as providing a better life for ordinary people.

Elsie Duncan-Jones looks briefly at Marvell's response to Milton's Latin pamphlet, *Defensio Secunda*, which raises again, through comparison with classical practices, the question of the political implications of literary form.

Inga-Stina Ewbank focuses on Middleton's *Hengist, King of Kent*, a play whose political and social criticism was highlighted by Margot Heinemann. Ewbank shows how Middleton offers a number of different perspectives within which the action of the play can be viewed, and how the range of alternative interpretations they produce undermines the dominance of the dominant ideology. She explains how the play introduces material from other works which also suggests a different way of viewing matters – what she calls 'subversive intertextuality'. She points out Middleton's technique of contrasting a conventional, patriarchal view of behaviour with what it means in the heroine's own life. By explaining attitudes in the play in relation to those presented in the film *Thelma and Louise*, she suggests a continuing resistance value and relevance for the play.

Finally, Andy Croft writes on Margot Heinemann's own novel, *The Adventurers*. Looking at the novel against a background of socialist realism – the convention of heroic figures struggling optimistically to transform the world – which Margot had herself advocated in print in the early 1950s, he shows how the novel escaped from this expected mould and developed into a work of complex motivation and individual feeling. Croft suggests that it was the events of 1956 – the exposure of Stalin's crimes, the Soviet invasion of Hungary, the haemorrhage of members from the Communist Party of Great Britain – that brought about this reorientation. After 1956, political rhetoric could no longer constrain personal perception, and this change is reflected in Margot's insistence on truthful representation and in her critical exploration of political behaviour. Croft's treatment shows the novel to be a work of personal cultural resistance that is finally positive, even without any uplifting conclusion, in its assertion that changing the world depends on a truthful recognition of what is really there.

Margot Heinemann's influence as a scholar, teacher, fighter for social justice, friend and mentor was profound. Each of these essays, however indirectly, has been affected by her intelligence and passion. We can hope only that they provide some recognition of our great debt to her, and that her contribution continues to live in our practice as in our memory.

2 THE POLITICS OF MODERNISM

David Forgacs

One evening in 1988 I told Margot Heinemann I was writing a paper for a conference called 'The Politics of Modernism'.[1] She asked whether the title meant there was just one political position in modernism. I guessed she was going to say that if it did it was wrong. I did not think it did, not just because the word 'politics' can be taken as either singular or plural but also because I thought the conference organisers would want the discussion open-ended. Still, her question has stayed with me. In fact, it has become increasingly difficult to ignore it, since so much has been written and said since then about the politics of modernism, modernity and postmodernity.

Is it true that one should not speak of a politics of modernism in the singular? Modernism on any definition has a long time-span: 1880 to 1940 maybe, or 1860 to 1950, or 1900 to 1965, depending on what criteria one invokes, which countries one is looking at and which arts.[2] In that time there were enormous changes on the world political scene. Nations industrialised, competed for empires, went to war. Some went through socialist revolutions, others through nationalist or fascist seizures of power. There were the first experiences of Keynesianism and welfare states; there were the historic confrontations between fascism, communism and liberal democracy; there were the mass killings and imprisonments done in the name of imperial domination, socialism or racial purification. This period encompassed both the movement of artists and intellectuals towards mass collective movements, exemplified by Mayakovsky, Brecht or Nizan and denounced by Julien Benda as the 'trahison des clercs', and the movement away from engulfment by party and state. Through all this, very different positions were taken up by different modernist artists and intellectuals in different places. Brecht was poles apart from Gottfried Benn who was poles apart from Thomas Mann. The Italian Futurists were pro-war, the Zurich Dadaists anti-war, Marinetti and Pirandello joined the Italian fascist party, Wyndham Lewis and Ezra Pound were fascist sympathisers, D. H. Lawrence went some way in the same direction. The Berlin Dadaists, Russian Futurists, Constructivists and Suprematists aligned with the left, in France some of the leading Surrealists joined the Communist Party, as did some of the English and Scottish modernists. T. S. Eliot was a conservative Anglo-Catholic, James Joyce more or less supported the Irish nationalist left. In other words, a dizzying array of political positions were taken up.

There was, moreover, always a plurality of critical perspectives on modernism in which strikingly different political assessments were made.

Within the left alone the conflicts were bitter. Lenin and Lunarcharsky fought over Futurism; Lukács and Bloch over Expressionism; Seghers and Lukács over realism; Gramsci criticised Nizan for exclusively supporting artistic vanguards. For Lukács modernism in its various forms represented a regression from the aesthetic advances of nineteenth-century realism. For Radek it represented the cultural decadence of the bourgeoisie in the era of monopoly capitalism. For Adorno, modernism tended to negate and transcend commodified or reified culture. For Piscator and Brecht, following the Russian Formalists, non-realist experimental theatre critically defamiliarised received common sense.

And yet, despite the seeming impossibility of speaking about a single 'politics of modernism' we are in a period, intellectually, in which it has become common to do just that. In contemporary criticism, modernism has come to assume more and more a single, stable political face. In part this is because the aesthetic ideals of modernism have come to be challenged, both within the art world and outside, and in this challenge the different inflections of modernism have come to look more similar to one another than they did before. In part it is because of recent political changes in the world which have made it possible to see the period before the 1980s in retrospect as having had a particular shape. In part, finally, it is because it has become possible theoretically to posit an 'end of modernity', in Gianni Vattimo's phrase, beyond which the period of modernism has come to look less fragmented and more coherent than it appeared to its protagonists. In other words, the debate about modernity and postmodernity has made it possible to represent modernism in a way that would not have been thinkable just a few years ago.

To be exact, modernism has come to look all of a piece in six distinct respects. First, it is, or was, about novelty: it was a set of artistic practices which shared a commitment to 'make it new', in Pound's phrase. The word 'modern' was derived from Latin *modo* ('now'), by analogy with *hodiernus* ('of today'), and it meant of the here and now, of the present. Its contemporary usage was consolidated in the eighteenth-century *querelle des anciens et des modernes*. The origin of the word 'modernity' is more recent. Walter Benjamin traced it to Baudelaire's art criticism of the 1860s.[3] For Baudelaire *modernité* ('the transitory, the fleeting, the contingent, the half of art of which the other half is the eternal and unchangeable') was linked to *nouveauté*: the painter of modern life must capture 'the ephemeral, contingent novelty of the present'.[4] Foucault, following Benjamin, understood modernity through a reading of Baudelaire as a kind of permanent contemporaneity achieved through a fashioning of the self within the present.[5] Modernity, then, is related to a new sense of temporality with respect to previous attitudes to time, consisting of a self-consciousness of the present as different from the past and as provisional, to be superseded. This sense of provisionality is important. For if on the one hand modernism carries forward the project of cultural modernity that had started with Romanticism and had developed through realism and naturalism, on the other hand, as Raymond Williams noted, it crucially differs from Roman-

ticism in that the latter, like the Renaissance, broke only with the immed-
iate past in order to connect up with a more distant past, whereas modern-
ism's characteristic gesture is to break with all of the past. [6] Thus, despite
the very different political terms in which different modernists conceived
of what they were doing, they shared the notion that the art of the present
had to be radically different from what had gone before.

We are not dealing here with a single politics, it is true, but we are
dealing with a shared valuation of the new as better, of newness itself as
a virtue. And it is precisely this valuation that has been challenged by
those who argue for a postmodern politics. For Vattimo, writing in
1989, the term 'postmodern' is not an intellectual fashion that can be
dismissed by the gesture of pronouncing it dead. Its function is precisely
to indicate that modernity itself, in certain of its essential features, is
over. If modernity means, as he proposed, 'the epoch in which the fact
of being modern becomes a determinant value' then this implies an
acceptance of the notion of history as progress, as tending towards
emancipation and human self-realisation. Modernity on this definition
ends when it is no longer possible to speak of history as unitary and
centred. Instead it becomes multiple; what Lyotard called the 'grand
narratives' or 'metanarratives' of knowledge legitimation (for example the
narrative of scientific advance liberating humanity from superstition and
servility) are replaced by criss-crossing and often mutually conflicting
little narratives. All of this, Vattimo stressed, has not taken place solely
in the realm of ideas, it is not just an effect of the battering inflicted by
twentieth-century philosophy on nineteenth-century historicism. It is an
effect also of changes in the world at large: the challenges from decolon-
ised societies to Western supremacy; the self-assertion of marginalised
groups; a radical politics resting on categories other than the individual
or the class and working without any transcendental guarantees. In par-
ticular, for Vattimo, the multiplication of media networks and of points
of access to these networks plays a major part in dispersing power and
opinions away from any one hegemonic centre and thus in contributing
to the overcoming of modernity. [7] From the vantage point of Vattimo's
critique, the politics of modernism comes to look closely implicated with
the politics of modernity. Modernists of the left, like Brecht or
Mayakovsky, and of the right, like Benn or Wyndham Lewis, shared the
belief in a single motor of history, in progress and delivery from the
weight of the past.

Second, and this is a corollary of the first point, many modernist
artists – those at any rate who took an interest in politics – envisaged
political change in terms of a radical and often violent break. Many of
the early avant-garde movements – Futurism, Dada, Expressionism,
Surrealism – had an intemperate, destructive character, though from
movement to movement the destructivism could take different forms
and be directed at different targets: the deadweight of tradition, the
complacency of bourgeois society, the injustices of capitalism, war. This
destructivism, sometimes (as in the case of certain exponents of Italian

futurism) coupled with a tolerance or advocacy of violence and a vision of political transition as a sweeping away, a clearing out, has come to be seen more critically in the light of a post-communist, feminist and post-modern politics, with its notion of plural as against single movements, the centrality of democracy, the critique of violence.

Third, modernism, it is claimed, cut out for itself a separate path from mass culture. It could – and frequently did – cite kitsch, ephemera and popular entertainments, but it did not want to merge with these or be confused with them. They remained modernism's other, the torn other half of a whole freedom, in Adorno's famous phrase.[8] As Fredric Jameson put this point of view, using it to distinguish modernism from postmodernism, modernism 'quoted' popular culture whereas postmodernism places it on the same level as high culture and thus destroys the boundaries between them.[9] Andreas Huyssen goes further, seeing much of the modernist aesthetic as a 'reaction formation' against mass culture.[10]

Fourth, it has been argued that modernism – in this respect like the realism to which in other ways it was diametrically opposed – was an art of 'depth' not of 'surfaces', in that the modernist art work, even at its most abstract, always signified something that was not itself a represen-tation: for example Mondrian's grid compositions explored the essence of colour and geometrical form. By contrast, postmodernism, in the view both of its critics (Jameson) and its defenders (Baudrillard), is relent-lessly an art of surfaces, of anti-depth, in which one representation ironically parodies or subverts another and one never gets outside the circuit of representations. The 'depth' of modernism was bound up with its self-importance, its taking itself too seriously, even when it was at play. What was Dada if not a use of play to attack the most treasured values of bourgeois society – respectability and profitability? The depth of modernism was another facet of its elitism: an art which declared itself to be about something other than what is manifest, to be difficult, even when ostensibly at play, and consequently not for the likes of you.

Fifth, large areas of modernism have been subjected to political critique by feminism and anti-racism. Feminism, as in so many other areas of academic life, has refused to accept the map of modernism drawn by a conventional historiography of the arts. It has done so in a number of ways. It has enlarged that map in order to site more women modernists on it, such as Varvara Stepanova, Sonia Delaunay, Frida Kahlo, Bridget Riley. It has drawn a new map in which women figure differently: for instance Whitney Chadwick's *Women, Art and Society* gives more prominence than most standard accounts of modernism to fashion and design, in which women were involved as producers and which affected women's everyday lives; she also argues that abstraction drew many of its motifs from late nineteenth-century textile designs.[11] And it has defaced the map or torn it up altogether; for example, the notion that much of the modernist tradition is a masculinist tradition that treats women's bodies as objects of fetishism, voyeurism or brutal-isation has been put forward for painting by Carol Duncan and for

literature by Naomi Segal.[12] Huyssen connects this with the earlier
point about mass culture, suggesting that 'the powerful masculine
mystique which is explicit in modernists such as Marinetti, Jünger,
Benn, Wyndham Lewis, Céline et al. (not to speak of Marx, Nietzsche
and Freud), and implicit in many others, has to be somehow related to
the persistent gendering of mass culture as feminine and inferior'.[13]

As for anti-racism, some of the key icons and values of modernism
look different from a post-colonial perspective. Its use of non-European
imagery (the tribal masks in Picasso's Les Demoiselles d'Avignon,
Gaudier-Brzeska, Epstein and Modigliani's borrowings of African sculp-
tural forms and motifs, Brancusi's totem poles, Gauguin's nude Tahitian
women, the jazz motifs in Ravel or Milhaud) can be read as a further
plundering of the non-European traditions to which the Old and New
World powers had gained access first through the slave trade and then
through imperial conquest. I would reject the more positive interpreta-
tions of them as either respectful citings of other cultures or as part of
a radical operation of bringing the colonial periphery into the metro-
politan centres in order to disrupt the latter's hegemonic culture. I reject
them because modernism was itself a part of that hegemonic culture. It
shared its racist view of the cultures of black peoples as raw, wild,
sexually energised. It shared its power to define these cultures as primi-
tive in relation to its own civility, a power given it by virtue of the
unequal relationship between it and these other cultures and therefore a
non-reversible power: those cultures could not choose to define Euro-
pean art as primitive. Thus, though there were some attempts by Euro-
pean modernists to oppose the dominant colonialist discourses of primi-
tivism (for instance, the Surrealists in 1931 mounted an Anti-Colonial
Exhibition to counter the official show on the art of France's colonies),
they still tended, as Julian Stallabrass has shown in an illuminating
essay, to share the dominant (Lévy-Bruhl, Piaget) view of a dichotomisa-
tion of civilised and primitive, of primitive societies as closer to nature,
as having an uninhibited attitude to sexuality (Mead), basing their art on
ritual and cult.[14] Among the English, D. H. Lawrence is the best-known
celebrator of the primitive: he seeks out the primitive on the peripheries
of civilisation; in Sardinia and Sicily, in New Mexico, in the Australian
outback, as well as within modern civilisation itself, where it takes the
shape of 'dark', instinctual forces. Marinetti, born in Egypt in 1876,
celebrated his Sudanese wet-nurse's breast in one of the founding docu-
ments of the avant-garde. Three years later he was to celebrate the
dropping of shells over Libya in a war of colonial possession between
Italy and Turkey.[15]

Sixth, and finally, there has been a critique of the status which modern-
ism has acquired in cultural history (including art history, literary history
and so forth). The notion, implicit in much Western scholarship and the
teaching of the arts since around 1950, that modernism constitutes the
most significant tradition, the leading-edge movement in the twentieth
century, has been contested. Other traditions have been invoked against it:

a continuing tradition of realism and representation in the West, non-modernist movements outside Europe and North America (for instance Latin American fresco painting, black African art), trends in popular and commercial culture in any geographical area. The rise of cultural studies, the challenges to the notion that Western high culture is normative in relation to other cultures and subcultures, have contributed to the weakening if not the demise of these once dominant assumptions.

As all this indicates, there is much at stake for present-day criticism and cultural practice in the question of 'the politics of modernism'. If all of modernism, despite the different local political inflections within it, was committed to notions of novelty and progress which were effectively totalising, if it was in its essence elitist and divorced from popular culture, if it was sexist and racist and excessively validated by authoritative cultural institutions, then it would seem to be right to be sceptical of any modernist practice now.

But I would object that, powerful as some of these critiques of modernism are when taken separately, put together they give a false and unreal picture of modernism and its politics. In particular, the grounds of the 'end of modernity' arguments need to be interrogated. They are certainly attractive arguments in their suggestion that the critique of views of history as governed by a teleological master narrative (the unfolding of rationality, the realisation of perfect freedom, the end of class struggle) allows for a non-hierarchised representation of diverse interests. On the basis of this critique, Vattimo has argued for a politics of postmodernity which he claims is more radical and democratic than the politics of modernity. A similar politics has been sketched out by Laclau and Mouffe.[16] But Lyotard and Vattimo's underlying thesis is vulnerable to the objection that its account of the end of grand narratives itself takes the form of yet another grand narrative, inscribed within the same temporal logic (postmodernism comes after modernism) and claiming for itself the same status of a transcendental truth: the old legitimations of knowledge, or 'History' in the singular, have come to an end; they are replaced by 'incredulity toward metanarratives' or 'histories' in the plural. Both Lyotard and Vattimo anticipate and reply to this objection, Lyotard by claiming that the postmodern does not come after the modern but resides within it as an attitude of suspicion or scepticism, Vattimo by asserting that 'the post-modern is characterised not only as novelty in relation to the modern but also as the dissolution of the category of- the new'.[17] Yet these defences, particularly Vattimo's, create fresh problems. If one dissolves the category of the new the main characterising feature of modernity falls away. Does that mean it was always a fictitious category? What replaces it as a definition of modernity? If there is no category of the new, how can any change take place in the various histories that have come to replace History?

A still more significant weakness in these accounts is their tendency to flatten out the contradictions of modernity and present it as all of a piece. Modernity as Vattimo portrays it retrospectively comes to look

almost childishly simple: an age of naive faith in 'reason', 'man', the 'Platonic dichotomies' of essence and appearance, values and existence before the discovery of the monistic but endlessly plural and therefore potentially radical surface of the real. Finally, Vattimo's picture of a society of 'generalised communication' is, as he himself acknowledges, more a vision of a potential than of a reality, given the effective skewing of media power and control towards oligopolies and large corporations.

In various other accounts of modernity in political and social theory it similarly comes to be defined as a more or less homogeneous entity. Modernity is that period, several centuries long, in which political ideologies come to base themselves not on transcendent concepts (divine right, absolute authority, the sovereign body) but on single or collective social subjects: liberalism (the individual), democracy (the people), nationalism (the nation-people), socialism and communism (the working class), feminism (women). Characteristically, these ideologies are given concrete embodiment in the political party or similar collective organisation (trade union, and so on) as bearers of individual or collective interest and of the rational movement of history. As William E. Connolly puts it:

> Individualism and community, realism and idealism, the public interest and the common good, technocracy and humanism, positive and negative freedom, utility and rights, empiricism and rationalism, liberalism and collectivism, capitalism and socialism, democracy and totalitarianism – all grow up together within the confines of modernity. [18]

The argument that modernity has been or is being supplanted by postmodernity is an argument both about the crisis of the political projects emerging from the Enlightenment and about the crisis of the counterprojects which were conceived as their mirror reversals. Marxism for instance shared the Enlightenment notion of society as tending towards higher forms of rationality: for Marx (as for many twentieth-century Marxists) industrialism combined with socialism would achieve this higher rationality. The crisis of modernity is thus also a crisis of these beliefs: in the political party as rational embodiment of the interests of a class (what Chantal Mouffe has called the 'Jacobin imaginary') [19] and in industrialism as vehicle for the development of economic rationality and social freedom.

Again, it seems to me that the weakness of this line of argument is that it collapses too much together. It may be true that the various modern political ideologies all possess a common denominator in their ideas of the subject of history and of political agency, but it also needs to be recalled that historically they have conflicted with and developed in reaction to one another. Radical notions of participatory democracy developed, during the French Revolution and after, in reaction to the theory and practice of limited representation; socialism developed in reaction to the limits of both conservatism and liberalism; democracy

reasserted itself in reaction to the anti-democratic practices of fascism and state socialism. It seems that as soon as one assumes a vantage point outside or after modernity one begins to lose sight of these concrete historical processes, processes which we have not moved beyond.

This has implications for the question of the politics of modernism. Just as with modernity, one can set up a perspective in which modernism comes to look all of a piece. It can be important to do this, because it shows up some fundamental limitations of the whole modernist project, but one pays a price for doing it, namely that of losing sight of the conflicts within modernism which constituted its inner dynamic. Many of these conflicts were local in character, conflicts between particular movements or individuals: the critique by Mayakovsky and the Russian Futurists of Marinetti and Italian Futurism for their bellicose nationalism, the development of the more political and revolutionary Berlin Dada out of Swiss Dada and then, in turn, of the applied arts movement (Bauhaus) out of Berlin Dada, and so forth. But there was a more fundamental conflict within modernism which needs to be accommodated in any complete account, namely the division of responses towards industrialism and urbanism. There were two quite distinct positions. On the one hand were those – the Futurists and Constructivists, De Stijl and the Bauhaus – who wanted to go with the grain of industrial rationalisation; on the other were those who sought to resist it: Yeats with his mysticism, Kandinsky with his spiritualism, Lawrence with his 'strange gods', the later Pound and Eliot. The conflict over industrialism was even incorporated into certain modernist works, such as Toller's play about the Luddites, *Die Maschinenstürmer* (1921), and Ehrenburg's *Life of the Automobile* (1929). The latter depicts tourists and aesthetes waxing ecstatic over the machines during a visit to the Citroën factory while a worker is carried off with an industrial injury.[20]

One might even argue, extrapolating from these instances, that modernism did not simply reproduce the dominant values of modernity (industrialism, rationality, progress, and so on) but tended to produce anxious, exaggerated versions of them which revealed them in tension with their opposites. Modernism consistently revealed the 'others' of rationality and industrialism, not only in the dream art of the Surrealists or in the various primitivisms but also in its most vociferous vindications of rationality. Marinetti's 1909 *Futurist Manifesto* is aggressive about the future because it is trying to shrug off the past. It exalts war and violence because it is trying to distance itself from the feminine. Conversely, Dada and Surrealism go on obsessively about the unconscious and desire because they see them as shackled by rationality. It is incorrect to say that modernism was simply synchronised with modernity, even late modernity, and that it translated the politics of modernity into aesthetic terms. In certain key respects it involved a critique of modernity, but from within, not from the extraneous vantage point assumed by postmodernity.[21]

There is, finally, one other respect in which the picture of the politics of modernism as single rather than plural needs to be resisted, namely its

relationship with mass culture. The notion that modernism as a whole (I consider the avant-garde, *pace* Peter Bürger, a part of modernism, not its antithesis) [22] was esoteric, difficult, detached from a popular public (the view of Ortega y Gasset in his essay of 1925, 'The Dehumanisation of Art', often repeated since from both left and right) seems to me wrong. Modernism had a complex relationship both with the new technologies of cultural production and reproduction and with the mass audience. On the one hand there was the attempt to appropriate new media: the Futurists in Italy tried their hand at cinema, fashion design and poster art; Eisenstein moved from agitprop theatre to cinema. On the other, there was a series of reactions against the way the new technologies of communication were commercially exploited and their products delivered to audiences. Avant-garde artists resisted commodification, searched out new functions for art, looked for new sites of distribution and display: hence the importance of the development of small presses, independent cinema production, alternative theatres. Modernism and the avant-garde were essentially early responses to the industrialisation of culture and communications. Only some of these responses fit the stereotype of coteries of intellectuals resisting the whole process and trying to reassert their status against it.

Linked to this is the question of high and popular culture, as regards both taste and contact with audiences. This issue too has been placed in perspective by postmodernism, but once again I find the perspective reductive. I am not convinced by Jameson's argument, mentioned earlier, that modernism quoted but assimilated popular culture whereas postmodernism places it on the same level as high culture and thus destroys the boundaries between them. Modernism did, at least in some cases (Brecht, Piscator's *Volksbühne*, Mayakovsky), address the issue of the popular audience, of a break with the elitism of high culture. Conversely, postmodernism does not, in terms of who has access to it and how it is consumed, effectively and unproblematically dissolve away the high/popular division. Against this view I would invoke Pierre Bourdieu's sociology of culture with its emphasis on the social stratification of taste and its relationship to inequalities of class and education. [23] The taste for postmodernism, and its market value, seem to me crucially determined, just as much as the taste for modernism and its value, by the class system and the education system. In this one respect at least – but it is by no means negligible – the politics of postmodernism is of a piece with the politics of modernism.

Notes

1. The paper (on Gramsci) and several others from that conference, which was organised by Oxford English Limited, were published, with additional contributions, in *News From Nowhere*, no. 7 (Winter 1989), with the title *The Politics of Modernism*. This title is also that of a volume of essays by Raymond Williams, edited by Tony Pinkney, published by Verso in 1989.

2. On the arbitrariness of datings of modernism and the ideological selectiveness of the category see Raymond Williams, 'When Was Modernism?', *New Left Review*, 175 (May–June 1989), pp. 48–52.

3. Walter Benjamin, *Gesammelte Schriften*, I, 3 (Frankfurt am Main: Suhrkamp, 1980), p. 1152.

4. 'Le Peintre de la vie moderne' (1863), in Charles Baudelaire, *Oeuvres complètes*, ed. Claude Pichois (Paris: Gallimard, 1976), vol. II, p. 695. For a good discussion of this side of Baudelaire, see David Frisby, *Fragments of Modernity: Theories of Modernity in the Work of Simmel, Kracauer and Benjamin* (Cambridge: Polity Press, 1985), Chapter 1.

5. Michel Foucault, 'What Is Enlightenment?', trans. Catherine Porter, in Paul Rabinow (ed.), *The Foucault Reader* (London: Penguin Books, 1984), pp. 39–42.

6. Raymond Williams, 'Introduction: The Politics of the Avant-garde', in Peter Collier and Edward Timms (eds), *Visions and Blueprints: Avant-garde Culture and Radical Politics in Early Twentieth-century Europe* (Manchester: Manchester University Press, 1988).

7. Gianni Vattimo, *La società trasparente* (Milan: Garzanti, 1989), pp. 7–20.

8. 'Both [high and low art] bear the stigmata of capitalism, both contain elements of change (but never, of course, the middle-term between Schönberg and the American film). Both are torn halves of an integral freedom, to which, however, they do not add up.' T.W. Adorno, letter to Walter Benjamin, 18 March 1936, trans. Harry Zohn, in Ernst Bloch et al., *Aesthetics and Politics* (London: Verso, 1977), p. 123.

9. Fredric Jameson, 'Postmodernism and Consumer Society', in E. Ann Kaplan (ed.), *Postmodernism and Its Discontents* (London and New York: Verso, 1988), p. 14: 'They [the newer postmodernisms] no longer "quote" such "texts" [of commercial popular culture], as a Joyce might have done, or a Mahler; they incorporate them, to the point where the line between high art and commercial forms seems increasingly difficult to draw.'

10. Andreas Huyssen, *After the Great Divide: Modernism, Mass Culture and Postmodernism* (London: Macmillan, 1986), p. 57.

11. Whitney Chadwick, *Women, Art and Society* (London: Thames and Hudson, 1990), Chapter 9.

12. Carol Duncan, 'Domination and Virility in Vanguard Painting', in Norma Broude and Mary Garrard (eds), *Feminism and Art History: Questioning the Litany* (New York: Harper and Row, 1982); Naomi Segal, 'Sexual Politics and the Avant-garde: From Apollinaire to Woolf', in Collier and Timms, *Visions and Blueprints*.

13. Huyssen, *After the Great Divide*, p. 55.

14. Julian Stallabrass, 'The Idea of the Primitive: British Art and Anthropology', *New Left Review*, 183, (September–October 1990) pp. 95–115, at p. 115.

15. Filippo Tommaso Marinetti, 'The Founding and Manifesto of Futurism' (1909), in Umbro Apollonio (ed.), *Futurist Manifestos* (London: Thames and Hudson, 1973), p. 21; 'La battaglia di Tripoli (26 ottobre 1911)' (Milan: Edizioni Futuriste di Poesia, 1912).
16. See Ernesto Laclau and Chantal Mouffe, *Hegemony and Socialist Strategy: Towards a Radical Democratic Politics* (London: Verso, 1985); also their subsequent defence and elaboration of that book's arguments in 'Post-Marxism without Apologies', *New Left Review*, 166 (November–December 1987), pp. 79–106.
17. See Jean-François Lyotard, 'Answering the Question: What Is Postmodernism?', trans. Régis Durand, published as an appendix to *The Postmodern Condition: A Report on Knowledge* (Manchester: Manchester University Press, 1984), p. 79; Gianni Vattimo, *La fine della modernità* (Milan: Garzanti, 1985), p. 12.
18. William E. Connolly, *Political Theory and Modernity* (Oxford: Blackwell, 1988), p. 3.
19. Chantal Mouffe, 'Radical Democracy: Modern or Postmodern?', in Andrew Ross (ed.), *Universal Abandon? The Politics of Postmodernism* (Edinburgh: Edinburgh University Press, 1989), p. 31.
20. Ilya Ehrenburg, *The Life of the Automobile*, trans. Joachim Neugroschel (London: Pluto Press, 1985), Chapter 5. Marshall Berman takes a different angle on this, namely to see the Futurist ability to aestheticise the machine, revolution and riot as producing a hardening to their social effects: 'What happens to all the people who get swept away in those tides? Their experience is nowhere in the Futurist picture. It appears that some very important kinds of human feeling are dying, even as machines are coming to life.' *All That Is Solid Melts into Air: The Experience of Modernity* (London: Verso, 1983), p. 25.
21. I find unconvincing Huyssen's argument (*After the Great Divide*, p. 56) that modernism was always complicit with modernisation even when it appeared to oppose or reject it.
22. Peter Bürger, *Theory of the Avant-Garde*, trans. Michael Shaw (Manchester: Manchester University Press, 1984).
23. Pierre Bourdieu, *La Distinction. Critique sociale du jugement* (Paris: Editions de Minuit, 1979); Pierre Bourdieu and Jean-Claude Passeron, *Reproduction in Education, Society and Culture*, 2nd edn (London: Sage, 1990).

3 'SAFEST IN STORMS': GEORGE WITHER IN THE 1650s

David Norbrook

Therfore, though *Scorners*, & those *dull soul'd things*,
Whose judgement knows not, whether better sings,
The *Nightingall* or *Cuckow*, flout me shall,
And in contempt, these *Hymnes* my Ballads call;
I will not be discouraged by these;
From saying, or, from singing, what I please;
But, in an awfull, Joyfull strain, begin
A *song*, to usher this dayes *praises* in.
Yea, in those *forms*, which are by them abhor'd;
I, and my *houshold*, thus, will praise the Lord. [1]

Those are the characteristic tones of George Wither: pugnaciously defy-
ing those who judge poetry by the traditional tastes of the ruling class,
maintaining his commitment in the face of censure. Wither's immediate
occasion here was the defence of the young English republic: he pub-
lished these lines just after the second anniversary of the execution of
Charles I, with the aim of rallying support to the regime. Future ages,
he claimed, would continue to sing his odes.

Future ages have not obliged. Wither's later poetry, if it is remembered
at all, remains subject to precisely the kind of ridicule he sought to fore-
stall; and literary historians have in general been unsympathetic to the
cause he defended. The very fact of supporting the Commonwealth or
Protectorate is often taken as evidence of a moral defect which can be
purged only by supreme aesthetic merit. Thus the safely canonical Andrew
Marvell's having written poems successively in praise of Charles I, the
Commonwealth, and Cromwell is acclaimed as displaying a quite extra-
ordinary open-mindedness, a refreshing contrast with Puritan or republi-
can dogmatism. A similar record on the part of Wither, however, is
denounced as contemptible time-serving. Of another defender of
Cromwell, Payne Fisher, one critic has written that his poetry was so bad
that 'he deserved to live poor and out of favour'. [2] Wither too belongs to
that group whose republicanism was not purged by conventional literary
merits, and whose (relative) poverty is considered by devotees of humane
letters to have been a fitting judgement on his politics.

But there is something conveniently circular about that model, where
literary value judgements reinforce a monarchist perspective on political
history. What has above all gained critical favour for Marvell's shifts of

allegiance is the sympathetic portrait of Charles I in his 'Horatian Ode upon Cromwell's Return from Ireland', the element of nostalgia for the deceased king and the courtly culture that surrounded him. That Wither felt no such nostalgia is simultaneously seen as an aesthetic and a moral failing. If Margot Heinemann was one of Wither's few modern admirers, it was partly because of her readiness to read against the grain of conservative mythology. For Wither, the trouble with the Court of Charles I was not that it whispered the last enchantments of the Middle Ages, but rather that it was an organisation devoted to a radical restructuring of traditional representative institutions. The elegance of the courtly culture was a mere veneer for political repression:

> *Prerogative*, had swallowed up the *Laws*,
> Or, seis'd upon the *Power*, by which, we might
> Regain possession, of our *Ancient-Right*.
> But, having, thereby, got that *Power* again,
> (Which, we are hopeful, they shall still retain)
> They [Parliament] (for abusing *Kingship*, heretofore)
> Enacted, that, we should have, *Kings*, no more. (p. 35)

Though Marvell's poem urges Cromwell to maintain the power gained by the new regime, its language remains equivocal: 'antient Rights' are threatened by the new republican order whose maintenance of its power appears sinister. For Wither, however, it is the monarchy that has threatened ancient liberties, and the republic that has restored them by a near-miraculous concatenation of events. Wither offers his poetry as a civic duty, committing his muses to the new political order.

That commitment was not, of course, a guarantee of high poetic interest. Wither was in the end more cuckoo than nightingale; he could be a repetitive, prosaic, unabashedly banal writer, casting colloquial speech into verse and often straining for rhymes in the process. He wins no prizes either for wit or for humour. Too much of his poetry consists of versified grouses against successive governments for failing to keep him in the style to which as a landed gentleman he was accustomed. Yet there was some method in what he conceded might seem to be a mad kind of poetry. As the opening quotation indicates, Wither deliberately chose 'forms' which were 'abhor'd' by his royalist critics; for him, ideological commitment involved poetic form as well as discursive content. Both in political and in poetic terms his was an iconoclastic poetic, seeking a more immediate, more open mode of representation which would cut through traditional hierarchical rankings. He almost entirely abandoned the classical allusions that were the staple of seventeenth-century poetry, adopting a populist idiom that could on occasion reach a remarkable directness and force. His later works were 'raptures', shifting at times from verse to prose and back again to dramatise the difficulty of containing the spirit of a turbulent age within traditional set forms. Wither consciously paralleled his own verse with the prophetic utter-

ances of such normally despised groups as children, fools, women and madmen, whose musings were

> too intricate
> For them to put in order, and relate.[3]

Wither aimed in his later verse at a spontaneous overflow of prophetic feeling, enacting the spiritual and political liberty he celebrated. To that extent he has as much in common with Whitman as with some of his contemporaries. He might also be compared to MacDiarmid, as a poet who began his career by fulfilling conventional lyric requirements and moved on ideological grounds to redefining the nature of poetry.

Such analogies, of course, have their limits. Wither was a committed Puritan, whose jeremiads were concerned with moral regeneration and discipline rather than with self-expression. At the centre of his world-view was a Protestant apocalyptic vision: he anticipated that the final fall of the papal Babylon would take place within 40 years, and judged all secular political causes by transcendental criteria. And this led to a tension between commitment and time-serving: Wither consistently proclaimed his loyalty to established authority, on the grounds that God was the ultimate arbiter. The title of his defence of the republic, *The British Appeals*, indicates that God had registered a decisive judgement by permitting Parliament to defeat the king by military force. On similar grounds, throughout his life he paid at least lip-service to each succeeding regime, adopting an uncompromising, quasi-Hobbesian variant of conquest theory. But his demands for obedience were always in tension with a desire for more representative government: the more he insisted on God's intervention in placing regimes in power, the more he lectured them on their duty to demolish corrupt structures of authority and establish more just ones. Similarly, even when he adopted a conventional language of public praise he tended to undercut that praise by a defiant individualism.

The British Appeals is a case in point. Parliament had called for public rejoicings at the republic's anniversary, and Wither offers his contribution. But his poem avoids the stock topoi of courtly panegyric; it is hedged about with hesitations and qualifications. Wither inverts the traditional deference of the poet to those in power:

> I may to teach my *Teachers*
> Take boldness. (p. 24)

In characteristically pungent terms, he draws attention to the possible disparity between external, ceremonial language and the actual, committed practice of civic virtue:

> Without those *ends*, the formall observation,
> Of one *set-day* is but a *profanation*;
> Or, meer *hypocrisie*: It, makes men think
> They offer *incense*, when they offer *stink*. (p. 8)

Wither recalls a previous occasion when public rejoicings had been
tempered by uneasy apprehension, the return of the young Charles from
Spain in 1623. There had been an outpouring of enthusiastic *prosphonetika*
(poems greeting a return, the genre which Marvell reshaped in his 'Ode'). [4]
Beneath the surface, however, there had been deep unease about the
future. Wither refuses to voice a facile optimism; he rounds on the many
groups who are surreptitiously undermining the regime, and warns that
rejoicings will be valid only if they are backed up by deeds. Wither drama-
tises this point by emphasising his own personal need to prepare himself
for his public utterance: the traditionally extravert form of the panegyric
acquires a personal, introspective cast. Only after 46 pages of such cau-
tions (in a poem the title-page describes as 'brief'!) does he move on to the
ceremonial climax, three 'Odes' in successively elevated style which drama-
tise the growing prophetic powers that seize the poet. The poems are to be
sung to psalm tunes, and lack the Horatian spirit of Marvell's 'Ode'. In
giving the name of odes to poems which hostile critics would describe as
ballads, Wither challenges the hierarchy of genres. [5] Having risen to this
high style, however, he comes down to earth again, warning against any
form of rejoicing that becomes facile jingoism:

> Yea, should you *conquer*, till, you did not know,
> Abroad, or here *at home*, one able foe ...
> Or, should you stand possest of all their *powrs*,
> Of whom, you are, or may be *Conquerours*

– unless reformation continued, calamity would ensue (p. 64). This down-
beat note is very different from the prophecies of foreign conquest at the
end of Marvell's 'Ode'. Marvell's poem is celebrated for its ambiguity, and
it has many generic complexities not found in Wither; but it is worth
pointing out that Wither did have his own forms of complexity. Both
poets, in their different ways, were engaged in revising courtly forms, and
the rambling, diffuse form of Wither's poem has its own rationale.

The young republic was already struggling with its contradictions.
Having called for the political system to be more representative, Wither
was confronted with a regime that resisted new elections and was very
suspicious of widening the franchise for fear of readmitting royalists.
Wither offered his own remedy in *The Perpetuall Parliament*, a poem
which called for a system of rotating elections to combine representation
with the screening-out of enemies. Characteristically, Wither linked this
proposal in the sphere of political representation with an analysis of
poetic representation. The poem reveals his platform in a dream vision
which Wither compares to a court masque; but he goes on to insist that
it was

> Distinctly represented, so that I
> Might perfectly discern with *reasons eye*,
> What in themselves they were ... [6]

By offering a clear discursive paraphrase, Wither avoids the mystification of courtly hieroglyphics; these images appeal to the eye of critical reason, not of courtly deference.

Unfortunately, events did not wait on such rationalistic schemes. On the very day *The Perpetuall Parliament* was published, Oliver Cromwell impatiently dissolved the Rump. (This was, as will be seen, the first of many examples of spectacular mistimings in the publication of his verse, which Wither recounted without any sense that this might call in question his skills as a prophet.) From now on, he faced a new set of political and poetic problems. In what sense were the successive regimes set up by Cromwell representative? Some republicans condemned him from the start; but might there not be divine judgement at work in his accession? And how could a poet find a language appropriate to register such quickly shifting and constitutionally ambiguous schemes: was Cromwell a monarch or was he not? It was, Wither complained,

> difficult, to know
> What, really *he is*; what *he would do*. [7]

Despite these problems, Wither determined to offer the new regime his support. And here inevitable questions arise about his political consistency. For committed republicans, the dissolution of the Rump was unforgivable. Like many contemporaries, however, Wither always put his understanding of divine providence to the fore, and he hoped that Cromwell might be an instrument to build the foundations of a reformed political order. He had long been disillusioned by Parliament's dwindling into a self-regarding oligarchy. Moreover, rule by one man might help him as a poet to wield an exceptional degree of influence. And Cromwell was, in fact, the first ruler who showed any propensity to listen to him. In the early period of the Protectorate, Wither proposed a draft constitution and Cromwell was warm in his praises, declaring that it 'answered to his heart, as the *shadow of his face* in the Glass (then hanging before him in the room) answered to his *face*'. All seemed clear and transparent; but Cromwell then suggested that the draft needed revision. He gave Wither the keys to his study with his private papers, and Wither enthusiastically set about the revisions, but he then found that Cromwell was unwilling to see him and he eventually gave up. This combination of openness to potential opponents and ultimate opacity was characteristic of Cromwell. [8]

Nevertheless, Wither joined Marvell and Waller in defending Cromwell's controversial new rank. The terms of that defence, however, were distinctive. Under the Protectorate there was a gradual return to courtly forms of ceremonial and language; despite his claim that he wished to be represented warts and all, Cromwell's panegyrists for the most part painted over any sign of warts. [9] Waller entitled his poem *A Panegyric to my Lord Protector*, and consciously patterned himself on the imperial court poet Claudian; his poem was an early manifestation of a campaign to declare Cromwell not just king but emperor. [10] His was a pragmatic,

politique monarchism: the new regime was starting to found a prosperous empire.[11] Wither, by contrast, puts his praise in strictly conditional form, and subordinates the ceremonial and secular to the apocalyptic:

> though none
> Should give their *Plaudits*, till the *Play* be done;
> (Or, crown men, till the *Coronation-day*,
> Which is their last) yet, somewhat I will say
> To hint, in brief, what, more at large, I might
> Express, should I, a *Panegyrick* write.[12]

If Waller's panegyric of Cromwell was straightforwardly complimentary, Marvell's *First Anniversary* was more oblique, hinting that the plan to crown Cromwell would actually reduce rather than elevate his status. Despite critics' praise of Marvell's 'functional indeterminacy', the fact is that his poem is far more courtly than Wither's in its reluctance to express open censure or uncertainty about the man it praises.[13] The closest Marvell comes to drawing attention to Cromwell's fallibility is in his placing emphasis on his potentially fatal coaching accident the previous year; Wither had characteristically seized on that incident for his first poetic address to Cromwell, and Marvell may in fact have borrowed from Wither's earlier poem.[14] Wither's *Protector* offers Cromwell repeated warnings against the possible dangers of tyranny. Like Marvell (l.101), Wither compares Cromwell to a star, but he is unable to advance praise without simultaneously qualifying it:

> *Thou*, who art now, the worlds new *Northern Star*,
> Let, in thine *Orb*, no *Course irregular*
> (*Oblique* or *Retrograde*) divert thee from
> Those motions, which thy *Circle* best become;
> Lest, from that *Heav'n*, in which thou now dost shine,
> Down to the *Earth*, thou back again decline,
> And, like the *Star* call'd *Wormwood*, bitter make
> Those *waters*, whence, we now *refreshments* take. (p. 25)

Here Wither fuses motifs of classical and of Christian republicanism. Lucan's ironic panegyric of the stellified Nero as in danger of toppling down (*Pharsalia*, i.45ff) is juxtaposed with the apocalyptic language of falling stars (Revelation 8:11).

Such double-edged imagery serves what Wither defines as Christ's aim in these last days:

> to break down
> Both our *Self-confidences*, and his *own*. (p. 28)

Marvell leaves considerably more of Cromwell's self-confidence intact than does Wither's iconoclastic poetic. Old titles like 'king', he declares,

are now discredited, and if 'Protector' is preferable, it is because it has no 'stamp of *Self-relation*' (p. 14). It is a transparent image of the true kingship of Christ,

> that *Heav'nly King,*
> Whom, he but represents; (p. 15)

it points toward the imminent, apocalyptic advent of Christ Himself, when

> *Kings* and *Emperours*
> Have lost their *Names,* their *Kingdoms,* & their *Pow'rs*:
> And ... here, that *King of kings* doth raign,
> Whose Glory, heav'n and earth, cannot contain. (p. 14)

Here Wither ventured on an apocalyptic register that was liable to make Cromwell uncomfortable; and before Wither had a chance to publish the poem, Cromwell had testified to the limits of his patience with criticism. Wither had intended to present *The Protector* as a gesture of support at the end of Cromwell's first, turbulent Parliament; but he dissolved it before the expected time, claiming that the constitutional provision referred to a minimum of five lunar months, not five calendar months. Wither deferred publication for six months to see which way the wind would blow (sig. A2v).

The question of Cromwell's status was still unresolved by the spring of 1657. Waller and Marvell both lent their poetic voices to a campaign to transform Protector into King when his title was renewed in June. Cromwell hesitated, and against some expectations he refused the crown. Wither marked this occasion by composing a new poem, *A Suddain Flash*. As in his poem on the coaching accident, Wither takes as focus a deliberately anticlimactic episode, one which subverts expectations of a traditionally festive kind. Cromwell's resistance to kingship is celebrated as a triumph, an imitation of Christ's true humility. Cromwell is likened to Christ being tempted by Satan with earthly crowns. [15] Wither reprinted some lines he had written much earlier with a possible application to Charles I and transferred them to Cromwell:

> *A King, shall willingly himself unking,*
> *And thereby grow farr greater than before.* (p. 4)

For Wither, as for Milton in *Paradise Regained*, true kingship involves the inner faith that rejects the external temptations of vainglory. In Cromwell's case this would involve rejecting kingship and settling the government in a true balance of the three estates, a constitutional settlement which firmly rejected the hereditary principle (p. 33).

By now, however, Wither had had so many difficulties with Cromwell's unpredictability that he held back for some months before publishing the poem, and left open the possibility that Cromwell might

soon change his mind over kingship. After praising his resistance,
Wither goes on to say that if Parliament were to insist strongly on a
monarchy, he should bow to their wishes (pp. 8ff); and later in the
poem he proposes a compromise formula for a title including the word
'king' (p. 42). His poem tacks uneasily back and forth between warning
against the emptiness and vainglory of the kingly title and trying to
anticipate the appropriate response should Cromwell nevertheless accept
it. When he proposes his compromise title, he presents it as breaking
the boundaries of poetic representation:

> on *feet*, in *Verse*, it goes
> But lamely; Therefore, take it here, in *Prose* ... (p. 41)

And he suggests that the word 'king' emerged at an almost unconscious
level:

> It, almost, into *words* was thus far brought,
> E're it was fully formed in my thought;
> And, *slipt out*, (as do such things now and then)
> Rather, to try the *mindes of other men*,
> Then to declare my *Judgment.* (p. 42)

Kingship enters the poem as an alien, troubling factor, disrupting its form.
Wither tries to persuade himself that the contention between pro- and
anti-monarchists may itself be a form of strength, for

> those things which bee
> Well done, are *Best done*, when, some disagree:
> And ... *Truth* doth appear in her perfection
> When she is polished by *Contradiction.* (p. 53)

He tries to encompass those contradictions within the to-ings and fro-ings
of his own poem. This was, however, his last attempt to engage with the
problems of kingship in public; from now on he addressed Cromwell only
in private admonitions. One was addressed to him on 3 September 1657, a
day which had special significance to Cromwell as the anniversary of his
victories at Dunbar and Worcester. The admonition which followed was
prepared for 3 September 1658, the day, Wither later said, on which it had
been expected that he would be crowned king. With hindsight, Wither saw
Cromwell's death as a clear sign of God's displeasure with kingship;
though he did not venture to suggest that his own poetry might have dealt
the final blow. [16]

In the event, Cromwell was crowned only in a bizarre posthumous
ritual: an 'effigy, or representation' which had lain in state was raised to its
feet and crowned. His son Richard was named his successor in monarch-
ical style. The tone for courtly mourning was set by Waller's elegy for
Oliver, which centred on pathetic fallacy: the storms that had raged just

before his death became the prince's own dying groans. He compared this storm to that in which Romulus had been caught up to heaven, leading the Romans to deify their first king: they 'from obeying fell to worshipping'. Waller then characteristically shifted from divine to secular considerations, praising Cromwell's foundation of a new empire: he had shifted the 'martial rage' of 'civil broils' into overseas conquests. [17] Marvell's elegy, at one stage scheduled for publication in the same volume as Waller's, was more complex but struck many similar notes.

Waller's poem, and the courtly tone of the mourning, provoked Wither into an indignant response. He was not the only person to find Waller's verses distasteful, though most of the hostility came from the royalist side. A volume was published containing responses to and parodies of the 'Panegyrike' and the elegy. [18] Wither had enough of a sense of common cause with other Cromwellians to acknowledge, grudgingly, the virtues of Waller's elegy, declaring it the best that had yet appeared. But all the elegies, he complained, had failed to represent Cromwell justly; they had shown either diminution or excess, 'Either of which, makes *great things*, to seem *less*.' [19]

Wither proceeds to reveal Waller's poem as just such flattering excess. His suspicion of Waller in fact went back a long way. [20] Having supported Parliament at the start of the Civil War, Waller had been implicated in a royalist plot and had escaped only by paying a huge fine from his large personal fortune. He had returned to England after the regicide and as one of Cromwell's kinsmen became on good terms with his regime. His record contrasted strongly with Wither's consistent struggles on behalf of Parliament. In satirising Waller's poem, Wither begins by prosaically observing that the storm that gave Waller his title had already blown over almost a week before Cromwell's death, and that in drawing attention to it Waller in fact risked undermining his own cause, for others might see it as a sign of God's judgement. And he proceeds to a savage demolition of Waller's hyperboles. Waller's

> His dying groans, his last breath, shakes our isle,
> And trees uncut fall for his funeral pile

becomes

> So, did His *last Breath* shake this *Isle* of our,
> As Pellets from a *Pot-Gun*, shake a *Tow'r*.
> For, all her *Shakings*, to my best perceiving,
> Rise from our own *Distempers* who are *Living*. (p. 8)

Waller's

> On Oeta's top, thus Hercules lay dead,
> With ruin'd oaks and vines about him spread

becomes

And, so, on Oeta, Hercules *lay dead,*
As *Chalk's* like *Cheese,* and *Beer* is like to *Bread.*

Wither thus demystifies Waller's courtly divinisation of Cromwell. He proceeds to attack Waller's secular grounds for praising him, the military victories which pave the way for empire:

So, from the Continent, He Towns hath torn,
As he, who tears a Hedge, and gets a Thorn ... (p.8)

Waller's vision is one of endless imperial expansion:

The ocean, which so long our hopes confined,
Could give no limits to his vaster mind ...
Under the tropic is our language spoke,
And part of Flanders hath received our yoke.

Wither deflates that vision, returning to the doubts about conquest he had voiced in *The British Appeals* in an early, and powerful, poetic protest against imperialism:

What *Comfort* yields it, to impose a *Yoke*
On others, if our *Fetters* be not broke? ...
What Pleasure brings it, if our *Confines* be
Inlarged, if in them, we are not free?
What *Profit* is it, unto us at *Home,*
That some in *Forraign Parts,* inrich'd become,
If we mean while are *Beggars*? or else more
At least, impov'rish'd, then we were before?
What *Honour* is it, that, both *Tropics* hear
Our *Language,* if to speak *Truth,* few men dare?
Or what by *Conquests,* will be got or sav'd,
If they who *Conquer'd,* are at last inslav'd?

As for

Our *Antient Way* of Conquering *abroad,*
Which this *Muse,* doth implicitely applaud)
What got we by it, but a *Cursed Game,*
Atchiev'd with *Blood,* and lost with *Blood again*? (p. 9)

Why, asks Wither, should we applaud

Those Deeds, for which, LAW, to their *Actors* gives
The stiles of *Pyrats, Murtherers* and *Thieves.* (p. 10)

Wither objects that these wars were waged without the full assent of Parliament.

Wither ends his onslaught on Waller by deflating the pathetic fallacy of his conclusion:

So, Nature, *hath took Notice of His Death*,
And, sighing, swel'd the Ocean with her breath,
The death of her great Ruler *to foreshew*,
As 'twas presaged when my *Cat* did *Mew*. (p. 11)

Nature, Wither insists, showed such omens only when the son of God died, and it is blasphemy to transfer them to mortals. He then enlarges his attack on Waller's flattery to include the pomp for Cromwell's funeral, which he describes as a '*costly Puppet-Play*' (p. 18). He points out that the regime had patterned the funeral on that of Philip II, and might therefore bring in further idolatrous practices. Who could believe, writes Wither,

　　　　that HE, who vilifide
Not long ago, the *vanitie* and *pride*
Of former *Princes*? That, HE, who had spoke
Against the *heavie burthens*, and the *yoak*
By them impos'd, and was himself the *Rod*
And *sword* assum'd into the hand of GOD,
To root them out ...
Should ever of his own accord, think fit
Those *Trinkets* which he sleighted to admit? (pp. 19–20)

The vehemence of that rhetorical question is insecure. Its force derives from Wither's professed certainty that Cromwell himself would always have held out against the crown, that however closely it may have hung around his head he would never actually have placed it there. Yet the previous year Wither had not been so sure. Through his attack on Waller, Wither is able to avoid attacking Cromwell directly; and yet his bitter denunciation of foreign expansion undermines one of the Protector's key policies. The fiasco of the Jamaican campaign had been a major focus for resistance to the Cromwellian regime. Wither goes on to catalogue a host of abuses in the realm which point to negligence at the top. Even now, however, Wither did not quite abandon the Cromwellian cause. He gave a (decidedly lukewarm) welcome to Richard Cromwell, and declared that the people's liberties had still been transferred by God to the Cromwells. And he concluded his poem by hoping that Waller would not take offence, praising his 'generous ... minde' (p. 49) and inviting him to do as much in return if it would be of wholesome use to others. Some kind of common cause among the different factions still seemed possible.

But the tension that had always existed in Wither's verse between courtly forms and outspoken individualism was pushed a long way in this poem. He revealingly declared that poets had to flatter their rulers to some degree, just as servants flatter children (p. 15): the analogy is as

demeaning to rulers as to subjects. It was in fact the intensity of his engagement with Waller that helped to sharpen his verse and give it an unusual degree of satiric economy. Though Wither retained enough sub-ordination to established authority to hail Cromwell's son as Protector, he expressed the hope that the people's liberties would soon be 'restor'd' (p. 40). And indeed by the time Wither published the poem, the dynasty had collapsed and the Rump was back in power; the publisher was the republican Livewell Chapman, who had played a leading role in opposition to Cromwell.

Wither's responses to Cromwell certainly do not offer a picture of clear-cut and consistent opposition. Republicans like Sir Henry Vane had been ready to attack Cromwell when he was alive; Wither rounded on him only when he was dead. The very vehemence of his attack on Waller's poem perhaps reflects his own repressed unease at having gone as far as he had done in praising the Protector. His response to the return of the Rump was embarrassed and defensive. He abandoned a scheme to bring out a collection of his unpublished Protectoral poems, and resolved to publish no more (a threat which was perhaps not greeted with as much dismay as Wither intended).[21] He could, however, claim with some valid-ity that his praise of Cromwell had been hedged with qualifications. And the contrast with Waller brings out how much less deftly pragmatic was Wither's response to events. When taxed on the Restoration with having written a welcome to Charles II that was inferior to his panegyric of Cromwell, Waller allegedly replied, 'Sir, we poets never succeed so well in writing truth as in fiction'; and he now began to turn out panegyrics of Charles and his court. For his part, Wither once again proclaimed his adhesion to the power favoured by God, but before long he pushed his boldness of speech too far, and was imprisoned; he was still under suspicion for his poetry the year before his death in 1667.

To some extent, Wither's lack of · worldly and critical success reflected his obstinate determination to tell the truth. But for all his complaints, he was also ready to accept the turbulence of his career: 'though I afect them not', he wrote, 'I am usually safest in *Storms*'. [22] He continued to exercise a considerable influence as poet and prophet. The quarrel that Wither had started between Waller's courtly poetic and his own truth-telling poetic set the agenda for much of the most important public poetry of the ensuing decade. When in 1665 Waller praised one of Charles II's naval victories, poet after poet moved in to demolish his urbane compliments. Foremost among them was Andrew Marvell; and the relentless demystification of his *Last Instructions to a Painter* was a long way from the polish of his early poems. Though Marvell retained his own distinctive qualities, the change of emphasis may have owed something to the clumsy, uneven, yet relentlessly independent writings of the ageing George Wither.

Notes

Many of Wither's minor works were reprinted by the Spenser Society (6 vols, Manchester, 1872–78). For ease of reference I have indicated the volume of the *Miscellaneous Works* (hereafter *MW*) in which those texts so reprinted appear.

1. George Wither, *The British Appeals* (London, 1651), pp. 46–7.
2. Charles S. Hensley, 'Wither, Waller and Marvell: Panegyrists for the Protector', *Ariel*, vol. iii, no. 1 (1979), pp. 5–16 (10 n1). It should be said, however, that Hensley's article pioneered the topic explored below, after he had published the only book on the later Wither, *The Later Career of George Wither* (The Hague and Paris: Mouton, 1969). Christopher Hill is the only historian to have made extensive use of Wither's writings; see his 'George Wither and John Milton', in *The Collected Essays of Christopher Hill, vol. 1: Writing and Revolution in Seventeenth-Century England* (Amherst: University of Massachusetts Press, 1985), pp. 133–56.
3. George Wither, *The Dark Lantern* (London, 1653; *MW*, III), p. 6; see also David Norbrook, 'Levelling Poetry: George Wither and the English Revolution, 1642–1649', *English Literary Renaissance*, vol. xi (1991), pp. 217–46.
4. Cf. David Norbrook, 'Marvell's "Horatian Ode" and the Politics of Genre', in Thomas Healy and Jonathan Sawday (eds), *Literature and the English Civil War* (Cambridge: Cambridge University Press, 1990), pp. 147–69. In the present article it is of course impossible to do justice to Marvell's poems, but I have tried to bring out some significant parallels and contrasts with Wither.
5. Wither also published these three poems separately as 'Hymnes' to be sung in church: *Three Grains of Spirituall Frankincense* (London, 1651).
6. Wither, *The Perpetuall Parliament*, published with *The Dark Lantern* (London, 1653; *MW*, III), p. 43.
7. George Wither, *The Protector* (London, 1655), p. 18.
8. George Wither, *A Cordial Confection* (London, 1659), pp. 6–8.
9. See Roy Sherwood, *The Court of Oliver Cromwell* (London: Croom Helm, 1977), and Roger Pooley, 'The Poets' Cromwell', *Critical Survey*, vol. v (1993), pp. 223–34.
10. David Armitage, 'The Cromwellian Protectorate and the Languages of Empire', *Historical Journal*, vol. xxxv (1992), pp. 531–55, at pp. 531–2. Wither attacked the style of emperor in *Vaticinium Causuale* (London, 1655; *MW*, I), p. 9, though he had qualified his views by the time of *The Protector*.
11. *The Poems of Edmund Waller*, ed. G. Thorn Drury, 2 vols (London, 1893), vol. II, p. 17.
12. Wither, *The Protector*, p. 30.

13. Annabel Patterson, *Marvell and the Civic Crown* (Princeton: Princeton University Press, 1978), p. 74, contrasting Marvell with Wither's 'propagandist tactics'. It could be argued that both poets are ambivalent on the question of kingship; on Marvell see Derek Hirst, ' "That Sober Liberty": Marvell's Cromwell in 1654', in J. M. Wallace (ed.), *The Golden and the Brazen World* (Berkeley: University of California Press, 1985), pp. 17–53. Nevertheless, Marvell reserves his criticisms for the Protector's enemies, whereas Wither frequently expresses fears that he may step out of line. Which approach is more 'propagandistic' is at least open to question.

14. For connections between Marvell and Wither's *Vaticinium Causuale* I am indebted to an unpublished paper by Joad Raymond.

15. George Wither, *A Suddain Flash* (London, 1657; *MW*, II), p. 5.

16. George Wither, *Fides-Anglicana* (London, 1660; *MW*, V), p. 93; *Salt upon Salt* (London, 1659; *MW*, IV), pp. 31–3.

17. Waller, *Poems*, vol. II, pp. 34–5.

18. *The Panegyrike and The Storme: Two Poëtike Libells ... answered* (London, 1659). A sharp parody by the republican Lucy Hutchinson remained in manuscript (BL MS Add. 17,018, fols. 213ff).

19. Wither, *Salt upon Salt*, p. 3.

20. Wither had attacked Waller in *Letters of Advice: Touching the Choice of Knights and Burgesses* (London, 1644; *MW*, I), p. 14, and *Opobalsamum Anglicanum* (London, 1646; *MW*, V), p. 7.

21. *Epistolium*, pp. 27, 29–30. Characteristically, Wither left some loopholes.

22. Wither, *A Cordial Confection*, p. 18.

4 'AUTHORITY' IN CALVINISM: THE SPIRIT BETWIXT SCRIPTURE AND POLITY

Robert Weimann

In her path-breaking study *Puritanism and Theatre*, Margot Heinemann, pointing to important links between revolutionary Protestantism and Renaissance drama, noted that 'even Calvin ... allowed the production of a Biblical play at Geneva', and that elsewhere in early modern Europe 'Reformers were at first not at all, and never completely, hostile to the stage.'[1] In this connection, Margot referred to John Foxe, who in his *Book of Martyrs* declared

> that it was no marvel that Bishop Gardiner attempted to thwart the players, printers and preachers, 'for he seeth these three things to be set up of God, as a triple bulwark against the triple crown of the Pope, to bring him down, as, God be praised, they have done meetly well already'.[2]

The reference to Foxe is pregnant on unsuspected levels of interconnection. What Gardiner in his letters to Lord Protector Edward Seymour, Duke of Somerset, sought to convey was an anxiety about the unlicensed appropriation of the word: for the conservative Bishop of Winchester, the unsanctioned urge for articulation must have appeared especially threatening when before his own eyes the printing press, public stages and the Protestant pulpit seemed to form an alliance in promoting unauthorised outlets of discourse and public discussion. What was at issue was the question of effective control and containment, the need for an authorisation of religious and political utterances. Printing, playing and preaching had joined forces in that, unauthorised by church and state, they could disseminate news and opinions that officially were neither endorsed nor in fact controllable.

But the absence, in the Protectorate, of an enforceable network of authorising public discourses was one thing. Closely connected with this state of affairs was the surfacing of anti-clerical and heretical matter. In other words, the question of authorisation was inseparable from the issue of authority itself. In provoking religious and political debate, the social forces of cultural change appropriated both an unsanctioned discursive space and a new mode of questioning authority itself. As Gardiner phrased it:

Certain printers, players, and preachers make a wonderment, as
though we knew not yet how to be justified, nor what sacraments we
should have. And if the agreement in religion made in the time of
our late sovereign lord [Henry VIII] be of no force in their judgment,
what establishment could any new agreement have? And any uncer-
tainty is noisome to any realm. And where every man will be master,
there must needs be uncertainty.[3]

Gardiner here is concerned with the impact that unauthorised discourses
appeared to have on social order and political stability. He is anxious, as
he writes in a later letter, 'not to suffer ... to slip the anchor-hold of
authority, and come to a loose disputation'.[4] To him, 'authority', far
from being the result of discussion and clarification, appeared to *precede*
'disputation'. In order to avoid the 'loose', that is, the uncontrolled uses
of public discourse, 'authority' was invoked once and for all to fix 'judg-
ment' and meaning and to serve as an anchor to hold against what
Richard Hooker in Book 7 of his *Laws* was to call 'the stratagem of
reformation for ever after'.[5]

 At this juncture, the area of concurrence between the Protestant pulpit
and the public stage needs to be further explored on a level which com-
prises, but ultimately is not confined by, the contemporary expansion in
the circulation of discursive practices. The point is that with the advent in
England of Protestantism in general and Calvinism in particular, modes of
authorisation, as well as the institutionalisation of authority itself, its pat-
tern and availability, underwent a number of profound and far-reaching
changes. The Elizabethan drama participated in and profited from these
changes whose results went into what, for better or worse, constitutes a
specifically modern element in the crisis in authority and representation.

 In order to substantiate so large a claim it is not good enough to refer
to whatever elements of a Protestant position were advanced by Edward
Seymour in his replies to Gardiner. True enough, a different mode of
authorisation was hinted at when the Lord Protector on his part noted an
'extreme license and liberty of speaking', only to remark that: 'The world
never was so quiet or so united, but that privily or openly those three
which you write of, printers, players, and preachers, would set forth some-
what of their own heads which the magistrates were unaware of.'[6]
Although this hinted at a new (and in many ways modern) source of
authorisation, to refer to its site as that of a discourse 'set forth somewhat
of their own heads' did not exactly specify the Reformation background to
these developments. But since it is this background against which the
larger pattern of authority and authorisation in sixteenth-century Protes-
tantism must be discussed, I propose to go back further to the Genevan
Reformation itself. The suggestion is to examine the *locus classicus*, the
writings of that foremost reformer, in the light of which late Elizabethan
debates about authority in the relations between political power and dis-
cursive practice can more profoundly be understood.

 In these debates, the theme of (and of course the word) 'authority'

abound. This is the case especially in late Elizabethan sermons and pamphlets by such diverse authors as Richard Bancroft, Oliver Ormerod and Richard Cosin. [7] In contemporary dramatic literature, it is Shakespeare who uses the word 'authority' no fewer than 60 times. Recent studies, following the lead of Margot Heinemann, have considerably enriched our sense of the significance of the links between Protestantism and English Renaissance literature, especially the drama. [8] Once we abandon the search for traces of 'influence', the constellation of Protestantism and dramatic writings is such that in both areas of discourse the question of authority was of particular stringency and consequence.

What makes Calvinism particularly interesting from the point of view of Elizabethan drama is that in Geneva (as opposed to, say, Wittenberg) there was a much more dynamic and interactive traffic between 'internal' and 'external' locations of power, justice and legitimacy; here, the Lutheran gulf between doctrine and polity was remarkably narrowed. There was in Geneva a sense of interconnection, unknown to the German Reformation, between political and religious practices, between secular and ecclesiastical institutions. As distinct from Luther's remoteness from the centres of feudal and imperial power in Germany, the cause of the Reformation in Geneva was inseparable from that of the safety and viability of the *chose publique*. Here, the affirmed line of distinction between church and state involved co-operation rather than indifference or hostility. [9] Although 'Christ's spiritual Kingdom and the civil jurisdiction are things completely distinct ... we must know that they are not at variance' (1486/1487). This confirms the need for 'a public manifestation of religion ... among Christians' (1488). Hence, the magistrates as true lieutenants or legates are not called upon to 'lay aside their authority and retire to private life, but submit to Christ the power with which they have been invested' (1490).

The ministers of the Genevan church, although strictly organised, formed no hierarchy; like the magistrates, they were all officeholders. It is, of course, true that the elective manner of their appointment did not reflect any sovereignty on the part of the electors; rather, it reflected their common subordination to God. Along these lines, neither political nor ecclesiastical authority was particularly personalised. The reformed pastor was expected to excel in his conduct, his knowledge, in the depth of his faith, his capacity for preaching, and his ability to inspire devotion in others. Sharing with his fellows in their corporate guardianship of the ways of the faithful, the pastor followed the Consistory of six ministers and twelve elders who recognised no need for any bishop. But any resistance to the authority of the Consistory was resistance to the authority of the government: Calvinism was the creed of the state; to challenge it was to defy the law and incur the charge of treasonable conduct. There was, as Calvin's thought at least from 1542 onwards shows, the attempt to establish some degree of 'homology between the order of ecclesiastical and of civil polity'; in fact, the 'apex' of his idea of a Christian commonwealth was, as we shall see, 'the twofold regime of magistrates and ministers'. [10]

In these circumstances, it must come as a surprise that Calvin's language of authority only partially reflects the peculiar situation of the foremost Protestant regime at the time. Although deeply immersed in humanist studies, the reformer at first sight seems rather close to Luther when, in his uses of Latin and French, there is a distinctly traditional, medieval refusal to differentiate between *potestas* and *auctoritas*. As in the last chapter of his main work, *potestas* stands not for imperial might and authority, but for that of the church, while 'civil government' is rendered as *administratio*. [11] Even more important, there is an undifferentiated connotation of legitimacy in his uses of both *potestas* and *autoritas* (sic), as well as in his signification of *imperium* or, even, *dominatio*. In this, the final Latin version of 1559 anticipates the equally authentic French version of 1560 which, for all the discrepancies between them, likewise fails to differentiate the semantic field indiscriminately marked by *puissance* and *authorité* as well as, again, by *domination*. [12] As in Luther, Calvin's language in its lexical order clearly precedes (even while it helps to bring about) modern differentiations among socio-cultural locations of authority.

However, if Calvin's vocabulary is deceptive in not mapping out the expanding semantic space of 'authority', the structure of his argument decidedly is not. For even though he follows Luther in emphasising the right of governors to expect obedience, citing familiar biblical precedence (above all, Romans 13), the conceptualisation of authority in its publicly verifiable and visible implications is spread out wide on the lexical co-ordinates of civil order, such as *civitas, magistratus, administratio* and related terms like *ordinatio, gubernatio, respublica*. Again, these by and large correspond to Calvin's uses of *chose publique, république* and *ordonnance*. [13] But while neither contemporary French nor German had any word adequate to render the semantic contours of the nascent (nation) state, owing to its Latin roots, Calvin's language confronted less severe impediments than did Luther's vernacular writings in coming to terms with the ongoing differentiations among the traditional locations of authority.

Thus, it would have been unthinkable for Luther to develop a concept which, in Calvin's approach to 'authority', was coined almost as a matter of course: for the Frenchman to think of a Protestant Christian 'polity' was possible once such *politia* or *civitas* could be conceived as structured by some bifold type of office-holding authority, some twofold government embracing the ministry of both political magistrates and evangelical pastors. Once church and state could be viewed equally as deriving their ultimate legitimations from some sacred or divine instance identical with God himself, the claims of the old church might well be exposed in their arrogance. According to Calvin, no church was exempt from the derivative quality of such authority as would as a matter of course pertain to *civitas* (or *administratio*) and *ecclesia* alike. For Calvin, the secular magistrate and the religious pastor equally were *lieutenants*, in the full sense of 'place-holders'. They were *vicari*, envoys to serve and

fulfil their duty to God, through either church or commonwealth. Hence, a Calvinistic keyword like *ministerium* was in its connotations of office qua authority considerably more encompassing and less divided than anything Luther, with his duality of sword and soul, worldly *gewallt* and Christian freedom, had at his disposal.

There is little doubt that Calvin sought to intertwine *ecclesia* and *politia*, in terms of their respective locations of authority. As Harro Höpfl notes in his study of *The Christian Polity of John Calvin*, the reformer's 'very choice of language ... points to the conclusion that he recognised himself as engaged on a labour of diminishing the distance between the office of magistracy and the minds and hearts of the godly.'[14] In fact, it is possible to say that Calvin sought 'to resacralise the magistracy by investing it with a dignity commensurate with so elevated a position in the divine economy'. Along these lines, he chose the term *administratio* so as 'to exploit the connotation of "ministry" implicit in the term', going as far as speaking of the magistracy as a *sacrum ministerium*. But if, on the one hand, he used the same terminology for magistrates that he had chosen for the pastorate, he, on the other hand, went out of his way to associate the ministers of the church with the language of secular authority. For that, he employed a terminology originally used 'to designate the relationship between a Roman emperor and his agents': the subordination of ministers to their 'sovereign' was conveyed by reference to their *mandatum* by which, acting as delegates (*legatione fungantur*), they represented God's person and *imperium*.[15]

Since, then, the Lutheran chasm between *spiritus* and *politia*, between faith and polity, must have been unknown in Geneva, the Calvinistic comprehension of authority stood a much greater chance of succeeding in a controlled politicisation of its Reformation project. At any rate, in Geneva Protestant notions of the relations of power, scripture and legitimacy were relieved from some of their more insidious antinomies – but only to confront a potentially even more massive contradiction in the mediation of authority itself. For if the Genevan administrators were considered 'the vicars of God' – if their judgments were 'appointed an instrument of divine truth' (*Institutes*, p. 1491) – how were they to relate to any such vicarious claims in the ecclesiastical sphere as even put forth by Calvin himself?

This question was not a purely theoretical one when we recall that in the late 1530s the evangelical ministers of Geneva were little more than civil servants and that their position – that of Pierre Viret and Guillaume Farel but also of Calvin – could be described as 'exceptionally vulnerable to shifts in political alliances within the city'.[16] As Farel's and Calvin's own expulsion from the city in 1538 would confirm, it was the city council that (in its desire to honour the anti-Savoy alliance with Berne on religious conformity) controlled religious affairs in Geneva. What was more, Calvin's return in 1541 was not at all in the nature of an unmitigated triumph; as a matter of fact, in the late 1540s the council again became

quite hostile to him, and at least until the mid-1550s he did not enjoy political status or any decisive support within the power structure of the city. [17]

In these circumstances, when issues of political power themselves were a prolonged formative element in the Genevan Reformation, the question of authority had to be searchingly renegotiated between the city-state and the reformed church. While both sides subscribed to the Word of God as the ultimate source of authority, it was out of the question for any secular authority to be conceived (as Luther defined that of the German feudal overlords) as categorically distinct from the true source of faith and Christian righteousness. Narrowing the Lutheran division between worldly power and heavenly truth, Calvin nevertheless thought of the Genevan city-state as an independent institution. The reformer himself was careful not to seek any office in it; in fact, he did not even become a citizen of Geneva until 1559. [18]

The question for Calvin, then, was how to reconcile with one another, or even regard as identical, two differing locations of authority, one secular-political, the other ecclesiastical. His solution to the problem (if solution it was) took as its point of departure the notion that *any* purely external authority by itself was untenable and that, as a consequence, both state and church had to accommodate themselves to this condition. The only true and lasting authority was scriptural, not – as the Romanists had it – ecclesiastical. The Word of God was traceable in the Bible only; but once the visible, readable scriptural text itself was held to contain the ultimate answer to the question of authority, the role of the church had to be a subservient one, serving merely as a highly respected means to an even greater end.

On this issue, Calvin's conviction was expressed in no uncertain terms. As early as in the title of Chapter vii of Book I, the reader is told that 'Scripture' and 'its authority [may] be established as certain [*ut certa constet eius authoritas*]; and it is a wicked falsehood that its credibility depends on the judgement of the Church' (74; *impium esse commentum, fidem eius pendere ab Ecclesiae iudicio*, III.65). This strong, almost polemical emphasis is sustained throughout the *Institutes*; it is explained at some length not only in Book I, but receives even more full treatment in Book IV, especially Chapter viii. Taking as his premise that 'the church is itself grounded upon Scripture' (74), [19] Calvin proceeds to trace the handing down of scriptural authority to 'the prophets and apostles.' Arguing against such 'wranglers' who, questioning divine authenticity for the received scriptural canon, argue 'that Scripture has only so much weight as is conceded to it by the consent of the church', he refers to the word of the apostle himself:

He testifies that the church is 'built upon the foundation of the prophets and apostles' [Eph. 2:20]. If the teaching of the prophets and apostles is the foundation, this must have had authority before the church began to exist. Groundless, too, is their [such wranglers']

subtle objection that, although the church took its beginning here, the writings to be attributed to the prophets and apostles nevertheless remain in doubt until decided by the church. For if the Christian church was from the beginning founded upon the writings of the prophets and the preaching of the apostles, wherever this doctrine is found, the acceptance of it – without which the church itself would never have existed – must certainly have preceded the church. It is utterly vain, then, to pretend that the power of judging Scripture so lies with the church that its certainty depends upon churchly assent. (75–76; *Vanissimum est igitur commentum, Scripturae iudicandae potestam esse penes Ecclesiam: ut ab huius nutu illius certitudo pendere intelligatur* [III.66])

Again, the church is close to and resembles the state in the derivative nature of whatever authority each possesses in its different provinces; neither can possess the more decisive authority for judging the authenticity (*certitudo*) of scripture. But if the church does not have such '*Scripturae indicandae potestam*', the question is where does such authority (*potestas*) reside? Which instance can authorise the mediating and determining link between authority's external locations in political and ecclesiastical institutions, and its truly valid and definitive source in the divinely revealed Word?

At this juncture, Calvin committed himself to a finished revelation in, necessarily, its textualised form. To all intents and purposes there was an unambiguous fountain of divine truth which, issuing from 'the writing of the prophets and the preaching of the apostles', must 'certainly have preceded the church'. But the prophets and apostles in their turn had submitted to such externals as were implicated in the circumstances of their 'writings' and their 'preaching'. They were inspired mouthpieces or, as Calvin in his sober manner wrote, 'reliable and authentic secretaries of the Holy Spirit' (*certi et authentici Spiritus sancti amanuenses*, V.141). Their knowledge, at any rate, was derived from a deeper and more magnificent source of truth which, or so it seemed, was even at this late date accessible as an 'inward' instance of guidance. For it is

that those whom the Holy Spirit has inwardly taught truly rest upon Scripture [*quos Spiritus sanctus intus docuit, solide acquiescere in Scripturae;* III.70], and that Scripture indeed is self-authenticated; hence, it is not right to subject it to proof and reasoning.

If 'credibility' of doctrine is not established until we are persuaded beyond doubt 'that God is its Author' (78), the prophets and apostles can, with the help of the Spirit, be believed. But at this point, it seems as if the reformer was not quite able to make up his mind: on the one hand, there is the inward guidance, the inspiration and certification of the Spirit; on the other hand, scriptural truth as such is self-evident: 'Indeed, Scripture exhibits fully as clear evidence of its own truth [*veritatis suae sensum ultro*

Scripturae prae se fert; III.66] as white and black things do of their color, or sweet and bitter things do of their taste' (76).

Understandably, Calvin is not content to leave the question of mediation at the level of such metaphoric intimations. In order to 'see manifest signs of God speaking in Scripture', Calvin addresses and revises the nature of Protestant faith by qualifying (and, to a certain extent, externalising) Luther's own somewhat unspecified vessel of mediation, that of each Christian believer's 'soul'. Luther in his *Freedom of a Christian* again and again referred to the 'soul' and the 'heart' (and 'the heart they cannot constrain') as a perfectly legitimate, self-authenticating receptacle of divine grace, as the valid location of the genuine faith and belief in Scripture. But so had the Anabaptists when, discarding the idea of a finished revelation, they resorted to each believer's 'soul' as an unquestioned organ of unending self-authorisation. At this point, Calvin would remember the dire consequences. Rather than trusting some such (all too readily available) purely internal medium of legitimation, he put forward, as the supreme criterion of divine truth, a much less accessible 'secret' testimony, that of the Holy Spirit.

Calvin's doctrine of the inner witness of the Holy Spirit to the truth of scripture is one of the most resolute, to a certain extent desperate, attempts at coming to terms with the issue of authority in the Reformation. In our context, this attempt is highly significant in that it culminates in the endeavour to close the gap between the letter and the spirit, the institution and the 'truth', external and internal correlatives of authority.

The doctrine of the Holy Spirit is first set out in Book I, Chapter vii. He returns to it in Book III, Chapters i and ii, but most squarely confronts and redefines the issue in direct reference to 'the doctrinal authority of the prophets' and 'the apostles' in Book IV, viii, 3–4, only to commit himself finally to the 'Scriptural foundation of the Word of God' and its incarnation in Jesus Christ through whom 'The Word became flesh' (1153, 1154). Emphasising the 'unity and multiplicity of revelation', Calvin is careful to disown revelatory practice as an ongoing source of authority after the advent of Christ:

> For Paul means, in fact, openly declares, that God will not speak hereafter as he did before, intermittently through some and through others; nor will he add prophecies to prophecies, revelations to revelations. Rather, he has so fulfilled all functions of teaching in his Son that we must regard this as the final and eternal testimony from him. (1154–1155; ut hoc ultimum aeternumque ab eo habendum sit testimonium; V.139)

Hereafter, then, 'the mouths of all men should be closed when once he has spoken' (1155). The closure of revelation affects all claims of doctrinal infallibility apart from the Word: 'Not even the apostles were free to go beyond the Word: much less their successors' (1156). So the church, far

from being infallible, cannot by itself sanction doctrine, not even through appeal to the presence of Christ.

Calvin here fights a battle on two fronts, one against the old church, the other against those who hold that revelation is unfinished. Carefully differentiating between 'true and false councils' he is, on the one hand, sceptical of the Roman authority of conciliar decisions when most of these departed from scripture (1166–71). On the other hand, he is no less severe on the recent practice of 'fanatics, abandoning Scripture and flying over to Revelation'. His impatience with these men is understandable when these 'fanatics wrongly appeal to the Holy Spirit' (93), that is, to that most sanctioned medium of divine authority to which Calvin himself had appealed. For the Genevan reformer rightly to appeal to the Holy Spirit was to make his 'testimony' serve as the firm line connecting the absolute authority of the Word and the contingent circumstances of its reception.

With the help of this fine differentiation, the Spirit is to be 'both "seal" and "guarantee" (II Cor. 1:22)' (80): it bears the 'seal' against unauthorised appropriations of the Word of Divinity and therewith serves as 'guarantee' of its authoritative reception, 'sealing' the reproduction of the Word in this world. The Spirit, so understood, was on the lips of the prophets; it was guiding the pens of the apostles and, in our own time, must again be present so as to 'penetrate into our hearts':

> ... the testimony of the Spirit is more excellent than all reason. For as God alone is a fit witness of himself in his Word, so also the Word will not find acceptance in men's hearts before it is sealed by the inward testimony of the Spirit. [ita etiam non ante fidem reperiet sermo hominem cordibus quam interiore Spiritus testimonio obsignetur; III.70] The same Spirit, therefore, who has spoken through the mouths of the prophets must penetrate into our hearts to persuade us that they faithfully proclaimed what had been divinely commanded. (79)

As supreme intermediary, the Spirit serves as both aperture and closure of revelation, *sealing* the faithful reception and 'acceptance in men's hearts' of divine authority. This, then, does not – as Luther's own soul did – constitute a site of fearful struggle and awesome questioning; rather, the Spirit for Calvin is to be conceived as interlinking and bringing together the sublime past of the sacred text and the respect for, and recovery of, its authentic meaning in the present. The Spirit 'has not the task of inventing new and unheard of revelations, or of forging a new kind of doctrine ... but of sealing our minds with that very doctrine which is commended by the gospel' (94).

Again, it is difficult not to read the imagery of the 'seal' as a strangely composite vehicle of both closure and certification (*et sigillum, et arrha*; III.70). In Calvin's text such metaphor was to serve as an antidote against self-authorised licence in the religious, social and sexual practice of 'certain giddy men ... who, with great haughtiness exalting the teaching office

of the Spirit, despise all reading and laugh at the simplicity of those who, as they express it, still follow the dead and killing letter' (93). Although in Book IV the main thrust of his argument was against the institutionalised location of authority in the Papacy and Roman councils, it is not fortuitous that, in his earlier design of Book I, the most ferociously pursued target is that 'devilish madness' of those 'giddy men' (93), against which the author of *Contre la secte phantastique et furieuse des Libertins* (1545) was elsewhere to intervene.

It is at this juncture that the remarkable balance in Calvin's discourse of guidance and reproof goes overboard and even his brilliant *clarté* leaves something to be desired. Perhaps the burden of a bifold polemic turns out to be too heavy when the proposed doctrine of the inner witness of the Spirit as 'seal' and 'guarantee' of ultimate authority attempts to bring together both its divine source and the task of assuring its truly sanctioned reception in the circumstantial world. It may well have been with the gruesome picture of Münster as slaughterhouse of the German Anabaptists in his mind that, as point of reference, he chooses 'these miserable folk':

> these miserable folk willingly prefer to wander to their doom, while they seek the Spirit from themselves rather than from him. Yet, indeed, they contend that it is not worthy of the Spirit of God, to whom all things ought to be subject, himself to be subject to Scripture. As if, indeed, this were ignominy for the Holy Spirit to be everywhere equal and in conformity with himself, to agree with himself in all things and to vary in nothing! To be sure, if the Spirit were judged by the rule of men, or of angels, or of anything else, then one would have to regard him as degraded, or if you like, reduced to bondage; but when he is compared with himself, when he is considered in himself, who will on this account say that injustice is done him? Nevertheless, he is thus put to a test, I confess, but a test by which it pleased him to establish his majesty among us. He ought to be sufficient for us as soon as he penetrates into us. But lest under his sign the spirit of Satan should creep in, he would have us recognise him in his own image, which he has stamped upon the Scriptures. He is the Author of the Scriptures: he cannot vary and differ from himself. (94)

Calvin, with his humanist background, was resolved not to follow the half-illiterate, least of all when, as he viewed it, they were determined to 'despise all reading'. Rejecting the dualism of Luther's antinomies between the freedom of the soul and the subservience of the flesh, between spiritual defiance and political submission, Calvin paradoxically projects a Holy Spirit whose identity, what with his bridge-building between two radically different worlds, must needs be resolutely fixed: for when all is said and done such fixture ('to be everywhere equal and in conformity with himself, to agree with himself in all things, and to vary in nothing!') is that of scriptural meaning itself.

The paradox was that here Calvin came close to echoing, and was yet contradicting, the language of contemporary mysticism (in its turn designed to do as the sects did): to make the Spirit penetrate into us. For Calvin, the 'test' of the spirit is that 'he penetrates into us' and yet does so 'in conformity with himself'. For as both authority and 'Author of the Scriptures' he is supposed 'to vary in nothing'. The argument, advanced in a spiral curve, ends up in a vicious circle. The Spirit, authorising the Protestant appropriation of Scripture, needs to bring forth his very own authority and legitimation: *'quam authoritatem habebit apud nos Spiritus, nisi certissima nota discernatur?'* (III.83). The difficulty could not be solved when the enormous energy in this spiritualised *lecture* of the sacred text was to be released as an appropriating force and yet was supposed to be appropriately harnessed in the potential of its meaning. No matter, when the great reformer aimed at a structure of authority and authentication that was to be more solid and substantial, less divided and more of a piece than Luther's. But even at its most tortured, this brave new language of Protestant authorisation signally failed in the attempt to relocate authority through strengthening the relations of institution and inspiration, State/Church and Spirit/scripture.

In conclusion, then, it may well be said that it was this shift in the constellation of a bifold authority that was most remarkable (and troublesome) in the Calvinist position. As a matter of consequence, it was this widening space between external and internal locations of authority (with a distinct puritan preference for the latter) which Elizabethan critics sought to address. Those who defended the establishment position did have a point when they declared, as Ormerod did in the subtitle of his book, 'that the Puritanes resemble the Anabaptists' (although even then it must have appeared somewhat far-fetched, when he continued, 'in above four score several things'). Similarly, Cosin was not altogether off the mark when he, too, noted 'a resemblance' between Puritan dissent and 'what happened heretofore in Germanie': the main target was the 'opinion of equality of authority and dignitie', [20] as associated with Thomas Müntzer.

In the theatre, discord in theology had of course no place, but the politics of authorisation was more than relevant. When Ormerod warned those in power that they were being challenged on the level of a common appropriation of spiritual authority, he disconcertedly asked the question: 'are all Prophets? are all teachers? ... do all interpret?' [21] In the theatre, it was not simply the alleged limitations of 'this unworthy scaffold' that made the prologue to *Henry V* appeal to the 'imaginary forces' (II.10, 18) of the audience. Here, all were authorised to 'interpret'; in fact, every spectator was summoned to 'make imaginary puissance': 'For 'tis your thoughts that now must deck our kings' (II.25, 28). Even more important, in dramatic representations, traditional sites of authority could be unfixed or perceived as contingent. It was possible to refer to the authorities of external station, office and degree and, at the same time, envision their vulnerability on the strength of internal sources of legitimation. Nor was the space between these two poles given; it was subject to negotiation, with an assisting

audience to follow and respond. Hence, the very linkage between the external authority of status symbol, 'ceremony' and 'name', and internal ones was subjected to scrutiny. We only have to think how the latter is made to triumph over the former, as when Lear sheds his 'lendings', when Henry V questions the use-value of 'ceremony', when Juliet asks, 'What's in a name?' and when Hamlet makes a distinction between the 'seems', that is, the outward signs of grief and his more profound experience 'within'.

If, as John N. King has noted, the mid-Tudor debate in the wake of the Reformation was over 'the relative merits of internal and external authority' [22] and if, as Christopher Hill notes, the 'distinction' between the two was 'what the Reformation had been about', [23] then this distinction had a most consequential and far-reaching correlative in the Elizabethan drama. The space between internal and external sites of authority was constitutive of a new and profound type of dramatic conflict. It was a conflict which, by indirection, thrived on images and intimations of a spirit betwixt scripture and polity. More immediately, its matrix was whatever tension resulted between language and power: between the authority of the text, the thinking and the writing, the 'imaginary puissance', on the one hand, and that 'great image of authority', the practice of brute force, when 'a dog's obey'd in office', on the other.

Notes

1. Margot Heinemann, *Puritanism and Theatre: Thomas Middleton and Opposition Drama under the Early Stuarts* (Cambridge: Cambridge University Press, 1980), p. 26.
2. Ibid.
3. John Foxe, *Acts and Monuments*, ed. Stephen Reed Cattley, 4th edn, rev. by J. Pratt, 8 vols (London: Seeley and Burnside, 1877), VI.31. I have discussed the Gardiner–Somerset correspondence at greater length in ' "Bifold Authority" in Reformation Discourse: Authorization, Representation, and Early Modern "Meaning" ', in Janet L. Smarr (ed.), *Historical Criticism and the Challenge of Theory* (Urbana: University of Illinois Press, 1993), pp. 167–82.
4. Foxe, *Acts and Monuments*, VI.41.
5. Richard Hooker, *The Works*, 2 vols (Oxford, 1850), II.328.
6. Foxe, *Acts and Monuments*, VI.34.
7. Richard Bancroft, *A Sermon Preached at Paul's Cross* (London, 1588); Oliver Ormerod, *The Picture of a Puritane*, enlarged edn (London, 1605); Richard Cosin, *Conspiracy for Pretended Reformation* (London, 1592). These, of course, respond to rather than propagate the Calvinist and the more radical redefinitions of 'authority', with remarkable insight (especially in Bancroft, pp. 33–6) and copious reference to the issue of authority (in Cosin, the word occurs more than a hundred times).

8. See, Martin Butler, *Theatre and Crisis, 1632–1642* (Cambridge: Cambridge University Press, 1984); more recently, Julia Gasper, *The Dragon and the Dove. The Plays of Thomas Dekker* (Oxford: Clarendon Press, 1990); Paul W. White, 'Patronage, Protestantism, and Stage Propaganda in Early Elizabethan England', *Yearbook of English Studies*, 21 (1991), pp. 39–52; Donna B. Hamilton, *Shakespeare and the Politics of Protestant England* (New York: Harvester Wheatsheaf, 1992); Paul Whitfield White, *Theatre and Reformation: Protestantism, Patronage, and Playing in Tudor England* (Cambridge: Cambridge University Press, 1993); Julia Gasper, 'The Reformation Plays on the Public Stage', in J. R. Mulryne and Margaret Shewring (eds), *Theatre and Government under the Early Stuarts* (Cambridge: Cambridge University Press, 1993).

9. See Jean Calvin, *Institutes of the Christian Religion*, ed. John T. McNeill, trans. F. L. Battles, 2 vols (Philadelphia: Westminster Press, 1964), esp. Book IV, Chapter xx, pp. 1485–521. All further references to this edition are given in the text. For a recent translation and annotated edition of this chapter, 'On Civil Government', see *Luther and Calvin on Secular Authority*, ed. and trans. Harro M. Höpfl (Cambridge: Cambridge University Press, 1991), pp. 47–86.

10. Harro M. Höpfl, *The Christian Polity of John Calvin* (Cambridge: Cambridge University Press, 1982), pp. 171, 152.

11. The chapter heading in its Latin original is 'De politica administratione'. See *Institutio Christianae Religionis* (1559); here cited in Joannis Calvini, *Opera Selecta*, eds Petrus Barth et Guilelmus Niesel, (Monachii in aedibus: Chr. Kaiser, 1957–1962), vols III-V, cit. V, p. 471. All further page references are to this edition, with volume in Roman numerals given in the text.

12. See the glossary in Höpfl (ed. and trans.), *Luther and Calvin*, pp. xxxii–xlv.

13. See ibid., p. xlii.

14. Höpfl, *Christian Polity*, p. 46.

15. See ibid., pp. 106f.

16. Alister E. McGrath, *A Life of John Calvin. A Study in the Shaping of Western Culture* (Oxford: Blackwell, 1990), pp. 97f.

17. Ibid., pp. 106f.; the two chapters on Geneva (pp. 79–128) provide an extremely well-balanced critical perspective on Calvin and Geneva as 'one of the great symbiotic relationships of history' (p. 79).

18. Rupert E. Davis, *The Problem of Authority in the Continental Reformers* (London: Epworth Press, 1946), p. 131.

19. This is the editor's (F. L. Battles) summary and subtitle; not in Calvin's Latin original (see III:66).

20. Cosin, *Conspiracy*, p. 83.

21. Ormerod, *Picture of a Puritane*, p. 70.

22. John N. King, *English Reformation Literature: The Tudor Origins of the Protestant Tradition* (Princeton: Princeton University Press, 1982), p. 84.

23. 'The Problem of Authority', *The Collected Essays of Christopher Hill*, vol. 2, *Religion and Politics in Seventeenth-Century England* (Amherst: University of Massachusetts Press, 1986), p. 47.

5 THE ASS WITH DOUBLE VISION: POLITICISING AN ANCIENT GREEK NOVEL

Edith Hall

When, just before the First World War, J. S. Phillimore addressed the Board of English Studies at the University of Oxford on ancient Greek fiction, he felt it necessary to excuse his lowly subject matter: 'And yet the triumphant Novel ... may condescend to look back at the distant founder of the family, as a modern patrician traces his pedigree proudly to an ancestor who was a scullion in William the Conqueror's kitchen.'[1]

It took a further 80 years for a paper on these literary 'scullions' to be introduced on to the undergraduate syllabus at the same university. Yet even within that group of works loosely termed 'the ancient novel' there are hierarchies, and classicists wrangle over the canon. While the humorous Latin novels – Petronius's riotous *Satyricon* and the Latin version of the tale of the man–ass transformation, Apuleius's *Golden Ass* or *Metamorphoses* – have enjoyed some popularity, the ruder Greek antecedent of Apuleius preserved in abridgement under the simple title *Ass* has been sorely neglected, despite being the first attested 'anti-novel' in Greek fiction.

One reason for this neglect has been its perceived aesthetic inferiority to its Latin counterpart, or, as an introduction to Adlington's wonderful sixteenth-century English translation of Apuleius expressed it, the 'elder ass, compared to its golden brother, is but a sorry jade, a withered beast, with senile, bloodshot eye, unredeemed even by its salaciousness'.[2] Another reason is an assumption among guardians of the canon that sexual exuberance is incompatible with literary merit. The novels in Greek for the most part centre on a romance between two aristocratic heterosexual teenagers, with a happy ending, and they are often described as 'the ideal' or 'typical' novel, enjoying several vogues since the Renaissance. An eminent scholar recently produced a canon of Greek novelists for which sexual propriety seems to have been a criterion of selection: 'With the exception of Longus, whose prurience has already been observed, they (Chariton, Heliodorus, Xenophon of Ephesus, Achilles Tatius) are consistently modest in sexual matters.'[3] *Ass* is silently excluded from this canon. Robert Graves appended a rendering of the Greek *Ass* to his translation of Apuleius, but he truncates it 'at the point where ... [the] sexual humour becomes offensively crude', that is, when its hero has just told his first lover that he wants to stick his fingers in her saucepan.[4]

The crudeness of the *Ass* that critics have found offensive provides a key to its significance. Its treatment of sex can be seen as a focus of its unrelentingly realistic reduction of the Greek landscape and socio-political system to their inherent ugliness and barbarism. Refined eroticism is central to the 'ideal' Greek novels, but the Greek *Ass* offers an examination of erotic activity, in a detail unparalleled in other ancient literature, which is unleavened by sentimentality or metaphysical mystification. Thus it burlesques, in the manner of Bakhtin, [5] all the beautifying and romantic elements characteristic of the 'ideal' novels. The scholarly view that the ancient novel 'is an escapist form; set in the past or at the ends of the earth, its fictions generally portray the human condition with the minimum of reference to the social and political structures within which its readers lived' [6] is turned upside down in the *Ass*. It is the earliest Greek novel that is set in the writer's immediate present, and, with a high degree of realistic detail, it paints a grim picture of the social and political structures of second-century Greece under Roman rule. But critics have been so busy arguing about the identity of authors that they have paid hardly any attention to content, particularly social content. [7] There is a secondary literature attached to the Greek *Ass* but it is almost exclusively directed towards its authorship and relation to Apuleius's famous Latin *Golden Ass*. [8]

There is much scope for such discussion, since the Greek *Ass* is an abridgement of the lost original Greek version of the story of Lucius, the archetypal man-who-changed-into-an-ass.The full novel, which went missing at some point after the ninth century C.E., was also a source for Apuleius. We do not know who produced either the original Greek novel or who abbreviated it, although the famous second-century satirist Lucian may have been involved at some point. [9]

Two things are nevertheless quite clear. First, the text, though an abridgement, is an important document of the early second-century Greek cultural imagination. Strong evidence indicates that the editorial activity which abbreviated the original text consisted not of adaptation but only of omission.[10] The *Ass* is faithful in linguistic detail and even syntax to the original, for we are told so by the ninth-century scholar Photius (patriarch of Constantinople), who had seen both texts, along with the censorious observation that they shared the same 'shameful indecency' (*Bibliotheke*, cod. 129). Second, the original of the Greek ass-novel antedated Apuleius who, while programmatically announcing that his story is a Greek one (I.1), changed, supplemented from other sources and eliminated different parts of it. Thus the surviving Greek *Ass* deserves independent attention, and I have deliberately focused on details that Apuleius ignored.

The unabridged Greek novel was the earliest known European text to use the man–ass metamorphosis as the frame tale of an extended narrative. [11] How can a story at whose heart lies the scientifically impossible metamorphosis of a man into an ass be described as 'realistic'? Paradoxically it is just this device which allows the text to offer a different, and truer, vision of the society from which it emanated than the 'ideal' Greek novels whose

viewpoint is invariably that of its aristocratic heroes. This is because the ass, socially speaking, has double vision: while retaining the consciousness of a member of the ruling elite, and ultimately returning to that privileged estate, the first-person narrative voice simultaneously offers the perspective of the dregs of society. The ass's cohabitation with peasants and cooks and slaves and market gardeners, his life of hunger, unbearable drudgery and agonising punishments, his absolute unfreedom and subjection, are counter-posed to his unrelenting social snobbery and unquestioning allegiance to the ruling class.

This bifurcated vision is articulated by the novel's ostentatiously varied style. Greek prose writers of this era (the so-called 'second sophistic') aspired to a uniform 'Atticism', the reproduction of the style of the canonical classical Athenian authors (Thucydides, Plato, Demosthenes) of 600 years before. Orthodox literary Greek was thus unusually artificial and estranged from everyday speech. But the Lucius-ass accurately verbalises his double vision through the medium of his social bilingualism. While fluent in the highbrow dialect of contemporary literati, he is also a flamboyant user of 'vulgar' demotic [12] (another ground on which this text has met with scholarly disapproval in more recent times: this Greek novel is not in 'good' Greek).

Lucius shares with many pagan citizens of the second-century Roman empire a fascination with the supernatural.[13] In Thessaly he takes up residence in the household of Hipparchus, whose wife practises witchcraft. Lucius persuades the slave-woman Palaestra to let him witness her mistress changing herself into a bird, but Palaestra accidentally gives him the wrong lotion when he wants to do the same.[14] The entire remainder of the novel consists of Lucius's ordeals in his asinine form until he finds the antidote.

He is passed serially from master to master. Stolen from Hipparchus's house by robbers, he is rescued by a detachment of Roman soldiers (26). He serves a slave-boy in an extended agrarian household, suffering abject cruelty (29–33). On the death of the householders their slaves emancipate themselves, and take the ass with them; he is sold at a market to a member of an eastern orgiastic cult. He labours for these itinerant worshippers, carrying the statue of their mother-goddess. The cult-members are arrested (41) and the ass is sold again, to a wheat merchant at whose mill he labours. He is sold twice more, once to a market gardener, and then to a slave, a cook in the house of the wealthy gentleman Menecles (46). When it is discovered that he can copulate with a woman, he is exhibited with one condemned to death in the amphitheatre at Thessalonica, and there he finds the roses which precipitate his return to humanity.

Such spectacular displays of the slaughter of criminals in amphitheatres – a nasty habit the Greeks picked up from the Romans – are a lamentably well-documented feature of the empire. At Rome the bandit Selurus was put on a replica of Mount Etna, which was designed to collapse inwards, casting him down to the wild beasts (Strabo, 6.273). The public

was enthralled by enactments, using condemned criminals as 'actors', of
the mythological castration of Attis or the live incineration of Hercules
(Tertullian, *Apol.*, 15.4–5). One real-life display closely mirrored that in
the *Ass*, for a woman was somehow coerced, in the mythical persona of
Pasiphaë, into coupling with a bull (Martial, *Lib. Spect.*, 5.2). [15] There is
also concrete evidence from an inscription that gladiatorial games were
held in 143 C.E. at Thessalonica. [16] The fantastic metamorphosis of the
hero of the *Ass* takes place against a literary backdrop that is a realistic
portrayal of contemporary social practices with a realistic precision and
a predilection for gory detail, and the *Ass*'s double vision thus facilitates
a reading which discloses the social tensions inherent in this barbaric
era.

The constituency of the readership of the ancient novel, in the absence
of all but scanty external evidence, has been much debated. Just as it has
been largely excluded from the modern classicists' canon, the ancients
disdained to mention in it in their catalogues of literary genres, and the
few references to the novel are largely derogatory. [17] Some critics have not
wanted to believe that ancient adult male intellects enjoyed such a 'low'
form of literature. Misled by analogies with modern formulaic romances
associated with the name of Mills and Boon, from time to time they have
been tempted 'to think of the novel as the first great literary form to have
had its main support among women'. [18] But while there is no evidence for
female consumption of fiction in the ancient world, it *is* clear that it was
regarded as sexually stimulating for male readers: Julian the Apostate
proscribes the reading of 'erotic stories' by priests in Asia Minor (*Ep.*,
89b), and the physician Theodorus Priscianus (early fifth century C.E.)
recommends that men with sexual problems read the works of Iamblichus,
who wrote novels (*Eupor. rer. med.*, 2. 11. 34). The overwhelming likeli-
hood is that fiction was produced for and consumed by the educated male
elite, well-off citizens of the Roman empire which, during the period in
question, encompassed much Greek-speaking territory in the eastern
Mediterranean.

The hero of the *Ass* describes himself as a 'writer of stories and other
things' (55). The male consciousness of the first-person narrator, a profes-
sional writer, shares much, therefore, with that of the educated writer and
reader of fiction. The massive rift between the homologous author/hero/
reader and the numerous characters of low or servile class who populate
this novel is underlined by what it has to say about writing. Through their
shared knowledge of writing and literature, the socially privileged males in
the novel maintain their complex system of obligations and alliances across
two Roman provinces and three cities: Patras, Hypata and Thessalonica
(this was in reality vital to the elite families in Greece under the empire). [19]
Lucius arrives in Hypata in Thessaly armed with a letter of introduction to
his host penned by 'Professor Decrianus of Patras' (1–2); his release is
secured by identifying himself to the provincial governor in Thessalonica
as a professional writer (55). But Palaestra, the female slave responsible
for the pharmaceutical error by which Lucius becomes an ass, tells him

that she knows little about the magic practised by her mistress *because she cannot read* (11), a crucial detail absent from Apuleius. Palaestra could never enjoy the very text in which she is a principal actor. This detail betrays the exclusivity of the shared male consciousness of author, hero and reader, collaborating in inspection of Palaestra as sex object; but since well-born women in the Greek novel *can* read and write,[20] it more sharply defines the *class* relationship the reader shares with the author and hero: he too is a free man, whose similar education, wealth[21] and leisure permit him to enjoy the very activity – reading – in which he is engaged.

Edward Said has recently argued that without empire there is no European novel: and without empire there would have been a less interesting *Ass*,[22] for the novel's double vision produces a deeply ambivalent perspective on the Greek provinces' relationships with the Roman imperial administration. This is particularly remarkable because all the other Greek novels try to erase the reality of submission to Rome, preferring to set their action nostalgically in the 'free', pre-Roman Greek past of a few hundred years before. The context of *Ass* is mainland Greece under the Roman empire in the early years of the second century C.E. Rome had finally secured its imperial domination of 'Achaea', the province of mainland Greece, in 31 B.C.E. By the time of the *Ass*, over a century later, the elite was culturally bilingual. Roman citizenship had spread throughout the Greek upper classes in the eastern Mediterranean, Greeks were manoeuvring themselves into positions of imperial power at Rome, while Greek remained the unchallenged language of high culture, in which any Latin-speaker from the middle class upwards had to be proficient. But Italian families also rose to prominence in the east, and Latin was the language of administration and power, used for coins, inscriptions and the governors' courts.[23] There must have been some resentment on the part of the Greek upper classes at the widely documented interference in the internal administration of their cities by Rome, but it was also in their interests to have the Roman militia to protect them from their own poor. Among the international Greco-Roman aristocracy, class interests unquestionably transcended those of ethnic identity.

The importance of studying the Greek *Ass* independently of Apuleius can be no better illustrated than by its own hero's ethnicity. In Apuleius the hero is emphatically a Greek (1.1), but in the Greek *Ass*, conversely, the hero and his brother, who both have stereotypically Roman names,[24] hail from Patras, a colonial foundation composed of both expatriated Roman veterans and members of the indigenous population. The choice of this city for the hero's provenance marks him out as a privileged member of the hyper-elite, descended from and especially loyal to and beloved by the Romans, for in 14 C.E. Augustus had given Patras, his 'pampered foundation', a number of special privileges, and given to its citizens freedoms denied to other cities in Achaea.[25] The city had an unusually high degree of inherited allegiance to Rome.

It is therefore singularly appropriate that, when the Lucius-ass is

abducted by robbers (16), his first instinct as a member of the upper class
of Patras is to summon the aid of the Roman emperor. But when he tries
to call out 'Oh, Caesar', he can manage nothing more than a bray. The
Roman citizen's dependence on the imperial machine is thus outrageously
subverted by its failed articulation in the mouth of this most undignified of
animals. The novel inverts the real-life domination of Greece by Rome: the
forces of local discontent and disorder embodied in the Greek robbers
defeat the Romophile citizen of Patras.

While the upper classes in the novel are loyal to and dependent on
Rome, the Roman regiments which march in and out of the novel's Greek
landscape are in direct conflict with the poor. This tension erupts into
open violence when the market gardener to whom the Lucius-ass has been
sold is stopped in the road by a soldier and asked 'in Latin' what is his
destination. He makes no answer, Lucius supposes, 'through ignorance' of
the language (bilingualism in Latin and Greek being the privilege of the
elite), and the Roman soldier strikes him with a whip. The Greek retali-
ates, trips up the soldier, beats him with his hands and feet and a rock
from the wayside, and even intellectually outmanoeuvres him by flinging
aside his sword (44). It should be remembered that 'the Roman armies of
occupation often treated the provincials badly, and since they were under
military and not local jurisdiction, it was hard ... for natives to get
redress'. [26] In this scene the Greek peasantry briefly strikes back.

Both robbers and peasant are eventually subordinated by Rome. The
robbers are arrested, and the Lucius-ass actually betrays the poor peasant
by collaborating with the army (45). But his collusion in imperial power
does him little good: he is sold yet again (46). The novel thus satirically
complicates the Greco-Roman relationships of its era: Lucius's collabora-
tion with the Roman army places him in a worse predicament than before,
and, remarkably, it is a Roman soldier – the novel's representative of the
force majeure underlying even apparently peaceful provinces under the
Roman empire – that is made 'the butt of the farce'. [27] It is equally remark-
able that violence committed against a Roman soldier by a Greek peasant
should be the source of pleasurable humour. Yet, in the end, restoring
Lucius of Patras to his true rank and identity through the unchallenged
authority of a provincial governor, the novel leaves the Roman empire as
much intact as when it began. Roman hegemony is thus simultaneously
subverted and maintained.

The authentic voices of slaves in the Greco-Roman world are silent to us.
Texts do not exist which record the consciousness of slaves undistorted by
representation by writers of a higher class, and there are few enough of
these, for they are reluctant, for the most part, to speak about the count-
less unnamed unfree labourers who serviced their writers' households,
their bodily needs, and many of their means of production. Yet an omni-
present theme of ancient Greek literature had always been the radical
reversal of social status: this was an expression of the anxieties of a world
dominated by warfare in which catastrophic movement down the social

pyramid was a haunting present danger. [28] In the famous words of Moses Finley: 'the condition of servitude was one which no man, woman, or child, regardless of status or wealth, could be sure to escape in case of war or some other unpredictable ... emergency.' [29] From the *Odyssey* where the perspective on the social order is for a time that of the king disguised as a beggar, [30] to the theatre where tragic queens are enslaved, comic gods can temporarily exchange roles with slaves, and Menander's disfranchised lovers are suddenly discovered to have been nobly born, Greek imaginative literature constantly meditates on class boundaries and their fictional transgression. But no text prior to the Greek *Ass* ever reduced a well-born hero to a state of such ignominious servitude.

The hero is turned into an animal (which does not make the novel 'a serious protest against cruelty to animals', as it has sometimes been seen); [31] he is treated *in identical ways to the lowest sub-class of ancient slaves*: he bears burdens, is starved, beaten, sold at markets, [32] humiliated, and sexually abused. At several points the text makes an explicit equation between the life of a beast of burden and the life of a slave: when the Lucius-ass is made to work in the mill (as humans often were, in one of the most punitive and feared of all forms of slave labour in antiquity), he calls himself and his fellow animals 'slaves' and is subjected to concerted cudgelling by his masters. He grimly concludes: 'I learned from experience that a slave should not wait for his master's hand before doing what he has to do' (42). This significant comment is absent from Apuleius.

The erasure of the slave/free boundary underlies numerous passages. There is even a scene of fantasy manumission: the young noblewoman's father gives instructions for the Lucius-ass to be 'set free under the open sky and to graze with the brood mares. "For he'll live the life of pleasure *as though in freedom*"' (27). He is delighted at the prospect not only of liberation but of freedom to engage in sex with the mares (one of the harshest facts of ancient servile life was the frequent banning of sexual relationships even with others of the same class). [33] One set of household slaves decide to emancipate themselves: 'Since the house had been bereaved of its young owners', the slaves 'decided to remain in slavery no longer, but after looting everything inside, they escaped to safety' taking the ass with them (34). But, with probable realism, the only alternative to life in servitude is, under constant menace from the Roman army, a life on the wrong side of the law.

The slave/master hierarchy is inverted by the extended sex scene with Palaestra. In reality her relationship with Lucius, a free male Roman citizen, was one of absolute subordination. But in the context of sex and its metaphoric portrayal as a wrestling match, Palaestra (whose name means 'wrestling arena') temporarily assumes dominance: '*I* will follow the rules of a trainer and manager, and I'll call out the names of the holds I want as I think of them: you've got to be ready to follow orders and do everything you're told' (8).

Despite such play on status-reversal, the *Ass* legitimises the upper-class premise that slaves are inferior, troublesome, difficult and base, for most

of the representatives of their class in the text are depicted as disloyal,
greedy, stupid or maliciously cruel. When Lucius has decided to approach
Palaestra, for example, he tells himself to 'strip for action with her ... you
can be sure that you'll easily get your information. *Slaves know it all, the
good and the bad*' (5) – another detail absent from Apuleius. The ancients
nurtured a deep anxiety, here incarnated by Palaestra, about the trust-
worthiness of household slaves, who often had access to private informa-
tion about their masters and could not be trusted to keep it secret. It is a
mark of Theophrastus' 'boorish' man that he shares his secrets with his
slaves while distrusting his own friends and family (*Characters*, 4.2).

The double vision of the Lucius-ass is clear also in the description of
physical abuse. Even though the heroes and heroines of the romantic
novels are enslaved and sometimes beaten, their suffering is described
elliptically and without detail; their bodies miraculously regain their 'true'
beauty despite the mistreatment they have supposedly endured. The
violence inflicted on the Lucius-ass, however, is presented with precision
and a sense of its reality. There is no equivalent in ancient literature of the
extended descriptions by the subject of his suffering such as this account
of the hero's treatment by the herdsman's boy (significantly himself a slave
of a slave and thus no doubt a victim of brutality, too):

> First he used to beat me ... and not with a plain stick, but one that
> was studded with numerous sharp knots, and he always struck me on
> the same part of the thigh, so at that spot on my thigh there was a
> constant open sore from the rod, and it was the wound he always
> struck at ... If ever I fell down exhausted and overburdened, then the
> horror was unbearable ... from up there, beginning with my head and
> ears, he would beat on me with his stick, until the blows forced me
> to get up. (30–31)

No doubt a readership which could enjoy the activities of the amphi-
theatres would have had a greater tolerance of this cruelty than we have.
Such treatment was unquestionably handed out not only to animals but to
slaves,[34] and here is an authentic attempt by an ancient author at least to
imagine the agony such physical abuse would cause. The important point
about the subjective description is that the hero-narrator, in retaining his
'human' class perspective, expresses to his privileged readership in their
own cultural language the pain they inflict on their subordinates. The
shared perspective of readers and narrator is emphasised. Lucius had
abandoned thoughts of escape after the shocking slaughter of his compan-
ion ass and decided to 'accept what was ahead of me like a gentleman'
(20). The term he actually uses is *eugenōs*, meaning 'in a manner suited to
one of noble birth and family'.

The novel is crowded with scenes of physical violence, eating and sex, and
extends its somatic focus to an emphasis on clothing, undressing and
nudity. When Lucius has just arrived in Hypata he encounters a woman,

'still young and, to guess from seeing her on the street, very comfortably off; for she had brightly coloured clothes, lots of slaves, and more than enough gold on her' (4). Clothing here is introduced as a marker of wealth and status. Lucius can distinguish the free woman from her slaves visually because of her apparel. It sets up early on the novel's consistent play on the sartorial distinction between slave and free, and its concomitant stress on the social levelling effect of nudity. The connection of costume with social status is emphasised when the outlaws sort through the 'clothes and a good deal of female and male jewelry' which they have stolen from the rich (21).

A character in a New Comedy had said long before: 'Even if someone is a slave, he is made of the same flesh. For nobody was ever born a slave by nature' (Philemon, fr. 95 Kock). In the *Ass* stripping to the flesh is a levelling device, to which members of all social classes are subjected, erasing the socially constructed distinctions between them. Lucius' lapse into the shape and status of an ass can only happen when he applies the wrong lotion to himself in his naked state (13). At the climax of this novel (abjured by Apuleius), although turned back into human shape, he finds himself still unfree, as he 'stood there naked' in the amphitheatre. It takes his appeal to shared social class to the local governor, who escorts him 'to his own home *like an equal*' (55), and the appearance of his own brother with money, to return the naked captive to his privileged social position. Clothing is a barrier against that peripety of status which is the main theme of the novel: all humans look just the same divested of ornament. Even the first band of robbers strip off and oil themselves for a bath on return to their den (20).

The novel concludes by stripping Lucius one last time. Rehumanised, he returns to the woman who had desired him as an ass. He takes off his clothes and stands naked, anticipating more sex. She rejects him, however, and he is borne forth from her house on the backs of her household slaves, turning him into exactly the same kind of burden which he had borne on his own back for so much of the novel. The last chapter accumulates instances of the term 'naked', as if to stress the reduction of its subjects to their natural state. Lucius overnights outside her house, for 'there, *naked*, elegantly wreathed and perfumed, I clasped the *naked* earth for my bed partner. At the break of dawn, I ran to the ship, *naked* as I was'; he sets sail with his brother for home (56). While returning Lucius to his original social status, the novel makes his 'animal' appetites reduce him once again to his state in nature, challenging the same socially constructed hierarchies which it simultaneously reinstates. None of this is in Apuleius.

The pervasive stress on nudity is also suggestive of the way in which the text 'strips' the novelistic genre down to its basic elements. In stripping its own characters' bodies it strips its genre as well. The novel contains many of the basic elements of the 'typical' or 'ideal' Greek novels, but bathetically replaces their romanticism and aristocratic ambience with the banal, the demotic and the everyday. One such procedure is the transformation of the customary survival of a shipwreck by a romantic couple

into their death by drowning (34). Another is the alteration in the dramatis personae. The characters who oppress the romantic leads in the other novels are usually of high social status: kings, princes, aristocrats, wealthy citizens and governors. They are also often exotic orientalised foreigners: Persians, Egyptians, Indians and so forth. Lucius, in bathetic contrast, is enslaved, beaten and oppressed by his own homegrown underclass: Greek slaves and peasants. And even his very journey, instead of taking him to the fabulous eastern wealth of Egypt or Ethiopia or the Levant, confines him to the poverty-stricken interior of mainland Greece. Finally, as we have seen, the erotic content is transfigured. Sex is denied all sentiment and does not occur between social equals. Lucius has intercourse as a human with a slave and as an ass with an upper-class nymphomaniac. A female convict is forced to fondle him (52), and only his retransformation prevents them, displayed in the amphitheatre as they are, from having to perform sexually for the delectation of the Thessalonican crowd (the Apuleian version evades both the fondling and the public exhibition). His owner Menecles, like many real-life counterparts with political ambitions, intends to 'display his generosity to the public' and to the provincial governor, who 'happens' to be there at the show (53–4). Rarely has an anticipated sexual act in literature been so cynically implicated in the maintenance of ruling-class economic and political power.

And of course sexual titillation is another function of nudity: as we have seen the ancients understood that novels could furnish sexual arousal in the (male) reader. Many of the women in the novel are explicitly stripped naked and erotically objectified by its author sooner or later, Palaestra on the very day Lucius arrives at her master's house (9). Her mistress is voyeuristically inspected by the hero through a chink in her bedroom door: 'I now saw the woman undressing. Then she approached the lamp naked ... she smeared herself' with oil (12). The woman who pays the ass's master for a night of sex with him is similarly described: 'taking off her clothes, she stood totally naked by the lamp, and, pouring out some oil from an alabaster jar, she smeared it on herself' (51): later she is studied by Menecles through yet another door-crack while she copulates with the Lucius-ass (52). This is all very different from the 'romantic' novels, in which, as a high-minded critic notes with approval, 'the heroines ... are not exhibited to the reader unclothed'.[35]

This final use of nudity points to the one great limitation, from a modern point of view, on the ass's double vision: he remains totally monocular when it comes to issues of gender. The female characters in the novel are painted from the standard unrelenting Greco-Roman palette of misogynist colours. They probably more closely reflect the ancient male viewpoint than the women in many of the other novels, where female sexuality is allowed some expression (within limitations policed by men) and the female leads, at least, can act with a degree of initiative.[36] But with one exception every woman in the *Ass* either practises witchcraft or is outrageously sexually voracious, or ostentatious, or stupid, or cruel, or old

and ugly, or criminal, or some combination of these. In the case of the single exception (who is as idealised as the others are demonised), the virginal young noblewoman captured by the first band of robbers, her disabling gender is apparently cancelled by her sexual inexperience and her class. Her function, also, is to provide voyeuristic pleasure for readers, though of a different kind: they are encouraged to enjoy the portrait of this 'extremely beautiful' young woman, 'who was crying, with her clothing and hair in tatters' (22), and the robbers' long discussion of the death with which to punish her: 'let us think up for her the most excruciating and lingering death and one that will keep her alive a long time in agony until it finally destroys her' (25). Ancient snuff literature.

The *Ass*'s double vision, therefore, while permitting a unique perspective on the brutalised lives of the lowest classes in Greece under the Roman imperial administration, does not do the same for the lived experience of ancient women. To conclude on an unashamedly anachronistic question: what if Lucius had found himself transformed, not into a male ass, but into a mare? Could the central narratological device have then allowed us to experience, through the eyes of the 'Lucia-ass', prostitution to an upper-class man with a proclivity for bestial sex, and a perspective on all the characters informed and transformed by his/her alteration in gender? The unabridged version of the Greek *Ass* may well have been the most subversive ancient novel ever written. But Hipparchus' wife turned into a bird; the most subversive ancient novel *never* written would surely have been the *Bird*, the one which recorded *her* perspectives on early second-century Greek society.

Notes

1. J. S. Phillimore, 'The Greek Romances', in G.S. Gordon (ed.), *English Literature and the Classics* (Oxford: Oxford University Press, 1912), pp. 87–117, at p. 116.
2. William Adlington, *The Golden Asse of Lucius Apuleius* (London: Simpkins, Marshall, Hamilton and Kent, 1922 edition of original 1566 translation), p. xi.
3. J. Griffin, *Latin Poets and Roman Life* (London: Duckworth, 1985), p. 111, n. 66.
4. *The Golden Ass by Lucius Apuleius* (London: Penguin Books, 1950), p. 295. There have been few English translations of the Greek *Ass*.
5. M. M. Bakhtin, *The Dialogic Imagination* (Austin: University of Texas Press, 1981), p. 6.
6. Donald Russell, 'The Arts of Prose: the Early Empire', in John Boardman, Jasper Griffin and Oswyn Murray (eds.), *The Oxford History of the Classical World* (Oxford: Oxford University Press, 1986), pp. 653–76, at p. 661.
7. I must commend the unusual insights of Rowland Prothero (Lord Ernie) in his eccentric *The Light Reading of Our Ancestors* (London:

Hutchinson, 1927), p. 20: the *Ass* portrays 'the contrast between the extravagant luxury of the rich ... and the grinding poverty of the hard-working market-gardener ... the licence of the soldiery ... the misery of slaves liable to torture on the slightest of suspicion or to cruel punishment'. It is probably relevant that the author was minister for agriculture during the First World War, had friends in the Labour Party, and spoke with passion in the House of Commons on the state of rural housing.

8. Detailed in Graham Anderson, *Studies in Lucian's Comic Fiction. Mnemosyne*, Supplement 43 (Leiden: E. J. Brill, 1976), p. 34, n. 1.

9. The abridgement has been transmitted under his name and one of the most important early manuscripts of Lucian, the early tenth-century *Vaticanus* 90, concludes the *Ass* with the notice 'Lucian's epitome of the *Metamorphoses* of Lucius'.

10. See John J. Winkler, *Auctor and Actor: A Narratological Reading of Apuleius' Golden Ass* (Berkeley: University of California Press, 1985), p. 255.

11. Anderson, *Lucian's Comic Fiction*, p. 49.

12. Ibid., pp. 42–3; Ben E. Perry, *The Ancient Romances* (Berkeley: University of California Press, 1967), p. 225.

13. See Elizabeth Haight, *Apuleius and His Influence* (London: Harrap, 1927), pp. 10–11.

14. *Ass*, in B. P. Reardon (ed.), *Collected Ancient Greek Novels* (Berkeley: University of California Press, 1989), pp. 589–618, at p. 612. All subsequent page references are to the excellent rendering by J. P. Sullivan in this edition.

15. See Kathy Coleman, 'Fatal Charades: Roman Executions Staged as Mythological Enactments', *Journal of Roman Studies*, vol. LXXX (1990), pp. 44–73. The Lucius-ass likens himself to Pasiphaë's lover (S1).

16. Minos Kokolakis, *Gladiatorial Games and Animal-Baiting in Lucian* (Athens: A. Sideris, 1959), p. 11.

17. Berber Wesseling, 'The Audience of the Ancient Novel', *Groningen Colloquia on the Novel*, vol.1 (1988), pp. 67–79, at pp. 67–9.

18. Tomas Hägg, *The Novel in Antiquity* (Oxford: Basil Blackwell, 1983), p. 95.

19. Susan Alcock, *Graecia Capta: The Landscapes of Roman Greece* (Cambridge: Cambridge University Press, 1993) p. 113.

20. Brigitte Egger, 'Zu den Frauenrollen im griechischen Roman: die Frau als Helderin und Leserin', *Groningen Colloquia on the Novel*, vol.1 (1988), pp. 33–66.

21. Books were not cheap. N. Lewis calculates that a roll of papyrus could cost the equivalent of a labourer's wages for as much as six days' work. *Papyrus in Classical Antiquity* (Oxford: Clarendon Press, 1974), p. 133.

22. Edward Said, *Culture and Imperialism* (London: Chatto, 1993). For a detailed commentary by a historian on the workings of the Roman

empire in Apuleius' novel, much of which applies equally to the *Ass*, see the excellent article by Fergus Millar, 'The World of the *Golden Ass*', *Journal of Roman Studies*, vol. LXXI (1981), pp. 63–75.

23. See further E. Bowie, 'Greeks and their Past in the Second Sophistic', in M. I. Finley (ed.), *Studies in Ancient Society* (London: Routledge and Kegan Paul, 1974) pp. 166–209; Alcock, *Graecia Capta, passim*.

24. Perry, *Ancient Romances*, p. 221, points out that 'Lucius' and 'Gaius' seem to have been chosen for the generic significance: Roman jurists used them together to indicate typical Roman citizens.

25. See Alcock, *Graecia Capta*, pp. 133–7.

26. Sullivan in Reardon, *Collected Ancient Greek Novels*, p. 611, n. 31.

27. Perry, *Ancient Romances*, p. 220.

28. Alvin Gouldner, *Enter Plato: Classical Greece and the Origins of Social Theory* (London: Routledge and Kegan Paul, 1967), pp. 24–7.

29. 'Was Greek Civilisation Based on Slave Labour?', in M. I. Finley (ed.), *Slavery in Classical Antiquity* (Cambridge: W. Heffer, 1960), pp. 53–72, at p. 69.

30. See Peter Rose's excellent Marxist analysis, *Sons of the Gods: Children of Earth: Ideology and Literary Form in Ancient Greece* (Ithaca: Cornell University Press, 1992).

31. Paul Turner (trans.), *Lucian's True History and Lucius or the Ass* (London: John Calder, 1958), p. ix.

32. For the scanty ancient sources on slave markets see Thomas Wiedemann, *Greek and Roman Slavery* (London: Croom Helm, 1981), pp. 106–11.

33. Ibid., pp. 177–8.

34. Ibid., pp. 179–82.

35. Griffin, *Latin Poets*, p. 111, n. 66.

36. See especially the late and much lamented John Winkler's gender-sensitive reading of Longus' *Daphnis and Chloe* in *The Constraints of Desire* (New York: Routledge, 1990), pp. 101–26.

6 UNITY THEATRE

Colin Chambers

Political commitment and cultural commitment share a long history of lively, if stressful, co-existence. In the twentieth century this tradition became overwhelmingly identified with the left. At one historically potent moment, in the 1930s, socialist and popular aspirations overlapped and combined to such a degree that the vigorous but isolated 'red' initiatives of the previous decade were able to grow into genuine mass cultural movements and become a fecund national nursery of hitherto untapped talent.

It was this unique interplay of the political and the cultural that lay behind the extraordinary success of Unity Theatre. Unity activists traced their heritage and inspiration back to the very origins of European drama; while Euripides had attacked the state warmongering of his day, nearer to home the labour movement after the First World War had embraced both an ethical, anti-militarist drama and a more combative theatre associated with the Independent Labour Party, the newly-formed Communist Party and educational institutions such as the Plebs League and the National Council for Labour Colleges.

This struggle-oriented strand became centred on the Workers' Theatre Movement (WTM), founded in 1926 and allied to the *proletcult* German agitprop groups and the Comintern's international theatre organisations. WTM groups around the country performed their revolutionary messages on 'open platform' stages – carts, lorries, steps – on street corners, in parks, at factory gates, often using a megaphone and wearing no costume save a uniform of dungarees (sometimes bearing the hammer and sickle). This 'propertyless theatre for the propertyless class' – its own slogan – was encouraged in its 'class against class' approach by the failure of the labour establishment to defend the General Strike and by the Comintern's sectarian policy up until 1935. The increasing prominence of the fight against fascism and unemployment, however, brought to a head differences within the WTM concerning its reliance on agitprop to the exclusion of other forms and its rejection of a strategy to broaden its appeal.

The focus for new thinking was a group called Rebel Players, which decided to perform both indoors and out, and to become a 'curtain stage' company instead of 'open platform'. Rebel Players practised in terms of theatre what was to become in political terms the Popular Front strategy; its appeal was explicitly political and was designed to unite the left as the driving force of a people's movement. It welcomed sympathetic artists from the professional theatre and made links with other drama organisations, including the main amateur umbrella body, the British Drama League. The core of Rebel Players comprised young Jewish people whose

parents had fled persecution and settled in London's East End but they consciously sought recruits from beyond this milieu; alongside tailors, labourers, bus workers, furniture craftsmen and the unemployed could be found civil servants, clerks, shop workers, hairdressers, skilled technicians and several graduates from Oxford and Cambridge. Whatever their social background and political experience, most joined the Communist Party because it had bright ideals and was a party of action.

Rebel Players embraced a wide range of styles, albeit crudely, within a more narrowly defined notion of what was politically acceptable. The group was criticised for placing content above form by Manchester's Theatre of Action (led by Ewan MacColl and Joan Littlewood and later transformed into the pioneering Theatre Workshop). Repertoire, as always, was the problem and Rebel Players borrowed heavily from its WTM days: outlandish skits, pugnacious agitprop, mass declamations. To this diet was added short realist plays and early attempts at Living Newspaper drama documentary borrowed from the US.

The play that synthesised the new impulses of Rebel Players and became the earliest symbol of the group's energetic new fusion of politics and art was *Waiting for Lefty* by the American Clifford Odets. The success of this play about a taxi strike galvanised Rebel Players into seeking a permanent base. The intention was to overcome the lack of stability and continuity that had prevented the group from expanding but it also involved a big gamble: would such a small group be able to sustain the artistic and organisational effort that a permanent theatre would require? They took the risk and in February 1936 a new theatre with the Popular Front name of Unity was opened in King's Cross, in a derelict hall that had been refurbished by members and friends. The aim was for Unity to be a social and cultural centre for music, dance, film, poetry and exhibitions as well as drama. Unity also hoped to revitalise a national left-wing theatre movement to replace the WTM. The organised left did little at the start to assist Unity's survival. The theatre's opening was low-key and not even reported in the *Daily Worker*. The Communist Party took culture seriously but gave greater priority to winning the high ground of art than to organising workers' self-activity.

At the end of a year of such self-activity, of hardship and debt, Unity had at last established itself within the left-wing movement and it moved to new premises in a disused Methodist chapel behind St Pancras in Goldington Street. This time the opening, in November 1937, was a gala occasion, covered by several papers including the *Daily Worker*, and graced by the presence of Paul Robeson, who changed the words of 'Ol' Man River' from 'tired of livin' and scared of dyin'' to 'must keep strugglin' until Ah'm dyin''. Sean O'Casey sent a message that said: 'I hope the Unity Theatre Club will smash the myth that culture and the enjoyment of art are confined to what is sometimes called the better classes.'

Converting the chapel into a well-equipped theatre required a heroic effort. It was a labour of self-creation that symbolised the spirit of Unity

and conferred upon the project an almost religious significance. Some 400 volunteers participated, with the co-operation of several craft unions: plumbers, upholsterers, architects, sign-writers, carpenters, bricklayers, painters, plasterers, metal workers, engineers, electricians and even a barber who gave free haircuts to anyone on the site. They were fed and watered by another bevy of helpers, all women. (One of them commented 50 years later: 'We didn't think twice about the implications, only about being useful.') Materials were begged or borrowed as well as bought; the whole job cost only £800 instead of the estimated £4,000 and took just two months instead of the expected six. Support for this expansion stretched beyond the labour movement and was backed by the likes of the American playwright Elmer Rice, H. G. Wells, who became Unity's first life member, and Bernard Shaw, who resisted donating to official appeals but gave money to buy reconditioned dimmers for the new theatre.

Unity's enormous appeal was highly political in both popular participation and its popular dramatic content, and both reinforced self-identity for the individual and the movement. Unity became a second home for many people, a place where they could escape the alien world and feel alive and useful among comrades. The social and intellectual life was considerable. There were dances, rambles, bazaars, weekend and summer schools and trips to the theatre. There were study classes on culture and politics and a Unity drama school that taught Stanislavsky's ensemble principles and attracted many distinguished lecturers, including Sybil Thorndike and Michel Saint-Denis. There were internal bulletins and a members' newsletter that developed into a magazine with interviews, reviews and articles on current trends in the arts and boasted a pre-war circulation of 4,000. A feeling of sharing, belonging and common ownership gave Unity its distinctive character. Everyone could muck in, sweeping the stage, cleaning or mending the toilets, sewing the costumes, painting the scenery. Alfie Bass, who learnt his skill at Unity before becoming nationally famous as an actor, used to bring the coal up from the cellar for the boilers when he first joined. 'It was a way of life. Everyone was devoted, especially to keeping the theatre open,' he said:

> We saw it as the first workers' theatre and people had sacrificed so much to get it going that the philosophy of 'the show must go on' was very strong. It was our duty to our audience. My pride was to be appearing for the cause. I'd do any part. I can't imagine anything more inspiring than creating a play or revue with a real purpose. Everyone participated, in the decor, the music, the acting. It was a rare thing. It was special because it was collective. No one dominated except the play and its purpose.

This spirit was much in evidence as Unity spread its popular base further through the founding of a new national drama movement of the left. Helped by Victor Gollancz, who had launched the Left Book Club with great success, Unity established the awkwardly named Left Book Club

Theatre Guild (LBCTG) and helped fledgling groups around the country to get hold of plays and to organise their audiences. Regional movements sprang up in South Wales, Yorkshire and Lancashire and a national committee met in Glasgow in 1938. London Unity's repertoire was popular but many groups added their own plays, such as *Cold Coal* in South Wales, *UAB-Scotland* in Glasgow, *Clogs* in Sheffield or *The Bull Sees Red* in Bristol. Membership figures are not that reliable – LBCTG claimed 70 groups in the summer of 1937, 140 by October, twentieth8 by early 1938 and 308 by September – but whatever the exact numbers, it is clear from reports of activity in the *Daily Worker* and the LBCTG newspaper that it did offer a surprising number of people the chance to express themselves politically through theatre. It provided a sense of common purpose and identity and of belonging to a larger movement for the greater good that affected an extraordinary diversity of cultural activities at the time.

A touchstone for such activities was defence of Republican Spain. Unity performed indoor and mobile shows, and also in the West End, to raise consciousness, money and goods for the Aid Spain movement. The repertoire included a Spanish play, *The Secret* by Ramón Sender, two mass declamations – *Spain* by Randall Swingler and Jack Lindsay's *On Guard for Spain* (which was performed on the plinth of Trafalgar Square at a huge rally and was also distributed as a record to accompany the film *The Spanish Dance*) – and Brecht's *Señora Carrar's Rifles* (the first Brecht play to be staged in Britain). Three well-known Unity members died fighting in Spain; two of them had founded a Unity group there and had performed stirring speeches from *Lefty* a few miles from the front, within earshot of the pounding guns. Several Unity members joined the Dependents' Aid Committee scheme to help families of returning International Brigaders and one member adopted two refugee Basque children. The close identification between Unity and Republican resistance, which continued throughout the Franco period, not only showed how Unity's functioning as an organisation was an expression of its political-cultural commitment but also showed how that functioning was an integral part of the wider movement.

The Unity banner could be seen at all the major demonstrations, often linked to a performance, as, for example, at a May Day rally in Hyde Park when 250,000 people feted the hunger-marchers. Unity's mobile shows were booked by many left-led groups within the labour and co-operative movement as well as by organisations of the political left, all of which were encouraged to affiliate to Unity and enjoy the benefits of an advance block-booking system that offered reduced-price tickets. It was this system that secured Unity's financial future by providing income in advance and cementing the relationship with its audience. Unity received no state subsidy or direct assistance from the labour movement, whose leadership was rarely in sympathy.

Oppositional ideas were still at the root of Unity's work. This was to be 'our' theatre with 'our' plays or as a leaflet of the time puts it:

Unity is a workers' theatre, built by the workers, for the workers to serve as a means of dramatising their life and struggles, and as an aid in making them conscious of their strength and of the need for united action. The aim of Unity Theatre is a simple one. It is to help in the terribly urgent struggle for world peace and a better social and economic order and against fascism, by establishing a drama which deals with realities and reflects contemporary life, instead of plays which merely provide a dream world of escape and at best depict false ideas of life.

Artistic experiments within the bourgeois theatre remained just that and did not touch on the lives of the majority. As one Unity director said of the attitude he found to Auden's leftish writing:

They do not attack ... his irritating neuroses, his lack of anything positive or forthright, judging that if that's the way he feels about things, that's the way he should write. The feeling is simply that he is speaking another language, writing for another class. He is the author of the dissatisfied bourgeoisie. His perceptive pen clarifies their bewilderment and prejudices; and those sentiments have little interest for the positive spirit of the militant working classes.

Yet there was nothing wrong in appropriating for 'our' use the tools that the bourgeoisie had perfected.

The repertoire that emerged at Unity built on the Rebel Players' heritage. *Lefty* was the centrepiece and Unity played it over 300 times before the war to more than 40,000 people. Its direct appeal to action, and its crossing of the stage barrier by having actors placed in the audience, made *Lefty* a powerful recruiter of new members, many of whom would be initiated into Unity by appearing in the play, as if doing the equivalent of national service. Theatre professionals disillusioned or frustrated by the narrowness of commercial theatre and the collapse of experimental outlets long before the era of state subsidy were also attracted by its vigour.

Nevertheless, despite the talk of revolution, Unity stuck with the traditional proscenium arch rather than pursuing other configurations, such as open stage or in the round, mainly because the emphasis was to be placed on content and a style of presentation that would establish an identity between audience and stage every bit as solid as that to be found in a bourgeois auditorium. This approach suited both the Marxism of Unity's communist teachers and the participatory nature of Unity. It was unlike, for example, the situation in Manchester where the Theatre of Action went in a different direction of more formal inquiry allied to new content, presented by an equally dedicated but elite band of players. Unity did experiment, however, and mounted some stylistically complex shows, such as a Living Newspaper based on the 1937 bus strike, which was collectively created with the help of some of those

who had taken part in the strike. Among the writers were Montague Slater, librettist of *Peter Grimes*, and a former taxi driver, Herbert Hodge, Unity's first homegrown working-class author. *Busmen* mixed naturalistic dialogue with verse and documentary detail with dance; a multi-level set providing separate acting areas that were lit in turn created a cinematic effect, cutting from one scene to the next, occasionally in the manner of expressionism, which also influenced the powerful staging of Irwin Shaw's anti-warmongering play *Bury the Dead*.

The success of Unity attracted closer attention from the Communist Party, which became more actively involved in choosing the theatre's leadership after Unity's expansion and move to Goldington Street. Politics had always been in the driving seat but now it came with authority from above and a new stringency associated with its source. Discipline was tightened and what was regarded as an amorphous intake of individuals had to be welded into a coherent whole. The Popular Front approach had nothing to do with indulging dilettantes and every facet of Unity's activities had to be subjected to a Marxist analysis. The play committee tested contenders for correctness. The saviour Odets had already fallen foul with *Till the Day I Die*; the play was in rehearsal when the production was cancelled because the portrayal of a German communist in the hands of Nazi interrogators was deemed too inward-looking. The communist commits suicide and this was not considered the right image to be presenting. Odets's *Awake and Sing*, set among a Jewish tenement family in the Bronx, was felt to be too sentimental. Both plays were later staged by Unity in the 1940s. Even O'Casey was offered advice before *The Star Turns Red* was accepted. The chutzpah was astonishing, and those on the receiving end did not always find it enlightening. There is no knowing how many potential writers it turned off, though the help was intended to be positive within the perspective of those offering it. The head of the play clinic says:

> We had to go beyond agitprop, but there was still a tendency not just to be against West End commercial theatre but against all 'bourgeois' theatre. We were for a working-class drama which did not then exist. Unity wanted plays that portrayed working-class life but they still had to have the right 'message'.

Optimism and a positive self-image were the rule. There was no disagreement over the role of politics, only over the nature of the politics and, necessarily, over the means of its expression.

Unanimity of purpose did not prevent continuous argument, which often erupted into serious discord. Distinctions between those who created and those who administered or supported became sharper, especially as Unity grew. (Casts remained anonymous in the programmes until 1943, although the director had been named as early as 1938.) Unity was prone to the personal rivalries and clashing egos common to many social activities and particularly prevalent in both politics and theatre. There was, however, general agreement on the fundamentals.

Unity came of age in 1938 with a remarkable run of productions that included the appearance of Paul Robeson in *Plant in the Sun* by Ben Bengal. Robeson, voted Britain's most popular radio singer in 1937, joined Unity's general council that year – a figurehead body that included theatre luminaries like Sean O'Casey, Tyrone Guthrie and Michel Saint-Denis as well as leading figures on the left like Victor Gollancz, D. N. Pritt, Harold Laski and Stafford Cripps, a future Chancellor of the Exchequer. The following year Robeson turned down a starring West End role to play, like everyone else at Unity without pay or programme credit, the part of a New York sweet-factory worker who is sacked for 'talking union'. In the two weeks following the opening, 400 new members joined Unity and the production, without Robeson, went on to win the British Drama League's area and national trophies. Robeson stayed close to Unity throughout his life and the theatre played an important part in the British side of the seven-year international campaign to win restoration of his passport after its withdrawal by the US authorities in 1950.

Robeson brought more than new members to Unity; he attracted the attention of the press, politicians (including Nehru) and West End theatregoers. The first night of *Plant in the Sun* was attended by Unity's inspiration from America, the Group Theater, who were in London to present Odets's *Golden Boy*, and Odets spoke from the stage. *New Statesman* editor Kingsley Martin thought Unity might be 'the germ of something as important in our national life as the Old Vic', and Sybil Thorndike believed Unity was the 'greatest hope for the stage in this country'.

Such verdicts were echoed as Unity responded explosively to the most pressing political events of the year that culminated in the Munich crisis. Three days before Chamberlain's visit Unity decided to mount a Living Newspaper on the danger to Czechoslovakia and imminent European war. Volunteer writers and actors improvised their way through 48 hours of experiment, and, on the day the Prime Minister flew to see Hitler, *Crisis* opened with a rough and urgent energy. It was played throughout October and November, being reshaped and rewritten as news came through of the latest developments. (One night many in the audience first heard from the stage that the First Lord of the Admiralty had resigned over Chamberlain's actions.) Attempts to perform *Crisis* elsewhere, outside of Unity's club conditions, were quashed by the censor, but if the establishment thought that would keep Unity quiet they were proved staggeringly wrong. That November, another Munich show, *Babes in the Wood*, won international renown. Unity's first pantomime turned expectations upside down by brilliantly translating into traditional pantomime conventions the unfolding process of appeasement: the babes stood for Austria and Czechoslovakia; the wicked uncle was Chamberlain; his two robber accomplices were Hitler and Mussolini; and Robin Hood the rescuer was the Popular Front against fascism, uniting with Marion as the people. Rough diamond humanity was represented by the rumbustious Dame Nanny Nicknack, the fascist-leaning aristocracy by the slithery Cliveden Set, and the moribund monarchy by King Eustace the Useless and Queen Quarantine. Add a

chorus of stormtroopers and a sprightly spreader of illusions, Fairy Wish-fulfilment – a delightful invention of the show's author, Robert Mitchell – and the stage was set for an enormous success, the like of which Unity had never seen or ever saw again.

Babes in the Wood ran for a record number of 160 performances, playing six nights a week to just under 48,000 people. Two of its songs, written by Geoffrey Parsons and Berkeley Fase, were recorded by Decca, and it was reviewed or reported in more than 70 publications abroad. A photograph of one of the actors playing the uncle appeared as *Life* mag-azine's picture of the week; before the end of stage censorship or the advent of television satire, it was one thing to lampoon foreign dictators or figures from the past, but it was quite another to impersonate a living Prime Minister. Chamberlain was reportedly furious that his caricature was being reprinted around the world and sought ways of stopping Unity, either by heavy fines or closing the theatre down, but was advised that this would be acting beyond the law.

Critics were mixed. *Picture Post* ran a special feature while Lord Beaverbrook (a prominent Fairy Wishfulfilment) was rumoured to have banned any mention of the show. Audiences continued to come and affilia-tions to Unity more than doubled from 130 organisations and 3,500 individual members to 289 organisations and nearly 8,000 individuals. Coaches from the Co-op guilds jostled for parking space next to Daimlers and Rolls-Royces.

While much of the show was rough, it was carried by Unity's character-istic energy, its wit and topicality and the sheer joy of an entertainment that has an urgent and sharp political point. The absurd but popular con-ventions of pantomime were turned to good use. There was audience participation in the singing and exchanges with different figures: cheers for Robin, boos for the robbers. Freshness was sustained by constant rewrites and improvisations. If a Left Book Club group or a trade union branch were in the audience, they would be greeted from the stage. An important speech that day in the Commons would be referred to in new dialogue. And the hilarious mimicry of Chamberlain always brought the house down. Such political satire could not be found anywhere else. For those in the left-wing movement it was a vindication of the Popular Front strategy at a time when politically the strategy was in deep trouble, and it was a vital public celebration of belonging to that movement.

The success of such an ambitious collective undertaking, involving more than 100 people, 70 of whom formed two casts to allow an unbroken run, was an extraordinary achievement for an amateur theatre, let alone a left-wing one. Coming on the heels of the Group Theater's insistence that Unity had a duty to become as well known by as many people as possible, it led directly to a reversal of opinion on the controversial issue of estab-lishing a professional company, something which would signify a sharp break with the past. The amateur nature of Unity's activity had been axiomatic and a source of deep pride. Others had, and continued to hold, practical objections to turning professional, but confidence was in the air

and it was infectious. The rise of Unity seemed to be as unstoppable as it was astonishing but the outbreak of war cut short all plans for expansion and Unity's high point could not be sustained.

It was by no means a sudden or an even decline. Unity adjusted remarkably well to wartime conditions and demonstrated the depth of support it had won. Much of its attention was focused on gaining new support and it transformed its mobile work into factory and shelter entertainment. Having survived divisions over the Nazi–Soviet pact and found renewed energy in the political isolation of the 'phoney war' period, Unity changed its perspective politically and artistically from a workers' theatre to a people's theatre. It broadened its repertoire to include classics, music hall and 'kitchen sink' drama and became a sound training ground for a professional theatre career. It rebuilt a national left-wing theatre movement, which at its peak in 1947 claimed an individual membership of 10,000, more than 3 million affiliates through various organisations, 50 theatre branches and a magazine *New Theatre*, a forerunner of *Encore*, with a circulation of 15,000. Unity contributed notably to the mood that saw a landslide Labour victory in 1945 and also to the introduction of state subsidy for the arts.

In the atmosphere of the intensifying cold war, Unity's role in the labour and co-operative movement came under increasing strain; fewer and fewer unions were block-booking or hiring the mobile shows, and those that did book often exerted a negative pressure on the management to reproduce past hits rather than innovate. Shaped by the Marxism of the Communist Party, Unity had offered a positive and cohesive self-image to a movement that for a time did have an accurate sense of its own strength and of the reality it was trying to transform. Unity presented stories, habits and speech not normally seen or heard on stage, except as figures of fun. Understandably, its perspective was more optimistic than self-critical. It displayed images that were emblematic of the strengths of its class but was unable to adjust the images as those strengths were questioned and altered. By the time a fire closed the theatre for good in 1975, many of the dramatic forms that Unity had pioneered had been absorbed into the mainstream and a new alternative theatre movement had emerged that was attracting young people with a politics defined as much by gender, ethnicity and community as by class.

Unity was of its time and place; yet, whatever ambitions its founders may have held, none could have foreseen the remarkable dimensions of its 40-year achievement. Survival for that length of time deserves credit enough, but Unity's non-professional activists had no notion of the profound if frequently unrecognised effect they would have on British culture and its theatre.

Unsurprisingly, little of the dramatic work has endured. The most successful shows, such as *Babes in the Wood*, enjoyed a life that was limited by the very topicality that made them so popular. As in traditional panto, the jokes, the dialogue, the music, the style soon became dated. Literature it was not. Nevertheless, figures who have been accepted into the pantheon

of literary merit – Adamov, Brecht, Gorky, O'Casey, Sartre – had premieres of their work staged alongside an impressive number of more modest indigenous pieces. In its liveliness, Unity embraced a rich diversity of sometimes contending styles, and its use of vernacular, its Living News-papers and documentary-based theatre, and its political satire occupy an honourable place in the development of modern native drama.

Unity saw its main function as encouraging expression by and for its own class, which was denied full access to political and cultural power. Its purpose was not to reproduce what could be found in the West End but to provide a completely 'other' kind of experience both for those making the drama as well as for those watching it. Technical excellence was an aim but not in itself. As an immensely fruitful seedbed, it provided training to scores of people who went on to work importantly and sometimes prom-inently in theatre and other cultural fields. Some became well known – for example, Maxine Audley, Lionel Bart, Alfie Bass, Michael Gambon, Bob Hoskins, David Kossoff, Warren Mitchell, Bill Owen, Ted Willis – but for Unity its greater value lay in being an 'open university', offering self-respect and the chance to 'do something' for the cause of socialism and progress.

Clearly, Unity was more than a theatre; it was a way of life. It was fired by an ethos rooted in a notion of collective endeavour that was oppositional but reached beyond resistance. At its best, Unity was vital, direct and popular, and it remains an outstanding twentieth-century landmark in the long and challenging partnership of politics and culture.

7 COMMUNITIES: BRITISH THEATRE IN THE 1980s

Peter Holland

Theatre depends on communities; it cannot exist without them. Drama, paradoxically, does not. At the least, theatre cannot exist without the community of presence, the shared uniqueness of the particular theatre performance, a community of experience of the event shared between performers and audience. That presence, the reality of the theatre, holds the event in common. But drama is not contained within theatre. The presence of drama is often mediated, distanced or alienated, rendered separate from its audience. In that distance there is a notion of the diffusion of community, a contradiction of the forms of immediate connection with the community of the audience that theatre celebrates. Yet the presence of drama in the community, that is within the experience of the people without reference to the specific places of theatre, is such as to make it a form of representation of community.

The division between drama and theatre is nowhere more manifest than in the new structures of consumption of drama. In 1974, in his inaugural lecture in Cambridge as Professor of Drama, Raymond Williams tried to describe something of the status of drama in what he dubbed 'a dramatized society'. With the availability of film, radio and television, drama 'is built into the rhythms of everyday life':

> On television alone it is normal for viewers ... to see anything up to three hours of drama ... a day. And not just one day; almost every day ... In earlier periods drama was important at a festival, in a season, or as a conscious journey to a theatre; from honouring Dionysus or Christ to taking in a show. What we have now is drama as a habitual experience: more in a week, in many cases, than most human beings would previously have seen in a lifetime. [1]

There has been little in the theatre in the 1980s to match works like Alan Bleasdale's *The Boys from the Blackstuff* or Dennis Potter's *The Singing Detective*, both in ambition and accomplishment. Bleasdale's achievement lay, not least, in his acceptance that the representation of the devastation of high levels of unemployment on the individuals and communities of Liverpool necessitated an unashamed emotional power. The result must be the only time that a line from a serious and weighty play has been taken up as a chant by a football club's supporters, as the Kop at Liverpool could be heard, week after week, chanting the desperate repeated demand of Yosser

Hughes in the series: 'Gissa job. I can do that.' Williams's sense of the new ubiquity of drama could have no better example than the presence of the language of such a drama on the football terraces.

But my focus here is on theatre, on the particular circumstances in which the nature of the activity of going to the theatre focuses a definition of the community of the audience, the circumstances in which it is possible to recognise the nature of the link and interaction between performers and audience. For, if television speaks of a community, it sees it as a large political, social and national unity; when it speaks of communities it recognises fragmentation. In spite of the concerns with regionalism in the ITV franchises, BBC1 and ITV are essentially national channels with what are quaintly called 'regional variations'. They speak of a culture perceived as homogeneous, a community co-extensive with nation. Channel 4 was founded with a sense that it would serve communities, not the community, groups defined as local, regional or ethnic or groups defined as communities of interest, people grouped according to their hobbies, their tastes, their culture. Channel 4's perception of the fragmentation of national community is something the theatre has long anxiously realised.

The Baldry report of 'The Community Arts Working Party' for the Arts Council of Great Britain (ACGB) in 1974 led to the establishment within ACGB of a department of community arts, lasting for a brief period before its concerns were devolved in 1979 to the Regional Arts Associations, a denial of a centralised, national significance to the concerns of communities in favour of a regionalism. Community, in this sense, means only a geographical location. [2] But the conventional use of the word in arts funding underrates the sheer complexity and tendentiousness of the term 'community' itself. As Williams recognised, there are oddities in the usages of the word 'community': 'it never seems to be used unfavourably, and never to be given any positive opposing or distinguishing term.' [3] In a lecture in 1977, he worried why it should be that

> People never, from any political position, want to say that they are against the community. You can have very sophisticated individualist arguments about the proper sphere of society, but the *community*, by contrast, is always right. [4]

Community functions, in our social usage, as a definition of a group that is mutually supportive, comforting and comfortable. Williams stresses its use as a 'warmly persuasive word'. [5] In times of stress the community will rally round; in times of joy the community will celebrate. Even in those cases where community is not geographical (in, for example, such usages as the Jewish community, the gay community, the black community) it carries notions of neighbourliness, the extended family, the group that deserves respect and friendship. Community is, as one recent critic has suggested, 'a friendly word'. [6]

But it is also a word that defines the group and limits it, defines exclusion as well as inclusion. Even more importantly, the word suggests

the complex of ideology that constitutes culture. As Anthony Cohen comments in his useful book, *The Symbolic Construction of Community*: 'Community, therefore, is where one learns and continues to practise to "be social". At the risk of substituting one indefinable category for another, we could say it is where one acquires "culture".'[7]

The perception of community is then a social extension of individualism, rather than an opposition to the individual. It is a definition of a group opposed to 'the more formal, more abstract and more instrumental relationships of *state*, or of *society*'.[8] It is a form of self-definition, of group allegiance, or of external expectation of that allegiance. Not all Jews are members of 'the Jewish community' and so on. But it is defined by those who are themselves defined as members. As Cohen sums up:

> whether or not its structural boundaries remain intact, the reality of community lies in its members' perception of the vitality of its culture. People construct community symbolically, making it a resource and repository of meaning, and a referent of their identity.[9]

In the fragmented culture of the 1980s, in a society which the government believed no longer existed, in the move from Thatcherite individualism to Major's classless state, the cultural forms of community are acutely visible in the interplay of drama and audience in the theatre. For while the Arts Council's major policy document of the 1980s, *The Glory of the Garden* (1984), attempted to regionalise in the terms of a centralised bureaucracy by creating 'centres of national excellence', the rapid development through the decade of particular kinds of theatre groups marked a new approach to community. Sir Kenneth Cork's report for the Arts Council may have proclaimed in its title 'Theatre is for All' (1986) but few of its recommendations were implemented in funding decisions.

While the state dismantled the large organisations of local government like the metropolitan authorities and the Greater London Council, theatre groups with clearly defined relationships to specific communities, of performers as often as of audiences, were springing up all over the place: theatre for the disabled (Graeae), theatre for the Greek community (Theatro Technis), Asian theatre (Tara Arts), black theatre (Temba). It was not that these companies had not existed earlier – many go back to the earliest stages of the development of fringe theatre in the late 1960s – but rather that they had an accepted importance, a new visibility in the decade. It is a process that might be typified in the attempt (and failure) to turn the Roundhouse in London, once the proposed site of Centre 42, a specific development of trade union-funded working-class theatre, into a centre for Caribbean arts, an explicit shift from class to a racially defined community.

My choice (reasonably arbitrary) of plays, inadequately representative as they are, is designed to do no more than suggest some forms of that change, the interaction of play and audience as a site of definition of community. In *The Bone Won't Break*, his outstanding consideration of the

culture of the theatre of the 1980s, John McGrath described some of the functions of alternative theatre:

> it can contribute to a definition, a revaluation of the cultural identity of a people or a section of society ... it can assert, draw attention to, give voice to threatened communities ... it can mount an attack on the standardisation of culture and consciousness which is a function of late industrial/early technological 'consumerist' societies ... it can make a challenge to the values imposed on it from a dominant group – it can help to stop ruling class, or ruling race, male, or multi-national capitalist values being 'universalised' as common sense, or self-evident truth. [10]

It can do all these things but it can also document the failure of the attempt. In the 1980s the strength and warm, cosy glow of the word 'community' was often underlined by a bitter perception of its loss.

In the 1950s, with *The Sport of My Mad Mother* (1958) and *The Knack* (1961), Ann Jellicoe established her reputation as the female angry young man of the first generation of Royal Court dramatists. In 1978, settled now in Dorset, she suggested to the headmaster of the comprehensive school in Lyme Regis that she write a community play for the school. What began as little more than a school play grew until she ended up with a work called *The Reckoning* for a cast of well over 100 and involving hundreds more local people. The play depended for its production on the talents and co-operation of remarkably diverse groups way beyond the school, in that strange entity 'the community at large', embracing the Mayor and Corporation, the Yacht Club and the local amateur dramatic society. Committees to raise funds, groups to sew costumes, people to produce publicity, all were energised by her enthusiasm. The result was the first of a series of 'community plays' in the South-west run under the aegis of the Colway Theatre Trust, an organisation which Jellicoe created and from which she resigned in 1985 after vicious funding cuts from the Regional Arts Association. [11]

Community plays depend on the networking of the community within which they are performed. When one of the professional actors involved in the project, Baz Kershaw, suggested that *The Reckoning* needed an interval, this was nothing to do with the length of the play but 'because that means coffee so you'll involve more people'. [12] At times almost a statistical game, community plays represent something of their success by the sheer number of people involved. The worth of the play can be submerged beneath the tide of people, the inventive strategies of involvement. Following *The Reckoning* and its successors, community plays have become a major mode of play-writing and performance.

The Reckoning was a play written for, with and by the help of the whole of the community, produced by them and watched by them. Local drama, a term often used for patronising abuse, became a term of pride. It matters that the community comes together in the project, that Lyme Regis

buzzed with it. This notion of a fine professional playwright writing local drama is, I think, a major innovation, whatever the strength of the traditions of local amateur drama in Britain. That Jellicoe inveigled dramatists like Howard Barker and David Edgar into subsequent projects shows both her persuasive powers and the potential of the project.

Not the least important part of the opening work was the subject matter of *The Reckoning*, for the play was not only *for* Lyme Regis but also *about* Lyme Regis, about the landing of the Duke of Monmouth in Lyme Bay in 1686, about the Protestant fears at a Catholic threat, about the fate of the local people who joined the Monmouth rebellion and experienced its savage suppression. The promenade production, later established as the conventional style of Jellicoe's community plays, also encouraged actors to watch the scenes, standing among the rest of the audience, mixing performers and spectators. As Jellicoe describes it, this interweaving generates a remarkable cohesiveness:

> So there we were, people of Lyme today watching and identifying with people of Lyme three hundred years ago ... It is an overwhelming experience, a mixture of us and them and then and now, of pride for what they did and in what we are achieving, of celebration. [13]

This celebratory carnival quality is a key to the work of community plays. [14] As Howard Barker commented after his experience of writing *The Poor Man's Friend* for Bridport:

> The demand for celebration here was such that my natural instincts as a writer went into abeyance – the qualities of cruelty, the extreme power of language, the taking of human relations to the edge of experience – were all inhibited ... Community plays lend tremendous resources to theatre, they can become powerfully ritualistic and mythical ... there is an overpowering emotional state generated which is irresistible, and which I approved of. [15]

The emotional power, the breadth of engagement, the carnivalesque celebration are all features that produce a myth of community in such works. As Graham Woodruff notes:

> Ann Jellicoe appears to think that this formulation of community plays avoids politics. Of course, it does nothing of the kind. It reinforces an idealized notion of community as an unchanging unity. It challenges none of the inequalities which exist in a West Dorset town which by her own admission is 'very right-wing, even feudal'. [16]

David Edgar's *Entertaining Strangers* was first performed in Dorchester in 1985. When Edgar revised the play for production at the National Theatre in 1987, it was precisely the carnivalesque that he intensified, adding as a recurrent framing motif extracts from a mumming play, a tradition of rural

mythic performance. In many ways the later National Theatre version of *Entertaining Strangers* is a finer play, tighter, more professional, but it is less intriguing than the earlier version written for a cast of over 180. [17]

Edgar's theatre work has always negotiated on a colossal scale: *Destiny* (1976) charted the underworld of far-right politics in post-war England; *Maydays* (1983) looked at the left throughout Europe. His best-known work, the adaptation of *Nicholas Nickleby* for the RSC in 1980, worked with a large cast of actors, and an even larger cast of characters, in an attempt to put on stage as much of the novel as possible, lasting over seven hours across two evenings.

The scope of *Entertaining Strangers* is equally vast. Its central confrontation is the development of the local brewing industry as exemplified in the career of Sarah Eldridge and the work of the local vicar, Reverend Henry Moule, in the deprived area of Fordington. The play begins in the 1830s and then moves to the 1850s. *Entertaining Strangers* is, in Edgar's view, 'about the attempt to impose two eminently Victorian values on an English country town in the process of transformation from an essentially rural to an urban society'; his aim was to present the confrontation of 'the values of entrepreneurial zeal with those of religious fundamentalism'.[18]

The play's climactic scenes chart the terrifying outbreak of cholera in Dorchester in 1854, brought by convicts moved to the town against the local council's complaints and warnings and spread to the community through the dirty washing laundered by the women of Fordington. In a brutally ironic sequence, one of the first victims is a girl who, following Moule's advice, has given up being a prostitute (with three children by age 17) and has started to take in washing. It is highly significant that the play was performed in a church founded by Moule himself, blurring time-scales in the manner of Jellicoe's *The Reckoning* and intensifying the drama.

Edgar's research team identified dozens of the people who lived in Dorchester in the 1850s. Every single person named in the play has a historically accurate name and status. But the scale of production means that *Entertaining Strangers* can avoid the tradition of exemplary sampling that underpins traditional naturalistic methods. Instead of one character standing for a class, there are 20 to represent the local gentry, 10 for the professionals, 25 tradespeople, 30 for Moule's congregation, 40 agricultural labourers and so on, each one fleshed out from the few spoken lines in the play-text by the physical and recurrent presence of the performer.

Sarah Eldridge, the brewer of vision, rises from a woman running a pub brewing its own beer to being a supplier, buying up pub freeholds and creating the system of tied houses (still the basis of British brewing), controlling manufacture and distribution. Edgar found the perfect image of her rise in the humble Post Office Directory, in this announcement by the local postmaster:

FRANCIS LOCK: Well, in fact, Mrs Eldridge, it has been decided that on account of your long service both as a commercial person of some innovatory accomplishments, and as a figure of some sub-

stance in the town, you are more appropriately placed in the Court and Gentry section or department of the Post Office Directory. Between, if this matter is of interest, the Reverend Devenish of Chartminster and Miss Eliza Feaver of Back South Street, Independent Lady.
Sarah can't speak. (p. 57)

Entertaining Strangers is a play for a community but it is also a play centrally about community, not simply those who make up the community and who are strangers but how people understand or learn what it means to be a member of a community. In the mad world generated by the onset of cholera, Moule leads his family, pupils and servants out to wash infected clothes, refusing the gentry offer of safe haven away from pestilence. Cholera, one of the play's strangers, has to be washed out of Fordington till the rains come and eliminate it. In a brilliant scene of multiple focus, one of the distinctive features of the play, [19] Moule, stumbling around at night while children sing songs and the litany of the names of the cholera dead is read out, sees a vision of women washing clothes, who turn out to be not as he thinks three angels but Sarah's children, his enemies in his fight against alcohol, now unexpectedly defining for him the Holy City, the New Jerusalem of Revelation. As Moule and Mrs Eldridge discover, there is an emphatic force in the passage from the Bible that gives the play its title, 'Be not forgetful to entertain strangers, for thereby some have entertained angels unawares' (Hebrews, 13:2). The play ends with a chant from the whole colossal cast, all the company of the play world and hence of present-day Dorchester, a definition of the participation that is community:

It's not your Jerusalem
It's not my Jerusalem
It is our Jerusalem
It is our Jerusalem (p. 64)

Entertaining Strangers may fight shy of some of the problems of low wages and deprivation which it touches on, the dissolution of community under capitalism, but in its power of performance and in the especial power of place the ending generates a sentimentality that cannot be dismissed. The play speaks to its audience by speaking of its audience and with its audience, connecting in a way that in itself defines a concept of community.

The binding of play to audience in the context of a community was a specific aim and expected achievement of the work of the Colway Theatre Trust and hence of the genre of 'community plays' in general. But there are other times when the binding of play to audience is unexpected, unpredictable and even subversive of the assumed function of the play, the intentions of playwright, director and cast. Caryl Churchill's play *Serious Money* was written for and first performed at the Royal Court in 1987. In the years since Ann Jellicoe was part of the first generation of Royal Court

dramatists in 1956 and after, the English Stage Company has continued to be at the centre of new English drama. Often outflanked by the radical experimentalism of the late 1960s and touring companies of the 1970s, the Royal Court was still performing and continues to perform, in the less headily radical forms of the 1980s and 1990s, its crucial function of finding, encouraging and staging the work of new dramatists, even if other companies have come to supplement, if not at times supplant, its role.

Serious Money continued a concern with the languages of business demonstrated in earlier plays, particularly *Top Girls* (1982). Theatre in recent years has seemed to recognise only two languages in which its dialogue can be constructed: the first is the language of articulate intellectuals, the class to which playwrights have, with some embarrassment, to admit to belonging, the language of the educated middle classes; the second is the language of the inarticulate, that is, the language assumed by intellectuals of the first group to be spoken by the working class. What Churchill perceived is the extraordinary nature of the classless language, the language of code and secret, the jargon of the Stock Exchange, a language of real power.

Serious Money calls itself 'a City Comedy', echoing the forms of Middleton and Jonson, though its opening scene is a long quotation from a play by Thomas Shadwell, *The Volunteers or the Stockjobbers* (1692), a Restoration drama of the mercantile working world of the new bourgeois culture. But *Serious Money*, written in a wonderfully rhythmic verse form, a language of dramatic excitement that is dead on the page and exuberantly alive in performance, is perhaps less a City comedy than a yuppie comedy, a cynical celebration of the gusto and self-seeking of the new breed of City people, the odd mixture of East End wideboys and public-school 'hooray Henrys' that moved into the bastions of financial power in the years surrounding the City's 'Big Bang'. At the end the cast – and, like *Entertaining Strangers*, *Serious Money* is a large-cast play with an effective chorus – sing in ecstatic celebration of their community, a community not of selfless concern like that of Moule's family and Sarah's children in Edgar's play but of the community of total selfishness, the delights of the freedom to be greedy enshrined in Thatcherite economics, their chorus anticipating her third term in office, 'Five More Glorious Years':

> These are the best years of our lives, with information from inside
> My new Ferrari has arrived, these pleasures stay unqualified ...
> Five more glorious years, five more glorious years
> we're saved from the valley of tears for five more glorious years
> pissed and promiscuous, the money's ridiculous
> send her victorious for five fucking morious
> five more glorious years [20]

as the backing group sing a chant going 'Fiddle diddle iddle fiddle diddle'.

The plot of *Serious Money* is ostensibly a search by Scilla for the murderer of her brother Jake. The play moves around the floor of the

Exchange, an astonishing evocation of the frenetic dealing in the futures market, the offices, boardrooms and country houses in England and abroad, tracing her search and the progress of multiple takeovers, arbitrage deals, the arrivals of white knights and all the other weird accompaniments of business. Everything, but everything, is in the end subordinate to the exhilarating flow of adrenalin created by being in high finance and hence in power. Scilla finally admits that she does not care about Jake; she is only concerned to get her share of money and power, a share that the company had refused her because of her gender. Success, not truth, is the only thing that makes life worth living.

Serious Money is a harsh and exhilarating satire. At the Royal Court, with its traditional audience of liberal intellectuals, the play's tone was immediately comprehensible and acceptable. But in the later stages of its run at the Royal Court and even more explicitly when it transferred to the West End, *Serious Money* found itself confronting a new audience. Those the play attacked and ridiculed now watched it; the play became the excited preserve of the yuppie City world it savaged and the laughter of recognition replaced the laughter of astonished delight. The Royal Court stalls bar had never sold so many bottles of champagne now that the audience, as well as the characters, lived on a diet of 'oysters and champagne ... Pon crystal mountains of cocaine' (p. 111).

Satire was outwitted by the refusal of the audience to see the play as satiric. The new community, thrilled to find itself mirrored on stage, found the play celebratory. The very exactness of Churchill's depiction, her accurate realism, was the source of the audience's pleasures. Sharing the values of the characters, the audience could not see what might be wrong with the world of the futures markets, why it might feel a need to object to the callous self-interest that motivated every character. Finding a totally unexpected and unintended community of interest with the play's characters, the audience took the play over as if it were another company, merging with the play like some multi-headed arbitrageur, stripping its assets and making use of what was left for its own self-glorification. As if to heap irony upon irony, the aftermath of a stock-market crash led to audiences falling away alarmingly, the play's vision of infinite success suddenly revealed as fantasy, the play's untruth of prediction undermining its own success. The play's run ended when its image of success clashed with its audience community's recognition of failure.

An emaciated dwarf beside the RSC and the National, the two companies whose share of the available subsidy increased substantially during the 1980s, the Royal Court is by comparison with most touring theatre companies a well-fed giant. In 1987–88, for instance, the English Stage Company received an Arts Council grant of £555,500 while Paines Plough received £83,000.[21] Paines Plough, named after the pub where the company first met, has however remained determined to make its other name, the Writers Company, true. Its policy was to consider all the plays it could lay its hands on, reporting back to writers, arranging play-readings, encouraging new writers by commissioning them and keeping faith with

them. At the same time it toured its work, refuting the premise that unless a play is seen in London it doesn't exist, recognising the rights of other cities, other communities. Kay Adshead, an actor turned playwright, benefited enormously from Paines Plough's concerned interest in her. Her first play, *Thatcher's Women*, was read by Pip Broughton, artistic director of Paines Plough; a second draft was commissioned, and director and playwright worked on the rewriting. The play was given a rehearsed reading and subsequently a production at the Tricycle Theatre in north London. [22] The result is a fair example of the outcome of the company's policy, not a great play but a decent one, exploring with honesty an aspect of contemporary society, though the play's fairly conventional naturalism is not a common feature of Paines Plough's work.

Thatcher's Women examines a new phenomenon of the combination of the economic collapse of manufacturing industries and the ease of travel. It follows three women as they are made redundant when a Manchester factory closes and come to London to work as prostitutes. The title comes from the term used by the prostitutes' union, the English Collective of Prostitutes, based at King's Cross, to describe 'the appearance, on the streets, of ordinary women, "housewives" from the north-east, north-west, Midlands and Scotland, coming down to London to work as prostitutes for short periods in order to pay the rent, feed and clothe their children'. [23]

Poverty and desperation force Marje, Norah and Lynda to go on the game and Adshead explores the decision as an economic and individualist one, not as a moral problem. Financial need drives them: Marje, for instance, married with children, sees it as the last-ditch means of making a decent Christmas for her family. She is untroubled by casual sex, except when a policeman demands sex as a bribe to avoid arrest. At the end Marje and Norah return home. Lynda, aged 17, is a natural entrepreneur, following the dictates of Thatcherite enterprise culture and getting on her bike, or in this case the train, in search of work, status, identity. She chooses to stay in London, moving up the ladder of prostitution, the career-structure:

At the moment most of my capital is having to be reinvested – my wardrobe, hairdressers, make-up, taxis, jewellery ... elocution lessons ... but if I can carry on my present earning capacity, it won't be long before I've covered overheads and I hit *pure profit*.[...] In years to come I'll register myself as a small business ... a little office somewhere ... find a catchy title ... 'Escort Elite'[...](*Ecstatically:*) I'll pay tax. Don't get me wrong. I've every sympathy with women like Norah and Marje, but I can't help thinking they bring a lot on themselves. I dragged myself up from the gutter – why can't they? (p. 45)

But, as the stage direction makes clear, she *'looks ten years older'*.

Each of the women is confronted by the alien quality of this new world, not only because to northerners London is a strange place but because the world of prostitution, far removed from the conventional

stereotypes of Soho, strip clubs and pimps, has its own bizarre codes. The play accepts its responsibility to depict this world, to put it on stage and let it speak, to see an unpalatable and real solution to these women's poverty in terms that are simultaneously and unexpectedly harmonious with government theories of individual economic salvation and totally opposed to the conservative addiction to 'family values'. The play sets out its unanswerable paradox calmly and almost politely. In a politically fragmented country, divided in its politics by its geography as the election defined Labour's control of the North and the Conservatives' more absolute control of the South, Adshead's analysis of Thatcher's women brings North and South together, showing the existence of other communities, more diffuse and widespread across the country than any I have so far suggested, a community of women and a community of poverty.

It is worth noting how the perception of this community of women is reflected in the forms of play publication. *Thatcher's Women* appeared in a series of 'Plays by Women'.[24] But while the series' title defines the gender of authorship, it also suggests the nature of the plays' concerns: 'plays by women' are also 'plays about women' just as a comparable series, 'Black Plays',[25] contains the work of black playwrights writing about blacks while 'Gay Plays'[26] defines the plays' concerns and, usually though not necessarily, the sexuality of the playwrights. The plays are the product of the communities' members. Communities write about themselves.

But the language of community may also be a language of oppression. For Brian Friel, writing in and of Northern Ireland, the problem is unequivocally focused in the nature of English. Writing of his translation of Chekhov's *Three Sisters* (1981), Friel has identified in the tradition of translations a form of Englishness that he wished to resist:

> Somehow the rhythms of these versions do not match with the rhythms of our own speech patterns ... in some way we are constantly overshadowed by the sound of English language, as well as by the printed word. Maybe this does not inhibit us, but it forms us and shapes us in a way that is neither healthy nor valuable for us.[27]

Friel's demand is that Irish dramatists 'must make English identifiably our own language ... We are talking to ourselves as we must and if we are overheard in America, or England, so much the better'.[28]

It is no accident that the first of a series of pamphlets issued by Field Day, the theatre company Friel and the actor Stephen Rea founded with the support of poets like Seamus Heaney and Seamus Deane, is Tom Paulin's 'A New Look at the Language Question'. Paulin's history of the linguistic conflict between English and Irish begins with the straightforward statement: 'The history of a language is often a story of possession and dispossession, territorial struggle and the establishment or imposition of a culture.'[29]

Friel's play *Translations* was the first production by Field Day, opening

at the Guildhall in Derry in 1980. As with *Entertaining Strangers*, Friel turns to history to define the present – *Translations* is set in 1833 – for the moment of history marks the imprint of change continuous with the present. Friel turns to a particular community to define, not its connections and continuities, but the gaps and dislocations. The particularity is naturalism's strategy of exemplification; as Friel wrote in 1970:

> I would like to write a play that would capture the peculiar spiritual, and indeed material, flux that this country is in at the moment ... I think it has got to be done at a local, parochial level, and hopefully this will have meaning for other people in other countries. [30]

But the meaning is closely tied to the perception of community in the play. The play charts the contact between an English military Ordnance Survey team, charged with mapping Ireland, and the community of Ballybeg in County Donegal. The active culture of the community is focused on the hedge-school where Latin and Greek are studied by the workers of the village. Language, even in translation, is here a pleasure without power: Jimmy Jack is first seen 'contentedly reading Homer in Greek and smiling to himself'. [31]

But the English soldiers are empowered to alter the terms of the community by changing its place-names into English, the immediate manifestation of what Friel has called 'the death of the Irish language and the acquisition of English'. [32] Owen, son of the hedge-school's teacher, is collaborating with the English, particularly with Yolland, who shares with him the philological pleasures of discovering the roots of names, the history of place forgotten even by the locals themselves but which informs the sense of place. But to lose the name is to lose the definition of community: [33]

> OWEN: Do you know where the priest lives?
> HUGH: At Lis na Muc, over near ...
> OWEN: No, he doesn't. Lis na Muc, the Fort of the Pigs, has become Swinefort ... And to get to Swinefort you pass through Greencastle and Fairhead and Strandhill and Gort and Whiteplains. And the new school isn't at Poll na gCaorach – it's at Sheepsrock. Will you be able to find your way? (p. 42)

The names themselves are heard in three litanies in the play: first, slowly, as Owen and Yolland perform the act of scholarly translation ('We are trying to denominate and at the same time describe that tiny area of soggy, rocky, sandy ground where that little stream enters the sea, an area known locally as Bun na hAbhann ... Burnfoot! What about Burnfoot?' p. 35); secondly, when Yolland, in love with Maire, a local girl, finding no language to share with her (she speaks no English and he little Irish), tentatively offers her a place-name, the nouns become a nonsense sequence to express passion and desire; finally, when Yolland

has been kidnapped by local 'terrorists', Captain Lancey announces, with Owen forced to act as his translator, that if Yolland is not found they will evict and level the villages:

> LANCEY: Swinefort.
> OWEN: Lis na Muc.
> LANCEY: Burnfoot.
> OWEN: Bun na hAbhann. (p. 62)

The clash of community and oppression is the clash of languages; the play celebrates Irish culture while being written in the language of the oppressor. There is no language for the play other than clashing Englishes: Maire and Yolland, side by side on the stage, each incomprehensible to the other, speak in the play's fiction two different languages but on stage the same language, English. But Maire is desperate to learn English because she believes, with Daniel O'Connell, that

> 'The old language is a barrier to modern progress.' He said that last month. And he's right. I don't want Greek. I don't want Latin. I want English ... I want to be able to speak English because I'm going to America as soon as the harvest's all saved. (pp. 25–6)

But the harvest is linked in the play with the terrifying 'sweet smell' (p. 21), the potato blight and impending famine that will force mass emigration, the diaspora of community.

Translations is British almost in spite of itself, written in English as an acknowledgement of the successful transformation of a native culture that the play is at the same time concerned to chart and to mourn. The language of *Translations* language recapitulates its own history, the collapse of one community at the hands of another, the effective annexation of the local and particular by the national. It documents what it means to be writing British theatre as a Catholic in Northern Ireland and worries about the community for which British theatre is itself a threatening presence.

Translations documents the historical moment of the destruction of community through its language. Jim Cartwright's *Road* (1986) documents the contemporary moment of the destruction of community through poverty. It is also a denial of the community with the audience: there can here be no reflection from stage to audience. Cartwright's characters are never to be found among a theatre audience. The place for *Road* is 'a road in a small Lancashire town', its time 'tonight'.³⁴ It narrates a Saturday night for the inhabitants of an inner-city, partially derelict area of near-total unemployment. Here geography defines class, an under-class, those beneath the definition of workers, a class that society has created and attempts to ignore. *Road* emphasises, as Gorky had done in *The Lower Depths*, the unexceptional nature of the events it shows. There is nothing here that will not be here next weekend. The only deaths, of Clare and

Joey who starve themselves to death for reasons they cannot express – an act that manifests their complete alienation from a community that can give them only despair – occur in the middle of the play, merely the climax of Act 1.

Road's dramatic form, the unity of time in its night-long span, is a cover for the fragmentation and dissociation of its materials. Where *Entertaining Strangers* used promenade production as a means of integrating drama and audience, filling the audience with its actors, *Road* uses the same technique to demonstrate the collapse of integration. The fragmented scenes take the audience to the different houses, bemused tourists under the aegis of the cynical guide Scullery: 'Wid' your night yous chose to come and see us ... THIS IS OUR ROAD! But tonight it's your Road an' all!' (p. 5). The disconnection of the sections of text mirrors the disconnection of the characters. Nothing holds these people together into a community of communication. Language is either monologic – this is a play full of enormous soliloquies which bring together the realist language of inarticulacy and the possibility of its poetics – or conducted in a rapid stichomythia that is the brutality of aggression and hostility in a form that mediates between the forms of traditional rhetoric and the forms of contemporary speech.

The geography of place is a fiction of unity revealing only the collective individualism of despair. Cartwright depicts a community that denies the premise of communality. Families are places of hate and loathing:

MOTHER: Aye, here I am and there you are so let's have something.
CAROL: What?
MOTHER: Respect and money.
CAROL: I'll give you your money Monday morning and your respect's
 down the bog. (p. 5)

Age is only an infinite extension of pain: 'Fucking long life, in'it?' (p. 6). The past is romanticised into the acute pain of loss, a memory of pleasure and collectivity that now has no resonance: 'I can't see how that time could turn into this time' (p. 14). Now there is only squalor and destruction. The loathing is also a desperate understanding of the reasons behind it. When Valerie describes her loathing of her drunken husband and her own humiliation begging for money from anyone she knows, she recognises only too clearly that the fault lies in long-term unemployment that strands him, 'so awkward and sad ... clumsy with the small things of the house, bewildered'(p. 25). But recognition is not acceptance:

I see the poor beast in the wrong world. I see his eyes sad and low. I see him as the days go on, old damp sacks one on top of another. I see him, the waste. The human waste of the land. But I can't forgive him. I can't forgive the cruel of the big fucking clumsy heap ... I hate him now, and I didn't used to. I hate him now, and I don't want to. (*She cries.*) Can we not have before again, can we not? (p. 25)

Cartwright ends *Road* with the evening of Eddie, Brink, Carol and Louise. The two men pick up the two women but the play, as so often, modulates the predictable rituals of Saturday night, drink and sex, into an unpredictable but equally ritualistic sequence. Eddie and Brink offer to show the girls what they do, 'a something that we always do when outside gets to you' (p. 33). The men enact their ritual and the women take part: drinking by the bottleful until they are drunk and then playing the only record that seems to make sense, Otis Redding's 'Try a Little Tenderness', and then, as Brink says, 'You get to the bottom of things and you let rip' (p. 34). Each in turn gives a speech, the language welling from beneath its normal repressions. Louise ends hers with a hope: 'If I keep shouting somehow a somehow I might escape' (p. 35) and the other three join her cry, becoming a chorus, 'all pressed together, arms and legs round each other', chanting and shouting at the audience, louder and louder, the hope of another place, as Friel's Maire had thought of her escape to America:

> Somehow a somehow a somehow – might escape!
> Somehow a somehow a somehow – might escape!
> Somehow a somehow a somehow – might escape!

Like *Entertaining Strangers*, *Road* ends with a chant but not a vision of the shared Jerusalem of community triumphant, only a desperation of the potential of escape. The generalisation here is absolute but it is also a denial of any specificity of solution. No one in *Road* perceives a political framework of the state within which action for change might be accomplished; their perception of community is essentially myopic, a short-sightedness created by the oppressive material conditions that prevent a view beyond the end of the road. The audience's ability to imagine the source of the 'somehow' is a virtue of its separation from the problem, its separation from the community of the road.

Cartwright resists the prescription of a party politics, offering only the exactness of documentation; he resists the lure of the sentimental, offering only the exactness of extreme pain. *Road* has an emotional power as potent as tragedy ever achieves. In the collapse of community, of holding things in common other than despair, in the collapse of communication and affection into the community of nihilism, *Road* finds community a meaningless concept, an offensively patronising illusion. The fragmentation of the state into communities now seems the abdication of national responsibility. The collectivity of community is seen as nothing more than a political myth.

Notes

1. Raymond Williams, 'Drama in a Dramatised Society', reprinted in Alan O'Connor (ed.), *Raymond Williams on Television: Selected Writings* (1989), p. 4.

2. See, for example, Owen Kelly, *Community, Art and the State: Storming the Citadels* (1984) or, more soberly, *Arts and Communities: The Report of the National Inquiry into Arts and the Community* (Community Development Foundation, 1992).
3. Raymond Williams, *Keywords* (1976), p. 66.
4. Raymond Williams, 'Homespun Philosophy', *New Statesman and Society*, (19 June 1992), p. 8.
5. Wiliams, *Keywords*, p. 66.
6. Graham Woodruff, 'Community, Class, and Control: a View of Community Plays', *New Theatre Quarterly*, vol. 5, no. 20 (1989), p. 370.
7. Anthony P. Cohen, *The Symbolic Construction of Community* (1985), p. 15.
8. Williams, *Keywords*, p. 66.
9. Cohen, *Symbolic Construction*, p. 118.
10. John McGrath, *The Bone Won't Break* (1990), p. 142.
11. On the work of the trust, see Ann Jellicoe's own account in her book *Community Plays: How to Put Them on* (1987) and Baz Kershaw's fine study in his *The Politics of Performance* (1992), pp. 168–205.
12. Jellicoe, *Community Plays*, p. 4.
13. Ibid., pp. 5–6.
14. See David Edgar's discussion in his article 'Festivals of the Oppressed' in *The Second Time as Farce* (1988), pp. 226–46.
15. Tony Dunn, 'Interview with Howard Barker', *Gambit*, no. 41 (1984), p. 43.
16. Woodruff, 'Community, Class and Control', p. 371.
17. Both versions have been published: David Edgar, *Entertaining Strangers* (1986, Colway Theatre Trust version; 1988, National Theatre version). All quotations are taken from the 1986 version.
18. Preface to 1988 edition, p. ii.
19. See Edgar, 'Festivals', pp. 237–8.
20. Caryl Churchill, *Serious Money* (1987), p. 111.
21. Arts Council of Great Britain, *43rd Annual Report and Accounts 1987-88* (1988), pp. 65–6.
22. See Kay Adshead's account in *Plays by Women*, vol. 7, ed. Mary Remnant (1988), pp. 49–50.
23. Ibid., p. 49.
24. *Plays by Women*, vols 1–4 ed. Michelene Wandor, vols 5– ed. Mary Remnant.
25. Yvonne Brewster (ed.), *Black Plays* (1987) and *Black Plays: Two* (1989).
26. Michael Wilcox (ed.), *Gay Plays*, 3 vols (1984–8).
27. Quoted in Ulf Dantanus, *Brian Friel: A Study* (1988), p. 183.
28. Ibid., pp. 183–4.
29. Tom Paulin, 'A New Look at the Language Question' (1983) reprinted in Field Day Theatre Company, *Ireland's Field Day* (1985), p. 3.
30. Quoted in Dantanus, *Brian Friel*, p. 15.

31. Brian Friel, *Translations* (1981), p. 11.
32. Brian Friel et al., 'Translations and a Paper Landscape: Between Fiction and History', *The Crane Bag*, 7 (1983), p. 122.
33. See Richard Pine, *Brian Friel and Ireland's Drama* (1990), p. 165.
34. Jim Cartwright, *Road* (1986), p. 3.

8 CLOSET KEYNESIANS: DISSIDENCE AND THEATRE

Alan Sinfield

When we were editing *Political Shakespeare*, Jonathan Dollimore and I asked Margot Heinemann to address Shakespeare and education, as she was ideally qualified to do. However, we were delighted when she offered us 'How Brecht Read Shakespeare', a beautifully socialist, humane and scholarly interpretation of the positive and negative potential in the bardic oeuvre.

> When Brecht calls *Lear*, for instance, a 'barbaric play', he doesn't mean that it has to be scrapped, only that the audience have to be encouraged to 'keep their heads', not to identify with social and class attitudes quite alien to them.

The point, always, is to show that character and predicament may be altered by social change.[1] Broadly, the project of political theatre since *Serjeant Musgrave's Dance* (1959) has been similar to that Heinemann located in Brecht. However, Brecht knew that he had to fashion different kinds of theatre organisation in order to realise his vision. I want to consider how our political theatre has fared within the cultural institutions of welfare-capitalism; and, in larger terms, how we have envisaged socialism in our time.

It was easy, when Margaret Thatcher lost office, to suppose that cultural workers should get back to where we were before: the state should resume its task of making an already-known good theatre available to everyone. 'It was to many of us in the arts as if the curse had been lifted,' Howard Brenton wrote. 'Perhaps now we can all get back to normal,' said Roland Rees, director of Foco Novo (which lost its grant in 1988).[2] Brenton writes of culture as 'a national café of the mind, in which we are all the clientele' – he derives this notion, with only a slight qualm, from Malcolm Muggeridge. 'When the café's working, we all take part; the rows, the jokes, the outbursts of singing, the meals we eat together, give us our sense of identity.'

Raymond Williams's idea, back in 1958, was similar. In *Culture and Society* he asserts the general value of 'the body of intellectual and imaginative work which each generation receives', and refuses the idea of a distinct 'proletarian' art; he believes the central body of work belongs to everyone.[3] However, that idea depends on a slippage between Arts Council culture – subsidised theatre, for instance, which is what Brenton is

talking about – and the whole culture. The central culture, necessarily, marginalises other cultures. Williams offered 'Culture is Ordinary' as a watchword: 'Learning was ordinary; we learned where we could. Always, from those scattered white houses, it had made sense to go out and become a scholar or a poet or a teacher.'[4] Well, of course one wants to 'go out' and join the more prestigious culture; the dominant ideology always 'makes sense'. In the process, unfortunately, one relegates one's initial, already subordinated, cultures of class, race and so on. Well before 1979, when he talked about it in *Politics and Letters*, Williams saw that the central culture, in which scholars, poets and teachers are supposed to find their places, works to marginalise other cultures:

> What I did not perceive at the time but I now understand is that the grammar schools were implanted in the towns of Wales for the purpose of Anglicisation. They imposed a completely English orientation, which cut one off thoroughly from Welshness.[5]

A divided society has a divided culture, and so it should. The Arts Council concept of culture is always aspiring to a centrality and unity that must be founded in mystification and oppression.

Theatre as we have known it has never even begun to be a meeting place where 'we all take part'. That is why the arts lobby is so weak, why it carries so little weight either with public opinion at large or with most factions and groups. I mean to throw a hard light on what the left has taken theatre to be, in the necessary contexts of the modern capitalist state and post-war European ideas of socialism.

Rectifying our Anomaly

It is often said that socialists have been fatally disheartened by the collapse of the Russian empire and its economic and political system. But this begs a fascinating question: who on the European left in recent times has believed that a centralised, command economy and a Soviet-style political system are the way to socialism? *Virtually no one*. What has been called '1968' amounted, as much as anything else, to the decisive arrival of a generation of leftists who did not feel obliged even to entertain the proposition that the Soviet Union was a model for socialism. Margot Heinemann had close friends in the German Democratic Republic and always spoke up for that country, recognising the difficulties it was experiencing and the dangers in any alternative. In much of this, we see now that she was right. But I don't believe she, or her friends there, thought the GDR a decisive step towards socialism, an example to be followed. So why do we allow the idea that we are taken aback by the collapse of the Russian empire? Something else is bothering us.

There have been two broad patterns on the Western European left since the 1960s. Some of us have looked for radical new possibilities.

These are envisaged, most often, as a kind of immediate local autonomy
(not, by any means, Soviet-style centralised bureaucracy); we might think
of this as the spirit of Greenham Common. Others of us, the larger part,
stayed with the pattern that had mostly prevailed since 1945: attempting
to develop the progressive potential of the mixed economy as it emerged
from the post-war settlement. Let's locate that, briskly. In the 1930s, there
seemed to be three kinds of future: fascism, communism, and a rejigging
of capitalism to make it fairer – welfare-capitalism. These three fought it
out between 1939 and 1945. Welfare-capitalism won in Western Europe;
on the right as well as the left, it was agreed that there should be no return
to pre-war conditions. Now all the people were to have a stake in society,
an adequate share of its resources as of right: a job, a pension or social
security, a roof over your head, healthcare, education. These promises
were to be sustained by government management of the economy in the
manner proposed by John Maynard Keynes (not by Soviet-style bureau-
cracy). Arts Council culture, I will argue, was conceived within this frame-
work. It is the consensus that broke down conclusively in the late 1970s,
allowing Thatcherism to confront it and to take us back, in theory and in
effect, to the 1930s.

It is my contention that, whatever we were saying on the left, we
hadn't really worked out a system to replace welfare-capitalism. This is
because, actually, so far from imagining a Soviet-style revolution, we
envisaged capitalism continuing, though with vastly more of the post-war
promises realised. We often used a revolutionary rhetoric – and with
justification, when we protested about nuclear weaponry, racism, unem-
ployment and poverty, the Vietnam War, any number of imperial wars.
For the most part, through diverse modes – trades unions, the Labour
Party, the courts, the left–liberal press, canvassing, lobbying, demon-
strating, infiltrating – we were looking for a delivery, within welfare-
capitalism, on the promises of 1945.

Consider three significant movements. The Greater London Council
when Ken Livingstone was its leader aspired to combine the two main
kinds of leftism that I have identified: an immediate, local autonomy and a
more humane welfare-capitalism; the idea was to redistribute wealth and
power through democratic municipal structures. But how was this to be
sustained, in the medium term, within the capitalist world order? If social-
ism in one country was tricky, how could there be socialism in one city?
Perhaps it would be the lever for a greater change, but how would that
develop, in the face of the capitalist world order? I don't think we thought
very hard about it. The capitalist world order asserted itself: the GLC was
abolished.

Remember Bennism. Joint planning of the economy was the initial
idea: the government and the multinationals were to get together, to make
planning agreements. And there was to be an extension of nationalisation,
to perhaps 25 manufacturing companies. The ambition was to shift the
culture of business towards industrial democracy, and that perhaps might
have been achieved; here, too, there was an idea of local autonomy within

a more benign state. But the project was both too weak and too strong: too weak to challenge the framework of capital, too strong to have been tolerated by international corporations.

Even the great industrial disputes ... The pattern is epitomised by my own union, the Association of University Teachers. At one moment, one of many moments, our pay had fallen out of line with that of others with whom we thought it strategic to compare ourselves. The slogan we produced, with all the intellectual resources at our command, was: 'Rectify our anomaly.' A potent challenge to capital, if there ever was one. But that has been the general stance in trade unionism: putting things into better proportion within the system.

Leftist attempts to work within welfare-capitalism have not been in bad faith. We did believe, very many of us, that 1945 was a breakthrough, that we were forming effective campaigns, that there was potential for a slow and uneven, but steady, movement towards equality and social justice. And it hasn't been all bad, especially if you overlook the fact that our relative wealth is premised on the poverty of most of the world. But, overall, it is dawning upon us now that welfare-capitalism is not going to deliver. *That is the failure that has distressed us*, not the failure of Soviet-style centralised direction. And it is so stunning that we cannot afford to recognise it. We prefer to allow the notion that it is Eastern Europe that has blown us off course; otherwise we will have to acknowledge the real poverty of our theories.

Stages in the Argument

British political theatre has been welfare-capitalist. To be sure, as in political rhetoric at large, revolutions have been proclaimed: at the Royal Court, in the name of Brecht and Artaud, by Joan Littlewood, the Royal Shakespeare Company, Peter Brook, Edward Bond, and by fringe groups from the Living Theatre to 7:84. I am raising no question about the excitement of much of that work, still less about the abilities and integrity of its hard-pressed producers. But the institutional framework and assumptions have been welfare-capitalist. The pattern was set with the formation of the English Stage Company at the Royal Court in 1956: the state was to fund quality theatre as 'a good thing' (correspondingly, other modes of entertainment were left to struggle in the market). The idea was to equalise access, relatively of course, to an already-known benefit. As with the rest of the 1945 settlement – health, housing, education and social security – the state intervened to give everyone a share of what had previously been middle- and upper-class privileges.

The remit of the Arts Council, in 1945, did include 'the encouragement of music-making and play-acting by the people themselves', but John Maynard Keynes – the theorist of welfare-capitalism – became chairman of the Council, and most of its money was committed to Covent Garden (of which Keynes was also chairman). By 1951, egalitarian aspirations were

abandoned in the interests of 'quality'.[6] The Labour Party manifesto of
1945 had not questioned the conventional idea of high culture: 'By the
provision of concert halls, modern libraries, theatres and suitable civic
centres, we desire to assure to our people full access to the great heritage
of culture in this nation.'[7]

We may be perplexed, now, at the general failure on the left to conceive
a stronger cultural alternative. One reason is that the most authoritative
pre-war theatre had been a site of middle-class dissidence, for instance in
the work of Ibsen, Shaw, O'Casey and Priestley. Middle-class dissidents
may be understood as a class fraction that manifests, mainly from within
the middle class, affiliations partly hostile to the hegemony of that class.[8]
This formation may be traced to the late eighteenth century, when enclos-
ures, the factory system and urbanisation helped to provoke the Romantic
movement. We may observe it lately in CND, the women's movement, gay
liberation and the Green movement. It is particularly attractive to intellec-
tuals, and has often endorsed art and literature as against the 'inhumanity'
of modern industrial societies. This is, in effect, the theme of Williams's
Culture and Society, which presents a sequence of literary figures who have
upheld ideas of culture against the general tendency of modern society.
From the Romantics on, Williams finds 'an emphasis on the embodiment
in art of certain human values, capacities, energies, which the development
of society towards an industrial civilisation was felt to be threatening or
even destroying.'[9]

Marxists, often, have been aligned with middle-class dissidents in
attitudes to culture. At times, proletarian writing has been vigorously
validated, but the idea that quality culture transcends material conditions,
such as class, has a decent socialist lineage. Marx fell over himself trying
to explain the continuing appeal of Greek art; Trotsky doesn't understand
art in any distinctively socialist way. The Communist Party in the 1950s
promoted Britishness and traditional culture as against the imperialist
inroads of a debased US commercial culture. The Party literary journal
Arena stated its belief in 'human values' and 'the artist's prophetic func-
tion', and lamented the undermining of national cultural standards by
existentialism and Hollywood.[10]

The 'new left', after 1956 (Williams, for instance), largely retained these
attitudes. In fact culture, rather than the economic or political system,
seemed the problem to be addressed, and (as with housing, the elderly and
so on) the state should intervene; that, it seemed, was a kind of socialism.
Subsidised theatre should be critical and stimulating – *about* something,
not just an occasion to mark your parents' wedding anniversary. The Royal
Shakespeare Company and National Theatre imitated the Royal Court
programme of elevated social usefulness, gesturing often towards wider
audiences and some degree of social critique, while drawing towards a
'classical' repertoire and hence a conservative ambience of heritage. Even
so, if the production was sufficiently vigorous and aware, the left often
thought it was probably going in the right direction. The Labour Party
agreed, and between 1964 and 1970 Arts Council budgets tripled.

And that is more or less where Labour thinking remains, though now with a 'sensible' admixture of Thatcherite economism. Its policy booklet for the 1992 election, *Arts and Media: Our Cultural Future*, starts off with 'the riches of our heritage' and how 'investment in the arts has enriched the life of their communities and enhanced their local economies'.[11] But its main drift is still 'the belief that the arts are for all' (p. 11). The task is to get wider appreciation for them: 'it is wrong that many children leave secondary school without ever having been given an introductory taste of what the arts could offer them by way of a visit to a theatre, a gallery, a concert or a dance performance' (p. 17). There is a brisk acknowledgement that 'our cultural life is dominated, by a sector of the population which is white, male and middle class', but it is supposed that this may be rectified by action within the system, 'to ensure equality of opportunity for all, regardless of age, ethnic origin, gender or disability' (p. 19). The centrist idea of 'the arts' is still dominant.

Not Insulting the Audience

Of course, diverse kinds of people go to diverse kinds of theatre. In the main, though, post-1956 subsidised theatre has fostered and accommodated what used to be called a 'new class' of people in professional, managerial and clerical occupations, and students on the way to those occupations. In fact, class mobility is often involved, and a higher-education ambience pervades this theatre; it seems to guarantee its quality and hence justify its funding. Plays are likely to be 'serious', ambiguous or difficult; they may be discussed in the pub afterwards in a kind of informal seminar, and may be regarded as literature and studied in schools and colleges; many of the venues used by alternative companies are in colleges and college towns. This is why the project of prising other groups away from their immediate cultures and enticing them into theatres has not got very far.

Parts of this audience are progressive, and have afforded the principal constituency for political theatre; subsidised theatre has contributed to a distinctive and powerful phase of middle-class dissidence. This, I have suggested, is an entirely viable and partly progressive formation in its own right; but its culture should not be imagined, even in potential, as a universal one.

Of course, some companies have succeeded, heroically, in cultivating other kinds of audience; I believe my analysis shows just how heroic they have been. And in certain circumstances – strikes, shut-downs, unjust legislation – habits are breached and theatre may become a significant focus for activism. It is not that diverse people can't or won't go to theatre (as we know it); rather, in the main, they just don't find it to be their kind of thing.

The question of the audience has been addressed most tellingly by John McGrath, in both his theatre work and his writing. 7:84 Scotland found an

audience by forsaking centrist ideas about culture, theatre as such, and audiences in general. They aimed at Scottish entertainments for Scottish people. In *The Bone Won't Break* (1990) McGrath asserts an explicit alternative to the Arts Council concept of 'educating the workers and the uninitiated into "appreciating" art, literature, music, opera, drama, the greatest in the world'. However, he does not, in the manner traditional to leftist theatre, propose a working-class audience as such. He makes three moves. First, he envisages his potential audiences coming from the 'many millions of "consumers" who are not content with the nourishment' of the mass media. On this formula, they need not have any particular allegiance of class, ethnicity, gender or sexuality; in fact, McGrath at one point refers to them very generally as 'The Resistance'. Second, he envisages them in terms of community, founded in locality. This affords both a constituency that may be cultivated, and the opportunity to discover and work on matters of local concern. Third, rather than simply applaud this local, popular culture, McGrath writes of 'the struggle for the "progressive" within popular culture'. [12] From this position, he can dispute aspects of popular culture that he dislikes; whether he believes he is doing this as a progressive voice 'within popular culture', or as an intellectual from outside, is unclear. Either way, the idea of struggle legitimises conflict with the audience, to a degree that was hard to account for when the working class was believed to be the privileged bearer of revolutionary potential.

I think McGrath's account is wise and constructive, and may easily be elaborated in terms that would embrace companies on bases other than locality; for instance, Tara Arts (Asian), the Temba company (black), the Women's Theatre Group, Gay Sweatshop. I think that is the way forward. Nevertheless, the question, still, concerns *which sectors* of those respective constituencies one meets at theatre performances by such companies. Though perhaps with more thought and integrity than at the Royals, these too are, generally speaking, students, managers, professionals – middle-class dissidents. The director of the Temba company recognised this at the 'Theatre under Threat' conference at Cambridge in 1990, when he said that companies like his will not be secure until there is a larger black middle class.

And it is usually assumed that this theatre should be funded by the state. The over-arching conception of culture, in other words, is very nearly continuous with the Arts Council, welfare-capitalist conception. Here, too, the dominant idea is that theatre is one of the good things of life to which everyone will respond if only they get a decent chance; the state should pay for it; and its very existence amounts to some kind of advance in social justice. This is why writers, directors and performers find it all too convenient to move between the fringe and the Royals. The 'centres of excellence', McGrath observes,

> busily buy up all the bright ideas and people of the independent companies, and put them through the mincer of their production-processes, sanitise their ideology, cover them in gooey lighting, and

they emerge no longer vibrant, different, startling or unique, but conformist, tame and toothless. [13]

The reason why this can happen so conveniently is the conceptual continuity between the Royals and the alternative companies.

There is a potentially progressive constituency for alternative theatre, then, and it is well worth cultivating. But there are two drawbacks. First, the centrist, Arts Council notion of quality culture tends to invade radical work. When the Federation of Worker Writers and Community Publishers was refused funding in 1980, Greg Wilkinson of the Commonword Workshop asked:

> Can we accept that there is just one Literature and set standards for all, and that these should be fixed by a little minority, who, in refining their writing skills to the standards of a relatively leisured class, remove themselves from the life and language of the majority? [14]

Wilkinson seeks to wrest the concept 'Literature' away from the specialists who control it, and if he wants funding that is his only move. But in that act of appropriation he risks contaminating 'the life and language of the majority'. By aspiring to be any kind of 'literature' at all, community writing is likely to engage in some degree of negotiation with centrist expectations. It is the same when Arts Council criteria of quality are applied to political theatre. 'Lack of artistic quality can, for example, manifest itself in presenting a picture of industry where the workers are all saints and the bosses are all wicked, foolish, or both. Reality is more muddled and subtle than that,' declared Roy Shaw, the Director-General of the Arts Council, back in the good old days, in 1982. [15] From within the conventional idea of artistic quality, Shaw's stance seems only reasonable. But it rules out a large part of our radical cultural traditions; it posits a culture without anger, and hence without serious reference to the conflicts of our time. Yet a company that seeks funding has to pretend to agree that reality is 'muddled and subtle'.

Second, there was the unmistakable blast of a chilly truth when, in 1991, Roger Foss assessed recent plays about Eastern Europe by Howard Brenton, Tariq Ali, Caryl Churchill, David Edgar and Peter Flannery. Foss observed 'something that many of us have suspected for a long time: that what we have come to know as political theatre in Britain has reached an artistic impasse, if not a full stop'. The work is good but, as 'played out on the great national stages', not enough. 'Sophisticated, intelligent, well-made "political" plays, interesting though they are, just don't make for an exciting, stimulating theatrical night out any more.' [16] Political theatre, as we have known it, has been losing impetus. And this, I believe, is related to a dawning realisation that welfare-capitalism doesn't work, and that we were perhaps mistaken to trust it in the first place.

We have scarcely begun to entertain a revolutionary cultural programme and, as in left politics generally, our disappointments relate to

this, rather than to the loss of a socialist model (for instance in Eastern Europe). On culture, as with the economy and social justice, we have been waiting for welfare-capitalism to deliver.

So I Hoped

OK, so Soviet-style communism didn't work very well; now let's see the evidence that capitalism works. In the 1970s it became apparent that the post-war settlement cannot pay its way. First, as Beveridge said at the start, it has to depend on fair shares and popular commitment. Unless people really believe in the system, the removal of the traditional threat of poverty allows wage inflation and skiving. This may have been the crucial failure: the system didn't change sufficiently to engage most of us to the point where we were prepared to sacrifice sectional interests. Whether it could have been otherwise is a question. Perhaps the framing ethos of competitive capitalism made fair shares impossible; perhaps the Attlee administration lost its opportunity when it went into Korea, and after 1951 the Tories shrivelled the scope of aspiration to keeping up with the Joneses. Now the Labour Party has lost the nerve to campaign on the idea of fairness, and we may never know whether it could have worked. Instead of pride in the job, we have terror that we will lose it.

Second, while the post-war/Vietnam War boom continued, and while the oil-rich territories could be dominated, there was usually more money to push round the system. But the boom ended, and suddenly the Keynesian mechanisms for holding the economy steady were revealed as emperor's new clothes. The moment of truth was when Denis Healey was forced to capitulate to the International Monetary Fund in 1976 (the Labour administrations were packed with moments of truth). This is the flaw: welfare-capitalism raises expectations, with a view to maintaining popular enthusiasm; but only for a while can the system produce enough wealth to keep pace with those expectations. In Sweden and New Zealand, even, they have found this. The system, to secure its legitimation, arouses aspirations but – even at the price of ransacking the world – cannot produce the wealth to meet them.

In the wake of welfare-capitalism, we are back where we were in the 1930s, with the consequences of unfettered capitalism. The attraction of welfare-capitalism was that we might humanise the system without having to go to the improbable length of overthrowing it. It hasn't worked. The fact is, whatever they do, capitalism produces booms and slumps, just as it produces extremes of wealth and poverty. It is not a matter, as the press and the Labour leadership seem to imagine, of discovering a 'new policy'. All the policies have been tried; the system is inherently cruel and inefficient. And socialists, whatever our confusions through the decades, are people who know this.

If we stop expecting welfare-capitalism to deliver, we may be able to

reassess the political scope of the prevailing cultural apparatus. Where we were before Thatcher was not good enough, and getting back to it wouldn't help much. We need cultural strategies that acknowledge this.

Starting with the Arts Council idea of theatre as a natural good is starting at the wrong end. 'The effort to work in a local popular culture is only worthwhile if it is alive and means something to the people of the area,' McGrath says. [17] That is right, but it is a hard text. We have to start with particular communities and see what modes they want to use to facilitate their conversations about who they are and where they want to be. They may want to do or sponsor theatre of one kind or another. Some lesbians and gay men, for instance, have valued Sweatshop – well, that's fine. Many communities urgently need opportunities for such cultural engagement, and theatre is well suited to supply them, especially when it is small-scale, flexible, local, responsive, relatively cheap. Of course, many people are committed to this already, and state and municipal resources, if you can get them, help make it possible. But if subordinated groups want to do something else – not what we have understood as theatre – well, that has to be fine too. As Steve Gooch puts it, 'Why should working-class people pay to see performers who've been abducted from their own culture revitalising bourgeois culture?' [18] Campaigning to get the state to put up money to persuade people to think otherwise is starting at the wrong end, wastes our resources, and traps us in a system that has failed.

One thing we should have learnt from the 1980s is that the state is not, as was imagined in 1945, that which protects us from capital; it is the major institution of capital. In culture, as in anything else, the state may be talked into funding ventures not in its medium-term interest, but when under pressure it will call the tune. To be sure, there is no pure place to be; no place outside the system. So get money from the state if you can. But don't get to rely on it; and, above all, don't get to believe the ideologies of equal opportunity, arm's length control, artistic quality, creative freedom.

Left-wing cultural production has to commit itself to working within (not slavishly following) the concerns and cultural structures of subordinated groups. The subordination has to be the first factor, not theatre or art as currently understood. These arguments will not be easy reading for many theatre workers, and perhaps it ill becomes me to offer them from the relative security of a university post. In fact, many of the same considerations apply to higher education; I have written about that elsewhere. [19] I do believe that we have been experiencing a confusion of principles about cultural production, owing to the current instability (to say the least) in welfare-capitalism, and that this confusion is immensely debilitating. My hope is that seeing the prevailing cultural arrangements for what they are – implicated in an ideological structure that was mystified from the beginning and is not going to produce – may help cultural workers to discover an alternative to dependence on the state and the pattern of ideas that goes with that, and to gain a more secure financial and creative ground.

I fear Margot would not have agreed with all of this; she would have

argued marvellously about it, and so generously. On the whole she remained more optimistic than myself – doubtless because of, rather than in spite of, having seen so much more. She could usually find something positive to build on. That was her spirit and resourcefulness, and I'm not sure where we are going to find those qualities now. She ended her *Political Shakespeare* essay with this quote from Brecht; I print it here for her: 'I could not do much, but without me / Those in power would have sat safer, so I hoped.'

Notes

1. Margot Heinemann, 'How Brecht Read Shakespeare', in Jonathan Dollimore and Alan Sinfield (eds), *Political Shakespeare* (Manchester: Manchester University Press, 1985), pp. 216, 213–14.
2. Howard Brenton, 'The Art of Survival', *Guardian* (29 November 1990); Brenton quotes Roland Rees.
3. Raymond Williams, *Culture and Society 1780–1950* (London: Penguin Books, 1961), pp. 307–8.
4. Raymond Williams, 'Culture is Ordinary', in Norman Mackenzie, (ed.), *Conviction* (London: MacGibbon and Kee, 1958), p. 76.
5. Raymond Williams, *Politics and Letters* (London: New Left Books, 1979), p. 25.
6. Robert Hutchison, *The Politics of the Arts Council* (London: Sinclair Browne, 1982), pp. 44–50.
7. Frances Borzello, *Civilising Caliban* (London: Routledge, 1987), p. 129.
8. See Raymond Williams, *Culture* (Glasgow: Fontana, 1981), pp. 74–83; Alan Sinfield, *Literature, Politics and Culture in Postwar Britain* (Oxford: Blackwell, 1989), pp. 238–45, 258–66, 271–4.
9. Williams, *Culture and Society*, p. 53.
10. Jenny Taylor (ed.), *Notebooks/Memoirs/Archives* (London: Routledge, 1982), p. 31.
11. *Arts and Media: Our Cultural Future* (London: Labour Party, 1991), p. 3.
12. John McGrath, *The Bone Won't Break* (London: Methuen, 1990), pp. 62–5.
13. Ibid., pp. 42–3.
14. Dave Morley and Ken Worpole (eds), *The Republic of Letters* (London: Comedia, 1982), p. 134. See Owen Kelly, *Community, Art and the State: Stormaing the Citadels* (London: Comedia, 1984).
15. McGrath, *The Bone Won't Break*, p. 32. See Steve Gooch, *All Together Now* (London: Methuen, 1984), pp. 45–6.
16. Roger Foss, 'Lesson from the East', *Red Letters*, 28 (Winter 1991), p. 5.
17. McGrath, *The Bone Won't Break*, p. 65.
18. Gooch, *All Together Now*, p. 69.

19. Alan Sinfield, *Cultural Politics – Queer Reading* (Philadelphia: University of Pennsylvania Press, and London: Routledge, 1994), Ch. 4.

9 DRAMATISING STRIFE: WORKING CLASSES ON THE ENGLISH STAGE

Jean Chothia

The twentieth-century theatre has recurrently flared into life with plays that feature working people involved in industrial discord and strike action, plays that count the physical and emotional cost of labour and its continuing conflict with, or exploitation by, capital. The characteristic method has been to present polarised political oratory and factory gate or boardroom debates, but there is also a group of plays which attends to the experience of people involved in the strike action and, doing so, claims a place on the stage for a previously neglected sector of society. James Agate's recognition in 1925 that *Juno and the Paycock* 'is as much a tragedy as *Macbeth*, but it is a tragedy taking place in the porter's family' [1] is suggestive beyond O'Casey's play.

As Agate's statement indicates, attention to the porter's family warranted comment in the post-First World War period. Working-class characters had scarcely figured on the pre-twentieth-century English stage except in small, usually comic, roles, most often as blandly loyal or humorously insouciant personal servants. There were sailors, bailiffs, milkmaids in nineteenth-century melodrama, just as there were bandits and wicked aristocrats, but they were involved in their *métier* in only the most general way. In the society drama that dominated the late nineteenth-century theatre, the earning of money was no more discussed than it would have been at a contemporary dinner party. In contrast, work did occur frequently in the new drama at the beginning of this century and was often crucial to the dramatic action. Those who worked, whether in trade or the professions, were pitted against those whose wealth came easily through inheritance or investment. Although the point of view was that of the liberal middle classes, careful distinctions were made between the functions and status of servants and between particular rankings of policemen, shop assistants and clerks.

Among the few full-length plays produced by the Independent Theatre, from whose foundation in London in 1891 the modern English theatre is usually dated, two, produced in 1893, introduced working-class characters. George Moore's *The Strike at Arlingford*, was a capital and labour play; the other, Elizabeth Robins's and Florence Bell's *Alan's Wife*, included a death from a horrific industrial accident, but directed attention to maternal feeling and the home rather than working conditions. Addressing working-

class life in markedly different ways, these two plays prefigured stage
practice in the next half century. They are local echoes of two mighty
classics of the new European theatre: Tolstoy's *Power of Darkness*,
premiered at the Théâtre Libre in Paris in 1888, is a bleak evocation of
Russian peasant life which explores the motivation of individuals involved
in a callous infanticide; Hauptmann's *The Weavers*, first produced in 1892
by the Freie Bühne in Berlin, uses some 40 named characters to dramatise
the discontent, combining for political action and eventual suppression by
the military of the Silesian weavers, in a succession of increasingly power-
ful crowd scenes that, in early performances, had the audience on their
feet with excitement.

Using material similar to Hauptmann's, Moore produced a remarkably
old-fashioned play. Set entirely in the elegant drawing room of a mine
owner whose workers are on strike, its central concern is the diversion
from his purpose of the 'great labour leader, John Reid' through his melo-
dramatic reunion with the owner, Lady Anne, who had rejected his love
ten years previously when he was her father's secretary. Like *The Weavers*,
the play includes a dispute over wages, a strike and the eventual suppres-
sion of a riotous mob by the military, but it lacks Hauptmann's engage-
ment with the lives and grievances of the workers and generates none of
the dramatic excitement or intense emotion of that play. No irony seems
intended when the employers watch the off-stage riot from their window
through opera glasses. Their concern is to maintain the mine and with it –
the claim is philanthropic – the jobs of the miners and to preserve civil
order, arguing that 'if the battle is lost here, we may expect strikes all over
the North of England' (Act I). The members of the miners' delegation are
demonstrably ignorant with a forelock-touching admiration of the house
and its lady and a comic propensity to be swayed by whoever spoke last.
Reid's assistant is a bigoted schoolteacher whose mind is closed to rational
argument and whose dialogue is peppered with parodic socialistic slogans.
Reid's own arguments turn on the pitiableness of the workers' conditions:
'that man, how miserable he seems – his slouching hungry gait. And those
children who follow their mother. She has no bread to give them', but
circumstances force him to acknowledge the workers' in-bred monstrosity
and ingratitude and his own fundamental class loyalties: 'The brutes. I still
feel their foul breath on my face, and their foul hands. I abandoned my
own class for their sakes, but I never could assimilate my life with theirs'
(Act III).

The innovation of *Alan's Wife*, by contrast, was its closely observed
setting among northern working-class women whose gossip, flavoured with
such dialect markers as 'Eh', 'nobbut', 'nowt', 'missis', is accompanied by
ceaseless activity: knitting, preparation of food, housework. Unfortunately,
the innovatory quality of the setting and the attribution to such people of a
capacity for passion and thought were neglected by contemporaries in the
furore provoked by the action which turns on a young widow's smothering
of her badly deformed child and her refusal to repent the deed. Although
never revived, the play has recently been reprinted.[2]

Galsworthy's *Strife* (1909) rather than *The Strike at Arlingford*, although closer to Moore's play than appearances might suggest, provided the model for one line in English strike plays. Set on the last day of a damaging strike, it presents the conflict between the two sides and, notably, the stand-off between the charismatic strike leader, David Roberts, and John Anthony, the iron-willed chairman of the Trenartha Tin Plate Works. Equal but opposite positions are delineated in the dialogue:

> ROBERTS: All those demands are fair. We have not asked anything that we are not entitled to ask. What I said up in London, I say again now: there is not anything on that piece of paper that a just man should not ask, and a just man give.
> ANTHONY: There is not one single demand on this paper that we will grant. (Act I)

Parallel settings and action demonstrate the contrast in life chances of the two sides. At the beginning of Act I, the Board of Directors discuss the badness of the hotel dinner and the good lunch in prospect and call for screens to protect them from the heat of the fire. There is just bread and cheese on the table at the opening of Act II, which unlike Moore's play takes the audience into a worker's cottage, and talk between the characters soon turns to practical ways of lessening hunger pangs. The stage direction asking for a 'meagre' fire is reinforced when a character comments, 'there ain't much heat to this fire. Come and warm yourself, Mrs. Rous, you're looking as white as the snow, you are.'

The public and private levels of *Strife* coincide in the second scene of Act II, the strike meeting, which is the most compelling sequence of the play. Out of a multitude of dissonant voices, Roberts speaks, gradually gaining control through the power of his oratory which is addressed directly to the audience as well as to the crowd. Galsworthy's relish for rhetoric is evident. With interruptions, the speech takes three pages of printed text. Alternating question and statement, long and short sentences, repeating key phrases in an anaphoric display, Roberts denounces capital, emphasises the importance of unity, derides would-be appeasers and, looking to the future, reaches a messianic climax in which the actor's delivery is skilfully directed by Galsworthy:

> They're welcome to the worst that can happen to me, to the worst that can happen to us all – aren't they? If we can shake (*passionately*) that white-faced monster with the bloody lips, that has sucked the life out of ourselves, our wives and children, since the world began. (*Dropping the note of passion but with the utmost weight and intensity.*) If we have not the hearts of men to stand against it, breast to breast, and eye to eye, and force it backward till it cry for mercy, it will go on sucking life; and we shall stay forever what we are (*in almost a whisper*) less than the very dogs. (II.ii)

The single figure addressing a crowd and gaining their attention and, eventually, total acquiescence, a scenic image that derives in the English theatre from Mark Antony's address to the Roman mob in *Julius Caesar*, is used to powerful effect here but, as the shout for Roberts goes up, news comes that his wife is dead. Directly contrary to the Shakespearean model, this abrupt turn of fortune subverts the effect of Roberts's oratory and, in the sudden anticlimax, control passes to the appeasers. It becomes clear that both the Board and the workers want compromise but have been prevented from it by the opposed ideological stance of the two leaders. The anti-heroic final scene, in which agreement is reached over the heads of the displaced Roberts and Antony to terms drawn up before the strike, endorses the argument for compromise.

Galsworthy took pains to be even-handed to capital and labour in the structure of the play. The argument insists on the value of compromise but emotion and analysis are curiously at odds: the contrasting conditions of food and warmth in the opening scenes; the novelty of the sequence in which the working-class women discuss the exigencies imposed by the strike; the fiery loyalty to her husband of the suffering Annie Roberts, and the sheer theatrical energy of the strike meeting, command attention. These are the scenes that remain in the mind, that give the play an emotional force at variance with its argument, and that prompted the comment of the revolutionary Emma Goldman that, 'not since Hauptmann's *Weavers* was placed before the thoughtful public, has there appeared anything more stirring than *Strife*'. [3]

Although Galsworthy was notable among Edwardian dramatists for his inclusion of working-class characters, his was a presentation of almost uniform pathos. Where they are not brutally drunk or mouthing platitudes of loyalty and honest poverty echoed from nineteenth-century melodrama, his working-class characters are demonstrably impotent. In play after play, sometimes as the central issue, sometimes merely glimpsed as a background to other matters, he presents the harshness of life on the breadline, of conditions which brutalise. Ford Maddox Ford suggested that

> The disease from which he suffered was pity ... or not so much pity as an insupportable anger at the sufferings of the weak or the impoverished in a harsh world. It was as if some portion of his mind had been flayed and bled at every touch. [4]

Those like David Roberts who do stand up for their rights are differentiated from the other workers. 'He was just as much a gentleman as my father', says Moore's Lady Anne of John Reid, and, 'I mean he's an engineer – a superior man', says Antony's daughter about Roberts. On the English stage, from *Coriolanus* to *Strife*, the common people have been roused or led astray by tribunes of superior ability with an axe to grind.

The truth is that the employers, however thoroughly castigated in the work of Galsworthy and his sympathetic contemporaries are 'we'; the workers, 'they'. Harold Brighouse, makes this clear when he hopes, in the

preface to *The Price of Coal* (1909), that his play will teach his readers to know the miner better and 'discover his simplicity of soul, his directness, his matter of fact self-sacrifice, the unconscious heroism of his life'. [5]

In the 1920s, a number of plays that dealt directly with the conflict of capital and labour took the structure of *Strife* as the model. Echoing the battle of wills between John Anthony and David Roberts, they focused on the contest between well-matched individuals with diametrically opposed opinions. Although the hardships the labourers endure evoke pity, the employers' position is sympathetically articulated. In Ernest Hutchinson's *The Right to Strike* (1920), which ran in the West End for 82 performances, a doctor, whose colleague has been killed in an attempt to bring food to a village starving because of a railway strike, is struck off the register for refusing to operate on the wife of the strike leader. The situation is happily resolved, the complexities of the situation dissipated when the doctor, despite having declared, 'for the right to strike I have sacrificed my livelihood and lost my dearest friend', renounces his determination not to operate because appealed to on grounds of common humanity by his dead colleague's forgiving widow. Sentiment takes over. It is less the right to strike that is promoted than the futility and probable damage of exercising it, which reiterates the comment that ended Galsworthy's play: 'D'you know, Sir, – these terms, they're the *very same* we drew up together, you and I, and put to both sides before the fight began? All this – all this – and – and what for?'

A similar line is followed in Eden Phillpotts's *Yellow Sands* (1926) and John Davison's *Shadows of Strife* (1929), in both of which, moreover, the strike is instigated not by well-meaning demagogues, as in Galsworthy, but by humourless bolshevik agitators. [6]

Industrial action and unemployment occur in another group of plays but as factors in the lives of their working-class participants. D. H. Lawrence's *The Daughter-in-Law* (written 1912), Joe Corrie's *In Time o' Strife* (1927) and Ronald Gow's adaptation of Walter Greenwood's *Love on the Dole* (1934), although different in provenance and performance history, were written from inside the culture they depict and, like the earlier *Alan's Wife*, create an impression of intense realism. *The Daughter-in-Law*, which remained unproduced in Lawrence's lifetime, presents the tensions within a mining family while a strike brews in the background. In *In Time o' Strife* Corrie, a Fife miner, dramatises the experience of the 1926 strike in the Scottish coalfield and the pressure to return to work on men whose families are starving. The amateur Bowhill Players turned themselves into the professional Fife Miner Players in 1929 to tour the play to institutes and music halls throughout Scotland. More conventionally successful, *Love on the Dole*, which introduces victimisation, unemployment and protest action rather than a strike as such, opened at Manchester Repertory Company in 1934 and, subsequently taken on tour, played continuously until the summer of 1937, being staged in London and New York and, under the title *Rêves sans Provisions*, in Paris.

Masters do not figure in the action of these plays, although each takes

conflict between masters and men as axiomatic. The talk of the working-class characters might be ignorant or cogent, comic or desperately serious, according to the insights and attitudes of individual characters but it is between them that lively debates about the rights and wrongs of political action, strike breaking and surrender take place. Leaders come from among the people: Anderson in Corrie's play, Larrie in Gow's, are both thinking socialists who demonstrate clear political insight and make fiercely coherent speeches. The positions of others, for all they are strongly felt, may be much less soundly based:

> TAM: It's the damned Bolshies that's keepin' us frae startin'.
> JOCK: And here's luck to them, says I.
> TAM: And it's them that dinna want to work that's on the pickets.
> JOCK: D'ye mean that I dinna want to work?
> TAM: I never mentioned you.
> JOCK: I was on the picket, and I'm damned sure I'll work beside you ony day.
> TAM: Did I say you couldna?
> JOCK: No, and you better no'. (*In Time o' Strife*, Act II)

The settings are domestic, the Lawrence and the Corrie plays being set entirely indoors in the kitchens of miners' cottages, the Gow mainly so. Instead of stereotypical representations of stage poverty, they contrive to be typical but also distinctive. A water pail and tin drinking mug for dipping, which is a feature of Corrie's set, helps to convey the extremity of deprivation but, for all that, a canary cage hangs in the window and the lad's cherished gramophone is the last item to be pawned. All the miners' cottages have blazing fires, coal at least not being in short supply, but, even there, distinctions are observed: although Mrs Gascoigne's kitchen is 'not poor', it exhibits none of the aspirations to gentility observable in her daughter-in-law's. Gow makes the point in his stage directions that, 'it is important to remember that this is not slum property but the house of a respectable working man' (Act I).

Strike meetings, marches, pickets, take place off-stage in each of these plays, although they are discussed on it. The effects of the struggle impinge on the lives we see and, as in *The Weavers*, the sounds of protest songs, workers marching and political speeches drift in as if from the street outside. Gow's two outdoor settings reveal two opposed aspects of working-class entertainment. First, in the Salford back alley, a row between drunken husband and angry wife gives way to a young couple's surreptitious courting, each pair retreating before a passing policeman. Excitement surges and a crowd gathers when news spreads that young Harry Hardcastle has won £22 on a threepenny street bet from an unlicensed local spiv. Then, the scene having shifted to 'a high rock, against the sky' in the Peak District (the play was written two years after the mass trespass on Kinder Scout), Sally Hardcastle, introduced to the moors by her political activist sweetheart, Larry, expresses a momentary

surge of hope: 'I've never found anything worth believing in Hanky Park. But it's different up here. Here you belong – you belong to something big – something grand' (II.iii).

In both the Corrie and the Gow, as later in Sean O'Casey's rather more expressionistic industrial action plays, *The Star Turns Red* (1940) and *Red Roses for Me* (1943), there is a degree of heroising when the action culminates in disastrous news from off-stage brought to a waiting woman. Anderson, in Corrie's play, gets three years imprisonment for joining the picket of blackleg workers, leaving Kate with a drunken father and small brothers and sisters to support; Larry, more melodramatically in Gow's, is killed attempting to divert a demonstration, leaving Sally hardened and dead to feeling. Although the action of *The Daughter-in-Law* is more private, even here Act IV begins with mother and wife waiting up anxiously for their men to return from activity against blacklegs and, although Mrs Gascoigne's fear ('when I heered that gun, I said: "Theer goes one o' my lads"') proves unfounded, this anti-heroic version of what was to become a recurrent motif contributes to the tension of the scene.

The dramatic reality of the characters is based on the impression of the authenticity of the dialogue. Of course, none of these writers gives an exhaustive account of a dialect: everyday speech cannot simply be transcribed for the stage. It would be far too slow and incoherent a process to permit meaning to emerge in the brief time-span of a play. Shaping, modification, the selection of markers to suggest a speech community, are all elements of even the most realistic-seeming dialogue whether working- or middle-class speakers are represented. The theatrical conventions developed earlier for signalling region and class by certain immediately identifiable and often crude speech markers demonstrate the minor or comic status of their speakers. Working-class speech was indicated by the inclusion of occasional solecisms: the use of 'ain't' for 'isn't'; dropped initial aspirates and final gs to denote generalised urban; substitution of z for s and v for f for generalised rural; and the inclusion of occasional familiar markers such as a reiterated 'sure' to denote Irish, 'bloomin' and 'Lor' bless you' for London. It was indicated, too, by obsequiousness or a chirpy brightness of manner. Such conventionality blocked serious or individualised treatment of character. What is new in the representation of vernacular speech in the plays of Lawrence, Gow and Corrie is that characters' speech is variously marked. The writers work from a basis of experience and observation rather than from the generalised substandard in common use on the stage.

Specific vocabulary is an important element in establishing a credible speech mode. It occurs as characteristic pronunciation or forms of words ('canna', 'dunna', 'axin'); non-standard plurals or verb forms; vernacular expressions ('shilly-shallying', 'get away', 'don't talk daft', 'looney'); trade jargon ('butty', 'day-men', 'hutches') and actual dialect words ('strap' [meaning credit], 'nowt', 'sluther', 'slobber', 'I ken that') which, more or less strongly present according to character, create an impression of individual registers. Divergent syntax is also indicative but operates most

crucially in the incorporation of syntactical patterns (repetition, irrelevancy, redundancy, hesitation, divergent word-order), commonly eliminated from written prose but characteristic of colloquial speech. There is, moreover, a colour and, frequently, a mordant humour lacking in contemporary representations of Standard English. Unwanted pregnancy prompts, 'he'd seen th' blossom i' flower, if he hadna spotted the fruit a-comin' ' and upward mobility, 'thinks I to myself, she's after a town johnny, a Bertie-Willie an' a yard o' cuffs'. There is also recourse to folk sayings, jingles and, particularly in the Corrie, to songs, which increase the liveliness of linguistic texture.

An example of the modification of real working-class speech into dramatic language is apparent in the matter of swearing. In part, this was dictated by the censor: although Eliza Doolittle's single utterance of the word 'bloody' in *Pygmalion* had passed the censor, its unaccustomed use caused a sensation in 1914. When Tom Thomas, rather later, persuaded the Lord Chamberlain that linguistic authenticity demanded some swearing in his adaptation of Tressell's *Ragged Trousered Philanthropists* (1927), they 'compromised on fifteen "bloodys" '.[7] Corrie, while usually avoiding such language, good-humouredly acknowledged its existence in a single exchange:

LIZ: I heard him swearin' the days, maw.
BOB: Wha heard me swearing'?
LIZ: Me
BOB: You're a flamin' wee liar. Where did you hear me swearin'? (Act II)

In *Love on the Dole*, Gow allows the midwife, Mrs Bull, the unusually strong 'You bleedin' little gutter rat! Aye, and take your face inside. You're blocking the traffic in the street.' Superfluous to the plot, this outburst thrown over her shoulder as she enters, suggests the roughness of the Salford streets that lie beyond the Hardcastles' door. Similarly, in the very brief scene in the back alley between the drunk and his wife we find, 'great fat guzzling pig', 'shut your trap will you or I'll break your blasted jaw', 'lousy coward', 'your blasted snout' and 'soaking swine'. Although Mr Hardcastle's speech has a liberal sprinkling of mild oaths, such as 'blasted', Gow suggests his rhythm of belligerence less by this than by the use of negatives and restricted-code declarations: 'I won't have no daughter o' mine ...'; 'I'm shovin' no blasted mill-stone of weekly payments round my neck'.

In Time o' Strife, the most politically committed of these plays, opens with the off-stage singing of 'We'll hang every blackleg to the sour apple tree' but it soon becomes clear that the deprivations of the strike are undermining unity; a breakaway of miners accepting the bosses' shilling is anticipated. The outcome, just as in *Strife*, is a return in defeat; as Jock says, 'we hae got knocked oot again.' But that 'we' is important: the structure of feeling of the play means that the audience participates

in the collapse. The engagement with the lives portrayed is felt as well as known and holds through the unexpectedly up-beat ending in which the mother, responding to distant singing of 'The Red Flag' with a sudden burst of prophetic fire, cries:

> That's the spirit, my he'rties! sing! sing! tho' they hae ye chained to the wheels and the darkness. Sing! tho' they hae ye crushed in the mire. Keep up your he'rts, my laddies, you'll win through yet, for there's nae power on earth can crush the men that can sing on a day like this. (Act III)

In these plays, the conflict of capital and labour is the context of an action remarkable for its close observation of character and place. Raymond Williams's suggestion that Lawrence's plays have 'an intense attachment' to experience which is 'both social and personal' and that they 'engage his audience, in a theatre of ordinary feeling raised to intensity and community by the writing of ordinary speech,'[8] captures something of the truth of this writing which not only breaks away from theatre's usual class base but is simultaneously alert to the individual and the typical. Far from being the simple slice of life Williams's reiteration of 'ordinariness' might suggest, such realism is dense with implication, the effect of rigorous selection and organisation.

The counter-polemic to the bolshevik agitator plays of 1920s mainstream theatre was more open in acknowledging itself partisan. In the wake of the General Strike and the realities of mass unemployment of the early 1930s, radical theatre groups, impatient with a realism that seemed to blur the clear-cut issues of the class struggle, used expressionistic and agitprop techniques as a means of revealing the 'reality existing beneath the polite surface of capitalist society'.[9] New ideas were embraced by Workers' Theatre practitioners. Manchester Theatre Union, London Unity, Merseyside Left Theatre Club, Glasgow Workers' Theatre, were only the most famous of the left theatre groups which spread throughout the country from the late 1920s, until there were some 300 groups operating in the late 1930s. Besides celebrated productions of Clifford Odets's archetypal strike play, *Waiting for Lefty* (by Workers' Theatre groups and Unity Theatre), these companies generated numbers of strike plays of their own.

The issues are markedly similar to those of earlier years: as in Moore's *Strike at Arlingford*, there is fear on the bosses' part of strikes spreading and anxiety among the strike leaders that privation will sap the workers' spirits and lead to breakaway returns or that employers will bring in blacklegs, but there is a novel specificity of information and the perspective is clearly that of the workers. The method is also new. Bosses are caricatured, workers heroised. Statement, declaration and direct questioning of the audience are the favoured means of expression. Song is exploited as a dramatic device and choric speech, group action and stylised gesture emphasise the message. *The Rail Revolt* (1932) offers an insight into the

method. The workers in this snatch respond to news that the directors of the railways have imposed wage cuts:

> 4TH RAILMAN: They're driving us down – down – DOWN.
> ALL: AND ALL THIS TO KEEP UP PROFITS.
> 1ST RAILMAN: They cut down the size of the gangs – less men have to do more work.
> 2ND: They have introduced more and more powerful locomotives – which pull double the load – and locomen are being degraded.
> 3RD: They build coal hoppers to sack hundreds of coalies.
> 4TH: They are introducing automatic carriage washers – and sacking cleaners ...
> 5TH: This is what the Companies are doing – what are we to do? [10]

Expressive staging contributed. An episode in London Unity's 1938 *Busmen*, dramatising the recent unofficial busmen's strike, begins with representative figures of the general public discussing with varying degrees of sympathy the rights and inconveniences of the strike. The impression of a huge march passing is given when these figures respond with gestures of support and cries of wonder to the noise of tramping feet, shouted slogans, and a band playing 'The Internationale', that come over the sound system while shadows, as if of passing crowds and banners, are thrown on to the stage. In Montague Slater's *Stay Down Miner* (Left Theatre, 1936), which dramatises the occupation of pits in the Welsh coalfield, shafts of lantern light suggest the covert nature of a night scene, and snatches of characteristic songs, whether 'Nearer my God to Thee' or 'The Red Flag', breaking out in the darkness, are speedily suppressed. The urgent argument of Bronwen, an elderly miner's wife, that direct action – the derailing of a train – will give the scabs 'the shelter of men's pity' is counter-pointed by the repeated chanting from anonymous voices of 'Stop the ghost train' and 'Pick up your stones' (II.v). Not only Bronwen but all the activists in these plays come, of course, from among the workers. [11]

Many of these pieces have an immediacy which quickens the assault on the audience. The final appeal of *Stay Down Miner* is directed to the auditorium:

> BRONWEN (*to audience*): You people of Cwyllynfach –
> MAGISTRATE: No more speeches please.
> BRONWEN: Tell the world.
> MAGISTRATE: Please –
> BRONWEN: Tell England and Scotland.
> MAGISTRATE: I said no speeches.
> BRONWEN: Tell them to join Wales. (III.v)

In keeping with the claims of *Busmen* to be a Living Newspaper, facts and statistics about wages and working conditions have all been verified. With startling specificity, board members and union officials – including

Ernest Bevin, then President of the TGWU – are portrayed with dialogue derived from their own speeches. This texture of actuality is turned to powerful effect when the workers, Fred, Bob, Tim and Jack, who have functioned as representative busmen in individual episodes of the play, emerge, when called by their full names at the culminating union meeting, as well-known union activists, suspended by the TGWU for leading independent action. Although the play ends, like so many mainstream strike plays, with the protagonists disgusted by the union's compromise with the board, its final lines, like those of Corrie's play, are positive. Fred gains a unified response of 'Yes' when he demands support for the suspended members with his closing cry, 'Unity will secure reinstatements. Defeat the Board and end reaction in the Transport and General Worker's Union. Is it a go, boys?', and they regroup ready to fight another day. [12]

The proliferation, splintering and re-formation of radical theatre groups in the late 1920s and 1930s can seem bewildering, but it was a remarkable area of theatrical activity, although one that has been shockingly neglected in theatre histories until very recently. [13] While much of its output was hasty, ideologically simplistic or clumsily performed, there was life and imaginative energy in both the domestic realism and the agitprop work produced which, in the seriousness of its representation of working-class characters and issues, registered and contributed to a shift in national and cultural consciousness and made a claim to social and political awareness sadly missing from mainstream English theatre.

Notes

1. James Agate, *Sunday Times*, 16 November 1925.
2. Elizabeth Robins and Florence Bell, *Alan's Wife*, Independent Theatre Series (London: Henry and Co., 1893). Reprinted in Linda Fitzsimmons and Viv Gardner (eds), *New Woman Plays* (London: Methuen, 1991). Act references for quotations from readily available plays are noted in the text.
3. Emma Goldman, *The Social Significance of Modern Drama* (1914; New York: Applause Theatre Books, 1987), p. 108.
4. 1931. Included in Ford Maddox Ford, *Memories and Impressions* (London: Penguin, 1979), p. 364.
5. Harold Brighouse, *The Price of Coal* in *Repertory Plays No. 3* (Glasgow: Gowan and Grey, 1911), p. 9.
6. For further information about these plays see Steve Nicholson, 'Bolshevism in Lancashire: British Strike Plays of the 1920s', *New Theatre Quarterly*, vol. 30 (May 1992), pp. 159–66.
7. Tom Thomas, 'A Propertyless Theatre for the Propertyless Class' (1977), in Raphael Samuel, Ewan MacColl and Stuart Cosgrove (eds), *Theatres of the Left, 1880–1935* (London: Routledge, 1985), pp. 77–96, at p. 84.
8. Raymond Williams (ed.), D. H. Lawrence, *Three Plays* (London: Penguin, 1969), Introduction, p. 14.

9. 'Workers' Theatre Movement First National Conference, 25–26 June, 1932', in Samuel et al. (eds), *Theatres of the Left*, pp. 99–105, at p. 101.

10. The text of *The Rail Revolt* is reprinted in Samuel et al. (eds), *Theatres of the Left*, pp. 125–30, at p. 129.

11. Quotations here from the first published version of *Stay Down Miner*, under the title *New Way Wins* (London: Lawrence and Wishart, 1937), p. 45.

12. Quotations here from the version printed in James Allen and Jean Chothia (eds), *Busmen* and *One Third of a Nation* (Nottingham: Nottingham Drama Texts, 1985), scene 24, p. 23.

13. See besides Samuel et al. (eds), *Theatres of the Left*, already cited, the following valuable sources: Jon Clark, Margot Heinemann, David Margolies and Carole Snee (eds), *Culture and Crisis in Britain in the Thirties* (London: Lawrence and Wishart, 1979); Howard Goorney, *Theatre Workshop Story* (London: Methuen, 1981); Howard Goorney and Ewan MacColl (eds), *Agit Prop to Theatre Workshop: Political Playscripts* (Manchester: Manchester University Press, 1986); Linda Mackenney (ed.), Joe Corrie, *Plays Poems and Theatre Writings* (Edinburgh: 7:84 Publications, 1985).

10 LIBERTY OUTSIDE THE LAW

Christopher Hill

From *A Jovial Crew* (1641) to *The Beggar's Opera* (1728)

The Royal Shakespeare Company recently revived Brome's *A Jovial Crew* and Gay's *The Beggar's Opera*. Separated by almost a century, the two plays have much in common: they raise questions about the conflict between liberty and property as a theme in English literature, from the Robin Hood ballads through libertarian pirates to highwaymen who robbed the rich and gave to the poor. How to explain the continuity-in-change of this theme? This article summarises some of the ideas which have occurred to me so far.

The plot is perhaps the least important thing about Brome's play.[1] On the surface it seems an escapist utopian fantasy. Two sisters, tired of life with their melancholy father, Oldrents, persuade their lovers to join a band of beggars with them, to enjoy 'absolute freedom, such as the very beggars have'.

Romance soon ends. The beggars live rough; they are liable to be flogged, their women to be seduced by their betters, for which they are flogged again. The beggars have some freedoms: they escape the slavery of wage labour, and within limits organise their own lives. But they have no political liberty: they are powerless and rightless. Arbitrary brutality is more typical of the society than Oldrents's generosity. So ultimately the lovers decide to quit, disillusioned not with the beggars, for whom they retain affection, but with the harsh reality of their nomadic existence. They return to the comforts of middle-class society. But the play contains a vision of freedom from property-ownership as well as the satirical comparison between courtiers and beggars. The irony in the beggars' claim that lack of property was true freedom, at a time when parliamentarians were insisting on the intimate connection between liberty and property, must be conscious.

A Jovial Crew does not sentimentalise. Only when the beggars are planning their masque do they describe their rather conservative 'Commonwealth utopia', in which there are

No fears of war, or state disturbances,
No alteration in a Common-wealth,
Or innovation.

'Without taxation' they 'lend or give, upon command, the whole/ Strength of our wealth for public benefit' (IV. ii). When the play was

acted in 1641 this must have seemed desperately topical. But when he
wrote it in 1636–7 Brome was criticising existing society rather than
advocating a brave new one. Nevertheless, himself a court dramatist, his
comparison of beggars with courtiers who live off the earnings of others
makes its own point. 'A courtier ... begged till wealth had laden him
with cares' (I. i).

With Charles I's personal rule on the verge of breakdown, Brome
asked questions without supplying answers. Escapism is not enough.
Oldrents's traditional hospitality and generosity to beggars is a sham: his
wealth derives from a swindling ancestor. He himself had an affair with
a beggar girl who produced a son for whom Oldrents did absolutely
nothing: he didn't even know that the girl had given birth. This ambigu-
ity about the virtuous no doubt helps to explain the play's popularity
when it was revived after 1660.[2]

A Jovial Crew, though staged later, was written earlier than the even
more outspoken *The Court Beggar* (played May 1640). The latter is an
unsparing demonstration of the bankruptcy of personal rule, an attack on
all that the court represented. The King is Lord of Beggars: a hierarchy of
scroungers is bleeding the country. In his epilogue Brome made a covert
appeal to Parliament, 'the great assembly'. After this play the actors were
imprisoned and their theatre closed – ten days before the King dissolved
the Short Parliament. Butler sees *The Court Beggar* as 'the tip of an ice-
berg of popular political drama' which has not survived.[3]

A Jovial Crew was staged in the last effective year of the old monarchy;
by 1728 the real ruler was not George II but the Whig magnate Sir Robert
Walpole. In *The Beggar's Opera* the beggars are more professional than in
A Jovial Crew, thieves rather than beggars, better organised as a gang. But
organisation gives power to the boss. In the opening scene Peachum sings

> The statesman because he's so great
> Thinks his trade as honest as mine. (I. i)

Whereas in fact courtiers and officials have to be bribed if honest men
are to get their due (II. v).

> The modes of the court so common are grown
> That a true friend can hardly be met. (III. iv)

There is no loyalty among the great thieves, Lockit stresses:

> Ourselves, like the Great, to secure a retreat,
> When matters require it, must give up our gang ...
> Or instead of the fry
> Even Peachum and I
> Like poor petty rascals might hang, hang (III. xi; cf. ii)

The limit is reached when Peachum's daughter, Polly, proposes to ruin

her financial prospects by marrying the highwayman Macheath (who anyway already has a wife of sorts). Peachum arranges for Macheath to be betrayed and hanged. Macheath's famous comment, 'that Jemmy Twitcher should peach me, I own surprised me ... Even our gang can no more trust one another than other people', refers back to Jemmy Twitcher's only contribution to the opera: 'Are we more dishonest than the rest of mankind? What we win, gentlemen, is our own by the law of arms, and the right of conquest' (II. i).

So the relationship between the governed and their governors is the theme. Direct political satire plays a much bigger part than in *A Jovial Crew*. Money is now decisive. Macheath justified highwaymen who 'have still known enough to break through the corruptions of the world'. But his song in Act III, scene iv,

> Friendship for interest is but a loan,
> Which they let out for what they can get,

is sung to the tune of 'Lillibullero', the Whig theme-song which drummed James II out of the country in 1688 and led to the Revolution settlement. Macheath hopes for release because

> Gold from law can take out the sting;
> And if rich men like us were to swing,
> 'Twould thin the land such numbers to string
> Upon Tyburn tree! (III. xiii)

But he is not rich enough. At the conclusion of the opera the Beggar/author discusses with a Player the moral: 'Do the fine gentlemen imitate the gentlemen of the road, or the gentlemen of the road the fine gentlemen?' His original intention, he says, had been to show that 'the lower sort of people have their vices in a degree as well as the rich. And that *they* are punished for them' (III. xvi, my italics).

The points are pressed home in Gay's sequel, *Polly*. In the West Indies the bawd Mrs Trapes sings

> Morals and honesty leave to the poor
> As they do at London. (I. i)

She is capped by Ducat:

> But even the rich are brave
> When money is at stake. (I. xii)

The native Indians have different standards ('How can you expect anything else from a creature who hath never seen a civilised country?' – II. viii). And Polly confirms 'You may rely upon the prince's word as if he was a poor man' (II. xii). The plantation slaves desert to the pirates (II. viii).

From Custom to Laws

The background to *A Jovial Crew* was two generations of economic
crisis in England. There had been a continuing fall in real wages. The
years between 1620 and 1640 were 'among the most terrible ... through
which the country has ever passed'.[4] England was a corn-importing
country, unable to feed its rapidly growing population. In bad harvest
years (the 1590s, 1620s, 1640s) there were many deaths from starva-
tion. England's basic industry, clothing, suffered from depression and
stagnation when the Thirty Years War (1618–48) cut off the north Ger-
man and Baltic markets for English cloths. An attempt to shift to the
lighter 'new draperies', suitable for export to south European countries,
was frustrated by pirates who dominated the Mediterranean and made
even the English Channel unsafe for English merchantmen. Charles I
ordered English merchants to keep out of the Mediterranean because he
could not provide naval protection there.

By diversifying production through enclosure of waste and common
lands, and by bringing forests and fens under cultivation, England was
ultimately to grow more food. Stuart governments, and agricultural writ-
ers from Blyth to Winstanley, agreed that this was the answer, though
they disagreed about who should profit by the change. These however
were long-term solutions: in the short run enclosure of commons or
forests led to eviction of cottagers and squatters, of commoners when
fens were drained. There were enclosures in Shakespeare's Forest of
Arden during the first half of the seventeenth century, risings against
enclosure in the Midlands in 1606–7 (when the names 'Leveller' and
'Digger' were first used to describe the rebels), repeated revolts in the
South-West in the late 1620s and 1630s. When the royal government
broke down in 1640 anti-enclosure riots followed, all over the country.

The depression in the clothing industry meant that there was no
alternative employment for landless peasants, who had to buy food at
prices which fluctuated wildly, especially in famine years. Vagabonds
were, in Bunyan's expressive phrase, 'kicked to and fro like footballs in
the world'.[5] Roaming bands moved about the countryside, looking hope-
lessly for work, or for a common on which to squat, subsisting by
begging and petty theft. The only solution that governments had to offer
was to flog vagabonds back to the villages from which they had fled.
'England is a prison', said Gerrard Winstanley in 1650, 'and poor men
are the prisoners.'[6] Anyone who *threatened* to run away from his or her
parish could be treated as a vagabond who might be conscripted to
forced labour. This created an under-class of permanent poor, dependent
on charity.

Vagabonds scared their betters. Where the Authorised Version speaks
of a riot being fomented in Thessalonica by 'lewd fellows of the baser
sort', the Geneva version had revealingly translated this as 'vagabonds',
equating them in the margin with the 'very sinks and dunghill knaves of

all towns and cities', who, where 'soever they come, they cause sedition and tumult' (Acts 17. 5). Even Levellers called for laws to reclaim the 'thousands of men and women who are permitted to live in beggary and wickedness all their life long'.[7] In fact joining a group of fellow-victims might seem like liberation. *A Jovial Crew* paints a roseate picture of wandering beggars: but Brome was right to see them as innocent victims rather than as idle trouble-makers.

There was indeed much popular sympathy for the victims of agricultural 'improvement' who had been forced out of their traditional self-sufficient modes of life. Oliver Cromwell first made his reputation as 'Lord of the Fens' by standing up for commoners against the court parasites who were evicting them. When in 1639 Charles I's unwilling army marched northwards to oppose Scottish invaders, the rebellious rank and file sympathetically pulled down hedges around enclosures as well as rails around communion tables in churches.

During the revolutionary decades reformers made suggestions for helping the poor. Peter Chamberlen wanted to set them on work cultivating commons, wastes, forests, heaths, moors and fens, together with confiscated church lands. But – like Blyth and other improvers – he assumed that the profits of these newly cultivated areas would go to private investors. Levellers wanted the poor to choose 'trustees to discover all stocks, houses, lands, etc., which of right belong to them' as well as improving waste lands. There was said to be fear of a Leveller-led rising of the poor in the crisis year 1649. Only Gerrard Winstanley the Digger insisted that waste lands should be communally cultivated, all the profits to be shared equally.[8]

From the late seventeenth century, if not earlier, traditional vails and customary perquisites which had buttressed inadequate wage rates in industry were being replaced by fixed but still inadequate wages. Taking the accustomed perquisites – for example, by dock labourers – was now accounted theft, and led to Tyburn no less than did piracy or highway robbery. Similarly customary rights were being withdrawn in the countryside – to graze cattle on commons, to glean after harvest, to gather furze and wood for fuel, all came to be regarded as theft. The poor no longer had rights in what used to be communal property. Hence hatred of wage labour, and the discipline which enforced it – both regarded as unfreedom.[9] Observation of St Monday as a rest day was a strong working-class tradition, an assertion of freedom at least one day a week. Colliers – social outsiders – insisted on retaining many of the abolished saints' days as non-working days.[10] Freedom had meant escape from the vagabond and settlement laws trying to shore up the decaying village community. Now it meant getting money, for which purpose theft, piracy or highway robbery seemed the most promising methods.

By the beginning of the eighteenth century things had changed. The abolition of feudal tenures (1646, confirmed 1660) gave big landowners absolute ownership of their properties, and so made possible long-term agricultural planning. Failure of the radicals' campaign to win security of

tenure for copyholders meant that tenants could be evicted whenever
this suited landlords' interests. Agriculture became what Edward Thomp-
son described as England's major capitalist industry. The food problem
had been solved: England was now a corn-exporting country. When in
the 1690s there was famine in France and Scotland, there was none in
England. The English navy, now the strongest in the world, was used to
make overseas conquests which rapidly extended the colonial area whose
trade English merchants monopolised, thanks to the Navigation Act of
1651 – also confirmed in 1661.

Compelling the landless poor to accept wage labour as a permanent
system now became an acute problem. Lower-class utopias, from the Land
of Cokayne onwards, had aimed at abolishing wage labour altogether, or
drastically reducing the working day. Many were the jokes by foreigners in
the seventeenth century about Englishmen preferring death to hard
work. [11] As Mandeville put it: 'men who are to remain and end their days
in a laborious, tiresome and painful station of life, the sooner they are put
upon it at first, the more patiently they'll submit to it *for ever after*.' [12] By
the time of *The Beggar's Opera* 'the wandering, masterless men of Eliza-
bethan times had acquired a new visibility as the unemployed poor'. [13]
London's vastly increased prosperity offered pickings for innumerable
sophisticated thieves. Political power now lay with the merchants and
gentry whom Parliament represented, and politics became a battle for jobs
and sinecures between rival groups of politicians and their protégés. The
analogy with beggars was obvious once it was pointed out. There was
nothing to sentimentalise about in the London underworld.

The Freedom of the Outlaw

The years before 1640, which saw a proliferation of roving bands of
vagabonds, also saw wide popularity for ballads about Robin Hood and
his merrie men. Perhaps their carefree life in the greenwood, so different
from the hunted existence of real outlaws, was a romantic fantasy of the
life dreamed of by those who listened to the ballads. Robin Hood,
Maurice Keen suggests, may never have existed, but he embodies 'a
principle ... of social justice'. The many proverbs about him tell us
something about the society. [14] Outlaws in 'the merry greenwood'

> lived by their hands
> Without any lands,

as one ballad put it. There were other ballads about 'banished men', who
through no fault of their own had been outlawed – for example 'The
Nut-Brown Maid': 'I must to the greenwood go ... I am a banished man.'[15]

There were plays about Robin Hood in Henry VIII's reign. Latimer
refers to him in a sermon. [16] He figures in two of the earliest printed
plays in Edward VI's reign, [17] in Greene's *The Pinner of Wakefield*

(1599), William Warner's *Albions England* (1602), Drayton's *Polyolbion* (1613–32), Dekker's *The Welsh Ambassador* (c. 1620) and in Jonson's *The Sad Shepherd* (posthumously printed in 1641). In Peele's *Edward I* Robin Hood of the mountains appears to be a Welsh robber (or an alias for Lluellen Prince of Wales?). [18]

Outlawry may for many have been the price of freedom, of being able to do their own thing: 'out of sight or out of slavery', as the Digger Gerrard Winstanley put it. [19] Robin Hood and his outlaws were said to have strict codes of conduct.

> The widow and the fatherless
> He would send means unto ...
> Nor would he injure husbandmen
> That toiled at cart and plough.

One version of Robin Hood's epitaph said 'He robbed the rich to feed the poor'. That was good sense as well as generous. For

> Robin with his courtesy
> So won the meaner sort

that they would never help to capture him. [20] The outlaws were fiercely anti-clerical. Abbots were the moneylenders of their time: they were fair game. This is echoed by Drayton in *Polyolbion*:

> From wealthy abbots' chests and churls' abundant store
> What oftentimes he took he shared amongst the poor. [21]

Since the clergy in question had been Roman Catholics, this was not unpopular in newly Protestant England. In *A True Tale of Robbin* Robin Hood is said to have gelded all clergy 'that lived in monstrous pride'. [22]

In the ballads the outlaws had no quarrel with the King: all they asked was to be left alone in their freedom. They were not traitors, since they recognised no allegiance to the King. [23] Their enemy was the sheriff, the notoriously venal local representative of the crown trying to force his law on their rural fastness. When it came to a show-down the King was impressed by the outlaws' honest integrity, and took them into his favour. There were thus two Kings. One was the abstract external power in whose name evil local rulers oppressed outlaws and the poor; the other was the human being with whom direct personal contact could be made. We recall the House of Commons in the 1620s insisting on *their* devotion to the King while attacking the 'evil councillors' whom he had chosen.

Ballads idealising sylvan liberty were addressed to an audience of 'freeborn' Englishmen, yeomen and higher ranks. The banished Duke in Shakespeare's *As You Like It* lived in 'the forest of Ardenne, and a many merry men with him; and there they live like the old Robin Hood of England. They say many gentlemen flock to him [the Duke] every day,

and fleet the time carelessly, as they did in the golden world' (I. i).
Rosalind and Celia went 'in content' into the forest, 'to liberty, and not
to banishment' (I. iii). Robin Hood often asked his merrie men, 'What
juster life than ours?'[24] The wise 'wild men' who appear in Elizabethan
and Jacobean pageants make a similar point.[25]

In Massinger's *The Guardian* (licensed 1633) a gang of bandits, os-
tensibly Neapolitan, but explicitly related to 'the courteous English
thieves', occupied the woods. They robbed only four categories: those
who ground the faces of the poor by hoarding grain, enclosers of com-
mons, builders of iron mills who grubbed up forests for fuel, and cheat-
ing shop-keepers and vintners. Among those to be spared were poor
scholars, soldiers, rent-racked farmers, needy market-men, carriers and
above all women.[26] Suckling's *The Goblins* (1638) had a similar band of
outlaws, who were compared to courtiers: 'Begging is but a kind of
robbing the Exchequer.'[27] Other itinerant groups of 'masterless men'
were sentimentalised too – gypsies, for instance. The Lady in the popu-
lar ballad who ran away from her husband to 'the raggle-taggle gypsies'
was no doubt romanticised. But a similar story is told in 'The Gypsy
Countess'.[28] Freedom from the trammels of property and respectability
had its attractions. Cf. Middleton's *The Spanish Gypsy*, 1623 (III. i) –
though these are disguised 'gypsies'. Gypsies were for long anathema to
authority. Statutes of 1530, 1544 and 1563 sentenced them to death.
But Abiezer Coppe in 1649 regarded gypsies as 'mine own brethren and
sisters, flesh of my flesh and as good as the greatest lord in England'.
Coppe 'clipt, hug'd and kissed the … she-gypsies … At that time I
abhorred the thoughts of Ladies'.[29]

During the 1640s 'masterless' itinerants who didn't fit into traditional
social categories – whether disbanded soldiers seeking work or preachers
and seekers looking for converts – were a new phenomenon. Some were
highly articulate: William Erbery, Abiezer Coppe, Lawrence Clarkson
and John Bunyan provide us with some of the best sociological analyses
of the period. The Ranter John Robins and some of his disciples el-
evated Cain, the first vagabond, to be the third person of the Trinity.[30]

Sir Walter Raleigh had stressed the radical associations of Robin
Hood during his trial in 1603: 'a Robin Hood, a Kett, or a Cade'.[31]
Forests and fens were reputed to be the resort of radical religious sects
and of witches.[32] The Isle of Ely was a centre of plebeian irreverence
and resistance before Oliver Cromwell became Lord of the Fens. In the
1640s it was a Seeker centre – the headquarters of William Erbery,
visited by Lawrence Clarkson. Commoners of the Isle of Axholme wel-
comed Leveller support in 1650–51. The Forest of Arden sheltered
blacksmiths and nailers as well as (in the 1640s) Tinker Fox and his
radical Parliamentarian volunteers and Coventry Ranters.[33] The outlaws'
'Lincoln Green' was the Leveller colour in the 1640s, though this is
usually attributed to craftsmen's green aprons. In the eighteenth century
the London Robin Hood Society was a group of radical artisans – anti-
clerical, critical of the Bible.[34]

Highwaymen, Pirates and Smugglers

Highwaymen succeeded to something of the Robin Hood legend. But
the outlaws had been linked together by strong social ties. The highway-
man was an individualist, as befitted a more capitalist society. He might
have assistants, but usually he was a loner. Elizabethan merchants, when
successful, had been credited with the aristocratic virtues;[35] gentlemanly
honourable feelings were attributed to highwaymen. In 1623 a highway-
man died a popular hero for insisting that he had robbed a Spanish
courier only out of hatred of the proposed marriage between Prince
Charles and a Spanish Infanta.[36] A century later a ballad about Dick
Turpin made him say

> The Scriptures I fulfilled
> For when the naked I beheld
> I clothed them with speed.
> The poor I fed, the rich likewise
> I empty sent away.[37]

Many highwaymen in the mid-seventeenth century were, or claimed to
be, former Royalist soldiers ruined for their loyalty to the King. Often
unpaid for long periods, plundering had become for them a habit; when
demobilised with nothing but a horse and a gun, highway robbery was
the natural resort. Two Verney cousins took to the road and were
hanged for it.[38] But even earlier Sir John Falstaff was not ashamed to
take part in highway robbery (1 *Henry IV*, I). 'Captain' Hind, a highway-
man hanged in 1652, cultivated the reputation of being a Royalist. He
too 'robbed the rich to feed the poor'.[39]

Radical Parliamentarians had no sympathy with highwaymen. Both
Lilburne and Winstanley refer to the republican regime as 'the government
of highwaymen'.[40] On the other hand Abiezer Coppe saw God as a high-
way robber, threatening the wicked rich man: 'Thou hast many bags of
money, and behold now I come as a thief in the night, with my sword
drawn in my hand, and like a thief as I am I say, "deliver your purse,
deliver Sirrah! Deliver or I'll cut thy throat!"'[41] Samuel Butler wrote an
ode to the memory of Claude Duval, hanged 1669, though very popular
with the ladies. Butler compared Duval's actions to those of a manorial
lord who in his court

> seized upon
> Whatever happened in his way
> As lawful waif and stray
> And after, by the custom, kept it as his own.

Dealing with lawyers, merchants, priests, he made them

To the smallest piece restore
All that by cheating they had gained before. [42]

In an eighteenth-century ballad Dick Turpin outsmarted a lawyer whom
he had overtaken on the road, and with a trick previously attributed to
Robin Hood, [43]

Turpin robbed him of his store
Because he knew he'd lie for more.

There is a sort of popular Robin Hood-like social justice here: the
highwayman may not give his loot to the poor, but it will circulate more
freely. We recall the radical tract of 1649, *Tyranipocrit Discovered*: 'if the
rulers of this world cannot make all the poor rich, yet they can [make]
the richest poorer ... Their sin is not so much in that some men are too
poor, as it is that some are too rich.' [44]

Another ambiguous occupation was piracy. In the sixteenth century
sea-dogs, plunderers of the Spanish Main, had a patriotic and Protestant
glamour. They brought much-needed bullion from Catholic Spain to Eng-
land. Queen Elizabeth found anti-Spanish pirates useful: she knighted
Drake and Hawkins. James I, less sensitive to public opinion, had Sir
Walter Raleigh executed – it was believed at the behest of Spain. Pirates,
like Robin Hood, saw themselves as rulers of a sphere independent of the
English crown. A ballad from the early seventeenth century, apparently
not published until after 1688, had a pirate boasting:

Tell your king from me
If he reigns king on all the land,
Ward will reign on the sea. [45]

If pirates sometimes plundered English merchants, the latter were mem-
bers of privileged trading companies, profiting by a monopoly at the
expense of the community. Pirates cut out those who had bought privi-
leges from the state. Even after governments at the beginning of the
eighteenth century clamped down on pirates who interfered with English
trade, juries were still sometimes reluctant to convict, and Tyburn
crowds showed some sympathy for a pirate who died well. [46] We may
compare the reluctance of juries to declare unmarried mothers guilty of
infanticide: there may in both instances have been a recognition of
overwhelming pressures bearing down on the accused.

The History of the Pyrates (1724), sometimes attributed to Defoe, is
not necessarily reliable as evidence of what pirates actually did or said.
But it is evidence of what public opinion was prepared to believe. The
author depicted piracy as a 'life of liberty'. One pirate crew was de-
scribed as 'men who were resolved to assert that liberty which God and
nature gave them and are no subjects to any, further than was for the
common good of all'. Captain Bellamy would not 'submit to be governed

by laws which rich men have made for their own security ... They rob the poor under cover of law, forsooth; and we plunder the rich under the protection of our own courage'. [47] One of his crew claimed to have joined 'those marine heroes, the scourge of tyrants and avarice and the true assertors of liberty'.

Pirate crews tended to be composed of men 'deeply alienated from their own societies'. [48] Their discipline, in contrast with that of naval or merchant vessels, was democratic. Like Robin Hood, many pirates were fiercely anti-clerical; they opposed the slave trade and liberated slaves. [49] The point was made by Gay's Polly in the West Indies: 'An open war with the whole world is brave and honourable' – as opposed to a clandestine pilfering war against neighbours in civil society. ' 'Tis only for poor people to be brave and desperate, who cannot afford to live.' [50] The name of the legendary Captain Kidd (*floruit* 1695–1701) was coupled with that of Robin Hood. [51] There was an extensive imaginative literature associated with pirates and their islands, from 1534 onwards down to the utopian settlements of Libertalia and on Madagascar, described in *The History of the Pyrates*. [52]

Smugglers and poachers may be seen as poor men's pirates. They too disregarded the law when supplying cheaper commodities in popular demand. Smuggling was more than tolerated by local opinion. Walpole admitted that the militia would protect rather than suppress smugglers. Twenty thousand people were said to be regularly engaged in smuggling in Sussex and Kent alone. [53] Very respectable characters had no more hesitation about buying goods from smugglers than from poachers, who similarly met local needs by breaking the law at some risk to themselves. 'The Lincolnshire Poacher' asserted his traditional right to take game wherever he found it. ('Bad luck to every magistrate that lives in Lincolnshire'.) [54] Deer stealing, Robin Hood's speciality, had been common during the revolutionary decades. [55]

Robin Hood's outlaws had aspired only to be left alone in their freedom. Gay's beggars and highwaymen intended to beat the monied men at their own game. Political radicals after the defeat of their revolution, like Polly and Mrs Trapes in the early eighteenth century, sought freedom in the New World; but there too the money power had taken over. The slave trade and West Indian sugar plantations were the basis of England's wealth. Some pirates liberated slaves. More, I fear, sold them at a profit. But pirates lost their glamour as England became a West Indian power aspiring to monopolise the slave trade. And by the time we get to stage-coaches highwaymen had become a nuisance, as well as a hindrance to export trade.

'Going Native'

The freedom towards which outlaws, beggars, highwaymen and pirates aspired was neither the constitutional nor the political or religious freedom

which figure so largely in histories of seventeenth-century England. It was freedom to be one's own master, neither a serf nor a wage-slave. The Clubmen who appeared in England during the last years of the Civil War are perhaps less accurately defined as 'neutrals' than as 'contractors-out' from the destructive politics of their rulers. Others had thought that freedom could be won by leaving England. There was, or seemed to be, more freedom in the open spaces of the New World, where outlaws survived longer than in England: their legend lasted as well as did that of Robin Hood in England.

Many who emigrated to Ireland or New England, we should recall, were not volunteers. They may have been taken as servants, or have been shanghaied, or sentenced to transportation: pauper children were shipped off to Virginia. Many emigrants, dissatisfied with continuing subjection, 'went native', finding a freer existence among Irish or Indian communities. Nicholas Canny emphasises that historians of colonial America and early modern Ireland have not appreciated that 'the English poor did not accept the English social and cultural superiority that were expounded by their betters', and were 'so indifferent to the extension of English civility that they happily integrated themselves into the indigenous society'. Some even came near to 'espousing the rights of the indigenous population against the intruders'. Hence the necessity for martial law – 'a feature of colonial settlement in Ireland and Virginia', though in Ireland it applied only to vagrants and masterless men. [56]

A writer of 1615, under the pseudonym 'E. S.', insisted that settlers in Munster must be strictly segregated from the native Irish, to whose 'barbarism' previous settlers had succumbed.[57] So too in New England. Idleness, Professor Morgan reminds us, was 'a masculine virtue among Indians', whereas it was a vice among lower-class Christians.[58] The danger of Thomas Morton's settlement at 'Merrymount' in 1628 was its 'celebration of masterlessness and idolatry' and acceptance of a 'more happy and freer life'. They lived as vagabonds, not cultivating the soil. Plymouth's rulers 'saw they should keep no servants', since the Indian way of life was found 'enormously attractive': more Englishmen chose to live with the Indians than vice versa.[59] People 'delivered' from Indian captivity ran away again. An English serving-woman who had been captured by the Algonquians reported that life with them had been hard but no harder than that of a serving-woman at home. Every colony condemned runaways to whipping, some imposed the death sentence. For centuries the open frontier, like Robin Hood's greenwood, offered release from the slavery of wage labour to the hardy.[60] Joining a pirate crew might equally offer independence to the bold – an opportunity of which some women took advantage.[61] Spanish colonisers faced similar problems. A man who had lived for eight years as a slave in Yucatan refused to be 'liberated': he had married an Indian woman by whom he had three children. A Spanish soldier who deserted to live with the Mayas led his adopted tribe in attacks on his own countrymen.[62]

Occasional Conformity

Discipline for the lower orders in nascent capitalist society could be enforced by wage labour and unemployment, or could be instilled by the religious congregations, which contrasted godly discipline with the licentious liberty that came naturally to fallen man. Paul Seaver has shown how in the 1640s members of the separatist churches were linked by trade, by marriage, by correspondence; the congregations set standards of economic behaviour for their members and offered shelter and protection in time of need.[63]

Contracting out of the state was something that religious heretics had long practised. From Lollards through Familists to Ranters, a popular reaction to the tightening up of religious discipline was quietly to evade it. Hermeticists, Rosicrucians, Familists, Muggletonians outwardly conformed while effectively disregarding the church's demands. When necessary they would make public recantation, and then continue as before.[64] Before 1640, even under Laud, there were still many mansions in the Church of England. In remote Yorkshire the Familist Roger Brearley lived and died a clergyman of the state church: his congregation at Grindleton continued his heresies. John Everard, in and out of prison, still retained his living.

The Protestant principle of the priesthood of all believers was a great liberator once all individual consciences were free to decide for themselves, as within limits they were for a short time after 1640. Congregations could then contract out of the state church, as squatters contracted out of the agrarian economy. After 1660 itinerant preachers were dealt with as vagabonds under the Settlement Acts. Those individuals who were not committed to a particular religious community would perforce have to become members of the Church of England: Milton (perhaps), Wither, Winstanley, Stubbe. Many dissenters advocated occasional conformity with the national church.[65] In 1940, when I was enrolling for the army, the corporal who was filling up our forms announced that the man in front of me 'says he's an atheist, sarge. Put him down C. of E.', was the inevitable reply. Agnostic or atheist were not recognised categories: the C. of E. was still the church of the uncommitted, including unbelievers.

Muggletonians – about whom we know more than about earlier opters-out – evaded the law by mobility, bribery, use of friends, legal stratagems, occasional conformity and other compromises. Since they did not proselytise and had no system of poor relief for members, they had little need for organisation. Their predestinarian beliefs precluded any necessity for martyrdom: suffering was to be avoided whenever possible. They raised flight and evasion to a moral principle.[66] Milton too discussed the legitimacy of prevarication, flight and evasion rather than useless martyrdom.[67]

There was often a great deal of sympathy for religious dissidents. Neighbours covered up for them. Frustrated political radicals who made

their way to North America and the West Indies after 1660 were protected by the local population against the forces of the English state. The regicides William Goffe and Edward Whalley lived for nearly 20 years in hiding in Massachusetts, despite a proffered reward for their capture. In England after 1660 congregations hitherto not organised as 'sects' had to combine in self-defence: Bunyan organised local congregations from jail, where he and many other pastors found themselves.

Sexual Freedom

Last, though not I think least, we may consider sexual freedom. Church and state combined to enforce church marriage as against traditional customary forms of union – handfast marriages, marriage by plighting troth, and many others; and against informal divorce by desertion or wife-sale. The discipline of parish registers and parochial assumption of control over the marriage of the poor complemented the discipline of the market. It was not to the financial advantage of well-to-do parish rulers that paupers should marry and gain a settlement for their unemployable offspring.

With this campaign went an exaggerated denigration of the sexual practices of vagabonds. 'Divers citizens' of Norwich complained in 1570 that beggars 'when their bellies were filled ... fell to lust and concupiscence ... and brought forth bastards in such quantitie that it passed belief'.[68] 'Not one amongst a hundred of them are married', wrote the Kentish landowner Thomas Harman in 1567.[69] It all depends, of course, on what you mean by 'married'. Harman's accounts of vagabonds were extensively copied, and came to be linked with propaganda against 'going native' in Ireland or New England. Of Ireland Sir Henry Sidney reported – no doubt exaggerating – that 'matrimony is no more regarded in effect than conjunction between unreasonable beasts'.[70] Lower-class deserters from the pressed English army in Ireland might be less disapproving; those in Massachusetts who were accused of 'keeping Indian women' may not have recognised the all-importance of church marriage – any more than did the Spaniards who fathered families among Indian tribes.

In *A Jovial Crew* it is the women who feel liberated. The two sisters took the initiative in persuading their men to join the beggars, and they stayed the pace better. A third girl joined them who had eloped with a clerk in order to escape from a marriage being forced on her by her guardian. The beggars have no need for church marriage: their wedding celebrations are conducted by 'parson under-Hedge'. Ladies who deserted their husbands for the gypsies, like Anne Bonny and Mary Read who turned pirate, all expected some sort of liberation. Mary Read thought that plighting troth was 'as good a marriage, in conscience, as if it had been done by a minister in a church'. Anne Bonny changed husbands on the basis of a formally witnessed document. Pirates were notorious for their tolerance of all sorts of sexual freedom.[71] Sex plays little part in the Robin Hood ballads, but Maid Marian is a symbol of

female independence, combined with chastity and loyalty to Robin Hood. [72] The outlaws, the ballads tell us, would never rob from or molest women.

Lollard opposition to church marriage [73] was inherited by some of the sects. Lawrence Clarkson performed his own marriage. [74] He and Coppe preached and apparently practised free love on principle. [75] Marcus Rediker speaks of 'an antinomian disdain for state authority', evident in the 'proletarian practice of self-marriage and self-divorce' of the two women pirates, as against 'the property-preserving marriage-practice of the middle and upper classes'. Pirates also exercised the 'marital liberty' of wife-sale. [76]

Before effective methods of birth control existed, sexual freedom too often turned out to be liberty for men only. As Gerrard Winstanley pointed out, the woman might be left alone to carry the baby. [77] Nevertheless, we should not underestimate the overall liberating effect for women of participation in the discussions and discipline of separatist congregations, and even of preaching. Quaker women missionaries toured the countryside preaching, sometimes unchaperoned; or even risked their lives trying to convert New England Puritans. For a time this opened up new vistas of independence for women.

Secularising Antinomianism

Antinomianism plays a part in our story, though it is too large a subject to be discussed properly. [78] Antinomians saw themselves as outside the laws of God and man rather as outlaws did. Luther's priesthood of all believers (*Ama et fac quod vis*) opened wide doors once it was available for discussion by all men, and women, not merely by the godly. (Who indeed are the godly? Who decides?)

William Perkins claimed that the master of a family might with a good conscience seek for a reasonable measure of wealth. He should follow 'the common judgment and practice of the most frugal, godly and wise men with whom we live'. [79] Milton put it more succinctly: 'The practice of the saints interprets the commandments.' [80] But the inner logic of Protestantism proved uncontrollably individualistic. In the liberty of the 1640s Ranters like Abiezer Coppe and Lawrence Clarkson interpreted the commandments in ways which would have horrified Milton no less than Perkins. Lawrence Clarkson 'apprehended there was no such thing as theft ... but as man made it so'. God had told him to break all the ten commandments except 'Thou shalt do no murder'. ' 'Till you can lie with all women as one woman, and not judge it sin,' Clarkson said, 'you can do nothing but sin.' [81]

Geneva, Scotland and English Puritans all struggled to curb the antinomianism which Luther had unwittingly unleashed, and to enforce godliness. But in the free-for-all of the 1640s this proved impossible. As Richard Baxter pointed out, antinomianism came naturally to the lower

classes. We recall the servant who said: 'I would have the liberty of my conscience, *not* to be catechised in the principles of religion.'[82] The Presbyterian state church set up by Parliament never established effective machinery for enforcing discipline. Nor did the Cromwellian state church. Independent congregations tried to impose discipline on their members, but what sanction had they? Excommunication, which even in pre-revolutionary days had been called 'the rusty sword of the church' was now useless: excommunicates from one congregation simply transferred to another. Contemporaries saw links between the antinomianism of the lower classes and their aptness to go native in the plantations. Thomas Shepard associated the defeat of the Pequot Indians with the prosecution and exile of Mrs Hutchinson and other subversive 'antinomians'. 'Indians and Familists ... arose and fell together.' Some of the latter had refused to serve in the army sent against the Pequots.[83]

The impossibility of determining who the saints were contributed greatly to the Restoration of 1660, and to nonconformist quietism after that date. The congregations could discipline themselves, within limits; they gave solidarity and useful business contacts. But the godly no longer aspired to run the state. Christ's kingdom was demonstrably not of this world. Closet antinomians survived until the eighteenth century: Blake has been described as the last of them, and he consciously inherited from Milton, perhaps from Ranters, a tradition which set men and women free from the law of the state as well as of the church.[84] The ballad which attributed Christian motives to Dick Turpin may link up with this tradition: so may the sympathy for pirates and highwaymen which we have noted. Marcus Rediker described the pirate Captain Bellamy's defence of plundering the rich who robbed the poor as 'the secularised eighteenth-century voice of the radical antinomians who had taken the law into his or her own hands during the English Revolution'.[85]

Some Afterthoughts

Outlaws, pirates, highwaymen, smugglers, poachers and beggars rejected the state and its laws. The lower classes had not much confidence in either. Why should they? Elizabeth's Secretary of State, Sir Thomas Smith, declared that 'no account is made of them, but only to be ruled'.[86] 'The poorer and meaner people have no interest in the commonwealth but only the use of breath', agreed George Monck a century later, who became Duke of Albemarle because he switched sides in time to bring about the Restoration of Charles II in 1660.[87] 'The laws of kings', according to Winstanley, 'have always been made against such actions as the common people were most inclinable to, on purpose to ensnare them into their commissions and courts.' Laws were written in French and Latin 'to keep the common people ignorant of their creation freedoms, lest they should rise to redeem themselves'.[88] Fielding was

being only mildly ironical when he made Jonathan Wild prove from Aristotle that 'the low, mean, useful part of mankind are born slaves to the wills of their superiors and are indeed as much their property as cattle'. [89]

Winstanley's remarks assume the traditional popular theory of the Norman Yoke. [90] Spenser had called the common law 'that which William of Normandy brought in with his conquest and laid upon the neck of England'. [91] Many others besides Winstanley developed the myth in the 1640s. In the eighteenth century the law protected property rights, many of them newly defined to the disadvantage of the lower orders. It appeared at its most bloodthirsty in defence of legislation that violated traditional customs.

The radical revolution was defeated. The Commonwealth suppressed the Levellers in 1649. In 1652 Gerrard Winstanley published *The Law of Freedom in a Platform*, two years after the forcible suppression of the commune that he and other Diggers had established on St George's Hill, Surrey. Its example had been followed by ten or more groups all over the south Midlands, also suppressed. My title contrasted 'law' and 'freedom': Winstanley's 'platform' – that is programme – hoped to bring them together again by abolishing private property. He failed, and was forgotten by history; but his *Law of Freedom* contains an impressive and sophisticated programme, still relevant.

The gloriousness of the 'revolution' of 1688 was that a king was expelled and property secured without any disturbance from the unpropertied. When the old republican Edmund Ludlow returned from 28 years of exile he was immediately hustled out of the country. 'Freedom for all manner of people' [92] was not established.

But 1688 did not satisfy everybody. Scepticism about the state and its laws is reflected in *The Fable of the Bees*, *Moll Flanders* and *Jonathan Wild*. Swift's *Modest Proposal* that Irish pauper children should be served up at the dinner tables of English gentry was a logical conclusion from the view that Irish natives were not really human.

Racialism is still with us; in Great Britain's welfare state homeless people still live rough, and New Age travellers are harassed from pillar to post. But pauper children are no longer shipped off to Commonwealth countries, and no one today congratulates beggars or travellers on their freedom. Progress, I suppose.

Notes

1. My debt throughout to Martin Butler's *Theatre and Crisis, 1632–1642* (1984) will be obvious. He opened my eyes to Brome. I have benefited greatly from the writings of and discussions with Marcus Rediker, Peter Linebaugh and Bridget Hill. Such coherence as this piece has is entirely due to the last-named.
2. Nancy K. Maguire, *Regicide and Restoration: English Tragicomedy, 1660–1671* (1992), p. 95. Pepys loved it.

3. Butler, *Theatre and Crisis*, pp. 135–6, 220–33.
4. P. Bowden, 'Agricultural Prices, Farm Profits and Rents', in J. Thirsk (ed.), *The Agrarian History of England and Wales*, vol. IV, 1500–1600 (1967), pp. 620–1.
5. John Bunyan, *The Desire of the Righteous Granted*, in G. Offor (ed.), *Works* vol. I (1860), p. 759.
6. Gerrard Winstanley, *Works*, ed. G. H. Sabine (1941), p. 361.
7. *The Large Petition* (1647), in W. Haller (ed.), *Tracts on Liberty in the Puritan Revolution, 1638–1647*, vol. III (1933–4), pp. 401, 404–5.
8. H. N. Brailsford, *The Levellers and the English Revolution* (1976), pp. 435, 323, 571–2; Winstanley, *Works*, passim.
9. Peter Linebaugh, *The London Hanged: Crime and Civil Society in the Eighteenth Century* (1991), Chapters 8–12.
10. Christopher Hill, *Society and Puritanism* (1969), pp. 142–6.
11. Anon., *The Worth of a Penny* (1647); B. L. de Auralt, *Lettres sur les Anglais et les Français*, quoted by L. Radzinowicz in *A History of the English Criminal Law*, vol. I (1948), p. 720. See Christopher Hill, *Change and Continuity in Seventeenth-century England* (1991), Chapter 10.
12. Bernard de Mandeville, *The Fable of the Bees*, vol. I (3rd edn, 1724), pp. 328–30. My italics.
13. Joyce Appleby, *Liberalism and Republicanism in the Historical Imagination* (1992), p. 98. See also pp. 54–7 and Chapter 3 passim for the importance of labour discipline.
14. Maurice Keen, *The Outlaws of Medieval England* (1961), pp. 193–214.
15. 'Robin Hood and Maid Marian', in Joseph Ritson (ed.), *Robin Hood: A Collection of Poems, Songs and Ballads* (1884), pp. 83–8, 392; A. T. Quiller-Couch (ed.), *The Oxford Book of Ballads* (1927), pp. 295–307. Cf. the 'banished men' among the outlaws in Shakespeare's *Two Gentlemen of Verona*.
16. Ritson (ed.), *Robin Hood*, pp. 73, 90.
17. L. G. Salingar, 'The Elizabethan Literary Renaissance', in Boris Ford (ed.), *The Age of Shakespeare* (1955), p. 61.
18. Cf. Anthony Munday, *The Downfall of Robert, Earl of Huntingdon* and *The Death of Robert, Earl of Huntingdon* (both 1601).
19. Winstanley, *Works*, p. 359.
20. Matthew Parker, *A True Tale of Robbin* (1631); Captain Charles Johnson, *A General History of the Lives and Adventures of the Most Famous Highwaymen ... and Pyrates* (1736), p. 24.
21. Michael Drayton, *Polyolbion* (1613–22), Song XXVI.
22. Parker, *True Tale of Robbin*.
23. Ritson (ed.), *Robin Hood*, p. 4.
24. Warner, *Albions England*, p. 132; cf. Anthony Munday, 'A Song of Robin Hood', in F. W. Fairholt (ed.), *The Civic Garland* (1845), pp. 15–16.
25. D. M. Bergeron, *English Civic Pageantry* (1971), esp. pp. 56, 71, 82–4.

26. Philip Massinger, *The Guardian*, Act II, scene iii.

27. Sir John Suckling, *The Goblins*, Act IV.

28. *Oxford Book of Ballads*, pp. 781–3.

29. Abiezer Coppe, *A Second Fiery Flying Roule* (1649), in N. Smith (ed.), *A Collection of Ranter Writings* (1983), pp. 106–7.

30. A. Hopton (ed.), *The Declaration of John Robins and Other Writings* (1992), p. 26; see Christopher Hill, *The World Turned Upside Down* (1972), pp. 145–7.

31. *State Trials*, I, p. 212.

32. E.g. Northamptonshire, Pendle and Knaresborough forests (Edward Fairfax, *Daemonologie*, 1621, pp. 34–5). Cf. the enchanted forest in *Comus*.

33. V. H. T. Skipp, 'Economic and Social Change in the Forest of Arden', *American Historical Review*, XVIII, Supplement, pp. 84–111.

34. Richard Lewis, *The Robin Hood Society, A Satire by Peter Pounce* (1756), esp. pp. v–vi, 19, 79. There had been a political and philosophical society called the Robin Hood Club which met in a City tavern in James I's reign (V. L. Pearl, *London and the Outbreak of the Puritan Revolution* [1961]), p. 233.

35. Laura C. Stevenson, *Praise and Paradox: Merchants and Craftsmen in Elizabethan Popular Literature* (1984), Chapter 6.

36. T. Cogswell, *The Blessed Revolution: English Politics and the Coming of War, 1621–1624* (1989), p. 49.

37. Quoted by Linebaugh, *The London Hanged*, pp. 203–4.

38. Margaret E. Verney (ed.), *Memoirs of the Verney Family* (1892–9), vol. IV, pp. 281–92. These pages contain some interesting anecdotes about gentleman highwaymen. Cf. the anonymous *The Triumph of Truth*, in S. Peterson (ed.), *The Counterfeit Lady Unveiled* (1961), pp. 107, 111–12, 130–4, 141.

39. See 'The True Portraiture of Captain James Hind' (?1652), in Samuel Pepys's *Penny Merriments*, ed. R. Thompson (1977), pp. 215–20; Charles Johnson, *A General History ... of the Pyrates* (1972), pp. 87–90.

40. 'The Picture of the Councel of State', in W. Haller and G. Davies (eds), *The Leveller Tracts, 1647–1653* (1944), pp. 205–7; Winstanley, 'The Law of Freedom', in *Works*, p. 529.

41. Coppe, *A Second Fiery Flying Roule*, p. 100.

42. S. Butler, *Poetical Works*, ed. G. Gilfillan, vol. II (1954), pp. 195–9.

43. Johnson, *A General History*, p. 21.

44. Cited in G. Orwell and R. Reynolds (eds), *British Pamphleteers*, I, *From the sixteenth Century to the French Revolution* (1948), p. 107.

45. A. L. Lloyd, *Folk-Song in England* (1975), pp. 259–60.

46. Evelyn Berckman, *Victims of Piracy: The Admiralty Court, 1575–1678* (1975), Chapter 6.

47. Johnson, *A General History*, p. 597; cf. Jemmy Twitcher's remark in *The Beggar's Opera*, quoted above.

48. See 'Radical Pirates?' in Christopher Hill, *People and Ideas in Seven-*

teenth-century England (1986). Cf. Marcus Rediker, ' "Under the Banner of King Death": The Social World of Anglo-American Pirates, 1716–1726', *William and Mary Quarterly*, 3rd series, XXXVIII (1981), pp. 203–27.

49. R. C. Ritchie, *Captain Kidd and the War against the Pirates* (1986), p. 233.

50. John Gay, *Polly: An Opera* (1729), Act II, scene v.

51. W. H. Bonner, *The Life and Legends of Captain Kidd* (1947), p. 203; Ritchie, *Captain Kidd*, passim.

52. See Hill, *People and Ideas*, esp. pp. 175–9.

53. Ian Gilmour, *Riot, Risings and Revolution: Governance and Violence in Eighteenth-century England* (1992), pp. 94–5, 98, 163.

54. R. Bell (ed.), *Ballads and Songs of the Peasantry of England* (n.d.), pp. 216–17.

55. Buchanan Sharp, 'Rural Discontents and the English Revolution', in R. C. Richardson (ed.), *Town and Countryside in the English Revolution* (1992), pp. 267–8.

56. N. Canny, 'The Permissive Frontier: Social Control in English Settlements in Ireland and Virginia, 1550–1650', in K. R. Andrews, N. P. Canny and P. E. Hair (eds), *The Westward Enterprise: English Activities in Ireland, the Atlantic and America, 1480–1650* (1978), pp. 34–6; Ciaran Brady, 'The Framework of Government in Tudor Ireland', in C. Brady and R. Gillespie (eds), *Natives and Newcomers: Essays on the Making of Irish Colonial Society, 1534–1641* (1986), p. 39.

57. N. Canny, 'Edmund Spenser and the Development of an Anglo-Irish Identity', *Yearbook of English Studies*, 13 (1983), pp. 16–17.

58. E. S. Morgan, *American Slavery, American Freedom: The Ordeal of Colonial Virginia* (1975), p. 61.

59. Neal Salisbury, *Manitou and Providence: Indians, Europeans and the Making of New England, 1500–1643* (1982), pp. 160–3, 132–9, 177; R. B. Morris, *Government and Labour in Early America* (1946), pp. 170, 454; K. O. Kupperman, *Settling with the Indians: The Meeting of English and Indian Cultures in America, 1580–1640* (1980), pp. 156–8.

60. Stephen Greenblatt, *Marvellous Possessions: The Wonders of the New World* (1992), pp. 146, 140–1; Marcus Rediker, ' "Good Hands, Stout Heart, and Fast Feet:" The History and Culture of Working People in Early America', *Labour/Le Travaileur*, 10 (1982), pp. 139–42.

61. See p. 124.

62. Greenblatt, *Marvellous Possessions*, pp. 146, 140–1.

63. Seaver, *Wallington's World: A Puritan Artisan in Seventeenth-century London* (1975), passim.

64. Joseph Martin, 'The Elizabethan Familists: A Separatist Group as Perceived by Their Contemporaries', *Baptist Quarterly*, XXIX, no. 6 (1982), pp. 221–8.

65. See Christopher Hill, 'Occasional Conformity and the Grindalian

Tradition' in *Religion and Politics in Seventeenth-century England* (1986).

66. Barry Reay, 'The Muggletonians: An Introductory Survey', in C. Hill, B. Reay and W. Lamont (eds), *The World of the Muggletonians* (1983), pp. 43–6.

67. John Milton, *De Doctrina Christiana*, in *Complete Prose Works* (Yale edn, 1953–82), vol. VI, pp. 605, 762–5, 801. This is one of the many reasons for thinking Milton was the author of the *De Doctrina*.

68. W. Hudson and J. C. Tingey (eds), *Records of the City of Norwich*, vol. II (1910), p. 344.

69. Thomas Harman, *A Caveat for Common Cursitors*, in G. A. Salgado (ed.), *Cony-Catchers and Bawdy Baskets* (1972), pp. 102, 121.

70. Quoted by N. Canny, *The Elizabethan Conquest of Ireland: A Pattern Established, 1565–1576* (1976), pp. 124–7; 'The Ideology of England's Colonization: From Ireland to America', *William and Mary Quarterly*, 3rd series, XXX (1973), pp. 584–5; 'The Anglo–American Colonial Experience', *Historical Journal*, 24 (1981), p. 494. Cf. Lorena S. Walsh, ' "Till Death us do part": Marriage and Family in Seventeenth-century Maryland', in T. W. Tate and D. L. Ammerman (eds), *The Chesapeake in the Seventeenth Century* (1979), pp. 132–40: 'general acceptance of sexual casualness'.

71. Hill, 'Radical Pirates', pp. 165,178, 181; Johnson, *A General History*, pp. 227–8; Ritchie, *Captain Kidd*, pp. 123–4, 258, 270. Cf. 'The Seaman's Song of Captain Ward' (*floruit* 1603–15).

72. One must hope that the lady called Clorinda who appears as Robin Hood's wife in some of the ballads is a fancy name for Maid Marian.

73. Lollard suspects in the diocese of Norwich were routinely asked whether they recognised the necessity of church marriage (N. P. Tanner [ed.], *Heresy Trials in the Diocese of Norwich, 1428–31*, Camden 4th series [1977], pp. 86–95, 111–77, 193–205).

74. A. L. Morton, *The World of the Ranters: Religious Radicalism in the English Revolution* (1970), pp. 122–4.

75. See p. 125–6.

76. Marcus Rediker, 'Liberty beneath the Jolly Roger: The Lives of Anne Bonny and Mary Read, Pirates', in Margaret Creighton and Lisa Norling (eds), *Iron Men, Wooden Women: Gender and Anglo-American Seafaring* (1993).

77. Hill, *The World Turned Upside Down*, p. 319, and references there cited.

78. For antinomianism in the eighteenth century see Peter Linebaugh, 'All the Atlantic Mountains Shook' in G. Eley and W. Hunter (eds), *Revising the English Revolution* (1988).

79. William Perkins, *Workes*, I, p. 769.

80. Milton, *De Doctrina Christiana*, p. 368.

81. Clarkson, *A Single Eye* (1650), passim; *The Lost Sheep Found* (1660; Rota reprint, 1974), pp. 25–6 and passim.

82. *Richard Baxter's Confutation of a Dissertation for the Justification of Infidels* (1654), p. 288; T. Edwards, *Gangraena* (1646), vol. I, p. 106. My italics.

83. M. McGiffert (ed.), *God's Plot: ... the Autobiography and Journal of Thomas Shepard* (1972), pp. 66–8.

84. A. L. Morton, *History and the Imagination* (1990), pp. 124, 134–8.

85. Rediker, 'Liberty beneath the Jolly Roger'.

86. Thomas Smith, *The Commonwealth of England* (1589), Book I, Chapter 24.

87. Monck, *Observations upon Military and Political Affairs* (1671), p. 146.

88. Winstanley, *Works*, pp. 587–9.

89. Henry Fielding, *Jonathan Wild the Great*, in *Works*, ed. G. Saintsbury, vol. X, p. 29.

90. See Hill, *Puritanism and Revolution* (1958), Chapter 3.

91. E. Spenser, *A View of the Present State of Ireland*, in *Works* (Globe edn, 1869), p. 610.

92. Wildman, quoted, with interesting comments, by Dona Torr, *Tom Mann and His Times* (1956), Chapter VII.

11 LOVE OF ENGLAND: PATRIOTISM AND THE MAKING OF VICTORIANISM

John Lucas

'Patriotism. Love of one's country. Zeal for one's country.' The dictionary definition is unexceptional. Yet it masks a difficulty. How can any one feel for so abstract a concept as 'country' or for that matter 'nation'? In practice, of course, no one is expected to. Patriotism is usually identified with iconic images or synecdochic patterns of association; and these images and patterns are then required to function as the emblems or symbols of readily identifiable values. When Eleanor Farjeon asked Edward Thomas why he had decided to fight in the First World War he explained himself by kneeling down, scooping up some earth, and holding it out to her. The gesture is part abashed, part defiant. It also shows Thomas as radical enough not to want to think of patriotism in terms of monarchy. He wasn't fighting for King and Country. The earth is what we all have, or ought to have, in common. 'Nobody can't stop 'ee. It's/ A footpath, right enough', as Thomas's most famous tutelary Englishman says. An earlier generation of Englishmen had, however, sung 'We're soldiers of the Queen', and this points to the intimate connections which existed between Queen and Country in the latter half of the nineteenth century. Indeed, it is possible to go further and say that in this period patriotism – love of England – meant almost exclusively love of England as embodied in and by Victoria. And although there is more than one image by means of which she attains such embodiment – in her reign of over 60 years she moved from being pictured as ardent, young and virginal to the more familiar aged, matriarchal Empress – successive images could be made to incorporate all that was thought proper to patriotic love, especially as they become merged in other significant images: of Liberty and Britannia.

At first glance this may seem embarrassingly obvious. In his recent *Victoria: An Intimate Biography*, Stanley Weintraub states that during her reign Victoria 'became England', a transformation which David Cannadine wittily refers to as 'an anthropomorphic miracle'.[1] Most miracles, however, turn out to have rational explanations, and my present purpose is to try and explain the process by which the Queen became identified as an embodiment of England during the latter half of the nineteenth century. This involves not merely the creation of Victoria as England but of England as Victorian, that is, as a royalist nation. And as soon as we put the matter in these terms we begin to see that, although Victoria's transforma-

tion may not have been miraculous, it was nevertheless achieved against considerable odds. For one thing, before her accession to the throne it seems to have been widely assumed that so progressive a nation as England would follow a pattern developing elsewhere in Europe and become a republic. For another, the construction of patriotism on royalist terms is largely the work of the middle class, who it might have been thought would have had most to gain from the monarchy's disappearance. Victoria's immediate predecessors had been of no use to trade, to the cause of progress, nor to the problems confronting an industrialising nation. George III, George IV and William IV had all been remarkable for their lack of interest in such matters and they were typically and properly regarded as both private nuisances and public dangers.

It may be for this reason that almost from the outset of her reign Victoria was promoted in terms that could be made to fit with middle-class values. Roy Strong notes that in the 'iconography of Victoria and Albert the allusions to the past, to *ancien régime* autocracy, were deliberately muted'. Most iconographic images concentrated on 'a refinement of bourgeois ideals of family life'. [2] And an alternative image of Victoria as Gloriana or medieval queen, to which Mark Girouard draws attention, is not difficult to reconcile with middle-class interests. [3] Altogether more contentious is the identification of Victoria as Britannia and as Liberty. Yet it is precisely this triune figure, produced not so much by way of specific pictorial images, although they occur, as by growing habits of association, which comes to be treated during the latter half of the nineteenth century as an object of love and even veneration. Victoria as Liberty may be under threat and so command deferential awe. In *Monuments and Maidens* Marina Warner remarks on the fact that after 1821 the images of Britannia on coins included Pallas Athena's helmet, and notes that this 'military aspect persisted throughout the nineteenth century'. [4] And I will add that, in this context, the image of Britannia may then be buttressed by that of Boadicea, and that in Tennyson's poem of 1859 (the year is significant for reasons that will later become apparent) he has Boadicea apostrophise herself as 'the lover of liberty'. [5] A complex female figure is produced as the emblem of England and of what are identified as English values.

Before Victoria's accession to the throne many contemporaries took for granted the prophecy that she would live to be 'plain Miss Guelph'. [6] By the time of her death the possibility of England becoming a republic had virtually disappeared. We can measure just how extraordinary this transformation of the monarchy's fortunes was if we note that the years of her reign became universally referred to as the Victorian Age. Raymond Williams has rightly criticised the English habit of periodising history by reference to the names of monarchs, but this is a distinctively modern enterprise. The English who lived in the latter half of the sixteenth century didn't go around calling themselves Elizabethans. They were first called that in 1815. But the term 'Victorian' was first used in 1875, at least according to the *OED*, which defines the word as 'a

person who lived in or has the characteristics typical of the reign of Queen Victoria'. Although David Cannadine makes no mention of this in his celebrated essay 'The Context, Performance and Meaning of Ritual: the British Monarchy and the "Invention of Tradition" 1820–1977', it may seem to help his argument that only in the 1870s did Victoria come to be considered as somehow 'above' politics and therefore capable of being an embodiment of England as a whole. It is undoubtedly true that in the period after Disraeli made her Empress of India England becomes marked with statues of her as well as with halls, parks, theatres and railway stations named after her. Before that, Cannadine claims, there was a much more contested view of the monarch, one she inherited from George IV ('What eye has wept for him? What heart has heaved one throb of unmercenary sorrow?' *The Times* famously asked on Prinny's death) and also from her uncle, William IV, whom Norman Gash characterises as a much resented meddler in political matters. [7]

No wonder, Cannadine argues, that Victoria's coronation should have been such a muffled, even shabby affair. He has great fun unwrapping its sorry details from Elizabeth Longford's hagiographic prose. The royal carriage looked far from splendid, the National Anthem wasn't sung, the man in charge of music, Sir George Smart, was quite stupendously incompetent, the clergy lost their place in the order of service, various attendants fell over their own and others' robes, the Archbishop of Canterbury screwed the ring on to Victoria's wrong finger; and two of the train-bearers talked throughout the entire ceremony. [8] For Cannadine, 1837 inaugurates a succession of comically insufficient rituals, all of them suggesting that nobody knew quite what to do about royalty. Except, that is, for Gladstone. Cannadine makes much of Gladstone's frustration at Victoria's refusal to appear in public after Albert's death in 1861, and he suggests that what worried him was the fear of growing republican sympathies across England. Cannadine points to the fact that during the 1870s there were an increasing number of Radical Republican Societies, and I know of the existence of several scurrilous – and unfortunately mostly inept and boring – satires on the monarchy. [9] But these are too few bricks with which to build a house for republicanism. I don't doubt that Gladstone fed fears (he may even have felt them); what needs explaining is why he should have done so.

It is reasonable to suppose that the Whigs and even a sizeable number of Tories would be unconcerned about the loss of the monarchy. What good did its retention do them? Little enough, it might seem. The monarchy wasn't of true 'English' descent and it was distressingly vulgar, or had been so since the turn of the century. Besides, the London through which Victoria drove to her coronation was a city whose wealth reflected not state power – as Anne's London had done and as for example Ringstrasse Vienna or Haussmann's Paris were to do – but private wealth. Yet monarchy could also be a way of legitimising such wealth, by ensuring that patriotism was the expression of a united nation and that rival class interests, which might otherwise threaten

wealth and the status of those who benefited by it, could thus be suppressed. That was why it was so important to promote images of the monarchy as 'above' politics or party interest and as reconciling opposing points of view in a single, seamless concept of 'Englishness'. In this sense you could say that Victoria became all things to all Englishmen (or Britons), and that those who refused to accept as much were not true Englishmen (or Britons) at all.

Where then might these potential traitors be found? The answer is obvious enough. The two seedbeds of treason were class and regionalism, and cross-pollination was by no means unusual. In *Sylvia's Lovers* (1863) Daniel Robson, who as so often with Elizabeth Gaskell's anti-heroes is allowed to put a compelling case for the opposition, remarks, 'Nation theer! I'm a man and you're another, but nation's nowhere ... nation, go hang' (Chapter 4). The remark prompts two reflections. First, Robson's essentially working-class distrust of appeals to patriotism suggests that Gaskell is alert to the fear articulated by James Mill in 1826, when he remarked: 'The classes, which the system of society makes subordinate, have little reason to put faith in any of the maxims which the same system of society may have established as principles.' [10] Second, Robson's is the voice of regionalism; and there can be no doubt that throughout the nineteenth century a perceived threat to what might be called national interest lay in competing regional interests, a matter developed by John Langton in an important essay on 'The Industrial Revolution and the Regional Geography of England'. [11] It is often argued that the modern state is characterised by fear of the enemy without, or beyond the border. But the enemy within remains a real threat, hence the desire of those who have hegemonic control to produce a concept of nationhood whose actual exclusivity pretends to a true inclusiveness. To be against this is, then, to be a traitor, or at the very least to be unpatriotic. But then comes the problem and its resolution. To combat class or regional interest by appeal to the abstract idea of 'nation', 'country' or 'England' is far from easy; to confront it with the image of a woman, now warrior-like, now vulnerable, is a very different matter. My suggestion is that long before the 1870s (long before the moment at which Cannadine thinks he can detect 'the growth in popular veneration for the monarchy') [12] Victoria was being produced in a manner that could easily be used by interested parties to affirm her as the embodiment of the nation. In the epilogue to his *Idylls of the King* (1873) Tennyson wrote of how the Queen, with the Prince of Wales, passed 'through thy people and their love,/ And London rolled one tide of joy through all/ Her trebled millions'. If Cannadine were to take note of this he would have to read it as indicating a transformation in popular feeling (always supposing Tennyson to be reflecting that and not indulging in wishful thinking). My own conviction is that the words merely confirm the prior existence of that feeling: Tennyson is drawing attention to an obvious phenomenon, the monarchy's widespread popularity.

Yet obviously a largely middle-class desire to produce a seamless image of nationhood had to be worked at; it couldn't be taken for granted. Quite

apart from well-attested aristocratic indifference to and contempt for the
royal line from which Victoria descended, there was the fear of outright
working-class hostility to the monarchy, especially in those instances
where radicalism and republicanism linked up with regionalism. The diffi-
culty, of course, is to know about the frequency of those instances. Just
how widespread were they? In his *Radicals, Secularists and Republicans*,
Edward Royle traces the evolution of various small, provincial republican
sects through the late years of the nineteenth century, all of them passion-
ately anti-monarchical, none of them, as far as can be estimated, having
much influence beyond their immediate intellectual membership. Nor did
they last for long. To take a key example, Royle refers to the founding of
'about two-dozen republican societies in the provinces' in 1871, but this
seems to have been in response to specific grievances, in particular those
prompted by parliamentary agitation against what were seen as excessively
generous allowances proposed for members of the Royal Family. It soon
died down, and it is possible that the dream of republicanism died with
it. [13] At all events, Gladstone's 'fears' of what these societies might
portend were almost certainly overstated as a way of recalling the Queen
from private grief to public duty.

This brings me to an important point. According to Eric Hobsbawm,
socialist historians have taken insufficient notice of working-class patriot-
ism, which he argues has always been more widespread than we have
wanted to accept. In an essay in *Marxism Today*, in January 1983,
Hobsbawm sets out to explain why the Falklands conflict proved so pop-
ular a cause. 'Patriotism', he says, 'cannot be neglected.' And he goes on:

> The British working-class has a long tradition of patriotism which
> was not always considered incompatible with a strong and militant
> class consciousness. In the history of Chartism, and the great radical
> movements in the early nineteenth century, we tend to stress con-
> sciousness. But when in the 1860s one of the few British workers
> actually to write about the working class, Thomas Wright the 'jour-
> neyman engineer', wrote a guide to the British working class for
> middle-class readers, because some of these workers were about to
> be given the vote, he gave an interesting thumbnail sketch of the
> various generations of workers he'd known as a skilled engineer.
>
> When he came to the Chartist generation, the people who had
> been born in the early nineteenth century, he noted that they hated
> anything to do with the upper classes, and would not trust them an
> inch. They refused to have anything to do with what we would call
> the class enemy. At the same time, he observed that they were
> strongly patriotic, strongly anti-foreign and particularly anti-French.
> They were people who had been brought up in their childhood in the
> anti-Napoleonic wars. Historians tend to stress the Jacobin element
> in British labour during these wars and not the anti-French element
> which also had popular roots. I'm simply saying that you cannot
> write Patriotism out of the scenario even in the most radical period

of the English working class ... Throughout the nineteenth century there was a very general admiration of the navy as an institution, much more so than the army. You can still see it in all the public houses named after Lord Nelson, a genuinely popular figure. [14]

I am not here to defend Hobsbawm's argument, least of all his implied suggestion that working-class patriotism can be detected in the readiness of working men to drink in pubs called after admirals. (Imagine the response of magistrates asked to license pubs called the Wat Tyler, say, or the Tom Paine.) Nevertheless, he is surely correct in seeing a connection between patriotism and anti-French feeling, and although he doesn't link that with monarchism, he might well have done so. We can see just how important this link is if we pause for a moment on George Cruikshank's engraving, 'Death or Liberty! or Britannia and the Virtues of the Constitution in Danger of Violation from the Gt. Political Libertine, Radical Reform', for it perfectly emblematises the early importance of this link. Cruikshank produced this work at the end of 1819, the year of Peterloo and, as it happens, the year of the birth of Princess Victoria. One element of the constitution in particular danger was, of course, the monarchy, simply because it had fallen into such disrepute. Cruikshank sensibly chooses not to make direct reference either to George III, that 'old, mad, blind, despised and dying king', as Shelley called him, or to his son, the even more despised Prince Regent. Even so, his figure of Britannia bears the royal motto 'Dieu et mon Droit'; and she shrinks back upon the rock of the Anglican Church, while the lion Loyalty bounds forward to save her from the would-be ravisher Radical Reform, whose French connections are unmistakable. His genitalia are made up of the spear and the drum so often associated with Jacobinism. In his left hand he bears the rod of Liberty, and on top of this sits the cap of Liberty in the act of turning into a dunce's cap. Behind him is his hellish brood, including Murder, Starvation, Slavery, Paine's *Age of Reason*, and Blasphemy. Cruikshank's Liberty thus equals Britannia equals constitutional monarchy and is deliberately opposed to Liberty as Marianne as Republicanism.

To appreciate the full political significance of this we need to go back two years. At the end of 1817 Shelley had written an obituary for Liberty in apparently mourning the death in childbirth of the Princess Charlotte, whom many had hoped would be a true queen for her people. Her death occurred on 6 November 1817. The following day Jeremiah Brandreth, William Turner and Isaac Ludlum were executed for high treason at Derby. They had been found guilty of acting as ringleaders for an abortive rising in Derbyshire the previous June. In his 'Address to the People on the Death of the Princess Charlotte' Shelley writes:

A beautiful Princess is dead:— she who should have been Queen of her beloved Nation, and whose posterity should have ruled for ever ... LIBERTY is dead ... Let us follow the corpse of British Liberty

slowly and reverentially to its tomb: and if some glorious Phantom should appear, and make its throne of broken swords and sceptres and royal crowns trampled in the dust, let us say that the Spirit of Liberty has arisen from its grave and left all that was gross and mortal there, and kneel down and worship it as our Queen.[15]

Needless to say, this Address was never distributed, any more than the Phantom rose from its tomb, although in his 'Sonnet: England in 1819' Shelley repeated his hope that it would 'Burst, to illumine our tempestuous day', and in his own radical version of the national anthem wrote:

> God Prosper, speed and save
> God raise from England's grave,
> Her murdered Queen.
> Pave with swift victory
> The steps of Liberty,
> Whom Britons own to be
> Immortal Queen.

What actually happened was, of course, very different. In *The Great Arch: English Formation as Cultural Revolution*, Philip Corrigan and Derek Sayer note that during the period 1780–1830 'the most comprehensive battery of legislative, practical and other regulatory devices against the emerging working-class is also ... established'.[16] They are referring to what E. P. Thompson has defined as the 'making' of the English working class, and this includes the making of Francophobia as a means of challenging republican concepts of liberty,[17] even while liberty is taken away from the working people. Indeed Francophobia became so inscribed in the social process that in 1833 Edward Bulwer-Lytton, in his *England and the English*, could feel able to announce that *'We no longer hate the French.'* This disavowal may in part be explained by the fact that the work is dedicated to 'his Excellency, the Prince Talleyrand', as may Bulwer's insistence that 'On the whole ... a hatred of foreigners has ceased to distinguish us; and of the two extremes, we must guard rather against a desire of imitating our neighbours, than a horror of resembling.'[18] Small chance of that! In an important essay called 'Anti-French Propaganda and British Liberal Nationalism in the Early nineteenth Century', Gerald Newman establishes just how closely tied to developing middle-class consciousness Francophobia was.[19] And Victor Kiernan, in a challenging contribution to *Rebels and Their Causes*, argues that although in the 1830s and 1840s some working-class groups wanted to 'use their power to transform society as well as government', they were defeated both by the events of 1848, especially the utter failure of the third presentation of the Charter, and by what Kiernan calls 'the ideology of Nation and State'.[20]

And here we come to the crux of the matter. In the 1850s such an ideology grew fat on a succession of French invasion scares, especially

those of 1852–53 and 1859. These scares were out of all proportion to reality. They were, however, assiduously fed, in the first instance by Palmerston, who early in 1853 announced in the House that it was quite likely that 'all England might waken up some morning to find that 50,000 Frenchmen had landed on her shores in the course of the previous night'.[21] A minority of MPs, chief among them Cobden, were unimpressed, but Palmerston knew what he was doing. Anti-French feeling took hold like a fever. Tennyson was already a victim. In 1852 the Poet Laureate had urged 'big limbed yeomen' to 'leave awhile / The fattening of your cattle; / And if indeed ye long for peace, / Make ready to do battle' ('The Penny-wise'). He also warned that ' "Vive l'Empereur" may follow by and bye', although he claimed that

> 'God save the Queen' is here a truer cry,
> God save the Nation,
> The toleration,
> And the free speech that makes a Briton known.
> Britons, guard your own.
> ('Britons, Guard Your Own')

In 1859 he returned to the subject:

> Form, be ready to do or die!
> Form in Freedom's name and the Queen's!
> True we have got ... *such* a faithful ally
> That only the Devil can tell what he means.
> Form, Form, Riflemen Form!
> Ready, be ready to meet the storm!
> Riflemen, Riflemen, Riflemen, form!

The poem was published in *The Times* under the title of 'The War'. Not long afterwards, Victoria reviewed the Scottish volunteers in Holyrood Park, Edinburgh (they were soldiers who had vowed themselves ready to fight the French whenever and wherever the expected invasion should occur) and 'a crowd of a hundred thousand "made the welkin ring with their reiterated cheers"'.[22] This is Cruikshank's vision made flesh. Victoria is to be adored and defended as the embodiment of Liberty, adored and championed as the embodiment of Britannia. Above all, she is to be saved from the papistic and priapic, if no longer republican, French. This is what love of England now means.

But this act of allegiance in 1859 would not have been possible without years of assiduous image-making, years in which Victoria was gradually turned into the triune figure. To some extent this was bound 'naturally' to occur. The majority of people left outside 'Society', or even groups with particular disadvantages, always nurture unrealistic if understandable hopes that some magical figure will come to power in order to lift them to favour. Hence, as we have already seen, the adulation of

Princess Charlotte. Hence the later appeal of that Prince of Wales who was to become Edward VIII, and whose visit to the South Wales mining areas prompted hopes of royal help for the workers ('Something must be done'). And in our own day Prince Charles visits the inner cities. It is not therefore surprising that at the time Victoria mounted the throne a number of street ballads confidently predicted ways in which she would become the champion of the poor.[23] It may even be possible to detect in such ballads an implicit threat: she'd better be, or else. And this, I think, goes some way towards explaining that working-class patriotism to which Hobsbawm draws attention and which can so be so often and so dishonestly turned into xenophobia.

But if all this is natural it is also, always, bound to be an expression of hopes that turn sour. For Victoria to emerge as 'England' something else was therefore needed and I suggest that it was supplied by that powerful middle-class desire to stabilise the concept of a unitary nation, one from which all signs of class struggle or party conflict would be banished.[24] Previous monarchs had served or been at the mercy of party; once produce Victoria as 'above politics' and she becomes a queen to the entire nation. A basically Whig view of history as an unfolding process and progress can then paradoxically be held to be consistent with that supreme anachronism, a monarchy. Victoria herself was quick to realise this. In a letter to Prince Albert, just before their marriage in 1840, she tells him that

> The Tories really are very astonishing; as they cannot and dare not attack us in Parliament, they do everything that they can do to be personally rude to me ... The Whigs are the only safe and loyal people, and the Radicals will also rally round their Queen to protect her from the Tories.[25]

Soon after their marriage, she is on trains (the first royal train was created in 1840 for the Queen Dowager Adelaide, and other followed), being sent about England on a succession of Royal Progresses. Much of this showing forth seems to have been the idea of Albert, who had a shrewd sense of what was needed. It was he who extended Buckingham Palace, adding a new wing in 1846, and a new ballroom ten years later (so that it could be a better social meeting place), he who bought the Balmoral estate in 1848 and who supervised the building of its castle (the Royal Family could then be seen to be among its Scottish people, could be thought of as truly British). Equally important, he becomes a confident, even aggressive, champion of art and especially of the manufacturing arts, in a manner that very specifically aligns him with emergent middle-class taste, as the frequent references in the *Art Journal* of the 1840s and 1850s to his purchases make clear.[26]

Most important of all, however, was the Prince Regent's involvement with the planning of the Great Exhibition, a matter which Cannadine conveniently forgets in his desire to uphold the image of a reclusive and

unpopular Queen (which may be why he also forgets the naming of the State of Victoria in 1851 and of the Victoria Falls four years later; and what of the formal portraits that soon began to appear and to be copied? and of the coinage? and of the postage stamps?). The Exhibition was opened on 1 May 1851, and in his prayer the Archbishop of Canterbury was able to assure God that 'Of Thee it cometh that violence is not heard in our Land, wasting nor destruction within its borders ... it is of Thee that there is peace within our walls and plenteousness within our palaces'. As Eric de Maré remarks in his account of the Exhibition, 'the Deity was clearly on the side of expanding markets'. [27] The ceremony with which the Exhibition opened was almost as impressive as the efforts to safeguard it against trouble from unruly elements. The widening of the streets around Hyde Park made it easier for cavalry to ride abreast in the event of riots, which there was reason to fear might occur. As the Duke of Wellington growled, 'glass is damned thin stuff'. [28] But the almost 'religious fervour' of the occasion was undisturbed.[29] And when, later that year, Victoria visited Manchester, she noted that although the population was

> painfully unhealthy-looking ... The streets were immensely full and the cheering and enthusiasm most gratifying ... Nobody moved, and therefore everybody saw well, and there was no squeezing ... everyone says that in no other town could one depend so entirely upon the quiet and orderly behaviour of the people as in Manchester. You had only to tell them what ought to be done, and it was sure to be carried out. [30]

It looks as though in his poem 'To the Queen', Tennyson's first offering as Poet Laureate, written in March 1851, he speaks a kind of truth when he imagines Victoria's children's children saying that:

> Statesmen at her council met
> Who knew the seasons when to take
> Occasion by the hand, and make
> The bounds of freedom wider yet
> By shaping some august decree,
> Which kept her throne unshaken still,
> Broad-based upon the people's will,
> And compassed by the inviolate sea.

The accord between queen and country is further enhanced by the fact that, in Kiernan's words:

> During the Crimean War, for the first time in English History, soldiers of all ranks were collected to shake hands with their sovereign and receive their medals from her. As she wrote lyrically to her Uncle Leopold, it was an exalting experience to feel 'the rough hand of the

brave and honest private soldier. Noble fellows. I own I feel as they were my own children; my heart beats for them as for my nearest and dearest.'[31]

The Victoria Cross was instituted in 1856 and quickly became the most coveted of all medals. 'All ranks in all services, and even civilians, were eligible,' says an historian of the Victorian Army, but as there was a tendency not to award it to senior officers, in order to discourage them from 'unnecessary displays of valour', the ordinary soldier could, for the first time, be singled out for the highest of all military honours, as a reward for fighting for his monarch.[32]

The image of the single nation, unified under its loved queen, might appear to be most completely realised in a single episode: that of Dickens's visit in 1860 to the Hoxton Britannia Music Hall, where he and a vast audience were entertained to a show in which

The Spirit of Liberty was the principal personage in the Introduction, and the Four Quarters of the World came out of the Globe, glittering, and discovered the Spirit, who sang charmingly. We were delighted to understand that there was no liberty anywhere but among ourselves, and we highly applauded the agreeable fact.[33]

The spirit of Liberty was, of course, dressed as a queen.

Yet I do not want to subscribe to Kiernan's view, which this moment may seem to support, that after 1848 'labourism' replaces thorough-going radicalism – including democratic republicanism – as the focus of working-class politics.[34] Nor can I agree with Gareth Stedman Jones's belief that you can read into the music hall the culture of consolation which he outlines in his influential and, I think, profoundly mistaken 'Working-class Culture and Working-class Politics in London, 1780–1890'. According to Stedman Jones, 'Music-hall was both a reflection and a reinforcement of the major trends in London working-class life from the 1870s to the 1900s … Music-hall was a participatory form of leisure activity, but not a demanding one.'[35] The major point Stedman Jones overlooks, or does not understand, is that although music hall was *for* the people it was, after its earliest years, neither *by* nor *of* them. In his 'Politics as Entertainment: Victorian Music-Hall Songs', Laurence Senelick proves conclusively that:

Although most of the performers were born in the lower ranks of society, the composers and lyricists were more frequently of the lower middle-class and nursed upward aspirations; while the theatrical managers, who strongly dictated what was to be seen on their stages, were too much allied with monied interests to be overly sympathetic to the working man's concerns.[36]

Senelick is probably wrong to argue that 'It must be recognised that, if music-hall failed to speak for the people, it could be a valuable tool in

moulding their political temper,'[37] but it is vital to see that you cannot treat music hall as *vox populi*, and this should be obvious as soon as you find Max Beerbohm, T. S. Eliot and John Betjeman agreeing that you *can*. 'Soldiers of the Queen' (1881) was sung *at* working men. How far it was sung by them, and whether it was assentingly or tongue-in-cheek, is a different matter and one I cannot begin to examine here. But both Senelick and Penelope Summerfield[38] have done much to explode the idea that music hall was in any simple way representative of working-class opinion or could be said to have shaped it, which was what J. A. Hobson believed.

In 1901, Hobson set himself the task of explaining how and why the nation had been gripped by jingoism at the time of the Boer War. His resulting book, *The Psychology of Jingoism*, points an accusing finger at music hall: 'the glorification of brute force and an ignorant contempt for foreigners are ever-present factors which at great political crises make the music-hall a very serviceable engine for generating military passion.'[39] Hobson might well have added that generating enthusiasm for the monarchy was every bit as much the work of music hall. At all events, songs and comic routines celebrating royalty cropped up with regular frequency and probably greatly outnumbered those 'generating military passion', although as 'Soldiers of the Queen' demonstrates, the two frequently coincided.

There is, however, a difficulty with Hobson's argument, attractive as it may seem. Long before the late 1890s, music halls had become 'respectable'. Managers and licensees were keen not to offend magistrates, who had the power to close 'rowdy' halls – and, of course, the apparent reason for a hall falling into disfavour (drunkenness) usually masked a deeper reason (its tolerance of radical opinion). Penelope Summerfield sets out the complex history of this evolution towards respectability in her brilliant essay 'The Effingham Arms and the Empire: Deliberate Selection in the Evolution of Music Hall in London' and, as she says, by the end of the century 'the theatres of variety allowed little scope for the alternative views to the Establishment conservative one'.[40] When it is then remembered that performers had to submit material to management for approval, and bearing in mind the pressures on management to play safe, it would be very unwise to conclude, as Hobson did and as Stedman Jones and others have done, that music-hall sentiment proves the death of republicanism among the working class. What must be accepted is that Corrigan and Sayer's 'Great Arch' had become by the end of the century so complete that it was very difficult to escape from its giant, oppressive shadow. On the other hand, to see how it was built up, and in particular to note the ways in which monarchy was cemented in as a kind of keystone, ought to help those of us on the left to combat that defeatism, the belief that 'things are what they are', always have been, always will be, which is a very worrying feature of much contemporary thought, even that which claims to come from the left.

Notes

1. David Cannadine, 'The Brass-Tacks Queen', *New York Review of Books*, 23 April 1987, pp. 30–1.
2. Roy Strong, *And When Did You Last See Your Father: the Victorian Painter and British History* (London, 1978), p. 44.
3. Mark Girouard, *The Return to Camelot: Chivalry and the English Gentleman* (New Haven, 1976). See esp. pp. 11–128 where Girouard spends much time in tracing the participation of Queen and Consort in chivalric events, and more generally, in teasing out their commitment to chivalry. Such fake medievalism or Renaissance taste is the more readily identifiable with mid-nineteenth century developments as soon as it is seen in the context of Young England, of the public school and (even) of muscular Christianity and Christian socialism.
4. Marina Warner, *Monuments and Maidens: The Allegory of the Female Form* (London, 1987), p. 48. However, the monument to Nelson at Great Yarmouth, dated 1817, has at its top a helmeted Britannia.
5. Christopher Ricks says that the poem was 'precipitated by an engraving of Thomas Stothard's Boadicea haranguing the Britons (1816), which Thomas Woolner sent to Tennyson 12 Feb. 1859.' See Christopher Ricks (ed.), *The Poems of Tennyson* (London, 1969), p. 148. Presumably Woolner thought the painting apt for the moment.
6. See for example John Wardroper, *Kings, Lords and Wicked Levellers* (London, 1973), pp. 239–40.
7. See also the same author's *Aristocracy and People* (London, 1979), esp. pp. 159–60, where Gash makes clear his belief that William was the last monarch of his kind and that had Victoria attempted to follow his ways she would not have lasted long.
8. See David Cannadine, 'The Context, Performance and Meaning of Ritual: The British Monarchy and the "Invention of Tradition", c.1820–1977', in Eric Hobsbawm and Terence Ranger (eds), *The Invention of Tradition* (Cambridge, 1983), pp. 110–18. Cannadine's argument is in some ways a sophisticated reworking of Kingsley Martin's Penguin Special, *The Crown and the Establishment.*
9. For example, I own a pamphlet called *Edward VII*, which is published complete with key to characters, but whose satiric edge is about as blunt as can be imagined.
10. For this see P. Corrigan and D. Sayer, *The Great Arch: English State Formation as Cultural Revolution* (London, 1985), p. 150.
11. John Langton, 'The Industrial Revolution and the Regional Geography of England', in *Transactions, Institute of British Geographers*, (London, 1983), pp. 145–67. It is relevant here to note the remark made by George Orwell's working-class friend, Jack Common, that in choosing his pseudonym Orwell was 'seeking for something that sounded solidly English. The rootless non-dialect speakers of the public-school elite are apt to over-value nationality, just as exiles do'. See Audrey Cop-

pard and Bernard Crick (eds), *Orwell Remembered* (London, 1984), p. 141.

12. Cannadine, 'The Context, Performance and Meaning of Ritual', p. 114.

13. E. Royle, *Radicals, Secularists and Republicans* (Manchester, 1980), esp. pp. 201–7.

14. See 'Falklands Fallout' in *Marxism Today* (January 1983), pp. 13–19.

15. For this see P. M. S. Dawson, *The Unacknowledged Legislator: Shelley and Politics* (Oxford, 1980), pp. 176–8.

16. Corrigan and Sayer, *The Great Arch*, p. 111.

17. See E. P. Thompson, *The Making of the English Working Class* (London, 1963), esp. pp. 807–8. In *Britons: Forging the Nation 1707–1837* (London edn, 1994), Linda Colley argues that Francophobia is an important determinant of patriotism throughout the eighteenth century.

18. Edward Bulwer-Lytton, *England and the English* (Chicago, 1970), pp. 38–9.

19. Gerald Newman, 'Anti-French Propaganda and British Liberal Nationalism in the Early nineteenth Century', *Victorian Studies*, vol. 23 (1975), pp. 385–418.

20. See M. Cornforth (ed.), *Rebels and their Causes* (London, 1978).

21. See John Morley, *The Life of Richard Cobden* (London, n.d.), p. 294.

22. For this see V. G. Kiernan, 'Working Class and Nation in Nineteenth-century Britain', in Cornforth (ed.), *Rebels*, p. 125.

23. A number of such ballads may be found in Charles Hindley, *Curiosities of Street Literature*, 2 vols, with a new introduction by Leslie Shepherd (London, 1966). It is also important to notice that several popular melodramas of the same period deal with Jolly Jack Tar, announcing that he has the ear of the new Queen and that he knows she is prepared to intervene on behalf of working people.

24. For this see Esmé Wingfield Stratford, *The History of English Patriotism*, 2 vols. (London, 1913) Vol. 2 *The Middle-Class Ascendancy* provides a full account of the argument I here sketch.

25. J. Raymond (ed.), *Queen Victoria's Early Letters* (London, 1963), p. 40.

26. For this see Winslow Ames, *Prince Albert and Victorian Taste* (London, 1967).

27. Eric de Maré, *London, 1851* (Folio Society, 1972), unpaginated.

28. Ibid.

29. For a full account of the pageantry surrounding the opening see R. Altick, *The Shows of London* (London, 1978), esp. pp. 456–60.

30. For this see Asa Briggs, *Victorian Cities* (London, 1963), p. 109.

31. Kiernan, in Cornforth (ed.), *Rebels*, p. 127.

32. Byron Farwell, *For Queen and Country: A Social History of the Victorian and Edwardian Army* (London, 1981), pp. 170–1.

33. Charles Dickens, *The Uncommercial Traveller*, Chapter IV.

34. Kiernan, in Cornforth (ed.), *Rebels*. Kiernan's view is of course an influential one and, as has been pointed out to me by Jenny Taylor,

most feminist historians see the end of the nineteenth century as regressive in as much as it is a period when growing concern with the family turns working-class consciousness in on itself and away from the collectivism of the mid-century. There is an obvious strength in this argument, but to endorse it uncritically is to forget those many attempts – often of course by women (I am thinking for example of the Match Girls strike) – to combat such consolation, such defeatism. And Royle's evidence about short-lived and tight-knit republican societies proves only that 'single issue' causes are not the same as deep-rooted radicalism, which is always more difficult to quantify.

35. Gareth Stedman Jones, *Languages of Class: Studies in English Working Class History, 1832–1982* (London), pp. 179–238.
36. L. Senelick, 'Politics as Entertainment: Victorian Music-Hall Songs', *Victorian Studies*, vol 19 (1975–76), pp. 149–80.
37. Senelick, 'Politics as Entertainment', p. 152.
38. See P. Summerfield: 'The Effingham Arms and the Empire: Deliberate Selection in the Evolution of Music Hall in London', in Eileen and Stephen Yeo (eds), *Popular Culture and Class Conflict 1590–1914* (Brighton, 1981); and P. Summerfield 'The Imperial Idea and the Music Hall', in John M. MacKenzie (ed.), *Imperialism and Popular Culture* (Manchester, 1986).
39. J. A. Hobson, *The Psychology of Jingoism* (London, 1901), p. 3. For a good account of the original use of the 'jingo', in a song sung by the Great Macdermott, at the time of the Russo–Turkish War, 1878, see J. S. Bratton, *The Victorian Popular Ballad* (London, 1975), pp. 53–4. Bratton is, however, wrong to call the song's author, G. W. Hunt, 'a music-hall hack'. Hunt was an aspiring member of the middle class, with very powerful upwardly mobile ambitions, as Senelick has established.
40. Summerfield, 'The Effingham Arms', p. 236.

12 RECLAIMING THE ROMANCE: ELLEN WILKINSON'S *CLASH* AND THE CULTURAL LEGACY OF SOCIALIST-FEMINISM

Maroula Joannou

Ellen Wilkinson's semi-autobiographical novel *Clash* (1929)[1] is an important feminist intervention in the socialist cultural politics of its day. In common with other inter-war socialist women writers whose fiction is now being reassessed,[2] Ellen Wilkinson attempted to write her signature as a woman into the deeply masculinist labour movement of her time, giving it a key role in her fiction while at the same time maintaining a critical distance from its more chauvinistic and insular proclivities.

Clash records the momentous events of the General Strike and miners' lock-out of 1926 from the feminist perspective of the novel's central character. It is essentially concerned with the predicament of a woman trade unionist who is torn between her desire for emotional independence and her romantic attachment to a man who does not share her political ideals. If *Clash* were of interest only as a spirited study of a politicised woman we would have good reason to welcome it as a useful attempt to correct the paucity of such representations within English fiction. However, the novel does not stop at this. Retaining some of the standard ingredients of the romantic novel and reconstituting others imaginatively, Ellen Wilkinson articulates the feminist demand that a democratic sexual politics should be recognised as an integral part of wider political struggle.

As a feminist, a creative writer and one of the first women to enter Parliament, Ellen Wilkinson had continually to confront the contradiction that the movement in which she invested much of herself – and which provided her with a sense of a shared political purpose and unique practical outlets for her organisational talents in return – did not, in the main, subscribe to her belief in the importance of equality between the sexes. Nor was opposition to feminist ideas confined to the male leadership of the Labour Party. As Olive Banks has noted, many rank-and-file party women were hostile to what they saw as a bourgeois feminist movement representing the interests of middle-class women rather than those of the working class.[3]

The prevailing belief of many important socialists – with notable

exceptions such as George Lansbury, who contested the Bromley and Bow parliamentary by-election of 1912 largely on the platform of votes for women, and Keir Hardie, a principled supporter of Sylvia Pankhurst and the work of the East London suffragettes – was that issues of gender should properly be subsumed under those of class. But Ellen Wilkinson was highly critical of the domination of women by men in both personal relationships and public life. At a time when large sections of the organised left showed little inclination to recognise the importance of gender as a primary social and analytical category, *Clash* provided Ellen Wilkinson with a fictional outlet for deeply felt convictions which she could neither jettison nor express fully in public elsewhere. Moreover, the serialisation of *Clash* in 1929 in the *Daily Express* helped her to popularise feminist ideas and to reach a readership extending beyond the left.

Reviewing Winifred Holtby's last novel, *South Riding*, in *Time and Tide* in 1936, Ellen Wilkinson observed that many people of her own age-group, herself included, had been influenced by two 'immense social movements' amounting to a social revolution: the 'rise in the status of women to something like equality with men, and the increase in the political power and influence of the organised working class'. [4] Her prominence in public life made her a role-model for women engaged in the struggle 'against our common enemies – poverty, sickness, ignorance, isolation, mental derangement and social maladjustment'.[5] According to Vera Brittain, Winifred Holtby's close friend, the character of Sarah Burton, the strong-minded, campaigning schoolteacher in *South Riding*, was modelled on Ellen Wilkinson: 'She made her heroine small and red-haired with the appearance of Ellen Wilkinson, MP, whom she had always liked and admired.'[6]

Much of what Ellen was able to achieve in public life would have been impossible for a woman of her modest origins a mere decade or so earlier. But by the time she was elected to Parliament to represent the Labour constituency of Middlesbrough, a seat she held from 1924 to 1931, the opportunities for women in public life had expanded considerably. Largely as a result of the campaigns to gain votes for women, entry into higher education, and better jobs, pay and working conditions, Ellen found herself one of 'hundreds of thousands of women between twenty and thirty, mothers, professional and working women', of whom Dora Russell wrote approvingly in *Hypatia* (1925), 'the principle of feminine equality is as natural as drawing breath – they are neither oppressed by tradition nor worn by rebellion'.[7]

The youngest child but one in a working-class family with strong connections to the local co-operative movement and also to the Lancashire cotton trade,[8] Ellen won a scholarship to Manchester University and graduated with honours in 1913. She then worked as a full-time organiser for the largest of the women's suffrage organisations, Millicent Garrett-Fawcett's National Union of Women's Suffrage Societies. The NUWSS, which was committed to non-violent, constitutional methods

of working, had abandoned its political neutrality in 1912 and urged women to vote Labour after the Labour Party had declared that it would not support any suffrage measure that did not include women. By 1915, on the strength of her reputation as an effective organiser of women, Ellen had been appointed National Women's Organiser for the Amalgamated Union of Co-operative Employees. Yet the feminist politics which she brought to this post not only marked her out from the shopworkers' leader Margaret Bondfield (her fellow MP and in 1929 the first woman ever to join the Cabinet, as Minister of Labour) but also from other leading women trade unionists who, while they encouraged women to organise together to redress the long hours, low pay and poor working conditions of many women workers, took care to distance themselves from feminism, which in many Labour-voting constituencies was widely distrusted as a middle-class phenomenon.

Clash reflects much of this personal history; it deals with the evolution of a formidably efficient type of woman who had demonstrated herself capable of assuming responsibility in the public sphere. When the novel opens, Joan Craig has already spent eight years organising women, first as a munitions worker during the 1914–18 war and then as a full-time trade-union official. The usual picture of men as the bearers of authority and prestige in public is inverted in the novel. Joan is energetic and charismatic; there is no male character to compete with her or to distract our attention. The narrative is structured to make the male characters, in the main, passive and Joan, in the main, active. The men who congregate around her, including her immediate superior in the union, William Royd, and the companionable Gerry Blain, come and go. It is Joan who makes key decisions, knows her own mind and is determined to exercise it. The attaché case carried by Ellen Wilkinson's down-to-earth Yorkshire heroine symbolises the power and status women are often deprived of in public life.

The name which Ellen Wilkinson chose for her heroine had acquired strong emotional resonance during the women's suffrage campaign. The mythical and historical personage of Joan of Arc, as Lisa Tickner has pointed out, was of symbolic importance to women because she was seen to have 'transcended the limitations of her sex and yet it was from the position of femininity – however unorthodox – that she posed a challenge to the English and to men' and had come to be regarded as 'the paradigm for militant virtue compounded with feminine audacity'.[9]

Joan's leadership qualities are quickly put to the test after she finds herself on the balcony of the Memorial Hall in London at the historic moment in 1926 when the TUC leadership has assembled to vote for a national withdrawal of labour. The decision inaugurates nine days of feverish activity in mobilising public support for the strike. Joan is asked to tour the country to address meetings as an officially accredited representative of the TUC. The speaking tour she embarks on is very like that made by Ellen Wilkinson herself in the company of her close friend Frank Horrabin (the editor of *Plebs* and Labour MP for the

constituency of Peterborough), who resembles the character Gerald Blain. She gives enthusiastic accounts of Crewe, Coventry and other towns 'being run by sheer Soviets' (p. 133) and of the exhilaration 'when democracy stops touching its hat and refuses to answer the bell' (p. 126). But her tour is unexpectedly halted when she hears the news that the General Strike has inexplicably been called off.

Joan reacts with stunned disbelief, as had Ellen Wilkinson in similar circumstances. Shortly afterwards she departs to Carey's Main, a village in the North of England where the families of miners have been reduced to penury as a result of their participation in the General Strike, to offer what practical support she can. This humanitarian mission paralleled Ellen Wilkinson's own efforts to alleviate the destitution in the coalfields in her role as the Chair of the Women's Committee for the Relief of Miners' Wives and Children. The committee, an important precursor of the many women's support groups formed during the miners' strike of 1984, was able to perform impressive work. As the miners' leader, A. J. Cook, wrote in appreciation: 'the Women's Committee worked night and day to collect funds, to arrange for our choirs and bands, and to dispatch money, clothes and boots ... The Labour women cared for Humanity, when the Government led by Baldwin tried to starve our people.'[10]

Ellen Wilkinson's credentials for writing a novel based on the General Strike were impeccable. She had first-hand experience of the events of 1926 having travelled about 2,000 miles as an official propagandist for the General Council of the TUC, through the West of England and back to London and then to the North. In the course of her tour she addressed 47 meetings in country towns and big industrial areas, attended strike committees, and encountered every kind of person, from clergymen and members of the aristocracy to children and old age pensioners who donated their last pennies.[11] Her impassioned support of the strike differed radically from the temporising and equivocal attitudes of many members of the TUC General Council, which made only three decisions during the strike: 'to refuse offers of money from Russia, to cancel all permits, and to call out the "second line" of unions.'[12] Ellen had come to know many of the members of the General Council personally. 'The tragedy of this strike,' she said, 'consists in just this fact, that it was led by men who did not believe in it, who could not want it to succeed.'[13]

Some of the most vivid political dialogues in *Clash* reflect the deep sympathy for the strikers expressed by metropolitan intellectuals, such as the Bloomsbury-based Helen Dacre who organises cultural events to raise money for the strikers' families. Kate Flint has provided an interesting account of the practical support for the General Strike offered by Virginia and Leonard Woolf and their social circle.[14] As Leonard Woolf observed in his autobiography, *Downhill All the Way*, 'when it comes to the practice of politics, anyone writing about his life in the years 1924–1939 must answer the crucial question: What did you do in the General Strike?'[15] Woolf's study of communal psychology, *After the*

Deluge, contains a lengthy section in support of the miners' case. He argues that the mine owners and the government had been able to win only by spurious appeals to country, community and the nation, whereas the miners were morally right to resist cuts in wages. [16]

Although she had left the Communist Party in 1924, the year Communists were declared ineligible for Labour Party membership, Ellen Wilkinson was still strongly influenced by Marxist ideas when she was writing *Clash*. Moreover, she had determinedly retained what Margaret, Lady Rhondda, described as the 'cultivated Marxist consciousness which made her tend to believe that there were barriers which no good, and in those days extreme, Left-Winger should ever really cross'. [17] The accounts she has left of the General Strike offer an uncompromisingly Marxist analysis of the relationship between labour and capital. In a post-mortem for *The Plebs*, the journal of the National Council of Labour Colleges, she wrote: 'the struggle was forced by a capitalist system desperately trying to stabilise itself at the expense of the workers. That process will not stop.' [18] She warned that unless 'the trade union movement is to be committed to the policy of assisting capitalism to get out of every crisis by accepting reduction after reduction in wages, our leaders must frankly prepare for struggle on a class basis'. [19]

Although the events of 1926 represented an enormous defeat for the British labour movement, and effectively signalled the end of the syndicalist project that underlay so much of its thinking and action since the first decade of the century, Ellen Wilkinson's position remained essentially optimistic. Her introduction to an account of the General Strike for readers in America, which she visited on a fund-raising tour (she had already visited the Soviet Union in 1921), underlines her belief in the revolutionary potential and significance of what had taken place: 'The General Strike may not be Britain's 1905, but it undoubtedly has been a rehearsal for something bigger. Who knows how soon the performance will be staged?' [20]

The extension of the vote to all adult women in 1928 marked the culmination of three generations of feminist activity. It was a landmark but also a turning point for women. Faced with a new political situation, feminists had to decide on a new set of priorities. As more women took on responsibilities in public life, the question of whether or not it was possible to combine such responsibilities with marriage was a frequent subject of debate in middle-class feminist circles. The 'marriage question' was frequently aired in *Time and Tide*, the feminist journal to which Ellen Wilkinson was a regular contributor (she wrote pieces, signed or unsigned, in almost every issue between 1936 and 1947, the year of her death). The veteran suffragist Mary Maud Meadowes in *Clash* is closely based on Ellen's friend Margaret, Lady Rhondda, the proprietor of *Time and Tide*, who lived in the same block of flats as Ellen. Mary Maud is used to voice many of the novel's feminist concerns ('the Women's Movement has been the only thing I ever really cared about', p. 94). She recognises the exceptional talents of Joan Craig as a natural inheritor of

the pioneering achievements of the suffragettes and predicts that her protegée will in future become a rallying point for women. However, Mary Maud also fears that it will be impossible for Joan to fulfil her potential as a feminist if she attempts to combine a career with marriage: 'There are lots of women leaders but they are all snowed under. As soon as a woman emerges from the crowd, she gets married ... Marriage takes so much more out of a woman, demands so much more time than it does for a man.' Mary Maud dreams that one day women will emerge 'to whom men will not be in the first place in their lives ... who will devote themselves to their job as men do, and make their private lives fit' (p. 95).

Clash politicises a mode of writing which, at the time, was generally considered inappropriate for the transmission of serious political ideas.[21] As a romance plot which ventures far beyond the conventional trajectories and constrictions of romantic fiction, *Clash* is a good example of what Rachel Blau Duplessis has termed 'writing beyond an ending'. Ellen Wilkinson's novel may be seen as part of a 'consistent project that unites some twentieth-century women writers across the century, writers who examine how social practices surrounding gender have entered narrative, and who consequently use narrative to make critical statements, about the psychosexual and sociocultural construction of women.'[22] Although the inter-war period witnessed an upsurge of interest in popular romantic writing, and the love stories which featured regularly in magazines like *Peg's Paper* (1919) were read avidly by working women and girls, many socialists were highly critical of romantic fiction and the deleterious effects it was thought to have on working-class readers. But Ellen Wilkinson deplored the rigid division made between 'high' and 'low' art as a major impediment to the creation of a popular, socialist culture.[23] A project dear to the heart of Gerry Blain in *Clash* is the launching of a popular labour movement paper 'that is not highbrow but lively', to be called something like *Wednesday Weekly*, and for which Joan Craig would be invited to write a regular series of 'Simple Stories from a Woman's Heart' (p. 258). Ellen Wilkinson's own desire to bring feminist and socialist ideas to as wide an audience as possible is reflected in the serialisation of *Clash* in the unlikely forum of the *Daily Express*.

In accordance with the conventions of romantic fiction, the emphasis is on Joan's sexuality; thin and graceful with black hair and quick black eyes, she is desirable *and* desiring (although 'magnificently unconscious' of her own appeal to the men with whom she worked, for 'Joan always declared that she hated women who used sex appeal in business relations', p. 15). Joan and Tony Dacre (who is unhappily married) are lovers in a 'modern way'. However, Joan also has an important platonic relationship with the prosaic Captain Gerald Blain who wishes to marry her. The trustworthy Gerry is Joan's pillar of support, a 'good friend to

have on the earth' (p. 231). As David Margolies has observed, the heroine's sense of insecurity is fundamental to the popular romantic novel,[24] but whereas the typical heroine in popular romantic fiction is tormented by inner doubts about her attractiveness to men, Joan Craig is far from insecure. Indeed, for much of the novel she is confident that she is the object of both men's desire, although she is a typically romantic heroine in knowing that she loves Tony Dacre passionately and that she can never love anyone else in the same way.

Ellen Wilkinson uses a romantic plot within a class-conscious narrative in *Clash*. But because the novel is concerned with a woman's need for intimacy *and* for solidarity, the importance attached to purely individualistic longings and impulses must ultimately be qualified. The familiar questions of popular romantic fiction – who does the heroine really love? and does he reciprocate her feelings? – are not the key questions in *Clash*. This is partly because the reader knows the answers from a very early stage, but it is also because the very questions themselves are transformed by the fact that Joan is both a socialist and a feminist. Tony Dacre, whom she loves romantically, possesses none of Joan's developed class consciousness, what Ellen Wilkinson calls her 'working class patriotism'. Furthermore, he understands neither her feminism nor her need for personal autonomy within their relationship. According to Dacre, marriage and motherhood should be a full-time occupation for a woman. '"Kirk, kinder and kitchen," mocked Joan. "I didn't expect this Victorianism from you, Tony"' (p. 190). When her work takes Joan away from London and Tony, she reflects on how pleasant it would have been to go home to him and to talk things over, but he would not have had the slightest idea why the strike was important to her. Gerald Blain, on the other hand, would have understood immediately, immersed as he is in the culture of the labour movement.

Clash illuminates the patriarchal as well as the pleasurable dimensions of heterosexual relationships. Ellen Wilkinson skilfully concludes Joan's romantic predicament in the grim setting of Carey's Main, a famine-stricken mining village where she is able to see her immediate situation in a wider political context and to acknowledge the connection between the personal and the political. Tony responds to Joan's sexual attractiveness and loves her for her gendered self. But while he satisfies her need for a relationship which is premised on intimacy and tenderness, he also withholds the recognition of her professional competence which is crucial to her self-esteem. He responds to Joan's absence from London by sending her carefully chosen love tokens: a batik cover for her bed, a woodcut for her room, a quaint jar for flowers on her desk – little luxuries that transform her lodging into an oasis of colour among the arid poverty of the coalfields. But in the unremittingly bleak environment in which Joan must work, his gifts come to symbolise the difference between their values and priorities.

The issue to be resolved in *Clash* is whether or not Joan should comply with Dacre's wishes and give up her public work. Joan has been

quickly accepted by the 'rather critical and very clannish Yorkshire women as one of themselves' (p. 242). As her admiration for the courage, honesty and determination of the working women in the coalfields grows – the strike has given positions of importance to ordinary working women for the first time – so does her understanding of her own position in relation to Tony's patriarchal expectations: 'Joan badly wanted to bring Anthony Dacre into some of these villages and say to him, "you say I can't be your wife and lover and do my job. Look at the work these women have to do"' (p. 239). Seeking to end the division between the private world of feeling and the public world of work, she chooses independence within marriage instead of romantic love. Her marriage to Gerry will be one of equals, with an understanding that her work must come first: 'The universe wouldn't be expected to stand still, as at some miracle, to allow Gerry Blain's baby to be born. Its mother would probably be correcting proofs or planning speeches to the minute of its arrival' (p. 300).

It is Joan's sense of loyalty to her class that finally prompts her to marry Gerald Blain. The decision is activated by her feelings of outrage when confronted with a well-heeled society woman at a fund-raising meeting whose ignorance of life makes her deny the very existence of working-class poverty and starvation which Joan has experienced at first hand: 'One can't live in luxury and pretend one is working with them just the same. I'm in the ring from now on. No more trips to the stalls' (pp. 309–10). As Joan puts it, class is the 'big broad issue' that the twentieth century will be 'occupied in fighting out' (p. 309). The novel refreshingly does not hedge its politics about with qualifications nor apologise for its sensibilities.

Class conflict is not introduced merely to be reconciled or harmonised later. The contradiction of radical attitudes to class politics co-existing alongside traditional attitudes to gender in working-class communities is sensitively explored in the novel. Ellen Wilkinson sees class identity infused with sexual identity and sexual identity infused with class meaning. Romantic love is demystified, shown not to conquer all but to be the product of specific gendered ideology and gendered expectations.

In an interview given to the *News Chronicle* in 1935, Ellen Wilkinson stated her ambition to 'get across' working-class people who are 'as naturally the centre of the book as middle-class people are of other sorts of novels'.[25] The Carey's Main episodes in *Clash* are good examples of the proletarian realism, in vogue at the time, which she admired in writers like A. J. Cronin. Ellen Wilkinson presents the miners' strike and lock-out in its human detail – the mother with no hot water, clothes or milk for her newborn baby (p. 245), the women and children grubbing 'like maggots on the refuse heaps trying to find precious bits of coal to sell for bread' (p. 236) – and uses these images to counter a 'woman's magazine' view of romantic love and question the romantic values that anchor the heroine's vision in the claustrophobic landscape of the inner world in the popular romantic novel.

Clash differs from the other novels directly concerned with the impact of the political ferment of 1926 – John Galsworthy's *Modern Comedy* (1929), Harry Heslop's *The Gate of a Strange Field* (1932) and Leslie Paul's *Men in May* (1936)[26] – in depicting the events from the perspective of a politicised woman. In this respect it shares something with Storm Jameson's impressionistic *None Turn Back* (1936). If politicised men feature only rarely as the subjects of fiction, politicised women feature even less. As Beatrix Campbell has argued, literary representations of strikes often carry the burden of a complaining wife who was never consulted and strikes are lived by women as economic hardships they knew nothing about.[27] There is perhaps some simplification here – one thinks of the women in the mining community in Lewis Jones's *Cwmardy* (1937) – but whatever the relationship of women to organised political activity, they are not usually represented as organisers, central to its success or failure.

It is relatively easy in a realist novel to demonstrate how mining communities live, but Ellen Wilkinson clearly found it more difficult to show how circumstances such as poverty were the result of a particular economic system or of socially structured patterns of inequality, because the focus on the individual, implicit in the conventions of realist writing, made her concentrate on empirically-observed facts and interpersonal dialogues for much of the novel, rather than on analysis of underlying causal relations.

The Carey's Main episodes in *Clash* illustrate what Pat Thane has described as 'the fundamental difference between the political vision of most of the Labour women and that of most of the men' at this time and 'the age-old regularity with which women have demonstrated independence of mind and to a limited degree exerted power at the personal and local level'.[28] In her time at Carey's Main Joan registers much that even the most sympathetic of men would not apprehend in the same way, and much of what she observes she expresses in the service of a recognisable feminist politics. For example, a miner's wife informs Joan that her out-of-work partner can now make himself useful in the house by turning the mangle and washing the floors even though the 'miners chaff them as do women's work'. The secretary of the local women's committee reflects that her husband is 'very handy' in the home, 'so long as I don't ask him to do anything the neighbours can see him doing, like windows or steps' (p. 240).

Ellen Wilkinson strongly objected to the unequal division of labour in the household. In answer to a complaint received from a woman activist in her own constituency, she asked in a piece in *The Plebs* in 1928: 'why is it that the more hard-boiled a Marxian a man is, the more he is convinced that women's place in the scheme of things is to wash up?'[29] The passage from *Clash* below indicates a feminist perception of the unfair distribution of power between men and women and an acute awareness of the *changing* balance of power, which has been brought

about by the gender-specific ways in which the lock-out is experienced. It is clear that the relief work of the women poses a strong threat to the traditional idea of a male breadwinner and the men resent the women's well-meaning initiatives:

> In a coalfield it is the man who counts. The women fit in – there is no other course open to them. Joan suddenly saw that all this relief organisation had shifted the balance. The men could not now provide for their families; that was done through the women and children. All charitable appeals were made on their behalf, and the money went to the mother. The guardians could not, by law, relieve able-bodied men, when work was, in theory, available to them. The relief had to be paid to the woman for herself and the children. The man's bread had to be taken out of their mouths, he had to share in what was sent for the mother and children if he ate at all.
>
> 'My goodness, how the men must hate it,' thought Joan, all conscience-stricken, 'and we've never done a thing to bring them in. We women have been so proud of doing it all ourselves here. We've been getting to feel that its our nice little war.' She put this idea to Mrs Greenhalgh, but that fierce little woman was more of a feminist even than Joan. 'Do 'em good. The men are too uppish, anyway. Let 'em see what we have to put up with for a change.' (pp. 263–4)

Birth control was an issue that brought together sexuality and class. Throughout the 1920s Ellen Wilkinson had been closely associated with the Workers' Birth Control Group, an active lobby of feminists and other radicals in the Labour Party. The aim of the group, which had to contend with the hostility or indifference of large sections of her party, was to put wider access to contraception on the political agenda by drawing attention to the health risks and economic hardships facing women who gave birth to too many children. At the party conference in 1926 Dora Russell moved a motion 'on behalf of the ancient and honourable Trade Union of Mothers, to which I belong', calling for advice on birth control to be available at health centres as an integral part of maternity care.[30] Thanks to the block votes of the railwaymen and the miners – it would be many years yet before the wielding of trade union block votes at Labour Party conferences would come to be widely condemned as undemocratic – conference endorsed the demand, and the first family planning clinic outside London was set up in the colliery district of Cannock Chase during the miners' lock-out.[31]

In the Carey's Main episodes of *Clash* Ellen Wilkinson makes it clear that contraception is a key issue for working-class women. Although the miners' wives are initially reluctant to talk about sex in front of Joan, she eventually wins their confidence and they talk freely about their intimate personal concerns ('If the wages coming into my house can only feed three children, does that mean that me and my man only dare be lovers three or four times in twenty years for fear of having more children than we can

feed?' p. 247). Joan learns that, apart from the Catholics, 'these intelligent women were desperately anxious for some medical advice to be made available to them' (p. 248), which reinforces her determination to make contraception a major item in the left's programme.

It is in such episodes that *Clash* can be read as a site of a transformative socialist-feminist politics: Ellen Wilkinson offers the reader revealing glimpses of how political struggle enables women, as a consequence of their very involvement, to identify and clarify their own priorities as women. Even if the brisk narrative pace makes it impossible to develop ideas in any real depth, the novel dramatises prescient feminist issues, including women's right to express their sexuality, the importance of paid employment, and their right to be psychically and economically independent of men. When any literary work is excavated for the discursive construction of the meaning of gender, that which is unearthed will relate both to the historical moment of production and to our present-day concerns. The dilemma of Joan Craig is still the dilemma of many feminists today – how to find some degree of personal, sexual and emotional fulfilment in a world where relationships premised on equality are an ideal rather than a reality. In this, and other respects to which I have drawn attention, *Clash* at once prefigures the concerns of later feminists and points us back to traditions of women's struggle inherited from Olive Schreiner and Mary Wollstonecraft.

Notes

1. Ellen Wilkinson, *Clash* (London: Cassell, 1929). All quotations are from the first edition and page references are given in brackets in the text.
2. Useful work on the connections between socialist and feminist writing in the 1930s is being undertaken in the United States. Daphne Patai and Angela Ingram (eds), *Rediscovering Forgotten Radicals: British Women Writers: 1889–1939* (Chapel Hill: University of North Carolina Press, 1993) contains two interesting articles concerned with the recovery of romance by socialist women: Pamela A. Fox, 'Ethel Carnie Holdsworth's "Revolt of the Gentle": Romance and the Politics of Resistance in Working-Class Women's Writing', pp. 57–74 and Andy Croft, 'Ethel Mannin: The Red Rose of Love and the Red Flower of Liberty', pp. 175–205. See also Maroula Joannou, '"The Woman in the Little House": Leonora Eyles and Socialist Feminism', in the same volume, pp. 57–75, for further discussion of socialist-feminist writing between the wars.
3. Olive Banks, *The Politics of British Feminism, 1918–1970* (Aldershot: Edward Elgar, 1992), p. 31.
4. Ellen Wilkinson, 'Winifred Holtby's Last Novel', *Time and Tide*, 7 March 1936, p. 323.
5. Winifred Holtby, 'Prefatory Letter to Alderman Mrs. Holtby', *South Riding: An English Landscape* (London: Collins, 1936), p. 6.

6. Vera Brittain, *Testament of Friendship: The Story of Winifred Holtby* (London: Macmillan, 1940), p. 420.

7. Dora Russell, *Hypatia: or Women and Knowledge* (London: Kegan Paul, Trench and Trubner, 1925), p. 7.

8. I am indebted to Betty Vernon's biography, *Ellen Wilkinson* (London: Croom Helm, 1982) for information about Ellen Wilkinson's life.

9. Lisa Tickner, *The Spectacle of Women: Imagery of the Suffrage Campaign* (London: Chatto and Windus, 1987), pp. 209–10.

10. A. J. Cook, quoted in Marion Phillips, *Women and the Miners' Lock-Out: The Story of the Women's Committee for the Relief of the Miner's Wives and Children* (London: Labour Publishing Company, 1927), p. 25.

11. Ellen Wilkinson, introduction to Scott Nearing, *The British General Strike: An Economic Interpretion of its Significance* (New York: Vanguard Press, 1927), p. xi.

12. Charles Loch Mowat, *Britain Between the Wars: 1918–1940* (London: Methuen, 1955), p. 313.

13. Ellen Wilkinson, *The Plebs*, vol. XVIII, no. 6 (June 1926), pp. 209–12, at p. 211.

14. Kate Flint, 'Virginia Woolf and the General Strike', *Essays in Criticism*, vol. XXXVI, no. 4 (October 1986), pp. 319–34.

15. Leonard Woolf, *Downhill All the Way: An Autobiography of the Years 1911–1939* (London: Hogarth Press, 1967), p. 217.

16. Leonard Woolf, *After the Deluge: A Study of Communal Psychology* (London: Hogarth Press, 1931), pp. 298–319.

17. Margaret, Lady Rhondda, 'Ellen Wilkinson' (obituary), *Time and Tide*, 15 February 1947, p. 192.

18. Ellen Wilkinson, *The Plebs*, vol. XVIII, no. 6 (June 1926), p. 209.

19. R. W. Postgate, Ellen Wilkinson and J. F. Horrabin, *A Workers' History of the Great Strike* (London: The Plebs League, 1927), p. 103.

20. Wilkinson, introduction to Nearing, *The British General Strike*, p. xxi.

21. This mistrust is still widespread despite the fact that feminist research has established that the concerns of feminism and romantic fiction are not incompatible. For example, Ann Rosalind Jones, analysing Mills and Boon titles, was 'astonished to find that every novel I read (sixteen, all published in 1983–4) either refers explicitly to feminism or deals implicitly with issues feminism has raised'. Ann Rosalind Jones, 'Mills and Boon Meets Feminism', in Jean Radford (ed.), *The Progress of Romance: The Politics of Popular Fiction* (London: Routledge and Kegan Paul, 1986), pp. 195–218, at p. 197.

22. Rachel Blau Duplessis, *Writing Beyond an Ending: Narrative Strategies of Twentieth-Century Women Writers* (Bloomington: University of Indiana Press, 1985), p. 4.

23. Ellen Wilkinson was also interested in detective fiction and published a parliamentary 'whodunnit', *The Division Bell Mystery*, in 1931.

24. David Margolies, 'Guilt Without Sex', *Red Letters*, vol. 14 (winter 1982–3), pp. 5–13, at p. 11.

25. J. L. Hodson, ' "Before I Die": Ellen Wilkinson's Ambition to Get Working People "Over" in a Novel', *News Chronicle*, 13 December 1935, p. 3.

26. I wish to thank Andy Croft for helpful discussions on the significance of the General Strike of 1926 and its literature.

27. Beatrix Campbell, 'Orwell – Paterfamilias or Big Brother?', in Christopher Norris (ed.), *Inside the Myth: Orwell, Views from the Left* (London: Lawrence and Wishart, 1984), p. 131.

28. Pat Thane, 'Women of the British Labour Party and Feminism', in Harold L. Smith (ed.), *British Feminism in the Twentieth Century* (Aldershot: Edward Elgar, 1990), pp. 124–41, at pp. 140, 141.

29. Ellen Wilkinson, 'Should Women Wash Up? or, The Marxist and his Missus', *The Plebs*, vol. XX, no. 1 (January 1928), p. 13.

30. Dora Russell, *The Tamarisk Tree: My Quest for Liberty and Love* (London: Elek/Pemberton, 1975), p. 188.

31. See Peter Fryer, *The Birth Controllers* (London: Secker and Warburg, 1965), p. 253.

13 MASSINGER, MOURNER OF AN UNBORN PAST

Victor Kiernan

Philip Massinger, born in 1583, was 33 when Shakespeare died, and himself died in 1640 only two years before the Civil War. His father was 'house-steward and agent', as a biographer calls him,[1] to the powerful Herbert family, Earls of Pembroke. He handled business of importance, and sometimes had a seat found for him in the House of Commons. He died in 1603; and either the young Philip's inheritance was small or he quickly wasted it, as sundry of his characters were to do. Left stranded after a spell at Oxford, in a no man's land on the fringes of gentility, he drifted towards literature and play writing. About 1613 he was in jail for debt; dedications to various of the plays show that he always remained largely dependent on affluent patrons. He became a collaborator with Beaumont and Fletcher in their fashionable tragicomedies, though also composing some plays of his own, and when Fletcher died in 1635 succeeded him as chief playwright to Shakespeare's old company. He abounds in echoes of Shakespeare.[2] Not all his output survived; 15 plays known to be his, and two others judged to be mainly his, are included in the Clarendon Press edition of 1976.[3]

Garrett's anthology of Massinger criticism over three and a half centuries[4] shows very fluctuating estimates of the plays; it is still open to any reader to form one of his or her own. He has nearly always been given credit for neat plotting and construction; U. M. Ellis-Fermor commends him and his partners Beaumont and Fletcher as 'consummate dramatic journalists', turning out 'nearly perfect theatre-work'.[5] L. G. Salingar feels that he could write tragedies with 'eloquent correctness' but that tragedy as an art was by his time drying up;[6] most of his plays are comedies, or mixtures. Middleton Murry thought that he only wrote them in verse – there is very little prose in them – for want of a more congenial medium, and that his blank verse is in reality 'excellent prose';[7] others have viewed his work, or the best of it, much more favourably. By comparison with Shakespeare the vital links he forges between individuals are far less striking, and this helps to make his characters less distinct in themselves. He esteemed friendship highly, but he shows us no friends like Brutus and Cassius. A symptom can be recognised here of a society in decay, its moral cement crumbling. His style has been deemed too rhetorical, intellectualising, overladen with debate;[8] as such it falls within a declining curve from imaginative poetry to the pamphlet warfare of the 1640s.

A moralising, didactive bent drew him towards political themes and current affairs, and at times landed him in trouble with an increasingly vigilant censorship. He took his art seriously, as having a kind of civilising mission to his fellow-men. This comes out most explicitly in his favourite among his plays, *The Roman Actor*, where Paris urges the other actors to show courage under the tyranny of Domitian and defends their profession before the Senate (I.i,iii). Six of the plays are set in modern Italy, four in antiquity, one in Tunis; only two, probably the best, belong to contemporary England. He seems to have taken a genuine interest in far-away lands, like those of the Turkish empire, as well as in classical history. In the prologue to *Believe as You List* he apologises for imperfect knowledge of Rome, but assures us that he has done his best, by turning over all the books he could, to get his facts right; the Clarendon editors commend him as 'always meticulous over local detail'.[9] All the same, it seems likely that political and social comment in all the plays can usually be taken as the feeling of a deeply concerned Englishman about England.

Massinger's work has not been interpreted by all students in the same way; and the fact that several of his later works have disappeared makes it harder to know whether his point of view was shifting as national crisis drew nearer. Among recent commentators Venables, a Marxist, regarded him as a neo-feudalist, a cobbler of old values.[10] Leslie Stephen thought him, as others have done, a moderate royalist.[11] Perhaps more helpfully, Cruickshank placed him in the 'Conservative Opposition'[12] of which the Pembroke family were pillars. Margot Heinemann saw him as a critic of court and government from the standpoint of 'the dissatisfied gentry and nobility', the 'aristocratic wing' of the malcontents.[13] His conservatism, like Shakespeare's in a way, often sounds like nostalgia for a vanished or vanishing past when life was somehow better for ordinary people; his picture of things as they are now is on the whole markedly uncomplimentary. We cannot suppose that he hoped for a revolution; but he clearly felt a need for a very thorough purging or spring-cleaning. Symons contrasted his jaundiced view of things with the light-hearted gaiety of Beaumont and Fletcher.[14]

This essay seeks to explore some of the public themes to be found in the plays. They are often associated with the rise of the new, more powerful state in Massinger's Europe, accompanied by changing social stresses and by new modes of warfare. Two pairs of plays are picked out as among the most interesting in this context: one pair from ancient history, *The Bondman* (1623) and *Believe as You List* (1631), the other English, *A New Way to Pay Old Debts* (1625) and *The City Madam* (1632).

Monarchy is the ordinary form of government in Massinger's gallery. His sovereigns range from the dignified, conscientious Alphonso of Naples, in *The Guardian*, to the half-crazy tyrant Domitian, who might be called an illustration of the principle that absolute power corrupts absolutely. In this play several allusions to a divine right of crowned heads can be heard, but they sound somewhat perfunctory, and one of

them ends in an assurance that Heaven will some day abandon a prince who violates its will (*RA*, III.i). Turks in *The Renegado* speak of their sultan Amurath with extreme reverence; Massinger must have recalled Shakespeare's Henry V, newly on the throne, reassuring his brothers that he is no Amurath, but an English Harry (*2 Henry IV*, V.ii).

That a ruler is only a creature of flesh and blood, however much buttered up by sycophants (*EE*, V.ii), was a truth that Shakespeare had made much of. In this play the good regent, Pulcheria, has special scorn for flatterers who in their own interests want their rulers to multiply taxes and din into his ears the maxim that 'All is the king's, his will above his laws' (I.ii). Her young brother Theodosius sees this himself and angrily tells his 'court-leeches' that he can never be greater than when he refuses 'to enrich a few with the injuries of many' (II.i). This must have been music to Massinger's audience; but before long Theodosius succumbs to temptation, grows extravagant, and persuades himself that the public likes him to have plenty of money and spend it lavishly (III.ii). He is ready now to sentence to death on suspicion the innocent Paulinus, but is soon conscience-stricken over his hasty anger:

> subjects' lives
> Are not their prince's tennis-balls, to be bandied
> In sport away. (V.ii)

Timoleon, who reluctantly accepts the governorship of Syracuse in an emergency, is a high-souled republican from Greece, convinced that all who desire to encroach on the liberty of others are 'rebels to nature' (*Bond.*, I.iii). But Syracuse, although a republic, is (like England, we are very likely meant to reflect) undermined by luxury and sloth, its wealth monopolised by a few individuals, 'the public coffers hollow with want', young men untrained to war, the navy neglected. Pepys's diary shows him to have been very fond of this play, partly we may surmise because he felt his country to be suffering from similar maladies in his day.

Paulinus, sounding a good deal like a Tudor nobleman on his way to the Tower, protests that he has always been loyal, and that although popular he has never courted applause: he knows too well that 'the people's love is short and fatal' (*EE*, V.i). A fallen minister too blames popular favour ('To new-raised men still fatal') for his ruin (*BL*, III.i). Yet popularity seems to have become a political need, however much Massinger may disapprove. When a group in *The Unnatural Combat* are engaged in satirical talk about how things go at Court, a quick-witted page observes that everyone there has to fawn on the one above him, and the highest of all has to fawn on 'the many-headed monster, the giddy multitude' (III.ii).

Rulers might be better or worse, but what affected the man in the street much more was the behaviour of their employees, the officialdom or bureaucracy sprouting all over Europe. Their growth was less luxuriant in England than under richer governments like the French or Span-

ish, but holders of monopoly patents from the Crown could be still
worse, and became one of the bones of contention between the Stuarts
and their Parliaments. Cuculo in *A Very Woman*, a counsellor as fool-
ishly self-important as Polonius, was doubtless only one of many such
pompous asses. Europeans from high to low were very litigious people,
which is always an index of social changes and instability; justice was
much in demand, but clean-handed judges might be hard to find. A
Lord Chancellor of England, Bacon, was disgraced in 1618 for taking
bribes. Massinger gives us a worthy judge in Burgundy, Rochefort, a
man of the strictest honesty and sense of duty; but he ends a near-tragic
figure, as he goes out to 'seek a grave' (*FD*, V.ii).

The society through which Massinger conducts us is a highly com-
mercialised one. Its atmosphere percolates into his imagery; a lover who
has won glory in the field thinks of himself as a 'factor' who has gone
'trading' for lustre to shed on his 'merchant', or mistress (*Bond.*, III.iv).
Less romantically Charalois complains that it must be easier nowadays
to escape out of hell than to obtain justice: instead of one Cerberus, a
hundred stand in the way, all barking for their sops (*FD*, I.i). Lower
down the scale a long purse is equally helpful. An eloping lover is
assured that it will be easy to get the city gate left open for him by
bribing the watchmen or getting them drunk (*Guard.*, III.iii).

Whether or not he ever saw service, Massinger clearly acquired a
familiarity with some aspects of military life. Playwrights had each their
special concern here, and his was with the often hard lot of the profes-
sional soldier, which may have seemed to him not unlike his own ill-
rewarded occupation. War and peace were often burning issues in the
politics of his England. For years the Court sought an alliance with
Spain, partly as a conservative counterweight to the radical ideas that
were spreading. In contradiction to this there were powerful interests in
favour of war with Spain, which offered rich colonial spoils, and religion
could be enlisted in this good cause. Humbler folk, men liable to con-
scription, may be supposed to have felt less enthusiasm. Massinger has
so much to say about the seamier aspects of war, so little about its
pomp and circumstance, that we are free to think of him as on the side
of King Roberto of Sicily, in the opening scene of *The Maid of Honour*,
rebuking young hotheads for wanting an unwise war, while his brother, a
fire-eater, invokes the stirring example of English seapower.

Another, more philosophical (or muddle-headed) mode of thinking
shows here and there in Massinger, as it does at least as often in Shake-
speare. To many pundits, Bacon among them, war was an indispensable
safety-valve for social discontents. Peace could not bring security, for
reasons never clearly spelled out. It was thought certain to make some
richer, others poorer, and hence to inflame class tensions. Romont reviles
the moneylenders who try to bribe judges against debtors as 'usurers, bred
by a riotous peace' (*FD*, I.i).

Standing armies were being built up. Money for pay and supplies was
scarce everywhere, nowhere more so than in England where the Stuarts

were always spending or throwing away more than they possessed. Mutinies were frequent, desertions numerous. Eubulus, a counsellor, goes on at length (*Pict.*, II.ii), rather in Kipling's vein, about how soldiers are caressed in times of peril by merchants and lawyers 'And such-like scarabs bred in the dung of peace' (the phrase recurs in *DM*, III.i); but when all is safe again, they are only 'paid with curses'. He applauds Queen Honoria for ordering full payment of arrears and a liberal 'donative' to the troops; this will make them fight well next time, whereas to be dismissed penniless, with no more than a licence to beg their way home, 'Turns their red blood to buttermilk'.

Belgarde, an unemployed captain, has little to do except to tell us about army grievances. Instead of reaping a rich reward, he has spent his own money in the service, and now bitterly declares that he would be content with no more than enough to set up a tavern or a brothel (*UC*, I.i). He breaks in on a banquet, in full armour, talks passionately of old soldiers who at the risk of their lives have swelled the fortunes of the rich, and shames the Governor and notables into loading him with gifts (III.iii). Recompensed at last, he is at once set upon by a bevy of creditors; this is the fate, he cries, of all captains who have no 'dead pays' and cannot trick the inspector at the muster (IV.ii). Many countries and eras have seen this dodge of commanders continuing to draw pay in the names of departed soldiers, and pocketing it. Charalois complains of his father, the old Marshal, being left to die in jail; the judges retort that he was well enough paid (*FD*, I.ii). The scene has a distinct resemblance to the one in *Timon of Athens* where Alcibiades wrangles with the Senate on behalf of soldiers and their rights. Altogether, the worthless Ricardo seems entitled to sneer at 'this bubble honour (Which is indeed the nothing soldiers fight for)' (*Pict.*, I.ii).

New armies required well-knit officer corps, with a more up-to-date code of conduct and sense of responsibility. Sentimentally Massinger's sympathies might be with the old order now fading, but he evidently felt that its leaders or figureheads, the nobility, ought to be doing more than they were for national defence: they were still supposed to be a *noblesse de l'épée*. Few men of rank will enter the 'dangerous profession' of arms, one character tells us (*BL*, I.i). Boldly leading an attack on a fort, Belgarde reflects that at moments like this the gentlemen are quite willing to yield precedence to the commoners (*UC*, V.ii). In Syracuse the heroine Cleora has to rebuke the aristocracy for being content to force peasants and slaves to do the fighting: the honour of defending their country, she reminds them, belongs first and foremost to them (*Bond.*, I.iii). Lord Lovell in *A New Way* is admired as a colonel who actually devotes himself to the army and accompanies it on campaign, instead of only wanting a meaningless title.

Various other officers are held up as patterns of their calling, like Timoleon in *The Bondman*. One decent, plain-spoken commander, Ferdinand, gets a word of praise for not taking all the credit of victory for himself, as some generals do (*Pict.*, II.ii). Paolo gives a high-flown

summing up of what a soldier's honour ought to mean: it includes an
injunction 'Rather to suffer than to do a wrong' (*VW*, IV.ii). Lady Allworth
cautions her stepson, when he wants to follow Lovell to the field, that war
can be an honourable career for men of virtuous nature, but will further
debase the evilly disposed (*NWP*, I.ii). One of the latter sort is Lorenzo,
Duke of Tuscany, a boastful and bloodthirsty militarist, out for conquest,
plunder and plaudits. He gives orders for a wood to be set on fire and the
beaten enemy hiding there to be massacred (*BL*, II.v; IV.i, iii). His rival
Gonzaga believes that success will desert him: his cruel butcheries must
have offended Heaven, and history shows that such men always pay a
penalty for their crimes: 'we have had a late example of it' (IV.iii). This
must be an allusion to some episode in the Thirty Years War, raging over
Europe from 1618 to 1648.

Ill-paid soldiers look forward with glee to the sacking of a town, with
all its horrors, and hope the enemy will not balk them of their prey by
surrendering and paying an indemnity; if this happens the money will go
to their ruler, or some favourite, with 'the poor soldier left to starve, or
fill up hospitals'. There is a strong note of class resentment in these
men's talk. If the town is stormed they will be able to get at the fat
burghers, 'These sponges that suck up a nation's fat'; and one of them
talks savagely of the pampered ladies who despise rough men at arms
(*DM*, III.i). The women whom soldiers see most of, among their camp-
followers, are 'cast suburb whores', worn-out prostitutes (*FD*, III.i). For
women as well as men the army was the last resort of the destitute. War
may be a necessity, but Massinger would like to see it at least brought
under some restraint, purged of some of its brutalities.

In *The Parliament of Love* we are introduced to a trio of licentious
courtiers, perfect cads in their flyweight fashion. Ricardo and Ubaldo in
The Picture come from the same nursery, and we may suppose that Mass-
inger encountered a good many such. Courtiers were fair game to any
playwright, but his account of the nobility and gentry at large seems unflat-
tering. Now and then he reveals an awareness of how heavily the self-
indulgence of the propertied classes weighed on the mass of people below.
A spoiled youth at Syracuse, who takes care to keep out of the fighting,
works off his irritations by beating his slave (*Bond.*, II.ii.). 'Drinking and
whoring', a cynic remarks, cannot be forbidden to 'men of acres' (*Ren.*,
III.ii): rich landlords cannot be expected to behave decently. Durazzo in
The Guardian, a Rabelaisian bon vivant, is a good-hearted fellow in his
own way. He urges his love-lorn nephew and ward Caldoro to come down
to their country estate with him, for a healthy course of hunting, hawking
and wenching. All the farmers' daughters will be at his disposal:

> I have bred them up to't; should their fathers murmur,
> Their leases are void. (I.i)

Massinger had aristocratic acquaintances, and here is a peep into a
corner of English social history that has been too little inquired into.

Russian landowners made free with their serf girls in a cavalier fashion, and their English cousins wielded not very much less power.

In this play, too, ostensibly about Naples, a nobleman under a cloud, Severino, has set up as a brigand chief, and emulates 'The courteous English thieves' (V.iii) – Robin Hood's band, presumably. His men have orders not to molest poor scholars (like Philip Massinger), or deserving soldiers, or rack-rented farmers and labourers; they are to go for miscreants like the profiteer who hoards food in expectation of scarcity, 'and, smiling, grinds the faces of the poor', or enclosers of village commons (privatisers, as we call such men today), or griping usurers, or manufacturers who destroy the forests (II.v).

A good many of Massinger's poor are individuals born to better things, who have come down in the world. When Charalois declares that he is a gentleman, Judge Novall retorts: 'So are many that rake dunghills' (FD, I.i). The decayed gentleman or gentlewoman was a familiar figure in that epoch of social whirligigs. Often a man owed his ruin to his own or his family's folly and waste; but he might be one of a swelling class of the educated for whom there were too few posts, or of the multitude of younger sons, with scanty portions, in an age when population was on the increase.

The Bondman can be taken as Massinger's counterpart to Shakespeare's *Henry VI, Part 2*, with the Kentish rebels led by Jack Cade, or to *Coriolanus*. In this loosely constructed drama it is the slave revolt at Syracuse that stands out as far the most interesting strand. Its leader is not one of the slaves, but the hero, Marullo, who stirs them up for purposes of his own. But once set going, it carries away both him and his creator: Massinger's dislike of the rich, with his own grudges to fuel it, makes him an eloquent advocate for the oppressed. He paints the cruelty of their masters in vivid colours; Marullo harangues the slaves – after plying them with wine – in something very like Anabaptist language: 'Equal Nature fashioned us all in one mould', and it was only the coming of despots that disrupted the golden harmony designed by God. Now the hour has struck: 'daring men' do not submit to misfortune, but 'Command and make their fates' (II.iii). The meeting ends with shouts of 'Liberty'.

The army being engaged in a foreign war, success is easy. There had been no rising of the masses in England (unlike, for instance, in France) for a long time; how they would behave if revolt broke out again no one knew, but many feared. These insurgents behave like cheery Cockneys out for a lark, more than brutal Calibans. They take their revenge not with bloodshed but by feasting while their masters go hungry, or parading one of them in the guise of an ape, a chain round his neck; a lady who was always beating her maid for nothing is made to carry her train. The victims feel that they have deserved their punishment, and Marullo rubs it into them: the well-off, accustomed to view themselves in 'The glass of servile flattery', must be made to realise how weak are the foundations on which their fool's paradise rests (III.iii).

The slaves are soon tipsy, but they are sobered by news that the army is

marching on the city, and energetically prepare for defence. When the army returns, victorious, they are alarmed but are quickly rallied by Marullo. He makes a long speech from the city wall: the slaves he says have been goaded into rebellion, and he contrasts the good old days, when servants were cherished by their masters like children, with today, when they are treated worse than animals (IV.ii). He demands a full amnesty, and emancipation for all. This is refused. An attack is driven off, leaving Massinger to hit on some way of calming the tempest he has unloosed. He does so by a theatrical trick: the masters brandish whips instead of swords, and the sight hypnotises their slaves into surrender, while their leader rages, like Jack Cade, at their base desertion (IV.iii).

He is captured and put on trial (V.iii). He had found the slaves, he maintains, growing mutinous, from 'too cruel usage', and put himself at their head in order to give their owners a warning for the future. They are brought in trembling; the governor Timoleon pardons them, but there is no question of freedom. Revolution has dwindled to mild reformism. Massinger had to take account of the censor, and however he might be fired by sympathy with the underdogs, he was limited by a backward-looking philosophy. Whether as time went on he was coming to see how unrealistic this was, we can only guess.

Believe as You List is a later, more mature play, and Massinger was more at home with its critique of political behaviour than with social problems of the lower depths. It was first written about the near-contemporary theme of Sebastian, king of Portugal, killed in battle in Morocco but long believed by many to be still alive and eager to recover his kingdom, taken over by Philip II of Spain. Because Charles I's government wanted good relations with Spain, Massinger was compelled by the censor to transform his play into a drama of ancient times. Spain's place was taken by Rome; Sebastian turned into Antiochus, a long-exiled ruler of somewhere in Asia Minor, and a model hero. In this case official intervention may have been a blessing in disguise; it turned anti-Spanish propaganda into something larger, a commentary on imperialism and on the morbid growth of state power and international rivalry. It is altogether a very political play, with no room for Venus.

Massinger was living in the formative age of modern Western expansionism, at work both within and outside Europe. It had many cross-currents; Englishmen denounced Spanish doing, but England and Holland, the two Protestant nations involved, were soon jealous opponents. Spain had far the largest empire, and was known to have treated its inhabitants barbarously. How many Englishmen were conscious of the barbarity of their country's doings in Ireland is unknown. Before long English colonialism would be too firmly enshrined in the national credo to be scrutinised objectively. Massinger had an interval of brief opportunity to make use of – and it is hard not to think that in some of his strictures on Rome he had England in mind as well as Spain. Shakespeare had written of Romans fighting one another, but not of their relations with their subject peoples, as his pupil does here.

Rome is 'The mistress of this earthly globe', Flaminius, its chief standard-bearer, pronounces (II.ii). When he brusquely silences some Asiatic merchants with grievances, their sponsor reminds him that it is men of their breed who furnish Rome's wealth by their hazardous journeyings as far as the Indies. Flaminius shrugs this off; he knows, and does not care,

> How odious the lordly Roman is
> To the despised Asian

– words that before long would only need 'Roman' changed to 'Englishman', or 'Dutchman', to be quite up to date. He adds a stern warning that Rome has 'iron hammers to pulverize rebellion' (I.ii). The traders' sponsor, Berecinthius, is a high priest of Cybele, neutered in obedience to his religion, fat and fatuous and ambitious. He gives the tragedy its touch of light relief; but his portrait is prophetic of the way European empire-builders were to view the religious dignitaries they met with in Asia.

Prusias, king of Bithinia, who would give the wandering Antiochus shelter if he dared, protests against Rome's never-satiated greed when it has already 'Seized with an unjust grasp on half the world' (III.iii). Antiochus himself is hoping that with his leadership and the aid of its gods 'oppressed Asia' may shake off 'the insulting Roman bondage' (I.ii). Flaminius makes an impressively sinister figure who can be put on a level with Overreach (Massinger's only character to achieve lasting fame) or even higher, in a sense, because he sins for his country as well as for himself, and is besides a thinker who has meditated deeply on the affairs of this world. He is a villain from head to foot, but one taken from reality, not from melodrama: he and his like, villains with good consciences, have been among the great makers of history.

After arranging to have one of his creatures discreetly poisoned, Flaminius is capable of a momentary twinge of conscience, but patriotism quickly stifles it. As a Roman he is bound to do whatever may be needful to 'preserve and propagate' the empire, whatever 'Necessity of state' dictates (II.i). *Raison d'état* was on its way to becoming the grand watchword and excuse of all organs of sovereignty in Europe. When Prusias has to be coerced into handing Antiochus over, Flaminius warns him of the hopelessness of defying Roman military might and tells him to think of his Bithinia overrun and subjected to rapine and devastation, as bloodcurdling a menace as Henry V's to the burghers of Harfleur. Prusias is cowed: he too pleads 'necessity of state' (III.iii).

Later on Flaminius and the proconsul Metellus agree on a scheme to induce Antiochus to confess himself an imposter by means of a lively courtesan. To Metellus this is distasteful: 'what botches are made in the shop of policy!' Any stratagems are eligible, Flaminius rejoins, if they serve to patch over the nakedness of whatever has to be concealed (IV.i). He likes to descant on the qualities required for success in public life: 'prompt alacrity', but no rashness; reliance on 'real certainties', not fantasies

(III.iii). In early life Massinger may well have heard his father, or acquaintances of his, conversing in this strain. Antiochus understands from the outset the ruthless egotism that he has to confront. Politicians will all shrink from helping him to challenge Rome. 'Ambition knows no kindred', and right and wrong have no place 'In the black book of profit' (I.i).

The new state of Massinger's age was breeding a new race of men conscious of being 'Selected instruments for deep designs', as Flaminius says, men who must have no private feelings, and never court ruin by going against accepted official designs (IV.i). Antiochus warns a Roman who shows him some commiseration that 'Pity in Roman officers is a crime' (IV.ii); blind obedience must be their rule (V.ii). Not all Romans are cast in the same iron mould. Marcellus, governor of Sicily, and his wife have known Antiochus well and been befriended by him in his days of prosperity. In a gloomy soliloquy Marcellus talks of the 'clouds of error' that befog human expectations. Men bring trouble on themselves by giving way to the hankering for office and power; often they abandon an easy, comfortable country life 'To wear the golden fetters of employment', cheated into fancying there can be no felicity except in state service. A functionary like himself is exposed to 'every subtle spy' on his conduct, and – an image surely borrowed from Hamlet – whatever wealth he sucks up, like a sponge, will one day be squeezed out of him 'By the rough hand of the law' (V.i).

He means to lay a rough hand of his own on Flaminius, who with all his zeal for Roman interests has not been neglecting his own – another hallmark of imperialism and its agents. Flaminius has felt the drain on his salary of the money he is forced to pay out on secret-service business, besides the strain of working in a political labyrinth, adapting himself to every shifting situation (III.i). When he is ready to quit Sicily with the captive Antiochus, Marcellus accuses him of taking bribes from Carthaginian merchants, and other misdemeanours, and arrests him. Flaminius draws the moral of his own downfall, as evil-doers in Massinger are wont to do: 'As heaven is merciful, man's cruelty never escapes unpunished.' Marcellus cannot save Antiochus, who is returned to prison to await death. The hero's last words are a reminder to potentates that heaven can pull them down as well as raise them (V.ii). He has shown contrition on his own part, by remaining hidden for more than 20 years, overwhelmed by shame – such as European monarchs never felt – for having through 'ambition's folly' led his 'poor butchered army' into Greece; there 12,000 men perished in a conflict with the Romans, leaving their country to be plundered, their women sold into slavery (I.i).

Massinger's two most effective comedies – both full of vitality, as L. C. Knights said [15] – show him on his native ground, exhibiting some social realities of the time without disguise. Sir Giles Overreach, the villain of *A New Way to Pay Old Debts*, has always been seen as inspired by Sir Giles Mompesson, a much detested hanger-on of the highly unpopular favourite Buckingham. The Clarendon editors remind us of differences: Mompesson was a gentleman by origin, not a bourgeois. [16]

He came to grief in 1621. More striking is the contrast between Over-reach and Shakespeare's grand moneylender, Shylock, who attains a tragic dignity when he speaks for an oppressed people as well as for himself. Overreach too is a usurer on a heroic scale; he comes from the City but has removed to the Midlands where he is busy grabbing all the land he can, by fair means or foul. He has turned into a hybrid, a man with a ready sword as well as a schemer in the dark. His frequent threats of an appeal to the sword, instead of to the law, give him indeed something of the look of a robber-baron. He is quite prepared to fight Lord Lovell, an approved soldier (III.ii, IV.i).

As an embodiment of the new competitive capitalism he tells his bankrupt nephew Wellborn that 'worldly men' like himself feel no desire to assist 'friends and kinsmen' who have come down in the world, but would rather help to push them into ruin; now, however, under the impression that Wellborn's luck is turning, he supplies him with a friendly thousand pounds (III.iii). His malignity is keenest against his social superiors. He admires, envies, hates and despises the old landowning class: his goal in life is to enter it, but by his ruffian methods he is sapping and dislocating what remains of an old feudal or patriarchal order, and is in this sense, if not a revolutionary, at least an iconoclast. He talks of a 'strange antipathy' between men of his kind and 'true gentry' (II.i); though this can scarcely be called a genuine *class* feeling since it does not rise above the egotistic level of an Iago's malice. Having got her husband into jail, he bestows Lady Downfallen on his daughter as a servant, with the injunction: 'Trample on her' (III.ii). The morbid psychology of social division was clearly something that intrigued Massinger, partly, it may be, because of his own indeterminate status.

Politics do not enter in, except that very lax government surveillance of local administration is implied in the way Overreach is able to employ his servants as bully-boys and make use of Justice Greedy, whom he has got on to the bench, as his creature, for example when he wants a poor farmer ruined (II.i). Overreach is a true *nouveau riche*, the opposite of Lovell, in his overbearing way of treating his minions. One is Marrall, crooked lawyer and notary public, who grows resentful, and betrays some shady secrets. It is typical of Massinger's mirage of an old-world society resting on mutual trust and loyalty that Marrall gets no thanks for this, but is kicked out of doors by the menials and left to lament that 'This is the haven false servants still arrive at' (V.i).

In the other camp Lovell is an ideal nobleman, 'gallant-minded, pop-ular' (II.i), but less vividly realised than his antagonist. True to the precepts of his caste, he cannot dream of marrying Overreach's daughter, who is being pressed on him, despite her wealth, beauty and goodness: a plebeian alliance would dilute and sully the mystic essence of blue blood. Circumstances alter cases, none the less: it is all right for the stepson of Lady Allworth, whom he is going to marry, to lead Margaret to the altar. Lovell is a prominent public figure, young Tom is an unknown.

Lady Allworth is another benign aristocrat. In her philosophy the

place of money is ambivalent. Persons 'of eminent blood' are concerned
to add to their honours, won by meritorious conduct; they cannot stoop
to hunting for lucre. All the same, wealth can be a good assistant, if
'well got', though a bad master (IV.i). How it is to be 'well got' she does
not specify, but it ought not to be rashly squandered, as it has been by
her deceased husband's favourite, Wellborn. She condemns the way he
has beggared himself by dissipation, but relents and helps him when he
reminds her of how he helped her husband through a time of financial
difficulties. Massinger lets us see that it is not Wellborn, but the trades-
men (and surgeon) he had left unpaid, that deserve sympathy. He pays
them off as soon as he has the means, and follows this with a resolve to
start a new life by joining the army and fighting for 'king and country'
(V.i) – an early use of a later well-worn phrase. A thought of Shake-
speare's later years recurs in this play: the best thing a man can be is
simply a *man;* to call him anything more is mere flattery (III.i).

The City Madam was written about seven years later and suggests
some shifts in Massinger's way of thinking besides the move from
Nottinghamshire to London. We see the new capitalism in a less baleful
light, with a conscience as well as a purse, though we see also the
contradictions that may arise. Sir John Frugal is another moneylender,
on a very large scale, and a great overseas merchant, like Shakespeare's
Antonio. These two activities often went together, partly because enter-
prise required credit, partly because so many wastrels were getting
through their money and wanting more. Lord Lacy admires him as a
man of integrity and upright dealing – 'a rare miracle in a rich citizen'
(III.i). Frugal's brother Luke admits that Sir John is a sensible 'citizen',
or businessman, who will not neglect 'what the law gives him', but
maintains that he is not cruel (I.ii). It must often have been hard to
know where to draw the line. When Sir John consents to give a set of
debtors more time to pay, he forbids any talking about it: if it is heard
of on the Exchange he will be laughed at as a sentimentalist (I.iii).

One of these debtors is a failed merchant whom Sir John is critical
of: he has been a 'glorious trader', or rash speculator, and he has let his
wife play spendthrift. Sir John himself has an extravagant wife and
daughters, who are undermining the secure place he has achieved by his
saving habits. A rich citizen might aspire to rise into the gentry, but he
must take care not to let his family make too much of a splash
prematurely: this would bring ridicule on him, and antagonise his peers,
as well as frittering away his funds. Much of the play's focus is on these
contraries within the upper-middle-class family; like the class as a whole,
it is far from homogeneous, and sex may represent one of its basic
divisions. One can understand why a man like Frugal was glad to have
preachers of Puritan morality at hand. His own brother Luke has gone
to the dogs and had to be redeemed from a debtor's cell – a middle-
class parallel to the dissipated gentleman Wellborn. Massinger is giving a
warning to heedless young men of all sorts. In the brothel scenes of the
play profligacy appears at its most repulsive.

In various contexts he deserves to be called a feminist,[17] but the citizenesses here are a highly unattractive trio. Lady Frugal and the daughters whom she has spoiled and misled are examples of how emancipation could have bad as well as good effects. 'London ladies', she informs their two suitors, consider it of prime importance that they should be supreme in the family; and Anne and Mary talk as tutored by her, about all the luxury and authority they will expect, until they are reduced to tears by the disgusted suitors walking out (II.ii). One of these, Mr Plenty – like Overreach in his different style – represents an evolutionary stage between bourgeois and gentleman. A plain simple fellow, he takes pride in his lands being uncumbered, and his servants and tradesmen paid punctually, as those of men of title seldom are. He has kept to his forebears' honest ways, but when his fellow wife-seeker Sir Maurice, Lord Lacy's son, twits him with his middle-class parentage, he whips out his sword and they fight until parted by Sir John (I.ii).

Holdfast the steward, who resembles the one in *Timon of Athens*, is horrified by the senseless display and waste that are going on. Meanwhile the scapegrace Luke is corrupting the two prentices, both sons of gentlemen: instead of letting themselves be loaded with work, like asses, they should show spirit and enjoy life. He mentions a common trick of fiddling receipts when a ship comes in with a rich cargo and is being unloaded. They need little schooling; Goldwire has already embezzled £600, and explains how he and other prentices come to one another's aid with pilfered money when any of their accounts are being examined (II.i). Evidently they as well as the womenfolk were in need of whatever moral reinforcement Puritan sermons could give them.

The plot takes a fanciful but amusing turn. Sir John pretends to retire from the world, leaving Luke in charge. Luke resolves to build up the family fortune, now his, to unheard-of heights. Money is what counts, he philosophises: all distinctions and pedigrees 'borrow their gloss from wealth', so that anyone who achieves riches can claim a share in the highest rank. He astonishes Lord Lacy by indulging in the same sadistic fantasy as Overreach: he will make Lady Frugal and his nieces rich enough to emulate the Roman dames 'who kept captive queens to be their housemaids' (III.i).

For the present, however, Luke revenges himself on the women, who have treated him insultingly, by putting them into the plainest dress and depriving them of attendants. He professes to be making an example of them 'to scourge a general vice' – the 'strange, nay monstrous metamorphosis' that makes citizens' wives disdain everything associated with the City. His sister-in-law is too conscious of her folly to be able to protest (IV.iv). He goes on to reveal the misconduct of the prentices, and when their fathers come to beg them off he is stern and unbending. The bonds for £1,000 deposited by them as surety for their sons' behaviour are to be forfeited, and they will be ruined. It has always been a mistake, in his opinion, for masters to take sons of the gentry into their service; such youngsters will go gadding about instead of working (V.ii).

We may guess that all this was not unwelcome to prentices in the audience whose fathers were *not* gentlemen, and who could not give themselves the same airs.

Unmasked in turn, as the 'Revengeful avaricious atheist' his brother calls him, Luke sneaks off crestfallen (V.iii). The remorseful daughters promise to be humble obedient wives, and Mr Plenty and Sir Maurice are content to take them – and their dowries – on these terms. Sir John repeats the play's keynote: 'city dames' must recognise 'A distance 'twixt the city and the court'. It need not be taken as a middle-class admission of inferiority; it expresses rather an old conception of the common-wealth as a harmony of separate estates, each with its own function. They are, none the less, learning to mix. Lord Lacy, much less standoff-ish than Lord Lovell, is happy to have his son marrying a City heiress. We may be expected to remember that when Luke was rummaging in the Frugal strongroom, he came on a mortgage of Lacy Manor (III.iii).

M. C. Bradbrook dismissed Massinger, as a tragedian at any rate, as 'always plausible but never convincing',[18] a generalisation which ought not to include what he wrote when there were thoughts in his head that really possessed him.[19] To Lowell he was a favourite among the old dramatists, a fine story-teller, capable of 'a good every-day kind of poet-ry', and, best of all, 'a man of large and generous sympathies'.[20] Gosse took leave of him, as we may do, as 'the last of the great men', even if the school he belonged to was in its 'final decay'.[21] Massinger might have endorsed this verdict. He may have been one of the many in his time who, like the king in his *Parliament of Love*, thought they saw 'The world decaying in her strength', modern man incapable of the antique virtue (V.i). He must surely at least have been often painfully conscious of the wide gap between himself and Shakespeare.

Notes

1. T. A. Dunn, *Philip Massinger: The Man and the Playwright* (London: Nelson, for University College of Ghana, 1957), p. 5.
2. A. H. Cruickshank, *Philip Massinger* (Oxford: Blackwell, 1920), App. 4, gives five pages of parallel quotations.
3. *The Plays and Poems of Philip Massinger*, 5 vols, eds Philip Edwards and Colin Gibson (Oxford: Clarendon Press, 1976). The titles of the fully authentic 15, with abbreviations used for reference and prob-able dates (see vol.1, pp. xxx-xxxi and lxxviii) are:
 The Maid of Honour (MH) ?1621–22
 The Duke of Milan (DM) ?1621–22
 The Unnatural Combat (UC) ?1624–25
 The Bondsman (Bond.) 1623
 The Renegade (Ren.) 1624
 The Parliament of Love (PL) 1624
 A New Way to Pay Old Debts (NWP) 1625
 The Roman Actor (RA) 1626

The Great Duke of Florence (GDF) 1627
The Picture (Pict.) 1629
Believe as You List (BAYL) 1631
The Emperor of the East (EE) 1631
The City Madam (CM) 1632
The Guardian (Guard.) 1633
The Bashful Lover (BL) 1636

The parts of *The Fatal Dowry* (before 1621) regarded as authentic are:

Act I, Act III to line 315, IV except sc.i, V (see vol. I, p. 1). In *A Very Woman* (1634): I, II to sc.iii, line 192, IV sc.ii, V. (See vol. 4, pp. 201–3; also Roma Gill, 'Collaboration and Revision in Massinger's *A Very Woman*', *Review of English Studies* [May 1967]).

It may be noticed that Massinger never used a personal name as the title of a play, as Shakespeare so often did. Perhaps Massinger could not feel as *close* to his characters as Shakespeare did to his.

4. Martin Garrett (ed.), *Massinger: The Critical Heritage* (London: Routledge, 1991).
5. U. M. Ellis-Fermor, *The Jacobean Drama* (London: Methuen, 1936), p. 225.
6. L. G. Salingar, 'The Decline of Tragedy', in Boris Ford (ed.), *The Age of Shakespeare* (London: Penguin Books, 1955), p. 110.
7. J. Middleton Murry, *The Problem of Style* (London: Oxford University Press, 1922), p. 57. Professor W. W. Robson drew my attention to this passage.
8. Dunn, *Philip Massinger*, pp. 139–40, 147. R. McDonald, 'The Maid of Honour', in Douglas Howard (ed.), *Philip Massinger. A Critical Reassessment* (Cambridge: Cambridge University Press, 1985), p. 114, recognises him as a serious thinker on moral problems.
9. Clarendon Press edn, vol. 3, p. 184.
10. Vernon Venables, *Human Nature: The Marxian View* (London: Dennis Dobson, 1946), p. 167.
11. Garrett, *Critical Heritage*, p. 37.
12. Cruickshank, *Philip Massinger*, p. 14.
13. Margot Heinemann, *Puritanism and Theatre: Thomas Middleton and Opposition Drama under the Early Stuarts* (Cambridge: Cambridge University Press, 1980), p. 213.
14. Arthur Symons, introduction to Mermaid Series edn of five Massinger plays (London: Vizetelly, 1887), p. xiii.
15. L. C. Knights, *Drama and Society in the Age of Jonson* (London: Chatto & Windus, 1937), p. 273.
16. Clarendon Press edn, vol. 2, pp. 277–8.
17. Cf. P. Edwards, 'Massinger's Men and Women', in Howard, *Philip Massinger*, p. 49, on his 'recognition of the rights of women'.
18. M. C. Bradbrook, *Themes and Conventions of Elizabethan Tragedy* (Cambridge: Cambridge University Press, 1935), p. 135.

19. Anne Barton, 'The Distinctive Voice of Massinger', a review of the Clarendon Press edn (in Howard, *Philip Massinger*, App.), pp. 230, 232, noted the impressive 'range and variety' of these plays and the 'dramatic verse of a very high order' to be found in them, along with simplicity.

20. James Russell Lowell, *The Old English Dramatists* (London: Macmillan, 1892), pp. 118, 122.

21. In Garrett, *Critical Heritage*, p. 239.

14 MARVELL, MILTON AND TRAJAN'S COLUMN

Elsie Duncan-Jones

Works of literature are often likened to unspecified monuments, whether of brass or stone or marble. It is rare, however, to find a particular piece of writing compared to a particular monument. There is something that provokes curiosity in Marvell's comparison of Milton's Latin pamphlet, the *Defensio Secunda*, published May 1654, to Trajan's column. Acknowledging the copy Milton had sent him, Marvell writes in June of the same year

> I shall now studie it even to the getting of it by heart: esteeming it according to my poor Judgement (which yet I wish it were so right in all Things else) as the most compendious Scale, for so much, to the Height of the Roman eloquence. When I consider how equally it turnes and rises with so many figures, it seems to me a Trajans columne in whose winding ascent we see imboss'd the severall Monuments of your learned victoryes. And Salmatius and Morus make up as great a Triumph as That of Decebalus, whom too for ought I know you shall have forced as Trajan the other, to make themselves away out of a just Desperation.[1]

The ingeniousness of the comparison is characteristic of Marvell. Words literally applicable to the column are metaphorically apt to Milton's prose: 'scale', 'height', 'figures'. Behind the phrase 'how equally it turns and rises' lies perhaps Marvell's observation of the fact that struck his contemporary Evelyn, who saw what he calls 'this stupendious pillar' on 26 February 1645, namely, that in the 'admirable Bass-relievo ... comprehending the Dacian War, the figures at the upper part' appear 'of the same proportion as those below'. It is worthwhile to recall, as Dr Margoliouth in his edition of Marvell invites us to do, that both Milton and Marvell had seen Trajan's column in Rome: a visual impression of the column adds something to the effect of Marvell's paragraph.

Marvell's comparison of Milton's book to Trajan's column is all the more apt when it is realised that the spiral bands on the column itself were intended as a pair of marble books. 'It is no accident', says M. Jérôme Carcopino, 'that the Column of Trajan was erected in the very centre of the city of books'. Behind it were the two great libraries.

Trajan must have intended the spirals which clothed it to represent the unrolling of two scrolls (*volumina*) which formed a marble record

of his warlike exploits ... One relief, three times as large as the others, separates the two series of records and reveals their significance. It represents a figure of Victory in the act of writing on her shield *Ense et stylo*. [2]

Whether or not Marvell realised that the two scrolls were *volumina*, thus completing the parallel with Milton's two *Defences*, his recollections of the column probably included the motto inscribed on it, *Ense et stylo*. Milton himself compares the achievements of the sword and the achievements of the pen:

> I thought that if God willed the success of such glorious achievements [as those of the Parliamentarian leaders] it was equally agreeable to his will that there should be others by whom these achievements should be recorded with dignity and elegance. [3]

Milton, writing in Latin, naturally enough recalls the deeds and records of antiquity, as when he says:

> much as I may be surpassed in the powers of eloquence and copiousness of diction by the illustrious orators of antiquity, yet the subject of which I treat was never surpassed in any age in dignity or in interest. It has excited such general and such ardent expectation, that I imagine myself not in the forum or on the rostra, surrounded only by the people of Athens or of Rome, but about to address in this, as I did in my former Defence, the whole collective body of peoples, cities, states, and councils of the wise and eminent. [4]

Marvell when he wrote his letter to Milton had evidently already read the *Defensio Secunda* closely, even if he had not literally got it by heart (did he ever? interesting that Marvell could contemplate memorising Latin prose). When he ascribes to Milton's pamphlet the 'Height of the Roman eloquence' he is no doubt consciously opposing the rhetorical modesty with which Milton had disclaimed the praise of eloquence. 'To the praise of eloquence except as far as eloquence consists in the force of truth, I lay no claim.'[5] And Marvell's suggestion that Milton may, for aught he knows, have brought about the deaths of Salmasius *and* Morus improves on Milton's 'There are some who impute his [Salmasius's] death to the penetrating severity of my strictures.'[6]

Marvell's praise of Milton's Latin as reaching the height of the Roman eloquence is echoed a century later by a scholar who had no liking for the men whom Milton honoured, nor for their achievements, nor for Milton himself. Of Milton's celebration of Cromwell, Johnson says: 'Caesar when he assumed the perpetual dictatorship had not more servile or more elegant flattery.'[7] Marvell's continued admiration of this pamphlet of Milton's is attested by his showing it about several years later among the learned men of Saumur. [8]

Notes

1. *Poems and Letters of Andrew Marvell*, ed. H. M. Margoliouth. 3rd edn rev. Pierre Legouis and E. E. Duncan-Jones (Oxford: Clarendon Press, 1971), vol. II, p. 306.
2. Jérôme Carcopino, *Daily Life in Ancient Rome*, trans. E. O. Lorimer (London: Penguin, 1941), p. 19. See also E. R. Curtius, *European Literature and the Latin Middle Ages*, trans. W. R. Trask (London, 1953), p. 310.
3. *The Prose Works of John Milton*, ed. H. G. Bohn, vol. I, *The Second Defence* (London, n.d. [1848]), p. 219. This translation of the *Defensio Secunda* is by Robert Fellowes (1771–1847).
4. Ibid.
5. Ibid., p. 249.
6. Ibid., p. 222.
7. Samuel Johnson, *Lives of the English Poets* (Oxford: World's Classics, 1955), vol. I, p. 84.
8. See my letter 'Marvell and Milton at Saumur', *Times Literary Supplement*, 31 July 1953, p. 493. A hidden and perhaps unconscious reason for Marvell's linking of Milton's pamphlet with Trajan's column might be that in one of the column's many bas-reliefs Roman soldiers are seen displaying the head of a defeated king, that Decebalus whose name occurs in Marvell's letter. The image of 'a bleeding head' would surely have been powerful to a mind that in 1650 had produced the 'Horatian Ode'. It is true that if, as is likely, Marvell had seen the column with his own eyes, it would have been at a time when there was no reason to pay special attention to a king's decapitation; but from 1576 onwards the details of the column could be studied in books of engravings. One of 1607 is in the British Library today. Another point: Marvell's interest in Roman emperors is striking. Who but Marvell would have introduced a reference to their 'donatives' into such a relatively light lyric as 'Mourning'? And Trajan, whom Dante puts in heaven, is perhaps the only one whose goodness was such as to make him suitable to figure in a compliment to Milton.

15 'O Cunning Texture to Enclose Adultery': Sexuality and Intertextuality in Middleton's *Hengist, King of Kent*

Inga-Stina Ewbank

All students of Jacobean and Caroline drama are indebted to Margot Heinemann. Her book, *Puritanism and Theatre: Thomas Middleton and Opposition Drama under the Early Stuarts*, has taught us to understand that social and political commitment can take many dramatic forms. Thanks to her it is no longer possible to see Middleton as 'merely a great recorder'[1] who, in *A Game at Chess*, happened to write one spectacularly censored play.

This paper is a small tribute to the memory of a great scholar, by way of an engagement with what is probably Middleton's least discussed play: his only historical-chronicle play, *Hengist, King of Kent*. In her book Margot Heinemann explores its political and social criticism and sees the hand of the censor in the differences between the two kinds of text which have survived: on the one hand the two manuscripts and, on the other hand, the text printed in 1661. My concern here is with the uses to which Middleton puts the texts of other dramatists and the uses to which the men and women in the play put each other's sexuality. These two questions can be seen, I believe, to be interrelated, and so I will enter them through a line which itself is a conduit for multiple voices.

In *Hengist, King of Kent*, IV.ii.155,[2] Vortiger, King of the Britons, dismisses his wife's claim that, though ''Tis truth, great sir, / The honour of your bed hath been abused', she is innocent because she was raped:

> O cunning texture to enclose adultery.

The stance is familiar. Like a Claudio, an Othello, a Posthumus, Vortiger can draw on cultural assumptions about women's sexuality and duplicity. A moment earlier he had declared his wife 'as pure as sanctity's best shrine / From all man's mixture,[3] save what's lawful, mine' (IV.ii.118–19). As he reverses this judgement, his language reflects the assumption that women are either saints or whores, and that the latter tend to appear like the former:

Mark but what subtle veil her sin puts on;
Religion brings her to confession first,
Then steps in art to sanctify that lust.
 (IV.ii.156–7)

But in the dramatic context this male discourse is undercut by irony,
more blatantly than is the case in any of those Shakespearean instances.
A 'cunning texture to enclose adultery' is exactly what Vortiger himself
is weaving. This public shaming of his queen (symbolically named
Castiza) is vital to a plot which enables him to cast her off in order to
satisfy his lust for another woman. The success of the plot is predicated
on Castiza's moral integrity: her inability to tell a lie when Vortiger
mounts a chastity test, challenging each of the ladies present to swear
'that you ne'er knew / The will of any man beside your husband's'
(IV.ii.86–7). She cannot swear, precisely because of the 'will' of her
husband: because in an earlier scene she was blindfolded, abducted and
(off-stage) raped by Vortiger himself – an early case of marital rape,
though she thinks it was done by a 'villain' (which of course it was).
 The irony does not stop there. The real weavers of a 'cunning texture to
enclose adultery' are the Saxons, Horsus and Roxena, lovers since before
they arrived in Britain and now using Vortiger's sexuality and Castiza's
chastity in a plot to 'enclose' their own continued liaison in a British royal
marriage for Roxena. Sexual and state politics are interwoven in this scene,
staged as a feast in Hengist's Kentish castle. The pathos of Castiza's
abused innocence is literally enclosed in a public framework, from
Hengist's welcoming ceremony[4] which he expounds in words that might
have been written for King James rather than Vortiger –

To show what power's in princes; not in us
Aught worthy, 'tis in you that makes us thus –
 (IV.ii.46–7)

to Vortiger's exit speech, in which he constructs his replacement of one
Queen with another (who has no compunction about falsely swearing to
her chastity, since 'they swear by that we worship not') as concern for
the royal succession:

 here's a fountain
To spring forth princes and the seeds of kingdoms!
Away with that infection of black honour,
And those her leprous pledges! – [5]
Here will we store succession with true peace;
And of pure virgins grace the poor increase.
 (IV.ii.214–19)

All of which is 'enclosed' by Horsus, left alone on stage to gloat over
the 'impudent confidence' of his 'precious whore' and, Iago-like, over his

own manipulation of Vortiger's sexuality ('I know his blood; / The grave's
not greedier') and its likely (and soon to be confirmed) political con-
sequences:

> Something will hap; for this astonishing choice
> Strikes pale the kingdom, at which I rejoice.
> (IV.ii.230–1)

So far, then, the line 'O cunning texture of adultery' says 'this is what
women are like' and unsays it by the contextual subtext of 'women –
and men, too – beware men'. But if we look further into its language,
we find it conducting a kind of dialogue with assumptions about female
sexuality. However unintentionally, it is a curiously self-referential line,
in that the ultimate weaver of 'a cunning texture to enclose adultery' is
of course Middleton. His play text purports to dramatise 'ancient
stories' of Britons and Saxons, as told by Raynulph, 'monk of Chester' –
let alone the 'drollery' of Simon, Mayor of Queenborough who became
so popular with the Blackfriars audience that he usurped the play's
title[6] – while in fact the historico-political action is governed by the
largely sourceless variety of sexual behaviour, including 'adultery', which
it is made to 'enclose'. Whole chunks of history and its crucial events –
acts of royal murder, depositions, coronations, and so on – are presen-
ted in dumb shows, while the verbal text (always excepting the doings of
the Mayor of Queenborough, with which I am not concerned in this
paper) concentrates on the sexuality of characters who are nowhere near
as fully explored as those in *The Changeling* or *Women Beware Women*
but who, perhaps because of this, are more immediately indicative of
Middleton's relationship with established ideologies.

As so often in Middleton's language, the line in question shows the
expected and the unexpected word meeting and forming, together, a
linguistic unit which is both simple and strangely teasing. 'Cunning'
would seem expected in the context of 'adultery'. The word still had a
neutral or positive sense of 'knowledgeable', as well as meaning 'crafty'
and 'guileful'. Used by men of women, who ought not to be 'cunning' in
either sense,[7] it becomes (as Vortiger intends it) particularly pejorative,
with almost inevitable associations of knowledge that is – as in Lucio's
unsolicited explication – 'carnal'.[8] Othello takes Desdemona for 'that
cunning whore of Venice'; Bertram blames Diana because 'Her inf'nite
cunning with her modern grace / Subdued me to her rate'; Claudio sees
Hero as 'cunning sin' covering itself with 'authority and show of truth';
and Venus, the Dark Lady, Olivia and (not least) Cleopatra are all called
'cunning'.[9] The unexpected enters with the image of a texture enclosing
the offence. The 'subtle veil' of the next line is a more conventional
code for women's guile in hiding sexual perfidy – a 'veil' to 'cover every
blot', as in Shakespeare's sonnet 95, or as in Middleton's own play *The
Witch*, where the Governor says of Isabella:

> If she be adulterous I will never trust
> Virtues in women, they're but veils for lust. [10]

'Enclose' avoids any suggestion of a simple binary opposition of appearance and reality, as in the idea of a veil covering the truth. It directs attention to a more ambivalent process, as in Shakespeare's only similar use of this verb, which is also in sonnet 95:

> How sweet and lovely dost thou make the shame
> Which, like a canker in the fragrant rose,
> Doth spot the beauty of thy budding name!
> O, in what sweets dost thou thy sins enclose!

As the petals fold round the canker devouring the reproductive organs of the rose, to present an apparently perfect flower, so Castiza's account of being 'surpris'd / By villains and so raught' is said to enfold her transgression. To enclose adultery in a 'texture' is not to cover it up but to 'sanctify' it, change its meaning by weaving it into a story – the language here tapping male suspicion of all that female weaving stands for. [11] The Duchess of Malfi is warned by her brothers against furtive sexual activity which, they say, will always 'come to light', even though 'Hypocrisy is woven of a fine small thread'. [12] In Renaissance English texts, we have been reminded, as in 'the old myths, weaving was women's speech, women's language, women's story'. [13] Castiza was allowed to keep her tongue, unlike Philomela or Lavinia; her spoken 'texture' is as revealing as that woven by Philomela, or as the Ovidian story of which Lavinia mutely 'quotes the leaves' [14] – but less effective than their silence. To be chaste is also to be silent, and Castiza played into the hands of her accuser by speaking up to defend her chastity. The line's articulation of its male topos manages to draw attention to the cultural assumptions on which such topoi are founded.

An unexpected word helps to flag that attention. Middleton does not call Castiza's story a 'web' – as when Venus 'unweaves the web that she hath wrought'. 'Texture', a word that is not part of Shakespeare's vocabulary, is recorded by the OED as first used, in the sense (sb 2c) of 'a "woven" or composed narrative or story', in Speed's History of Great Britain of 1611. Middleton may have read Speed, as City Chronologer and/or in preparation for Hengist, [15] and may have remembered his reference to 'the texture of our English Saxon Kings'; but my point is not so much that of an 'echo' as such, as it is Middleton's discovery of a newish and wondrous necessary word to hold both concrete and abstract meanings and to alert the listener to a range of viewpoints, male and female. The OED also locates in Speed's chronicle the earliest purely figurative sense of 'texture' (sb 5): 'Constitution; nature or quality, as resulting from composition' – a definition applicable to all the cunning textures evoked by the line, but most of all to the author's, as it both voices and critically steps aside from male language and attitudes.

The above exegesis points, I hope, to Vortiger's line as something of a paradigm of the intertextuality of Middleton's 'texture', verbal and dramatic, 'as resulting from composition'. My references to other texts have not been intended to pinpoint 'parallel passages' or specific sources, but to suggest the kind of resonances sounded by particular words in particular combinations and in a particular dramatic situation. Three decades or more into a period of unequalled dramatic activity new texts could hardly help echoing old ones, and some of course are only too anxious to signal such influences. Editors and other critics have shown that Middleton drew heavily on existing texts, dramatic and narrative; and I have tried to suggest [16] that he was particularly alert to the possibilities inherent in intertextuality between plays acted by the same actors in the same repertory. Marking and manipulating conventions of action and speech, he subverts them to his own use – as, for example, in *More Dissemblers Besides Women*, where the convention of the chaste/ unchaste widow becomes exposed as a male text, and where the widow herself attempts to rewrite this text by way of a strange ritual which draws attention to itself and to its use and abuse of the 'Mousetrap' in *Hamlet.* [17]

In *Hengist*, the rape of Castiza similarly draws attention to itself as a particularly brutal version – indeed, inversion – of the conventional bedtrick. Instead of the substitute bride, and the coupling leading to marriage and a happy ending, there is the husband as substitute rapist, and a spectacular dishonouring of the wife and her family. Middleton, I suggest, is turning the convention inside out to revalue it by conveying something of the human (female as well as male) reality which, *qua* convention, it tends to obscure. He does not allow us to forget, as Castiza is carried off-stage, 'with what anguish / She lies with her own lord' (III.ii.100–1). Of course he is also entertaining his audience with this twist to a familiar device, much as the sleeve on the video cassette of *Thelma and Louise*, Ridley Scott's 1991 film, describes it as 'the most entertaining road movie since *Bonnie and Clyde*'. But the tricking of Castiza asks to be apprehended – seen and read – through other bedtricks, much as Thelma's holding up of the supermarket asks to be read through innumerable scenes of male hold-ups. The formalised staging both of the abduction and the defamation of Castiza marks these scenes as set-pieces, plays within a play which is already self-consciously formalised as enacting Raynulph's choric narration – much as Thelma's robbery is presented as a film within the film, recorded by the store's security TV camera and later watched by policemen and by a husband who at last sees her with amazed admiration. However different these two works, and the cultures that have produced them, they share a technique of subversive intertextuality and an effect of at least raising questions about what the world looks like if you are a woman.

It used to be said, in order to reconcile plot and psychology in *Measure for Measure* and *All's Well That Ends Well*, that audiences would unquestioningly accept the convention of the substitute bedmate,

descending from folktales of clever wenches.[18] In *All's Well*, as in its Boccacian source, the bed-trick is a way for a woman to take control of the story; but even there the woman is allowed to make us uncomfortably aware, after the event, of the blindness of male lust which has made the trick possible:

> O, strange men,
> That can such sweet use make of what they hate,
> When saucy trusting of the cozened thoughts
> Defiles the pitchy night. So lust doth play
> With what it loathes, for that which is away.
> (IV.iv.21–5)

And, with the Duke as the engineer of the bed-trick, *Measure for Measure* presents it as a male story of female cunning, involving the translation of woman into a receptacle. In Mariana's only account of the experience, before the returned Duke, her language performs such an objectifying translation:

> This is the body
> That took away the match from Isabel,
> And did supply thee at thy garden-house
> In her imagined person.
> (V.i.206–9)

The unease one feels at lines like these is not merely a product of feminist criticism of the last few decades. It is surprising how rarely the bed-trick is used as just an unquestioned convention in the drama.[19] It takes the 'copious' Heywood to get full value out of a 'straight' use: in Part 2 of *The Fair Maid of the West* he achieves a happy ending by doubling the trick so that the King and Queen of Fez are both – separately – cheated of the English bedmates they believe they have slept with. Middleton's only similar use of this convention is in the stylised world of *A Game at Chess*. In *The Witch*, a play of several intrigue plots, all saturated with sexual betrayals of sorts, one character (Sebastian) enables a tragicomic solution to his plot by aborting an elaborate trick: a spontaneous flicker of conscience stops him from satisfying his frustrated lust on his ex-betrothed, though he has her at his mercy. *The Witch*, I believe, looks sceptically at the tragicomic form it uses;[20] and it is in keeping with this that the bed-trick proper, engineered by the Duchess in order to blackmail Almachildes into murdering the Duke, is driven towards self-conscious parody. Almachildes thinks first that the woman he slept with was Amoretta, the girl he is in love with (or was, until the blindfolded coupling revealed, he thinks, that she was no virgin), then that she was the Duchess – and so do we, until the very end of the play when it is revealed that she was 'a hired strumpet' (a convenience whom we never see, like Ragozine). At this

point Almachildes draws a wonderfully bathetic moral which undercuts
the entire convention:

> A common strumpet?
> This comes of scarves! I'll never more wear
> An haberdasher's shop before mine eyes again.
> (V.iii.120–1)

Alsemero, in *The Changeling*, does not wear a scarf but still does not
realise that he is embracing Diaphanta rather than Beatrice Joanna:
virginity is all. But here the convention wears thin under the pressure of
naturalism, as the substitute bride so enjoys the sexual pleasure women
are not supposed to experience that she overstays her time, and the
trick misfires – for her literally so. Middleton, as it were, has his cake
and eats it too: he extracts the faint absurdity of the artifice and then
turns on the full horror of the blind sexuality which it represents. 'Lust
and forgetfulness', as in *Women Beware Women*, is a pernicious combina-
tion; it drives the instigators as well as the objects of the bed-trick.

In Middleton's tragedies there is no one to stop and say, as Sebastian
does in *The Witch*, 'I cannot so deceive her [or him], 'twere too sinful', and
sexuality becomes destructive. He might have been impressed by
Marston's use of the bed-trick to dramatise its destructiveness, particu-
larly in *Sophonisba*, written c. 1605 for the Queen's Revels Children at
Blackfriars. Between Acts IV and V and to the sound of 'a bass lute and a
treble viol', Syphax ('a character of extreme and cynical appetite')[21] thinks
he is having intercourse with Sophonisba, magicked there by the witch
Erichto. In fact his bedfellow is the infernal witch herself, and he thus
presumably shares the fate of Faustus and others who sleep with a suc-
cubus. But in Middleton people damn themselves and destroy others
through their own appetites, without supernatural aid.

When the deceived partner in the bed-trick is a woman (unless she is
the Queen of Fez or a common strumpet), her fate, in accordance with
contemporary sexual ideology, is likely to be worse than death. Middleton
may well have known an extreme example of this, in the anonymous anti-
Spanish play *Alphonsus, Emperor of Germany* which, though probably
dating from the 1590s, ended up in the King's Men's repertory.[22] At the
Court of Alphonsus – a sadistic tyrant – Edward, Prince of Wales, marries
Hedewick, daughter to the Duke of Saxony, and reluctantly accepts the
German custom of letting his virginal bride sleep alone the first night.
Alphonsus uses his Page, Alexander, as a tool in all manner of villainies,
Alexander believing that he is thus avenging the murder of his father (in
fact killed by Alphonsus himself); and he seizes the opportunity of sending
Alexander as a substitute bridegroom to the Princess's bed:

> By night all cats are grey, and in the dark
> She will embrace thee for the Prince of Wales,
> Thinking that he hath found her chamber out;
> Fall to thy business and make few words. [23]

The next day she prattles ingenuously (in German) about having been slept with, and Edward, who has not been near her (though not for lack of trying to find her), denounces her as a whore. The consequences are horrendous. The Duke of Saxony throws Edward into prison for defaming his daughter; and when, as a result of the rape, she bears a child which Edward will not acknowledge as his, the Duke – in a scene to exceed the worst imaginings of Lady Macbeth – tears the babe from its mother's arms, 'dashes out the child's brains' and stabs his daughter to death.

Unlike Hedewick, the equally unhistorical Castiza is raped by her own husband and so can be allowed to survive (as he cannot). The extra twist that Middleton has given to the device enables him not only to show it up for the brutality that it is – the abduction scene, with Castiza fainting as she realises her plight, and being revived, reads like an early version of *Clarissa* – but also to explore the woman's experience of defilement. This is all the more remarkable since, unlike other Middleton heroines, she flatly conforms to the archetype of the chaste, silent and obedient woman. [24] She enters the play as a virgin, 'never yet, my Lord, / Known to the will of man'; she is betrothed to Vortiger but unwillingly thrust at the unwilling King Constantius, whose sermon on the blessings of virginity she so takes to heart that she departs to 'a monastery'. We next see her in dumbshow being married off to Vortiger 'with a kind of constrained consent', [25] while Raynulph's choric commentary presents the marriage as a kind of rape by the King who can

> force the maid,
> That vowed a virgin life, to wed;
> Such a strength great power extends,
> It conquers fathers, kindred, friends.
> (II.i Dumb Show, xi.11–14)

However, she conforms to cultural expectations and 'proves as holy in a wife' – indeed her abductors arrive on stage as she is soliloquising on the 'contented blessedness' of her marriage. Only as an orthodox paragon and as a fruitlessly pleading victim – in the abduction scene and in the scene discussed at the beginning of this paper – is she allowed first-person speech. As an abused and suffering being after the rape, she is a 'she', a 'poor lady', trapped in male discourse, appearing on stage only to disappear at once because she 'dare not look' on her lord, and reappearing only to speak (in an aside) her fear that 'He may read my shame / Now in my blush'.

But, just as the minute particulars from which I began suggested Middleton's ability to see and convey what such entrapment involves, so this is repeated in a larger structural unit in III.iii. Here Castiza's predicament is transmitted through the mind of Horsus, as he reports to Vortiger on overhearing how she unburdened herself in the confessional – a solace unavailable to the pagan Lucrece. Although Horsus 'behind the hangings'

could only *hear*, it is to all intents an act of male voyeurism, which would seem to confirm Castiza's identity as a mere object, albeit a holy one. In theory, Horsus' function is only to check on the success of the plot against Castiza, and that is how Vortiger receives his report, gloating that 'still fortune / Sits bettering our inventions'. But unexpectedly Middleton makes Horsus explain his motivation for this intrusion on her confession (a rape on her spiritual privacy), in terms which – like Camillo's on wanting to see Leontes again, or Achilles' on yearning for the sight of Hector [26] – draw a self-conscious analogy with the cravings of a pregnant woman, a slightly embarrassed gesture meant both to define and to excuse unmanliness:

> I had such a woman's first and second longing in me
> To hear how she would bear her mocked abuse
> After she was returned to privacy.
> (III.iii.143–5)

And from this tonal ambiguity and gender ambivalence he moves on, taking no notice of Vortiger's interjection, to shift his function from that of a spy to one of sympathiser. He is not so much observing Castiza as transparently rendering her distress as uniquely her own: 'I never heard a sigh till I heard hers'. In lines which occur only in the manuscripts of the play his language is made to enter into the reality of her woe:

> She fetched three short turns, I shall ne'er forget 'em.
> Like an imprisoned lark that offers still
> Her wing at liberty and returns checked,
> So would her soul fain have been gone, and even hung
> Flittering upon the bars of poor mortality,
> Which ever as it offered, drove her back again.
> (Bald, III.iii.277–82)

'Borrowings' from *The Duchess of Malfi* in other Middleton plays of the early 1620s have been noted, and Roger Holdsworth recently drew attention to several 'probable echoes' of this play in *Hengist*. [27] They do not include this passage, which seems to me to have been composed by someone who knew – possibly by seeing and hearing as much as by reading them – Bosola's words to the Duchess:

> didst thou ever see a lark in a cage? such is the soul
> in the body: this world is like her little turf of
> grass, and the heaven o'er our heads, like her looking-
> glass, only gives us a miserable knowledge of the small
> compass of our prison.
> (IV.ii.128–32)

My concern is not so much with the echo of the caged-lark image as

such but with the way that *The Duchess of Malfi* is deeply woven into, indeed 'enclosed' in, the 'texture' of this scene in *Hengist*. 'Who e're saw this Duchess live and die, / That could get off under a bleeding eye?' Middleton wrote in his commendatory poem 'upon this masterpiece of tragedy' prefacing the 1623 quarto of *The Duchess of Malfi*; and even allowing for the inflated language of such verses (though this was the only play for which Middleton wrote them), they support the evidence that the play had impressed itself on him. As a 'character', Castiza has little power to move; she exists as a function of a series of dramatic situations. The moving power of this particular moment has much to do with its implicit dialogue with Webster's play. The dramatic situations of the two women are very different – the Duchess literally 'imprisoned', her plight being taken up into a universalising image by Bosola who addresses her as her tomb-maker – but they share a fundamental entrapment in a world where women can only be saints or whores. They differ in their sexuality – the Duchess as warmly sensuous and philoprogenitive (and, incidentally, with a 'woman's first and second longing' for apricots) as Castiza is coldly chaste – but share the extreme powerlessness of womanhood. Behind Horsus' lines on the unseen Castiza we glimpse the seen Duchess of IV.ii as well as IV.i. [28] But at the same time Middleton composes his own texture, in which Bosola's systematic expansion of his image into a simile for the human condition is transmuted into something less generalised and more painful. The words alone have to move us here; and they do, as the action of the desperate bird becomes identified with that of the despairing soul in Castiza's ravished body which 'hung / Flittering upon the bars of poor mortality'. The Duchess is about to suffer death, Castiza to suffer life; and Middleton's lines give an intimation of what a fate worse than death feels like.

Playhouse intertextuality involves more than verbal echoes. For one thing, parts cling to actors, not least in the type-casting which seems to have been practised in the London companies of the early seventeenth century, and performance in one part may well activate memories of another. *Hengist* and *The Duchess of Malfi* were in the King's Men's repertory at the same time. It seems to me more than likely that the parts of Bosola and Horsus were taken by the same actor. The cast list in the 1623 quarto of Webster's play shows that, while the part of Ferdinand was taken over by John Taylor when Burbage died in 1619, that of Bosola continued to be played by John Lowin. There is enough evidence from a number of cast lists for G. E. Bentley to describe Lowin as 'the bluff and outspoken character, sometimes the honest friend, sometimes villain'[29] – all of which would fit Horsus as well as it fits Bosola. By far the most interesting figure in *Hengist*, he is both scheming villain and malcontent critic; he can be cynical but he can also, Othello-like, be driven by jealousy into a fit, and, as we have seen, he can feel with Castiza. An actor as experienced as Lowin[30] might have held together what on the page looks like a series of separate stances. From the descriptive cast list in the 1652 folio edition of

Fletcher's *The Wild Goose Chase* – probably first performed in 1620–21 and referred to as a new play by the 'cheaters' who come to act before the Mayor of Queenborough – we learn that the part of Belleur, 'of a stout blunt humour' was 'most naturally acted by Mr. John Lowin'.[31]

If Middleton wrote the lines about Castiza with John Lowin in mind, it may still be that Lowin never did get to act them, 'most naturally' or otherwise. Their absence from the quarto text suggests that they were cut for performance. This was not one of the cuts clearly made because of political censorship, as discussed by Margot Heinemann;[32] perhaps, like a number of other lines, they were found in performance to be more literary than dramatic. This does not change the fact that Middleton wrote them, but it suggests that the audience was less responsive to the plight of Castiza than he was. So does the reshaped ending of the play: in the quarto Castiza is written out of it, whereas in the manuscripts she comes on to be cleared. She

> Lives firm in honour, neither by consent
> Or act of violence stained, as her grief judges;
> 'Twas her own lord abused her honest fear
> Whose ends shamed him, only to make her clear.
> (Bald, V.ii.261–4)

This closure of the play hands Castiza on to her next patriarchal lord. The new king, Aurelius, does not so much propose as announce marriage –

> Nay, to approve thy pureness to posterity
> The fruitful hopes of a fair peaceful kingdom
> Here will I plant –
> (Bald, V.ii.279–81)

and Castiza, unlike the ambiguously silent Isabella in *Measure for Measure*, humbly accepts: 'Too worthless are my merits.' In the quarto text, where the final scene concentrates on Aurelius securing the realm 'from the convulsions it hath long endured' (V.ii.181), she never reappears after the defamation with which I began this paper. She ends as a blank. A reader in the mid-1990s will find the two alternatives – submission or absence – equally indicative of the ultimate marginalisation of woman. But the reader who has seen *Thelma and Louise* may be more attuned to the quarto ending. The manuscript's closure would correspond to a surrender and a life sentence for striking out against male abuse of female sexuality, but the quarto ending suspends the woman in mid-air, much as the film sends Thelma and Louise out into empty nothing, above 'the goddam Grand Canyon'. Perhaps the revision[33] represents the ultimate Middletonian irony in a play which Margot Heinemann tellingly described as 'at once powerful and inconsistent'.

Notes

1. T. S. Eliot, *Selected Essays* (New York, 1950), p. 148.
2. I have chosen to focus on *Hengist*, sharing the belief which prompted Samuel Schoenbaum's largely unheeded plea of nearly forty years ago, that 'the play most certainly does not deserve the apathy or scorn with which it has been received by so many critics', and that the play's 'merits ... far outweigh the defects, and its very faults have an interest of their own' (*Middleton's Tragedies* [New York, 1955], p. 101). I owe the reawakening of my own interest in the play to Dr John Flint, of whose PhD thesis, 'A Textual Study of *Hengist King of Kent*' (1992: unpublished dissertation in the Library of the University of Reading) I was an examiner. While I hope I have not inadvertently stolen any points from Dr Flint, I owe much to his thorough examination of the texts of the play – the two MSS and the 1661 quarto – and their contexts, and to the video recording of his production of the play. In particular I am persuaded by Flint's arguments for dating the play c. 1622. Evidence for this dating has also been given by Roger Holdsworth, 'The Date of *Hengist, King of Kent*', *Notes and Queries*, 236:4 (December 1991), pp. 516–19.

 Until the Oxford edition of *The Works of Thomas Middleton*, under the general editorship of Gary Taylor, is published, we have to make do with A. H. Bullen's edition of *Hengist* (that is, *The Mayor of Queenborough*), in vol. 2 of *The Works of Thomas Middleton* (London, 1885); and, unless otherwise indicated, citations in my paper are from this edition. MS readings, or lines which are found only in the MSS, are cited from R. C. Bald's edition of MS in the Folger Shakespeare Library, *Hengist, King of Kent; or The Mayor of Queenborough* (New York and London, 1938). Such citations, marked as 'Bald', have been modernised for consistency.
3. 'Mixture' is, of course, a most apposite pun in that, as well as objectively denoting the opposite of purity (*OED*, 1c: 'Mixed state or condition'), it meant 'sexual intercourse' (*OED*, 1e).
4. By making Hengist open the scene on a note of superlative flattery ('There's no brass / Would pass your praise, my lord; 'twould last beyond it, / And shame our durablest metal') and by the use of music and a celebratory song ('If in music were a power': in MSS only [Bald, p. 62]), Middleton insists on the conventions of a royal entertainment, ironically inappropriate when the monarch being honoured is Vortiger, whose whole intent with this occasion is to dishonour Castiza.
5. The 'leprous pledges' are Castiza's father and uncle, Devonshire and Stafford, whose honour, and much more, is at stake with Castiza's. Pressure on her to forswear herself is intensified as they declare belief in her purity and Vortiger seizes on this opportunity: 'Perfect your undertakings with your fames; / Or by the issues of abused

belief, / I'll take the forfeit of lives, lands, and honours, / And make one ruin serve our joys and yours' (IV.ii.141–4). In the MSS the fact that Castiza's ruin is also her noble family's is emphasised by the following line-and-a-half after 'pledges', not in the quarto: 'by her poison / Blemished and spotted in their fames for ever' (Bald, IV.ii.266–7).

6. The title is given as 'The maior of Quinborow &c' in the list of plays supplied in 1641 to the Lord Chamberlain by the King's Men (indicating, incidentally, that the play was in their repertory right up to the closing of the theatres). Under the same title it was entered on the Stationers' Register in 1646 and again in February 1660/61, and published as a quarto (*The Mayor of Quinborough: A Comedy*) in 1661.

7. Castiza could be faulted in the other sense, too, for in the scene where she is abducted she enters '(with a Book) and two Ladies' (Q) and makes it clear that she prefers reading to the company of her women, whose opinion of female learning is orthodox. 'Books in women's hands are as much against the hair, methinks', says one of them, 'as to see men wear stomachers, or night-rails' (III.ii.8–10). Castiza's Hamlet-like fondness for solitary reading makes possible the abduction and rape.

8. *Measure for Measure*, V.i.211. Shakespeare quotations in this paper are from *The Complete Works*, ed. Stanley Wells and Gary Taylor (Oxford, 1988).

9. *Othello*, IV.ii.93; *All's Well*, V.iii.219–20; *Much Ado*, IV.i.35–6; *Venus and Adonis*, 471; Sonnet 148, and cf. 139; *Twelfth Night*, II.ii.22; *Antony and Cleopatra*, I.ii.137.

10. *The Witch*, V.i.114–15. Quoted from the edition of the play in *Three Jacobean Witchcraft Plays*, ed. Peter Corbin and Douglas Sedge (Manchester, 1986).

11. Freud, it may be worth remembering, thought that 'women have made few contributions to the discoveries and inventions in the history of civilization; there is, however, one technique which they have invented – that of plaiting and weaving ... Nature herself would seem to have given the model which this achievement imitates by causing the growth at maturity of the pubic hair that conceals the genitals'. See the lecture on 'Femininity' in *New Introductory Lectures on Psycho-Analysis*, vol. XXII of *The Complete Psychological Works of Sigmund Freud*, ed. James Strachey (London, 1933), p. 132.

12. *The Duchess of Malfi*, I.ii.236. Quoted from John Russell Brown's Revels edition (London, 1964).

13. Carolyn G. Heilbrun, 'What Was Penelope Unweaving?', in *Hamlet's Mother and Other Women: Feminist Essays on Literature* (London, 1991), p. 103.

14. *Titus Andronicus*, IV.i.50.

15. As Bald points out (p. xvii), the story of Hengist and Horsa and the coming of the Saxons 'was to be found in all the Elizabethan chronicles, from Fabyan to Stow and Speed'. He argues for Fabyan as the

chief source, beside Holinshed; however, he also concedes that, as official Chronologer to the City of London (or in preparation for this office, to which he was appointed in 1620), Middleton can reasonably be supposed to have read widely in the old chronicles (Bald, p. 135).

16. Inga Stina-Ewbank, 'The Middle of Middleton', in Murray Biggs, Philip Edwards, Inga-Stina Ewbank and Eugene M. Waith (eds), *The Arts of Performance in Elizabethan and Early Stuart Drama* (Edinburgh, 1991), pp. 156–72.

17. Ewbank, 'The Middle of Middleton', pp. 164–9.

18. See W. W. Lawrence, *Shakespeare's Problem Comedies* (New York, 1931).

19. See that invaluable compendium, R. S. Forsythe, *The Relations of Shirley's Plays to the Elizabethan Drama* (New York, 1914; reprinted 1965), pp. 330–1, for a list of bed-tricks.

20. Ewbank, 'The Middle of Middleton', pp. 158–60.

21. *Three Jacobean Witchcraft Plays*, 'Introduction', p. 6.

22. See G. E. Bentley, *The Jacobean and Caroline Stage*, vol. I (Oxford, 1941), pp. 132–3. In 1630 the King's Men played *Alphonsus* at court on 3 October and *The Duchess of Malfi* on 26 December.

23. *Alphonsus, Emperor of Germany*, III.i.332–5. Cited from *The Tragedies of George Chapman*, ed. T.M. Parrott (London, 1910).

24. As a dramatic character, Roxena, the 'bad' woman, is far more interesting, because active and articulate, from the moment she enters the play and pretends to cure Horsus from his fit by 'a virgin's right hand strok'd upon his heart' (II.iii.219) to her slow and eloquent (more so in the MSS) death in the flames of wild-fire. She is resourceful; she understands the sex / power nexus, as she assures Horsus of her loyalty to him even when married to Vortiger ('Take reason's advice, and you'll find it impossible / For you to lose me in this king's advancement, / Who's an usurper here; and as the kingdom, / So shall he have my love by usurpation', III.i.53–6); and she articulates a pragmatism central to Middletonian drama: 'What's he can judge of a man's appetite / before he sees him eat? / Who knows the strength of any's constancy / That never yet was tempted? We can call / Nothing our own, if they be deeds to come; / They're only ours when they are passed and done' (III.i.7–12).

25. MS reading: Bald D.S.ii.20; the quarto reads 'comes unwillingly'.

26. *The Winter's Tale*, IV.iv.667–8; *Troilus and Cressida*, III.iii.230–2.

27. Holdsworth, 'The Date of *Hengist, King of Kent*', pp. 517–18.

28. Horsus earlier imagined how Castiza 'could curse / All into barrenness, and beguile herself by't' (III.ii.101–2), which is reminiscent of the Duchess cursing 'the world / To its first chaos'in IV.i.94–8.

29. G. E. Bentley, *The Jacobean and Caroline Stage*, vol. II (Oxford, 1941), p. 500.

30. Lowin was with the King's Men for nearly forty years, until the closing of the theatres; he ranks with Heminges and Condell as the

best known of Shakespeare's fellows and with Taylor as the most famous members of the Caroline company.

31. The 'Drammatis Personae' is reproduced in G. E. Bentley, *The Profession of Player in Shakespeare's Time, 1590–1642* (Princeton, NJ, 1984), p. 256.

32. If there is an underlying allegory in which Castiza represents the Church of England and Roxena the Church of Rome (the Whore of Babylon), then the revisions have implications for national as well as sexual politics. See *Puritanism and Theatre*, p. 141.

33. Unlike Bald, and like Flint (who produces a convincing argument for his theory), I believe that *Hengist* was written for the King's Men and revised by Middleton himself in the light of stage experience.

16 THE END OF SOCIALIST REALISM: MARGOT HEINEMANN'S *THE ADVENTURERS*

Andy Croft

Margot Heinemann's novel *The Adventurers* begins in 1943 and ends in 1956, two *anni mirabiles* in the history of the twentieth century. Between these two dates the long trajectory of the left in Europe curves through its highest point. Even in Britain, the ideas and aspirations of the left were briefly hegemonic, helping to construct and sustain the popular sense of the post-war British consensus, and the labour movement was strong enough to challenge the authority of the old ruling classes, and for a few years to grasp, through only a second-hand, the levers of state power.

For communists like Margot Heinemann, these two dates marked another trajectory. Between the defence of Stalingrad and the invasion of Hungary, the contrast in the Communist Party's fortunes could not have been more striking. In 1943 the Red Army was winning the war and the party was expanding rapidly to its highest-ever figure of over 60,000 members; that year the party was able to wage an energetic, and almost successful, campaign to affiliate to the Labour Party. By early 1956, however, membership was down to 33,000, over a quarter of the membership were to leave as a result of the party's reflex support for the Soviet invasion of Hungary, and within two years there were just over 24,000 left, less than half the 1943 total. [1]

The lines are not exactly parallel, but they nevertheless suggest a familial relationship between the two histories, the Communist Party's rising influence informing the wider ascendancy of radical ideas about life in post-war Britain, its sclerotic decline anticipating – and contributing to – the defeat of those ideas. These overlapping trajectories are the subject of *The Adventurers*; as the reviewer in the *Transport and General Workers' Union Record* observed, the central figure in the novel was the labour movement itself. [2] The novel begins, as Heinemann began writing it, full of hope for the future; it ends, like so many of those hopes, in 1956.

The Party that Creates and Guides

Although she studied English at Cambridge, Margot Heinemann spent the first 16 years of her working life as an economist and propagandist, for the Labour Research Department (LRD), the Miners' Federation

(MFGB), the NUM and the Communist Party (which she joined in 1934). She started working for the Labour Research Department in 1937, and in 1938 she was appointed editor of *Labour Research* (where most of her writing was unsigned). In 1942 the LRD published her first book, *The Health of the War Worker*. That year, though she was to continue as a member of the LRD staff until 1948, she ceased to edit *Labour Research* in order to concentrate on work commissioned by one of the LRD's affiliate organisations, the Miners' Federation, helping to prepare their case for the Greene Inquiry on miners' wages. Thereafter she continued to do much work for the MFGB; she regularly taught on Scottish NUM Areas schools (where she met two young communist miners called Lawrence Daly and Mick McGahey). In 1944 the Left Book Club published *Britain's Coal*. With an introduction by MFGB President Will Lawther, the book sold over 23,000 copies. This was soon followed by *Wages Front* in 1947 and a book about nationalisation, *Coal Must Come First*, in 1948.

Heinemann had been writing on labour economics in *Labour Monthly* since the beginning of the war, and she soon began contributing to the *Daily Worker*, *The Modern Quarterly*, *Communist Review* and *World News and Views*, forcefully expressing the party's economic policies as they slipped from post-war optimism to the increasingly embattled positions of the late 1940s and the Cold War. [3] She was elected to the London District Committee of the party in 1944, and stood in Lambeth and Vauxhall as the party's candidate in the 1950 general election (polling 508 votes, or 1.3 per cent of the votes cast). From 1949 to 1953 she worked full-time for the party in the Propaganda Department, writing speeches for Harry Pollitt (with whom she enjoyed a close personal relationship), drafting pamphlets, leaflets and speakers' notes, and serving on the editorial board of *The Modern Quarterly* and editing *World News and Views* from 1949 to 1951. Although she gave up full-time work for the party in 1953 in order to care for her daughter Janey, she joined the influential publications commission (overseeing the *Marxist Quarterly*, *World News and Views* and *Communist Review*) and began reading for Lawrence and Wishart.

After the dramatic growth of the party during the war and the relative openness of the immediate post-war years, the party now found itself pitched into the front line of the Cold War's 'Battle of Ideas', isolated, defensive, and in relentless decline. Unable to exert any real influence on British intellectual life, King Street tried to assert its authority over its own members, particularly the party's own writers and intellectuals, provoking a series of bruising battles between the National Cultural Committee and the journals *Our Time* and *Arena*. Heinemann's closeness to the party leadership and the thinking of the NCC was evident in her contribution to the 'Caudwell Debate' in *The Modern Quarterly* in 1951. The debate had begun with a clumsy attempt to introduce an Anglicised Zhdanovism into the party and quickly became a coded argument about the creative autonomy of poetry (and therefore

of the party's own writers). Heinemann supported the assault on Caud-well, invoking Mao and Stalin to argue against the 'un-Marxist' and 'idealist muddle' of Caudwell's ideas about poetry and his distinction between external and internal reality, thought and feeling. Caudwell, she argued, was 'confusing and discouraging many who ought themselves to be trying to make the new poetry we so desperately need'.[4]

From this point it was clear that the Cold War 'Battle of Ideas' was also to be fought inside the party. And while other writers and intellectuals began to group around the dissenting positions from which they left the party in 1956, Heinemann was increasingly identified with the hardening cultural orthodoxies of King Street. When *The Modern Quarterly* was replaced in 1953 by the still narrower *Marxist Quarterly*, Heinemann sat on the advisory council. In 1954 she contributed a long essay about André Stil's trilogy *The First Clash*, a triumphant example of socialist realism:

> The greatest attractive power of a book like *The First Clash* is its *optimism* ... Stil's book is truly optimistic because it shows again and again, without exaggeration or false sentimentality, the real, undefeat-able goodness and courage of ordinary working people; and also because it gives, more clearly than any novel that has yet come from the capitalist countries, the picture of the advanced revolutionary worker, the man who is a step ahead of the rest in consciousness and responsibility, and the Party that creates and guides such men ... Stil's picture of the working class stresses what is positive ... his emphasis is on the fine qualities – the toughness and devotion, the endless care and sacrifice for the children, the ability of ordinary workers to read and study and master the most complicated ideas, the unconquerable humour and initiative. And is not this essentially the *true* picture of the class that is going to change the world?[5]

Dismissing the 'complexity' of contemporary novelists like Graham Greene and Elizabeth Bowen (at the time two of the party's favourite examples of 'decadent bourgeois' writers), she urged the party's writers to follow the example of Stil, 'to deepen their knowledge, and hence the content of their work, through participation in the struggle'.

Closer to the Party

This was a common refrain in the party's cultural life in the early 1950s, a repeated complaint about the decline in the party's cultural and liter-ary life, using the revived Soviet model of socialist realism as a stick with which to beat the party's own best writers, few of whom showed any interest in this kind of fiction. The importance the party now attached to the work of its 'cultural comrades' was evident when in January 1952 the EC adopted a resolution on cultural work, congratulat-ing the National Cultural Committee on its activities but identifying

several weakness, particularly the need for more

> systematic efforts by our professional workers to strengthen their
> Marxist outlook and fighting spirit ... and to bring their work closer
> to the Party organisations, especially our Factory Branches, and to
> the needs of the Party's fight for peace, independence and Socialism.

The party's writers were urged to 'produce works related to the British
working-class struggle, and based on the standpoint of Socialist realism',
to expose 'the false ideas which serve the interests of the warmongers
and the reactionaries', and to pay more attention to cultural achieve-
ments of the Soviet Union, China and the People's Democracies.[6] That
Easter the party's 22nd Congress also passed a resolution on cultural
work, calling on all party organisations to develop the cultural struggle
as part of the political struggle and in particular:

(1) To extend our work through film shows, pictorial propaganda, choirs
 and orchestras; to support all working-class and democratic cultural
 activities; and to press for the fuller use of existing powers by local
 authorities.
(2) To increase activity against the Americanisation of Britain's cultural
 life, against reactionary films and lurid and debased literature and
 comics.
(3) To endeavour to make our national cultural heritage the pride and
 possession of the working-class.
(4) To help our members working in this field to bring their work closer
 to the needs of the Party's fight for peace, independence and Social-
 ism; and to strengthen their Marxist–Leninist approach in the fight
 against capitalist and social-democratic ideas and propaganda.

The following month, at a conference of group and district committee
delegates called to implement the Congress resolution, Sam Aaronovitch
(Secretary of the NCC) again drew attention to the position of the
party's writers:

> Our main weakness, however, is in the field of creative writing ... It is not
> the stage of the mass struggle which is holding us back. What then are
> the problems? Firstly, the necessity of our writers, professional or
> otherwise, identifying themselves with the struggle of the working class
> ... Our writers need above all political clarity; they must themselves be
> participants in the struggle for peace ... the needs of the people, and
> their work must be regarded as a weapon in this struggle.[7]

The May and July meetings of the NCC in 1952 addressed the need to
stimulate imaginative writing 'which will actively help the fight for peace,
independence and the advance to Socialism'. Having effectively closed
down Jack Lindsay's journal *Arena* (too 'eclectic' for these narrow times)

the Political Committee approved the production of a new 'fighting journal of popular culture', a quarterly sixpenny literary supplement to *World News and Views* which would bring the party's literary culture under the control of King Street. Announcing the launch of *Daylight*, Emile Burns took care to emphasise the break with those writers, like Randall Swingler, Jack Lindsay and Edgell Rickword, who had been involved in *Our Time* and *Arena* (and indeed all the party's literary publications since the early 1930s). *Daylight* was 'NOT a journal for a clique', he insisted. Instead it must

> serve as a vehicle for the fight to develop a Marxist attitude in relation to literature and art, to combat reactionary trends, to provide a platform for writers and artists fighting for peace and socialism ... Such a journal can only fulfil its task as educator and organiser in the cultural sphere if it is recognised as ... the voice of the Party in this sphere ... two pressing needs confront us – to conduct and win the fight inside the Party for Marxist principles, for the theory and practice of Socialist Realism, and to capture the initiative in these matters from the Catholics, Trotskyites and other bourgeois ideologists, who have a clear field to themselves at present. [8]

The editor was to be Margot Heinemann.

Diminishing Cloth

The party's ownership of *Daylight* was clear from the first issue in autumn 1952. The editorial board consisted of Writers' Group members like Jack Beeching, Montagu Slater, Doris Lessing and Ewart Milne, and the magazine was illustrated by members of the Artists' Group like Paul Hogarth, Cliff Rowe, Ern Brooks and Ken Sprague. *Daylight* published contributions by some of the party's most distinguished writers, like Swingler, Edward Thompson, A. L. Lloyd, Ewan MacColl, as well as pieces by Albert Maltz, Nazim Hikmet and Brecht. But the emphasis was overwhelmingly on writing about industrial struggles by working-class party members. Party full-timers like Brian Behan and Harry Bourne contributed; so too did the young Norman Buchan. A competition was held for stories 'describing an experience of struggle in which the writer himself took part'. The importance of the project for the party's sense of identity and its hopes – still – of building a partisan working-class literary culture were clear in Heinemann's second editorial:

> If we haven't as yet found a new Jack London, William Morris or Maxim Gorky, we can say we have got in touch with men and women throughout the country who are trying to set down and give form to their experiences, their *struggles*, their striving for peace and Socialism ... One or two of our readers thought we were 'too political'. But most

of our readers evidently welcomed the fact that the paper did not only show people's hardships and problems, but also gave something of the struggle for a better world. It is, after all, not passive suffering, but socialist-inspiration that has made a book like *The Ragged Trousered Philanthropists* a classic ... So if you like this issue, buy another copy for the worker next to you on the bench, the lad you play darts with, your neighbour or your mother-in-law. This is the way to help *Daylight* to grow into a bigger, better paper. It is also the way to help towards a new, vigorous people's art and literature in Britain. [9]

It was a brave experiment, whose militant workerism recalls the 'fighting culture' of the party during earlier periods of isolation and decline: *Storm*, early issues of *Left Review* and *Poetry and the People*. Nevertheless, *Daylight* clearly tapped a rich seam. The first issue sold over 9,000 copies, and Heinemann received more than 700 submissions by the second year, far too many to publish. As Heinemann later recalled, 'we didn't get much chance to edit it':

Emile insisted that we couldn't *reject* stories and poems, we must write making detailed suggestions to improve every one – an impossible job for a spare-time group with the mass of stuff coming in. However there was a real demand and the circulation was around 7,000 ... Whereupon Emile closed it, on the grounds that the Party had already too many papers to sell and it was a diversion of effort ... the Party was in an increasingly defensive, weak and marginalised position, and there was no doubt a feeling of cutting back the coat to diminishing cloth.[10]

How to Drive the Bus

Considering the defensive and isolated position of the party in the Cold War, the party's increasingly narrow conception of literature, it is hardly surprising that its strident calls for a 'new, vigorous people's art and literature in Britain' were unsuccessful. What remained of the party's metropolitan literary culture was increasingly a focus for opposition inside the party, a process made explicit during the events of 1956. According to Heinemann, the party was planning to launch another journal that year, 'a much grander "Communist New Statesman" with all the big names'. Unfortunately, most of the party's literary 'big names' – Edgell Rickword, Randall Swingler, John Sommerfield, Doris Lessing, Edward Thompson – had left the party by the end of the year. [11]

Although the party launched *Marxism Today* in 1956 as a forum for discussion, it rarely discussed literary issues and of course contained no creative writing, suggesting that the party had at last recognised the difficulty of making a priority of what was now one of its weakest areas of work. This weakness was evident the following year when Arnold Kettle offered a defence in *Marxism Today* of *Novy Mir*'s decision not to publish

Doctor Zhivago ('a socialist society feels no obligation to publish work that is fundamentally opposed to and has the effect of misrepresenting the human advances and ideals of the socialist revolution'). The resulting correspondence 'On the Artist and Politics' was remarkable only for its level of abstraction, soon deteriorating into a debate between those who wanted the party to 'guide' its writers and those who believed in the 'special' quality of the artist. Jack Lindsay struck a rather more specific note, criticising the 'mechanical and trivialising applications' of socialist realism in the Soviet Union. Meanwhile, a young novelist called Dave Wallis wrote in ridiculing the idea of the party 'guiding' a writer: 'why not tell the bus driver, not just our plan for his industry and how his life would be transformed under socialism, but how to drive the bus as well?' [12]

Wallis was one of a group of working-class party members who emerged through *Daylight* to publish their first novels with Lawrence and Wishart in the years immediately following 1956. Unsurprisingly, they were all written in the earnest style so enjoyed by *Daylight*, romantic party novels about life, work and politics in factory, shipyard and pit, jolly dramatisations of *The British Road to Socialism*. What is most striking about these novels, however, is the way they turn their gaze away from the difficult political realities of contemporary Britain. Brian Almond's *Gild the Brass Farthing* and both Dave Lambert's Clydeside novels, *He Must So Live* and *No Time for Sleeping*, were set in the 1930s; Frederick Harper's *Tilewright's Acre* and *Joseph Capper* were set in the early nineteenth century; Wallis's first and most successful novel, *A Trampstop by the Nile*, was set in Egypt among the occupying British forces there. It was clearly easier to squeeze the past through the socialist-realist mangle than it was the disappointments of contemporary Britain. Even the prolific Jack Lindsay began a kind of forced retreat into translations and autobiography; though he wrote the first four of his 'Novels of the British Way' sequence in the 1950s, they were all set in the late 1940s. James Barke, meanwhile, had abandoned contemporary fiction altogether to write a five-novel sequence about Robert Burns and Jean Armour. The most promising and successful of these young novelists was the South Yorkshire miner Len Doherty, whose first novel, *A Miner's Sons*, sold over 3,000 copies. Doherty, however, left the party after 1956. The rest of the Lawrence and Wishart novels proved a commercial and critical disaster; Herbert Smith's *A Field of Folk* and *A Morning to Remember* sold barely 600 copies. [13] This was not, in the circumstances, surprising; the party was anyway habituated by now to the failure of its cultural efforts. And this kind of disappointment could always be assuaged theoretically by a determinism that sounded more like the early 1920s:

> because economic exploitation continues, because monopoly capitalism continues to own the means of production, distribution and exchange ... the working people are culturally robbed. While this position exists there can never be a working-class culture in Britain. [14]

At last!

In the middle of this unedifying exchange, at the end of this long and disappointing decade of political decline, intellectual crisis and cultural failure, Lawrence and Wishart published *The Adventurers*, in October 1960. The importance of the novel for the party, particularly for its hopes of reviving a distinctive communist literary culture, was clear. 'At last!', declared Dave Wallis in *World News*, 'a novel of the Labour movement and its life and victories and defeats over the years since the war.' It was, he said 'always readable and often brilliant', a 'fine, moving and very courageous novel written with a talent which the cultural mandarins of the press will not be able to ignore.' 'A First Novel – and it breaks New Ground', announced Arnold Kettle in the *Daily Worker*. [15]

The only unsympathetic reviews were in the *TLS* ('marred by posturing', the characters 'treated rather as class symbols than human beings') and *John O'London's Weekly* ('drab', 'pedestrian', 'shows signs of strain and toil, of desire without ability'). Elsewhere, the reviews were almost entirely favourable, despite the novel's obvious communist provenance. 'It is the kind of book that could easily have been turned into a Marxist tract,' said *Tribune*, adding that 'it is the best working-class novel I've read for years.' William Cooper in the *Listener* praised it as 'solid, humane, and warm-hearted', 'first rate'; 'in Miss Heinemann's book there is a streak of near-documentary – strong enough for people who define the spectrum of permissable components of "The Novel" very narrowly to say *The Adventurers* does not get in.' *Books and Bookmen* was pleased to discover 'in the contemporary welter of social-realism-for-its-own sake' a novel of working-class life 'in the big tradition'. 'It is a relief to read a novel that is not a mere mass of sensibility,' declared John Davenport in the *Observer*, favourably comparing Heinemann to C. P. Snow, Nigel Balchin and Bruce Marshall, Walter Allen and Alan Sillitoe. Not surprisingly, the novel was well received in trade union publications such as the *Foundry Workers Journal*, the *Transport and General Workers' Union Record* and the *Scottish Miner*, where it was reviewed by Abe Moffat, President of the Scottish NUM. But no one was more enthusiastic than Walter Allen, writing in the *New Statesman* about a novel which 'for all its deceptive simplicity, is in the end quite unlike anything in contemporary English fiction':

> a novel genuinely about politics, about the ways in which power is achieved and used. Miss Heinemann has a Balzacian grasp of trades and techniques which allows her to do things very rare in English fiction. No one, I think, has caught more unerringly the public mood that put Labour in power in 1945 – and the disillusionment that followed. One expects, I suppose, a Communist novel to be tendentious, propagandist. *The Adventurers* does not seem to me so at all ... the most considerable and the most formidable new novel in English I have read this year. [16]

The novel sold out almost immediately. In 1962 it was reprinted as the August choice of the Readers Union 'Contemporary Fiction' book club and published by Seven Seas Books in the GDR. The BBC even considered a television dramatisation. What ten years of strident exhortation had failed to encourage, the crisis of 1956 had helped to produce. [17]

Abergoch Russian

Margot Heinemann began writing *The Adventurers* some time in 1954 or 1955. One afternoon a week a friend came round to look after Janey and she took the opportunity to start the novel she had long wanted to write about the miners (this partly explains the episodic nature of the book, largely written in sequences of 500 words). For her previous books Heinemann had been able to draw on her friendship with communist miners' leaders such as Arthur Horner (then President of the SWMF), Bill Paynter, Abe Moffat and Bert Wynne, as well as regional officials in South Wales like Dai Dai Evans and Idural Penhallurick. [18] This time she could not easily leave London to discuss the novel with friends in the coalfields. The books she most admired about the lives of miners were by miners themselves – Lewis Jones, Len Doherty, B. L. Coombes and Sid Chaplin – and though she knew a great deal about the workings of the NUM, she knew less about ordinary life in the coalfields, particularly since the war:

> I didn't set out to write a book centred entirely on the pit and the mining village I knew. Other writers, who lived it, would do that infinitely better than I ever could ... What I did know something about was the role of the miners in the labour movement at all levels; the arguments and pressures over capitalist and socialist ideas and how to make a career; the influence of the mass media on solidarity and trade union unity; the relation of the mining communities to the country as a whole. [19]

The Adventurers opens in the fictional 'mid-Wales coalfield' in 1943. Eighteen-year-old Danny Owen does not want to follow his father and the rest of the boys in Abergoch down the pit. He is keen to serve in the RAF, but the government needs more miners, and he is directed to work underground. When he refuses, he is sentenced to three months' imprisonment. He keeps his spirits high in prison by dreaming of becoming a writer in the service of the miners, and thinking of the books he has read of great men imprisoned for their beliefs ('To fight for the right to be what you were, to bring to flower the talent you had'). When some of his friends bring the two local pits out in protest, the union is brought in, and Dan is eventually released to a hero's welcome. He serves in the RAF, is swept along in the excitement of the 1945 election, and wins a two-year scholarship to Ruskin-like 'Keir

Hardie' College at Cambridge. There he meets other young working-
class radicals and makes contact with some communist students in the
university Socialist Club, who join his sense of himself and the past with
their own sense of the wider world, of the future:

> Someone began to sing: songs Dan knew, one or two he didn't know,
> Army songs or songs they had learned at camps and summer schools,
> 'Bless 'Em All', and 'Mairzy Doats', and 'The Man Who Watered the
> Workers' Beer'. And then Richard, who couldn't sing a note in tune,
> struck up one that only a few of them knew, *Stenka Razin*; but Danny
> knew it, because Dai James at home had an old battered song-sheet
> with it on. Oh but it was sad, it was sadder than anything in the world,
> sadder and more beautiful for all it was Russian ... It was not of the
> Volga Danny thought, though ... It was of Dai James in his little dark
> shop at the broken piano, and Alun the good singer, with no legs now;
> years ago it had been; and the crowd of workless men too thin for their
> clothes, pressed round the old piano, and Dai's clever fingers tickling
> her up to a frenzy. If the tune was Russian, by Christ it was Abergoch
> Russian, anyway![20]

After Keir Hardie, Dan works as an industrial correspondent for a Fleet
Street trade paper, *Skills*. His literary ambitions are still inseparable from
his feelings of paying back a debt to his past, to Abergoch, particularly to
his contemporaries whose industrial action in 1943 had 'saved' him from
going down the pit. He proudly sends copies of his first feature, about the
mechanisation of work underground, to his father and to his childhood
friend Tommy Rhys Evans. Soon Dan acquires a reputation as an indus-
trial journalist with good contacts in the coalfields and a sharp eye for a
human story, and he is invited to submit a talk for the BBC Home Service
about Abergoch before the War:

> How he and Tommy used to go to school when they'd got boots
> from the Quakers of the teachers' fund, and stay home when they'd
> none. How he remembered his father, stumbling into the gate bent
> double under a bag of small coal scratched from the tip, a day's long,
> slow pickings. How Dad would have three days work and two idle,
> and that week they'd pay the rent and the grocery, but still nothing
> off the old debt. Those were times. (p. 153)

Up to this point the novel has been carried forward by Dan's successes.
He climbs each new 'rung on the ladder of his dreams' as the Labour
government climbs out of the problems of post-war reconstruction and
as conditions back in Abergoch steadily improve under nationalisation.
This certainly feels like a kind of Anglicised socialist realism, the per-
sonal and public worlds of the novel rising in a parallel forward move-
ment, Dan's good fortune an expression of the new opportunities of
Labour Britain, his moral stature measured in terms of his loyalty to

Abergoch. Dan is a representative generational figure carrying the hopes of Abergoch and the novel into the wider world, *de haut en bas*, against the solid background of family, pit, union and politics. His successes are theirs; their problems are his.

Warts and All

But if Heinemann had started writing *The Adventurers* as a socialist-realist novel, she found she needed a new fictional model in order to finish it:

> In the older working-class novel, the group was so strongly exalted that often the human being as a separate individual was little developed. Remembering some of those books now – *Barricades in Berlin*, *May Day*, *Cement* – we can see that the style was an international one, it belonged to a period. The strike, the construction job, the Revolution became itself the hero. Today we are much more conscious of the need to avoid over-simplification ... We certainly don't want ... 'wishful thinking' novels, in which political alignments are more important than people and the writer solves simply with a stroke of the pen all the problems which are still unsolved in life. Nor novels which, out of a mistaken idea of the kind of loyalty to principle demanded of a socialist artist, ignore all the sore places, all the tragic mistakes and failures which anyone involved in the fight for socialism feels and suffers under. We don't want cardboard heroes or 'push-over' masses: we want real people, 'warts and all', absorbed in their own lives and problems; real conflicts, real failures, real determination ... We will not have working-class or socialist novels on the level we need until we as writers break out of the convention which inhibits and censors a great part of the world we know. [21]

Between this article and her call in 1954 for more socialist-realist novels, lay of course the events of 1956, which shook her sense of herself as a novelist as much as it challenged her identity as a communist. The 'international' style of socialist realism was now as much a problem as the international obligations of the party, a point of both aesthetic and political conflict. Although she abandoned neither the Communist Party nor her desire to write a political novel, Heinemann's attitude to both was fundamentally changed. *The Adventurers* marks the end, in Britain at least, of the confident chase after socialist realism in fiction. The second half of the novel is a record of the loss of that confidence, and a warning against its temptations, the narrative suddenly exchanging a self-defeating 'optimism' for an understated and guarded uncertainty about the future.

Dan has always been troubled by conflicts between his sense of destiny – his future – and his sense of loyalty – his past. At Keir Hardie

he pretended to have laryngitis in order to avoid being associated with student complaints about the staff in front of the governor. On the other hand, he refuses to write a report on the meeting for the student newspaper in case it incriminates his friends ('there were things you couldn't do to your friends'). Shortly before the 1950 election Dan sets up an outside broadcast for the BBC on the government's house-building programme. To his amusement, a group of builders led by an old friend from Keir Hardie use the occasion to stage a protest against cuts in the housing programme, and the broadcast ends with a chorus from 'The Red Flag', to the BBC's embarrassment. His producer is blamed, she blames Dan, and he has no one to blame but Curly Farrell and his 'Bolshie friends'. Curly is of course delighted by the effect of the broadcast, but so in the end are the BBC, since they want stories like this to embarrass the Labour government in order to 'balance' their coverage before the election.

From this point Dan decides to protect himself, his first responsibility now always to his own career as a journalist, 'to master the raw material and make it work for you'. He starts writing for the up-market *Industrialist*, even occasionally contributing to the Sunday papers, enjoying the cynical camaraderie of Fleet Street. When he is asked to write an anti-communist piece about the Garment Workers' Union, his sense of responsibility narrows to a knowing professionalism; 'Danny never changed his views so he could remember. It was rather that, after a couple of years of this kind of thing, one got a sense of proportion.' (p. 182).

Thereafter the novel begins to follow a very different trajectory, as Dan slips from the centre of the novel to its very edges. Dan quickly becomes the hapless victim of his own success, his fall from grace as effortless as his rise to fame. Dan's moral 'progress' is made explicit when his girlfriend finds she is pregnant. 'I won't let you down', he is quick to assure her. He means, however, only that he will find the money for an abortion, unwilling to see that she wants to have the baby, terrified 'of being trapped into steadiness and monotony, stranded on the bank of the ever-swirling river'.

The Divisions Between Them

At this point the novel turns decisively away from Dan, back to Abergoch and the life on the far side of the swirling river he has crossed. If Dan and London had remained the novel's centre, *The Adventurers* might perhaps be better known, a study in 'success' and social mobility in post-war Britain, inviting comparison with novels by John Wain, William Cooper, John Braine and Raymond Williams (whose *Border Country* was also published in 1960). But if Heinemann was wary of the temptations of the heroic, she was also critical of what she called the 'anti-vitalising' effect of post-war anti-heroic fiction. As she later wrote: 'I particularly *didn't* want to treat it as inevitable that Dan, in a good job, would

simply start to sell his mates for money ... the line I want to draw here is between the Dans and the rest.'[22]

Early in 1959 Heinemann sent a draft of the novel to C. P. Snow, whom she knew through her partner, J. D. Bernal. Snow wrote immediately to say how much he liked it, 'the only readable book about English left-wing politics that I've read', 'intelligent, sensitive, painful and moving'. While Heinemann was waiting for Bodley Head to make a decision on the book, Snow offered to write in support; when they turned the novel down in September, he urged Heinemann to use his name when sending the manuscript out again. Over the next six months Snow gave her detailed advice on a number of technical questions. In particular, Snow was unsure about her use of interior monologue to effect a shifting narrative point of view in the second half of the novel. But though the context had changed, for Heinemann such formal considerations were still inseparable from political ones:

> I'm not convinced that there is any other way – clumsy as it may seem – of presenting the ideas, as I mean to do, in the raw ... The same applies to 'shift of viewpoint'. This is necessary if one wants to show *more* than a good book like 'Room at the Top', say, or (I suppose) Walter Allen's new one. I'm aware that to say Tolstoy did it sounds arrogant – but is it any more so than to say Henry James stuck to one or two fine consciences, so I should? If the viewpoint were more static the author would obtrude more (unless the book were to be purely negative in effect): and since most readers don't agree with the author their sympathy with the book would be weakened.[23]

The return to Abergoch in the second half of the novel does not therefore involve a narrowing of its range, but a sudden expansion of the cast and of the terms in which the novel discusses loyalty. Between them Tommy Rhys Evans, Lewis Connor and Richard Adams represent everything that Dan has escaped (failure) and everything he has lost (Abergoch). Tommy still works at the Louisa pit, now married with small children; Connor is a regional NUM official; Richard, whom Dan knew at Cambridge, is a member of the Communist Party, now working in adult education in the valley.[24] And while Dan's success absolves him of loyalty to anyone but himself, they are shaped respectively by local, national and international loyalties. Over the next five years these distinctions, like their loyalties, are severely tested, as they have to learn new ways of inhabiting hard choices and harder defeats. They are obliged to make difficult decisions, not because the 'right' decisions will change the world (the novel now insists on the overwhelming odds against any individual choice or action affecting anything directly) but because History is the sum of every uncertain choice between loyalty and destiny, the past and the future. And through those choices emerges a new set of values conditioned by rather frailer terms like decency and responsibility.

Connor is a popular leader and a skilled negotiator (he negotiated Dan's release from prison at the beginning of the novel), but he is increasingly conscious that nationalisation has somehow changed him from a leader into a 'lion-tamer'. His position in the union and with the board is never simple, always vulnerable to accusations from communists in the union that he is selling the miners short and from the board that he is impeding progress. The Abergoch pits have a reputation for militancy which makes them a target for closure, and hard to defend. It is easy for Connor to argue against the NCB when they urge the NUM to take a longer view over colliery closures; it is harder when he finds himself making the same argument to a deputation from the Abergoch pits, needing to persuade them to return to work in order to strengthen his negotiating position with the board. Eventually he wins a reprieve for the Abergoch pits with a utopian speech about the valleys as they might one day be:

> He saw arising there a new, clean township, a memorial to all who had suffered and starved between those steep and shouldering hills. He saw the tips levelled, the roadways paved, and ranks of fresh, bright little houses climbing the grey slopes among gardens of flowers. (p. 227)

At this point, however, the fine rhetoric is burst and all Connor's hard negotiating undone as news comes in of another unofficial stoppage in Abergoch. The NCB suspends the reprieve.

For Richard and Kate Adams the campaign to save the Abergoch pits is a welcome respite from the frustrations of working for the Communist Party in the valley, where its strength in the NUM is not reflected in branch life. They work hard in the campaign, for once not needing to rely on the 'longer view' of the party to sustain their energies, not knowing that the campaign is only going to make the closures more likely. And, for all their efforts, the pits are in the end reprieved, not by the public campaign in the valley, but by Connor who leaks the information about the board's original decision to the press. And though they are excited by the apparent success of the campaign, the party is left afterwards as isolated as ever. When they try to build on the success by organising a public meeting on peace, the room is half empty. As Tommy explains, without conscious irony, 'it's different, see, when it's something that really matters to people, like.' The campaign has its lessons for him too:

> you must live in your own time, in your own place, to live at all; and the exultation, the sense of being carried beyond it, that he'd had at times in this battle wasn't enough to live by always. Already at the big Victory social, even during the singing, he thought: next week we shan't be together like this. The shopkeepers will be banding together to stop wasting our good rate-payers' money on school outings, and

Chapel and colliers will be at one another again over the pubs open-
ing on Sundays. When those big chords sounded out, it seemed as if
we would stand in the brightness of them for ever. But we shan't, I
know. (pp. 224, 239)

Tommy is elected chair of the combined Abergoch lodges, but even
within the union he finds only more divisions. When he is elected dele-
gate to the 1954 TUC, he hopes to find there some wider sense of
unity, 'the sense of man's brotherhood'. But the Congress is divided
over German re-armament:

> so deep in this great assembly, dedicated to the unity of the common
> people, were trenched the divisions between them. And all he could
> do was to watch it like a show ... It was hard to remember that in
> this fun-fair, in this week of cheerful and machine-made relaxation
> from the grime of pit and foundry, the fate of the world was being
> decided. And yet how little Tom had to do with deciding it. He
> hadn't ever imagined himself making a dazzling speech to the Con-
> gress; he had no such ambitions. What he did expect was a chance
> to hold up his hand for those things he and his mates believed in
> and to vote against plain evil. And just this was denied him. You
> voted as the delegation decided, which was almost always as the
> officials decided. Most of the time working miners seemed to have
> little to do but act as scenery, to make it look like a miners' repre-
> sentation. (pp. 268, 269)

Looking for the battle lines between Good and Evil, he finds the real
divisions in himself, torn between loyalty to the memory of a school
friend who lost his legs on a Normandy beach, and loyalty to the union.
Like Lewis Connor and Richard Adams, Tommy learns that every fine
vision frays on the hard edges of experience.

These unravelling threads wind away and out of Abergoch to the real
centres of power and decision-making, eventually twisting together in a
knot which pulls Dan back to Abergoch and the line of the narrative.
Connor stands for election to a national position in the NUM, and Dan
is asked to 'research' Connor's political history for an anti-communist
caucus inside the TUC. The material is used in a BBC television docu-
mentary which presents Connor as a dupe of the Communist Party, and
which contributes to Connor's defeat in the election and his own grow-
ing dismay and self-doubt:

> it was not so much a blow to ambition, breaking off short the
> dazzling arc of his career, it was also a blow to all the things by
> which, though not too desperately in late years, he had lived. He had
> done his share of manoeuvring and twisting – who in public life
> hadn't done that? But all that had seemed best and most honourable
> in the pattern of his work – his loyalty to the men underground, his

witness to the brotherhood of man – all this had been cheapened and degraded, and rejected among his own people. (p. 262) [25]

When Tommy discovers Dan's involvement in the programme, Dan airily defends his actions as the work of a journalist who could not let a personal debt to Connor affect his professional judgement, and accuses Tommy of political naivety:

'It's not me started the ganging up, as you call it ... This is how the world is, boy – the real world. To you, a Communist's just another lad who'd do his share if the face came in. Probably he would too. He may be a nice fellow – that's not the point. It's what he signed on for, what he's being used for. The union's just a stamping-ground for their Party, and what they want is what Russia wants ... You're determined to be innocent ... Your mistake is to take all this person- ally. Politics isn't a moral affair like being kind to your family and honouring your father and mother. It isn't that simple ... no one in this business is a free agent. No one can just do what they think right and damn the consequences. That's only street-corner shouting ... If Britain wasn't a world power and we lived like the Danes by raising bacon and butter; and if the Russians read *Peace News* and relied on spiritual persuasion; and if there weren't any British General Staff or American General Staff or gangsters in the Kremlin. Sure, we'd be free as air to choose. And if my aunt had balls she'd be my uncle.' (pp. 284–8)

The matter is settled, uselessly but conclusively, when Tommy hits Dan, and though they are soon laughing at their tempers, the friendship is clearly over. Tommy has discovered that there is nothing so valuable that it cannot be sold. For Dan, the affair has confirmed the process by which he has changed, sealed his separation from Abergoch for good.

For Richard and Kate, Connor's defeat only deepens their political despair, as they watch half an hour of television undoing the work of a lifetime. Richard sees the implications of this kind of political power for the party, rendering them more helpless than 'peashooters against the hurricane'. Khrushchev's revelations about Stalin at the twentieth Con- gress in 1956 and the incipient intellectual thaw in the Soviet Union restore their faith in the party, but the events in Hungary later that year reveal how brittle a faith this has become:

It seemed to Richard now that all the people who had refused to listen were quite right. If they dug their gardens and looked after their children, they were fully entitled to feel contempt, even anger, towards those who had claimed to understand and settle the world. (p. 303)

The Only World There Is

And there the novel ends, abruptly, in contempt and in anger, at the
lowest ebb of all their fortunes. The adventure is over. As Richard walks
down the valley towards their house, he is still struggling in the fading
light with old arguments about responsibility and loyalty, still trying to
find the 'longer view' of socialism:

> One might of course say: 'I don't like this world, either side; if I had,
> personally, the building of Socialism I wouldn't have done it like this,
> but quite differently. And for that matter, if I wanted to get to Social-
> ism, I wouldn't have started from there at all, a backward, ignorant
> country. A plague on both your houses!' But ... like it or not, this world
> is the one we live in – though we only partly control or understand it,
> labouring and crushed as it is with the weight of its ugly, time-hon-
> oured, brutal past, so that victory itself distorts and almost founders
> under the load. But this is the only world there is. (p. 315) [26]

Reading the novel in manuscript for Lawrence and Wishart, Arnold Kettle
wrote to Heinemann about the ending:

> I'm not of course arguing for a sunshine ending or the leaving out of
> the Party's difficulties or weaknesses. What I'm not quite happy about
> is a certain overall sense of increasing disillusion; whereas I should
> have thought that the point about this period is that the struggle takes
> new forms, I don't want to exaggerate my point here: I'm not for a
> moment suggesting that the Epilogue as it stands is defeatist in any
> disastrous way ('playing into the hands of the enemy' etc.). Not at all
> ... I see the difficulty of gaining an upward trend at the end without
> falling into vague uplift or wishful thinking and I don't think the answer
> is to include a scene in which twenty new recruits are won! [27]

But Heinemann was clear about the novel's need for an uncertain and
understated anti-heroic ending, not just a 'realistic' one. Though she was
prepared to 'put in another sentence or two carrying Richard's recovery
of confidence a shade further', she insisted that it could 'only be a
rather fine shade', otherwise 'he'll seem to be getting over it all much
too quickly and easily to convince one of his sincerity in the first place'.
The final scene, which she wanted to be a 'reminder that whether you
feel enthusiastic or not the fight will go on, with or without you' was,
she felt, the '*right* end, for these particular people.' And it was not just a
question of characterisation:

> Of course this raises the old problem of typicality – is Richard
> typical, is Tommy, is the epilogue typical of the Fifties and so on.
> Again it's difficult – because if everything has to be strictly average,

in the end all the novels will be the same novel, as there has been a tendency at times for a good many of them to be in the USSR ... for much of the time I have had the common illusion, common I believe in writers, that the characters were real people and I was recording what they did and felt, and couldn't possibly alter it to make it more typical. This is of course exactly the kind of thing that makes contributors to *Marxism Today* ... so angry, it sounds both mystical and arrogant, but I don't think I could possibly have the confidence or power to write without it ... This perhaps raises the real point about what the Party can and can't do to help writers produce the right books. In the main, its job [is] to make them better Communists – the whole man, not just the writer – so that what he sees as real and convincing is what a Communist sees. One can never get it right by starting at the other end, at the book itself. [28]

For ten years, starting at the 'wrong end', the party had expected its novelists to portray the world as it wanted it to be. Starting at the other end, *The Adventurers* sought to portray the world as it was and the party as Heinemann now saw that it needed to be – abashed, modest and genuinely self-critical – if it was ever to recover from the shock of 1956 and the loss of its claims to absolute truth. The ends of socialist realism were clearly incompatible with the end of that claim. *The Adventurers* was as much an account of the faith she had lost as it was a statement of her own renewed, and qualified, commitment to the Communist Party, in the only world there is:

> What *was* new about that period for many of us was that for the first time one didn't, in one sense, get over it at all: some kinds of easy confidence one will *never* have again, and I would think rightly not. [29]

Notes

I wish to record my thanks to Janey Bernal for permission to quote from her mother's papers and to Hilary Wilson for making them available, to Noreen Branson for information about Margot's work at the LRD, to George Matthews for making available copies of the National Cultural Committee papers, and to the librarians at Middlesbrough Central Library for battling on my behalf with the inter-library loans service.

1. For the Communist Party in this period, see Willie Thompson, *The Good Old Cause: British Communism 1920–1991* (1992) and Noreen Branson, *History of the Communist Party of Great Britain 1941–51* (1994).
2. *Transport and General Workers' Union Record*, November 1960.
3. According to Noreen Branson, who also worked at the LRD, Heinemann's report on the 1948 Margate TUC in *World News and Views*

(as M. Hudson), September 1948, was used by the General Council as a pretext for an anti-communist witch-hunt in the TUC.

4. 'The Caudwell Discussion', *The Modern Quarterly*, Autumn 1951. For the Communist Party's Writers' Group in these years see Andy Croft, 'Writers, the Communist Party and the Battle of Ideas, 1945–50', *Socialist History*, no. 5 (1994); see also Andy Croft, 'Authors Take Sides: Writers and the Communist Party, 1920–56', in Geoff Andrews, Nina Fishman and Kevin Morgan (eds), *Opening the Books: Essays on the Social and Cultural History of British Communism* (London: Pluto Press, 1995).

5. 'André Stil and the Novel of Socialist Realism', *Marxist Quarterly*, April 1954. Stil was editor of *l'Humanité*.

6. 'The Cultural Work of the Party', *World News and Views*, 2 February 1952.

7. Sam Aaronovitch, 'The Party's Cultural Work', *Communist Review*, July 1952.

8. *'Daylight'* (supplement), *World News and Views*, no. 36, 1952; NCC circular, May 1951. Burns was chair of the NCC.

9. *Daylight*, vol. 1, no. 2.

10. Margot Heinemann, undated letter to the author.

11. For the impact of the events of this year on Heinemann, see her '1956 and the Communist Party' in the *Socialist Register*, 1976.

12. This debate began in *Marxism Today* in May 1959 with Arnold Kettle's 'The Artist and Politics', followed by contributions by Robbie Wilson, Laurie Green and Osmond Robb (July 1959), Jack Lindsay (September 1959), Stan Searchfield, Peter Pink, Dave Wallis and D. Lesslie (October 1959), Ruscoe Clarke, T. D. Smith and David Craig (January 1960) and Kettle again (February 1960).

13. For a discussion of these novels see Ingrid von Rosenberg, 'Militancy, Anger and Resignation: Alternative Moods in the Working-class Novel of the 1950s and early 1960s', in H. Gustav Klaus (ed.), *The Socialist Novel in Britain* (1982); Doherty also appeared thinly disguised as the painter 'Davie' in Clancy Sigal's *Weekend in Dinlock* (1960).

14. Michael A. Cohen, 'Culture and Socialism', *Marxism Today*, June 1960. This was followed by contributions from Eddie Dare (August 1960), Lionel Munby (September 1960) and Michael A. Cohen again (December 1960).

15. *World News*, 22 October 1960; *Daily Worker*, 20 October 1960. Several senior party critics like Douglas Garman, Alick West and Honor Arundel wrote to Heinemann to congratulate her.

16. *TLS*, 4 November 1960; *John O'London's Weekly*, 27 October 1960; *Tribune*, 4 November 1960; *Listener*, 20 October 1960; *Books and Bookmen*, November 1960; *Observer*, 25 December 1960; *Scottish Miner*, December 1960 (Abe Moffat had read the novel in proof for Lawrence and Wishart in the summer of 1960); *New Statesman*, 3 December 1960; Heinemann had earlier ridiculed Allen in the *Marxist Quarterly* for his unsympathetic treatment of André Stil's

trilogy in the *New Statesman*. Other notably enthusiastic reviews
were in the *Guardian*, 4 November 1960, and *British Book News*,
April 1961. Even the *Western Mail*, traditionally no friend of the
miners, had nothing but praise of the novel, 31 October 1961.

17. The novel sold 1,304 copies between 20 October and 31 December
1960, leaving only 422 unsold. The Contemporary Fiction Book
Club was founded in 1960; the editor was Walter Allen. Other
novelists whose work was offered to club members in 1962 were
Camus, Chinua Achebe and V. S. Pritchett.

18. According to Eric Hobsbawm, after the Second World War Heine-
mann was offered a full-time job by the NUM which she refused
only on the advice of Harry Pollitt.

19. Notes for a talk to the Llafur/South Wales NUM 'Miners in the
Modern World' conference in Swansea, April 1980.

20. *The Adventurers* (1960, new edn, 1962), p. 72.

21. 'Workers and Writers', *Marxism Today*, April 1962. Interestingly,
this piece refers to Bowen and Greene as examples to whom social-
ist writers should now attend.

22. Margot Heinemann, undated letter to Arnold Kettle. It was a sign of
the Communist Party's deepening isolation from British society that,
while the party was still wringing its hands about the dearth of a
native working-class literature, a generation of young, provincial,
male, working-class writers was of course taking London publishing
by storm (see, for example, Arnold Kettle's unsympathetic 'How
New is the "New Left"?', *Marxism Today*, October 1960. *The Adven-
turers* has been almost entirely overlooked by cultural historians of
this period, though Alan Sinfield in *Literature, Politics and Culture in
Postwar Britain* (1989) describes it as 'the sharpest version of the
revisiting fable' of the late 1950s and early 1960s, 'the most positive
and astute representation of working people that I have seen in the
period'.

23. Undated notes on Snow's comments among Heinemann's papers.
Bernal was the model for the character of 'Constantine' in Snow's own
early novel, *The Search* (1934). Several reviewers compared *The Adven-
turers* with Snow's 'Strangers and Brothers' series of novels. For Snow
and Bernal, see C. P. Snow, 'J. D. Bernal, a Personal Portrait', in M.
Goldsmith and A. MacKay (eds), *Society and Science* (1964) and,
more generally, Gary Werskey, *The Visible College* (1978).

24. The character of Richard Adams bears a striking resemblance to the
young Edward Thompson: 'tall, well-built and slightly shaggy, with
rough lion-coloured hair and a frowning seriousness about his
speeches in discussion', a passionate, charismatic figure, who returns
to Cambridge after the war and Italy, his communism partly inspired
by the memory of his brother killed in Spain (Thompson's brother
Frank was killed in Bulgaria during the war), now teaching literature
and history in adult education, active in the early Peace Movement,
and swinging between struggles with his conscience and with his

party. Unlike Thompson, however, Richard doesn't leave the party in 1956. C. P. Snow thought the character of Richard the novel's best.

25. Unfortunately, the year *The Adventurers* was published, the communist ballot-rigging scandal began to unfold inside the ETU.

26. Only after the novel had been rejected by Heinemann and Bodley Head did Margot Heinemann send it to Lawrence and Wishart. This was partly because she was worried she might lose her job at Camden School for Girls if the authorities knew she was a member of the Communist Party (she originally wanted to publish the novel under the name of 'R. J. Paul'). But she was also anxious that the novel's treatment of 1956 would prove too painful for the party's own publishers. Maurice Cornforth, however, was keen to publish the book and wrote to reassure her that though the ending 'might discourage foreign translations', there were no 'grounds for opposition' to the novel at either Chancery Lane or King Street: 'In particular, I do not think the treatment of the twentieth Congress at the end would be found objectionable at all ... What is said about Hungary is the same as is said in the novel "October Storm", which is now a bestseller in Hungary and they are translating it for us.' Cornforth's main anxiety was the possibility of libel action; he thought the anti-communist 'Murdoch' might be identifiable as Woodrow Wyatt and the character of the ex-party member was too close to Bob Darke, the Hackney bus conductor whose *The Communist Technique in Britain* had been published in 1952. The manuscript was accordingly checked for libel by Dick Freeman.

27. Arnold Kettle, undated letter to Heinemann. In the *Daily Worker*, however, Kettle made this point rather more sharply, regretting that at the end 'the Party's answer to its critics is not given quite the force that reality ... demands'. Though Andrew Rothstein wrote to congratulate her on the novel, he complained that 'the party is too shadowy in it'. According to Heinemann, several senior party figures expressed disappointment that Tommy did not join the party at the end of the novel.

28. Margot Heinemann, undated reply to Kettle.

29. Ibid.

ADDRESS AT THE FUNERAL OF MARGOT HEINEMANN 19 JUNE 1992

Eric Hobsbawm

We're here to say good bye to Margot, friend and comrade for so many years – since 1936 or 1937 in my case. We grieve about our loss, and especially Janey's, and about her suffering in the last months, but not about her death, which was a release from pain. But rather than talk about her death, we should celebrate her life: the life of an extraordinary person, one of the most remarkable I have known, and the life of an exemplary communist.

By chance her obituaries, at all events those I have seen, have also printed pictures of Margot at different ages. One thing stands out from them, and it is what probably struck most people who met her for the first time: her eyes, wide-spaced, deep-set, radiating intelligence, and which looked straight at you. I think anyone who met her, or at least who was in her company for more than a few casual moments, recognised that they were in the presence of an exceptional person, even if they knew nothing about her. She projected her passion, and she was absolutely without sentimentality and bullshit. That was one of the things that made her such a good teacher. And, incidentally, she knew what needed teaching. When as a student I went to work for her in vacations at the old LRD – where was it then, in Doughty Street I think? – she taught me what nobody at Cambridge had bothered to, namely how to use reference libraries and how to introduce raw students to one kind of research. So I owe Margot a professional as well as a personal debt. Like so many others.

My personal debt to her is that she, more than any other single individual I can think of, taught me, by her example, what being a communist meant, or should mean, especially for intellectuals. Give or take two or three years, we belonged to the same generation, even to the point of having become communists (though not, in my case, joining the party) before the 7th World Congress of 1935. For communists of that generation joining the cause of the October Revolution and the international army of the Comintern was a total commitment, and the only thing to do with their lives. Margot dedicated her abilities and her life to this cause, as others did, without any thought of self, without even considering that others might think there were other and better ways of passing one's life, and with even less thought of career or

success in the conventional terms. Or indeed in any other terms. In our time at Cambridge we got good degrees because the party line was that communist students were good students, although it would probably have been difficult to prevent Margot from getting the most brilliant English First of her year – perhaps of the '30s – with her left hand, while the right was engaged in writing pamphlets. The strength of communism at the time was that it attracted top talent, both among working-class cadres and among intellectuals, to an extraordinary extent, and nobody quite knows how. But there is no mystery about why: in the collapse of the old society, in the dangers of fascism and war, communism seemed the great, the only hope.

The historic period that began with the October Revolution is now at an end, though the battles we fought go on in one way or another. Margot's generation of communists are historical monuments, in so far as they are still alive. Even for us the faith in the society created by the October Revolution dimmed, and flickered, and went out after 1956. Even before 1956, for I remember, on the only occasion when I spent some time in the USSR, shortly after Stalin's death, noticing that this seemed to be a country without communists, but just a country governed by the CPSU and in which therefore people made careers as communists. It was a country without people like Margot. I suppose we could say that British communists were lucky not to win power, which would have turned us into apparatchiks or the victims of apparatchiks; at first communist ones, eventually just careerist ones. Anyway, we never expected to. Still, I cannot possibly imagine communists on the model of Margot doing what evidently 99 per cent of the leading cadres of the USSR did in 1991, namely turn their coats from one day to the next and convert to free market anti-communism in 24 hours.

The dedication of people like her and their moral example would be admirable, even if they had wasted their lives, and turned out to have chosen the wrong cause. But we did not waste our lives, even though many of us lost their hopes. In the first place we, the communists and what was at the time the only communist state in the world, the USSR, won the most important negative victory of this century. We defeated fascism, which would have won the Second World War but for the USSR and the great national anti-fascist mobilisations of which we were the champions and pioneers. This was the great achievement of Margot's generation. Those of us old enough to remember can conceive of what a world might have been like which was predominantly fascist on the Nazi model or authoritarian in various styles, except perhaps for North America. Luckily for those who have grown up after the defeat of Germany, they don't have to.

In the second place, we were concerned with the world revolution and the Soviet Union only indirectly. Directly we were concerned with our own front in the battle, which was here. And this is particularly true for Margot, because what she committed herself to on that day when the hunger-marchers came through Cambridge was not just an idea and

an ideal, but concretely *people*, a class, the workers. Britain is where the workers belonged, even though my fondest memory of her and Janey is as a tourist lost in Venice. Well, the future of the industrial workers in an age of deindustrialisation is problematic, and so, in an era of trans-national capitalism, is the future of the unions. But it is as true now as it ever was that a country without unions is a country of social injustice. Margot worked for the unions, and especially the miners, and she has a right to ask that her life be judged by that and what she did for British workers and not by what Stalin did in Russia. And what she did as a British communist was good.

But my point isn't to defend Margot's life against latter-day anti-communism or yuppie politics. She would not have thought it needed defending and she would have been right. What I want to say is that she became an example and an inspiration to others, and certainly to me, because she never let her communism go on autopilot or, even worse, programmed her mind to justify whatever party line came from the top. Unlike Palme Dutt, who never used his superb mind for any other purpose, Margot never confused the demands of 'democratic centralism' with intellectual abdication. Unlike her – our – admired comrade James Klugmann, she never confused loyalty with evasiveness. Even before 1956, even in Britain, those who remained communists were either those who decided that 'theirs not to reason why', or those who faced the possible conflict between theory and practice, between belief and reality, and concluded, nevertheless, that their commitment held good. Margot was one of the second kind, and that is one reason why in the 1930s she taught me more about what being a communist meant than anyone else. And, in a way, she stayed younger than all of us whom she influenced and who shared her readiness to face the hard realities of being a communist. For she never became cynical about our cause – she could be scathing enough about other things – she never lost hope, she was, to the end, in Andy Croft's words, 'excited by the possibilities of change'.

Outstanding people who devote their lives and talents to a small party without thinking of their public image risk being underestimated, especially if they are women, who tended to stay out of the limelight even in great movements of the left. This is a risk even for someone like Margot, who left behind her books and poems which *will* go on being read, and which bridge the deep canyon that separates the memory of those who have known a person from those who could not have ever known them. If you look at the leading book on Cambridge between the wars, she is not in it. John Cornford and Bernal are, Klugmann and Kiernan are, and so are Kettle and myself, but not Margot Heinemann. It isn't quite an anti-feminine plot, but still, if she had been a man ... Margot wasn't a general secretary nor on the EC, she wasn't an MP though once, protesting bitterly, she had to stand as one of the 100 forlorn hope party candidates which a particularly stupid line had decided on. If she is in any of the histories of the CP, I've missed her.

The deep respect in which she was held was not based on her formal positions. That is why it is important for those of us who knew her, and who knew what she was, to tell those who come after us that Margot Heinemann was a person to be remembered and remarked even in a remarkable generation: one of the blest, one of the most talented, in her way one of the most quietly heroic. Perhaps she wouldn't have wanted me to say that about her, though she knew her merits. But it needs saying. Still, what she would want to be remembered by is the cause to which she devoted her life and which, through its ideals and its hopes, and not least through the lives of people like her, will survive the memory of Stalin and what used to be called 'really existing socialism'.

It was my great good luck to have been her friend for 55 years. We are all better for having been her contemporaries.

NOTES ON CONTRIBUTORS

Colin Chambers is literary manager of the Royal Shakespeare Company. He has written on contemporary theatre for newspapers, magazines and journals, and is the author of *Making Plays: The Writer-Director Relationship in the Theatre Today* (1995), *The Story of Unity Theatre* (1989), *Playwrights' Progress: Patterns of Postwar British Drama* (co-author, 1987), *Other Spaces: New Theatre and the RSC* (1980) and the editor of *Theatre London* (1980). He is currently writing a history of the Peggy Ramsay play agency and editing the *Blackwell Companion to Twentieth Century Theatre*. He came to know Margot Heinemann through the cultural committee of the Communist Party, which he chaired in the 1970s.

Jean Chothia Friend and colleague in the Cambridge Faculty of English, she taught English Drama and Theatre Seminar with Margot. She is a Fellow of Selwyn College and Lecturer in English and American Literature, Cambridge University. She is the author of *Forging a Language: A Study of the Plays of Eugene O'Neill* (1979) and *André Antoine* (1991).

Andy Croft Andy Croft teaches Literature and Creative Writing in Middlesbrough for the University of Leeds Department of Adult Continuing Education. He has published and broadcast widely on the literary history of the Communist Party, including *Red Letter Days*, a study of British novelists and the Popular Front, a 45-minute documentary for Radio Four, 'Damn, Damn, Damn the Communist Party Man', and Harry Heslop's *Out of the Old Earth*, which he has recently edited. He is currently writing a critical biography of the communist poet Randall Swingler. He first met Margot Heinemann at the last Communist University of London in the mid-1980s. It was her example that persuaded him to join the Communist Party soon afterwards.

Elsie Duncan-Jones was born in 1908. She was a close friend of both Dorothy and Margot Heinemann and first came to know Margot well in Birmingham in the 1930s. Once described by Frank Kermode as the 'doyenne of Marvell studies', she was for many years Reader in English at Birmingham University. She acted as one of Margot's referees when she was appointed a Fellow of New Hall in 1976.

Inga-Stina Ewbank is Professor of English Literature in the University of Leeds and is the author of works on the Brontës, on Scandinavian drama and theatre, and on Shakespeare and Renaissance drama and theatre, including co-editorship of *The Arts of Performance in Elizabethan and Early Stuart Drama* (1991).

She writes: I first met Margot on the plane taking European Shakespeare scholars to the 1976 World Shakespeare Congress in Washington, DC, and was struck, even in those literally stuffy circumstances, by her lively and eye-opening engagement with Elizabethan drama. I remained an admirer of her work in that field; but what I remember best of all is her coming to talk to us at Leeds, only a couple of years before her death, on the 1930s. She held a packed audience spellbound with her unique ability of conveying *lived* experience and political commitment.

David Forgacs teaches in the Department of Italian at the University of Cambridge. His most recent book is *Italian Culture in the Industrial Era* (1990). In the 1980s he was a member, with Margot Heinemann, of the Communist Party's Theory and Ideology Committee. They later co-founded (with Tom Shakespeare and Martin Yuille) Cambridge Left Forum, which flourished briefly in 1990–91.

Edith Hall writes: I enjoyed many meals, numerous hair-raising lifts (she was still driving) and long discussions with Margot during my time as Research Fellow at New Hall, Cambridge (1987–89), where she vigorously befriended me. Without her I might well have given up academic life. I will thank her for ever for one wonderful rebuke: when I complained to her about my political isolation in Classics and the near-absence of any tradition of progressive criticism to develop, she referred to the moral of *The Wizard of Oz*, and told me to stop whining and do it for myself.

Christopher Hill was awarded a first in Modern History at Oxford in 1934. He was Fellow of All Souls College, Oxford, 1934–38; Assistant Lecturer in Modern History, University College, Cardiff, 1936–38; Fellow and Tutor in Modern History, Balliol College, Oxford, 1938–65; Master of Balliol College, 1965–78; Visiting Professor, Open University, 1978–80. His most recent books are *Milton and the English Revolution* (1977), *The Experience of Defeat: Milton and Some Contemporaries* (1984), *A Turbulent, Seditious and Factious People: John Bunyan and His Church* (1988), *A Nation of Change and Novelty* (1990), *The English Bible and the 17th-Century Revolution* (1993).

He writes: I was a friend of Margot Heinemann's for many years, and had innumerable fertile discussions with her about seventeenth-century English literature from the late 1640s onwards, especially concerning her splendid *Puritanism and Theatre*. Her influence and example are in great part responsible for the literary emphasis in books I have published since 1977. Most of them contain grateful acknowledgements to Margot 'who has contributed so much to our understanding of the relation between literature and politics' in seventeenth-century England. I always sought her guidance before venturing into print on such subjects: her judgements were sometimes severe, but always positive and helpful. It is a great sadness that I was unable to discuss with her my contribution to the present volume.

Peter Holland is Judith E. Wilson University Lecturer in Drama in the Faculty of English, Cambridge University, and a Fellow of Trinity Hall, Cambridge. He has published widely on Shakespeare, Chekhov and recent drama. He regularly taught seminars with Margot and Jean Chothia and grew used to Margot's ability to cut through academic waffle. He has never quite recovered from arguing with Margot about Howard Barker's attempt to provide a new ending for Middleton's *Women Beware Women* as Margot stormed furiously out of the Royal Court Theatre.

Maroula Joannou is Senior Lecturer in English Studies at Anglia Polytechnic University and the author of *Ladies, Please Don't Smash These Windows: Women's Writing, Feminist Consciousness and Social Change 1918–38*.

She writes: I met Margot regularly at the Communist University of London in the 1970s and could not have begun or finished my PhD at New Hall without her. Margot was the most generous of mentors and friends while I was there, reading and commenting helpfully on much of my writing, including an earlier version of the essay in this book.

Victor Kiernan grew up in Manchester, and was at the Manchester Grammar School, and then at Trinity College, Cambridge, reading History; he was a fellow member with Margot Heinemann of the Socialist Society. He spent some years in India, and from 1948 until his retirement from teaching belonged to the History Department at Edinburgh University. He was in periodical touch with Margot, more frequently in her later years, and like her was a contributor to the volume of essays published in 1988 in honour of Christopher Hill.

John Lucas is Professor of English at Loughborough University. Among his more than twenty books are works of poetry, criticism and biography. His most recent book-length publication is *Dickens: The Major Novels* (1992). A study of John Clare is forthcoming in the British Council Writers and their Work series.

He writes: I remember a meeting with Margot in the spring of 1976. She and I had both been invited to give papers at the conference to launch *Literature and History*. Mine was on Engels' and Elizabeth Gaskell's accounts of Manchester, and rather to my surprise Margot approved of the criticisms I made of Engels. But having her in the audience felt a bit like being a very junior senator in the presence of Moneta. You never quite knew when she was going to pronounce something you'd said hopelessly wrong or plain daft. On a later occasion she did, indeed, tell me off for daring to say anything in favour of Palgrave's *Golden Treasury*. 'Indomitable' was how I thought of her on both occasions, a generous but unyielding opponent and, more importantly, ally. It's how I think of her still.

David Margolies teaches English at Goldsmiths College. He edited the cultural politics journal *Red Letters* for many years and has written widely

on Renaissance studies and literary theory (*Monsters of the Deep: Social Dissolution in Shakespeare's Tragedies* is his most recent book).

He writes: I first met Margot at a conference on the 1930s in 1977 and got to know her as part of the team that edited the conference papers (published as *Culture and Crisis in Britain in the 1930s*). We worked together on various projects and for several years on the Communist Party's Theory and Ideology Committee. We had a close friendship, which three times survived our travelling together to the annual German Shakespeare conference in Weimar.

David Norbrook is Fellow and Tutor in English at Magdalen College, Oxford. His publications include *Poetry and Politics in the English Renaissance* (1984) and *The Penguin Book of Renaissance Verse* (with Henry Woudhuysen, 1992). He is currently working on a study of republicanism and literary culture in the mid-seventeenth century.

He writes: I first encountered Margot Heinemann in the early 1970s when she gave a paper on Middleton in a graduate seminar organised by Christopher Hill, and opened up an entirely new way of looking at the period. In her last years she offered generous and galvanising help with my Renaissance verse anthology and other projects.

Alan Sinfield got to know Margot Heinemann through the Literature Teaching Politics movement of the early 1980s, and is proud to have her important chapter on Brecht in *Political Shakespeare: New Essays on Cultural Materialism* (edited with Jonathan Dollimore, 1985). Her work and talk influenced in diverse ways his book *Literature, Politics and Culture in Postwar Britain* (1989). He is now working, particularly in lesbian and gay studies, at the University of Sussex.

Robert Weimann is Professor in the University of California, Irvine, and Chair of Forschungsschwerpunkt Literaturwissenschaft, Munich/Berlin. He served as President of the German Shakespeare Society, Weimar (1985–93) and is a regular contributor to *Shakespeare Jahrbuch*. His publications in English include *Shakespeare and the Popular Tradition in the Theater* (1978) and *Structure and Society in Literary History* (1984).

He writes: I first met Margot in connection with the Shakespeare quatercentenary and the publication of *Shakespeare in a Changing World*, edited by Arnold Kettle (1964), to which we both had contributed. In later years Margot often came and joined us at the annual Shakespeare Society conference and festival in Weimar (then GDR), where her presence and her contributions were highly valued. Entirely undogmatic and critical in every respect, she gave me overwhelmingly strong support for a *Festvortrag* on the issue of authority in Luther and Shakespeare (1983) – a highly sensitive topic at the time. We were proud when she accepted the invitation (1988) to become an Honorary Member of the Weimar Shakespeare Society.

INDEX

Note: Books and plays are indexed by the first significant word.
Abbreviation: MH (in subheadings) – Margot Heinemann.

Published by Pluto Press

OPENING THE BOOKS
The Cultural and Social History
of the British Communist Party

Edited by
GEOFF ANDREWS, NINA FISHMAN and KEVIN MORGAN

Opening the Books serves as an introduction and overview of key issues and themes in the history of the Communist Party in Britain, and an asssessment of the CP's changing historiography, particularly in the light of availability of newly accessible Communist archives.

Thirteen contributors examine particular aspects of the party's history from the early period, up to the events in Hungary in 1956 to the Eurocommunism and cultural politics of more recent years.

The scope is deliberately broad, covering not only the more conventional aspects of CP participation in the labour movement, but also the broader cultural influence of the party on writers, artists, scholars, activists and opinion-formers from the 1920s to the 1990s.

ISBNs hardback 0 7453 0871 6 softback: 0 7453 0872 4

Order from your local bookseller or contact the publisher on
0181 348 2724.

Pluto Press 345 Archway Road, London N6 5AA

Published by Pluto Press

The Good Old Cause

British Communism 1920–1991

Willie Thompson

*I take my hat off to Willie Thompson ... He has done
something I shouldn't have believed possible ...*
Peter Fryer, Worker's Press

How could a political group with overtly revolutionary aims
and a strong commitment to a faraway country find a place
inside a society which is both markedly conservative and
decidedly insular? *The Good Old Cause* is a unique attempt to
answer this question.

ISBNs hardback: 0 7453 0578 4 softback: 0 7453 0579 2

The Long Death of British Labourism

Willie Thompson

Willie Thompson argues that the hierarchical and disciplined
structure of organisations within the British labour movement
prevented it from ever becoming a real threat to the
Establishment. And for this reason it prospered. At the same
time, he suggests, it was its willingness to accommodate the
status quo that led to its slow decline in the second half of the
twentieth century. Willie Thompson concludes that it is time to
recognise that the labour movement has brought about its
own demise.

ISBNs hardback: 0 7453 0580 6 softback: 0 7453 0581 4

Order from your local bookseller or contact the publisher on
0181 348 2724.

Pluto Press 345 Archway Road, London N6 5AA